The Performing
Observer

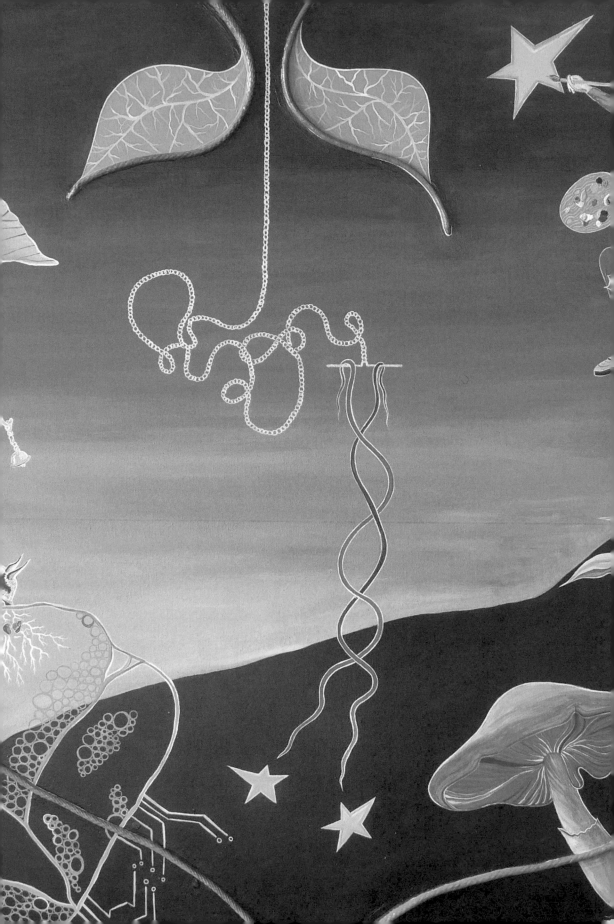

The Performing Observer

Essays on Contemporary Art, Performance and Photography

Martin Patrick

Bristol, UK / Chicago, USA

First published in the UK in 2023 by
Intellect, The Mill, Parnall Road, Fishponds, Bristol, BS16 3JG, UK

First published in the USA in 2023 by
Intellect, The University of Chicago Press, 1427 E. 60th Street,
Chicago, IL 60637, USA

A catalogue record for this book is available from the British Library.

Copy editor: MPS Limited
Cover designer: Aleksandra Szumlas
Cover image: Catherine Bagnall, *Alpine Walking with Tails and Ears*, 2013.
Photograph by Scott Austin. Courtesy of the artist.
Frontispiece image: Georgette Brown, *When The Bell's Tongue Licks,
I Work On My House: Part 2*, 2019. Courtesy of the artist.
Indexer: Lyn Greenwood
Production manager: Sophia Munyengeterwa
Typesetter: MPS Limited

Paperback ISBN 978-1-78938-674-5
ePDF ISBN 978-1-78938-675-2
ePUB ISBN 978-1-78938-676-9

Printed and bound by Short Run

To find out about all our publications, please visit our website.
There you can subscribe to our e-newsletter, browse or download our current
catalogue and buy any titles that are in print.

www.intellectbooks.com
This is a peer-reviewed publication.

Contents

List of Figures ix

Acknowledgements xiii

Original Sources of Publication xvii

Preface: The Performing Observer xix

PART I: PERFORMANCE 1

1. Chris Burden, Iggy Pop, and the Aesthetics of Early 1970s Performance Art (2004) 3

2. Laurie Anderson's Adventures in George W. Bush's America (2005) 10

3. David Cross's Confounding Hybridity (2018) 16

4. Richard Maloy: Try and Try Again (2010) 23

5. Victoria Singh: *The Waiting Room* (2014) 30

6. Interview with Artist Catherine Bagnall (2015) 33

7. 'My Life Is One Big Experiment': A Conversation with Laurie Anderson (2020) 44

PART II: PHOTOGRAPHY 51

8. Francis Alÿs and Photography: Snapshots from an Indefinite Vacation (2007) 53

9. William Eggleston on Film (2006) 61

10. 'Vaguely Stealthy Creatures': Max Kozloff on the Poetics of Street Photography (2002) 67

11. Vantage Points and Vanishing Spaces: Ann Shelton (2008) 75

12. Imagined Landscapes and Subterranean Simulacra (2011) 81

13. Gregory Crewdson: *In a Lonely Place* (2013) 86
14. On Taryn Simon's 2007 series *An American Index of the Hidden* 89
 and Unfamiliar (2010)
15. On the Recent Photographs of Simon Mark (2010) 94
16. Talking Around (and Around) Yvonne Todd (2012) 97
17. Cindy Sherman: Morphing Changeling (2016) 103

PART III: PUBLICNESS 109

18. Encounter (2009) 111
19. On False Leads, Readymades and Seascapes (2008) 117
20. Hope Is Not About What We Expect (2011) 122
21. Echoes, Signs, Disruptions (2015) 129
22. Billy Apple: Mercurial Consistency (2015) 133
23. Reorientations (2018) 141

PART IV: VIDEO 143

24. Shannon Te Ao: *A torch and a light (cover)* (2015) 145
25. Watching Sean Grattan's *HADHAD* (2015) 150
26. On Mike Heynes: Video Art, Animation and Activist 155
 Critique (2016)
27. Pat Badani: *[in time time]* (2008) 160
28. Bogdan Perzyński: *Selected Photographic Documents and Video* 166
 Works (2011)

PART V: BOOKS 171

29. *Clement Greenberg: Late Writings* ed. Robert C. Morgan, University 173
 of Minnesota Press, 2003
30. *The Experimental Group: Ilya Kabakov, Moscow Conceptualism,* 176
 Soviet Avant-Gardes, Matthew Jesse Jackson, University of Chicago
 Press, 2010
31. *Parallel Presents: The Art of Pierre Huyghe*, Amelia Barikin, 180
 MIT Press, 2012

32. *Performing Contagious Bodies: Ritual Participation in Contemporary Art*, Christopher Braddock, Palgrave Macmillan, 2012 184

33. *It's the Political Economy, Stupid: The Global Financial Crisis in Art and Theory*, eds. Gregory Sholette and Oliver Ressler, Pluto Press, 2013 188

34. *Zizz! The Life and Art of Len Lye, in His Own Words*, with Roger Horrocks, Awa Press, 2015 191

PART VI: EXHIBITIONS 195

35. Theresa Hak Kyung Cha (2003) 197
36. Robyn Kahukiwa (2012) 200
37. *Sad Songs* (2005) 203
38. Shona Macdonald: *Simmer Dim* (2010) 212
39. Craig Easton: *Collapse* (2009) 216
40. 18th Biennale of Sydney (2012) 221
41. Simon Starling: *In Speculum* (2014) 224
42. Chris Heaphy's Kaleidoscopic Eye (2012) 227
43. Niki Hastings-McFall: *In Flyte* (2013) 233
44. Simon Morris: *Black Water Colour Painting* (2015) 236
45. Dan Graham: *Beyond* (2009) 240
46. Richard Long: *Heaven and Earth* (2009) 242
47. *Split Level View Finder: Theo Schoon and New Zealand Art* (2019) 245
48. Elisabeth Pointon's Pop Problematics (or the Customer Might Just Be Wrong) (2020) 249
49. *Warhol: Immortal* (2013) 252
50. *Is It the Beginning of a New Age?* (2016) 255

Notes 263
Bibliography 275
Index 285

Figures

1.1 Chris Burden, *Through the Night Softly*, 1973, video. © 2021 4
 Chris Burden/licensed by The Chris Burden Estate and Artists
 Rights Society (ARS)/Copyright Agency. Photograph by Charles
 Hill. Courtesy of Gagosian.

1.2 Leni Sinclair, *Iggy Pop at the Grande Ballroom in Detroit*, 1968, 7
 photograph. © 2021 Leni Sinclair. Courtesy of the artist.

2.1 Laurie Anderson, *New Music America*, 1979, performance, The 13
 Kitchen, New York, NY. Photograph by Anzi. Courtesy of the artist.

3.1 David Cross, *Hold*, 2010, performance space, Sydney, as part of 20
 Liveworks curated by Bec Dean. Photograph credit to Alex Davies.
 Courtesy of the artist.

4.1 Richard Maloy, *Raw Attempts*, Artspace, Auckland, 2009–10. 24
 Courtesy of the artist.

4.2 Richard Maloy, *Tree Hut*, Sue Crockford Gallery, 2004. Courtesy 27
 of the artist.

5.1 Victoria Singh, *The Waiting Room*, 2014, Wellington, New Zealand. 32
 Courtesy of the artist.

6.1 Catherine Bagnall, *Alpine Walking with Tails and Ears*, 2013. 36
 Photograph by Scott Austin. Courtesy of the artist.

6.2 Catherine Bagnall, *Alpine Walking with Tails and Ears*, 2013. 38
 Photograph by Scott Austin. Courtesy of the artist.

7.1 Laurie Anderson, *Songs and Stories from Moby Dick*, 1999, BAM, 47
 Brooklyn, NY – performing 'One White Whale'. Photograph by Frank
 Micelota. Courtesy of the artist.

8.1 Francis Alÿs, *Paradox of Praxis 1 (Sometimes doing something leads* 55
 to nothing), 1997, Mexico City, photographic and video documentation
 of an action (five minutes). Photograph by Enrique Huerta. Courtesy
 of the artist.

11.1 Ann Shelton, *Phoenix block, room # unknown [pink wallpaper]*, 2008, 76
C type print 84 × 119 cm². *Phoenix block, room # unknown [blue bed]*,
2008, C type print 84 × 119 cm². *Phoenix block, room #54*, 2008, C type print
84 × 119 cm². *Phoenix block, room # unknown [yellow walls]*, 2008, C type
print 84 × 119 cm². Titles – Top to bottom/left to right. Courtesy of the artist.

12.1 Anne Noble, *Emperor Penguins, Antarctic diorama*, Canterbury 82
Museum, Christchurch, New Zealand, 2004, photograph. © 2021
Anne Noble. Courtesy of the artist.

12.2 Wayne Barrar, *Vehicle storage, Brady's Bend*, Pennsylvania, USA, 84
2006, photograph. © 2021 Wayne Barrar. Courtesy of the artist.

13.1 Gregory Crewdson, *Untitled*, 2003, digital chromogenic print, 87
framed: 64 1/4 × 94 1/3 inches (163.2 × 239.4 cm²) edition of
6 + 2 AP. © Gregory Crewdson. Courtesy Gagosian.

14.1 Taryn Simon, 'Nuclear Waste Encapsulation and Storage Facility, 91
Cherenkov Radiation Hanford Site, U.S. Department of Energy
Southeastern Washington State', from the series *An American Index
of the Hidden and Unfamiliar*, 2007, chromogenic colour print.
© Taryn Simon. Courtesy of Gagosian.

15.1 Simon Mark, *Kings Neon*, Fiji, 2008, digital photograph. 95
© Simon Mark. Courtesy of the artist.

16.1 Yvonne Todd, *Ethlyn*, 2005, photograph. © Yvonne Todd. 99
Courtesy of the artist and McLeavey Gallery.

17.1 Cindy Sherman, *Untitled*, 2010/2011, chromogenic colour print, 106
79 3/4 × 136 7/8 inches. © Cindy Sherman. Courtesy the artist and
Hauser & Wirth.

18.1 Thomas Hirschhorn, *Cavemanman*, 2002 exhibition view: 115
Gladstone Gallery, New York, 2002. © Thomas Hirschhorn.
Courtesy of the artist, Gladstone Gallery and D. Daskalopoulos
Collection (Halandri, Greece).

19.1 Maddie Leach, *Perigee #11*, 28 August 2008, Breaker Bay, Wellington, 118
New Zealand. Photograph by Stephen Rowe. Courtesy of the artist.

20.1 Colin Hodson, *The Market Testament*, 2011, installation, Wellington, 125
New Zealand. Image by Murray Lloyd. Courtesy of the artist.

22.1 Billy Apple, *Paid: The Artist Has to Live like Everybody Else*, New Zealand 139
Police Motor Vehicle Offence Infringement Notice 2009, mounted on
A3 paper printed by offset lithography, 565 × 420 × 25 mm³, collection
of Chris McCafferty. Photograph courtesy of Billy Apple® Archive.

24.1 Shannon Te Ao, *A torch and a light (cover)*, 2015, installation view 147
 Te Tuhi, Auckland. Photograph by Sam Hartnett. Courtesy of the artist.

24.2 Shannon Te Ao, *A torch and a light (cover)*, 2015. Courtesy of 147
 the artist.

25.1 Sean Grattan, video still: *HADHAD*, 2012. Courtesy of Sean Grattan. 151

26.1 Mike Heynes, *News of the Uruguay Round*, 2016, installation view, 158
 Adam Art Gallery (2021) as part of 'Image Processors: Artists in the
 Medium 1968–2020'. Image courtesy of Adam Art Gallery.

27.1 Pat Badani, *8-bits*, 2008, video stills extracted from *8-bits*, a split screen 163
 video documentary included in the installation titled *[in time time]*,
 commissioned by the EIU Foundation for their Contemporary Currents
 series and exhibited at the eGallery, Tarble Arts Center, Eastern Illinois
 University, 2008. © 2008 Pat Badani. Courtesy of the artist.

28.1 Bogdan Perzyński, *Fortune Teller*, 2004–10, video stills. Courtesy 167
 of the artist.

30.1 Ilya Kabakov, *The Man Who Flew into Space from His Apartment*, 178
 1988, installation view, Ronald Feldman Fine Arts, New York.
 Photograph by D. James Dee, © Emilia and Ilya Kabakov. Courtesy
 of the artists.

31.1 Pierre Huyghe, *A Journey that wasn't*, 2005, Super 16 mm film 182
 and HD video transferred to HD video, colour, sound, 21 minutes
 41 seconds. © Pierre Huyghe. Courtesy of the artist.

32.1 Laresa Kosloff, *CAST* (with Jennifer Allora, Hany Armanious, 186
 Richard Bell, Karla Black, Christian Boltanski, Mikala Dwyer,
 Dora Garcia, Charles Green & Lyndell Brown, Thomas Hirschhorn,
 Anastasia Klose, David Noonan, Michael Parekowhai, Grayson
 Perry, Stuart Ringholt, Renee So, Kathy Temin, Luc Tuymans, Angel
 Vergara and Catherine de Zegher), live performance, ACCA Pop Up
 Program, 54th Venice Biennale, 1–3 June 2011. Photograph by Liv
 Barret. Image courtesy of the Artist and Sutton Gallery, Melbourne.

34.1 Len Lye with his painting *Land and Sea*, c.1979. Photographer 192
 unknown. Courtesy of Len Lye Foundation Collection,
 Govett-Brewster Art Gallery, New Zealand.

35.1 Theresa Hak Kyung Cha, *Aveugle Voix*, 1975, black and white 198
 photograph, 9 1/2 × 6 3/4 inches, University of California, Berkeley
 Art Museum and Pacific Film Archive. Gift of Theresa Hak Kyung
 Cha Memorial Foundation.

36.1 Robyn Kahukiwa, *Resistance, Te Tohenga*, 2009, oil, alkyd oil 201
on canvas 2000 × 3000 mm², Auckland Art Gallery Toi o Tāmaki.
Gift of the artist, 2012 (Accession No 2012/23). Reproduced with
permission of the artist.

37.1 Albrecht Dürer, *Melencolia I*, 1514, Engraving, Plate 204
9 7/16 × 7 5/16 inches (24 × 18.5 cm²), Metropolitan Museum of
Art. Harris Brisbane Dick Fund, 1943 (Accession no. 43.106.1).

37.2 Katy Grannan, *Meghan, Saw Kill River*, Annandale, NY, 2002. 210
© Katy Grannan. Courtesy of the artist and Fraenkel Gallery,
San Francisco.

38.1 Shona Macdonald, *Waves, Shore*, 2009, recycled envelopes, archival 214
PVA, cardboard and packing tape, 72 × 70 inches. Courtesy of the artist.

39.1 Craig Easton, studio view, 2009. Courtesy of the artist. 217

41.1 Simon Starling, *Le Jardin Suspendu*, 1998, installation 225
© Simon Starling. Courtesy of the artist.

42.1 Chris Heaphy, *Maukatere*, 2012, acrylic on linen, 228
1900 × 2700 mm². © Chris Heaphy. Courtesy of the artist.

43.1 Niki Hastings-McFall, *Polynisation* series, 2005. Courtesy of the artist. 234

44.1 Simon Morris, *Black Water Colour Painting*, 2015, Ilam Art 237
Gallery, Christchurch, New Zealand. © Simon Morris. Photograph
by Mitchell Bright. Courtesy of the artist.

47.1 *Split Level View Finder: Theo Schoon and New Zealand Art*, City 247
Gallery Wellington Te Whare Toi, 2019. Courtesy of Anna-Maria
Hertzer and Sally Schoon.

48.1 Elisabeth Pointon, *SPECTACULAR*, from *WOULD YOU LOOK* 250
AT THAT, 2019. Image by Kasmira Krefft. Courtesy of the artist.

49.1 Andy Warhol, *Self-portrait in Drag*, 1981–82, dye diffusion print, 254
image: 9.5 × 7.3 cm² (3 3/4 × 2 7/8 inches), sheet: 10.8 × 8.6 cm²
(4 1/4 × 3 3/8 inches), The J. Paul Getty Museum, Los Angeles.
© The Andy Warhol Foundation for the Visual Arts, Inc.

50.1 Dhyana Beaumont, *Unified Heart Consciousness: Flower of Life*, 260
2016. Courtesy of the artist.

50.2 Kane Laing, *Meditation*, 2015. 2 hrs 40 min video loop. Courtesy 260
of the artist.

Acknowledgements

Compiling a book of this sort is heavily reliant upon the many opportunities I have had in the past to contribute to so many different artists' projects and various editorial initiatives. I would like to first and foremost thank all the artists discussed in this book along with those that I have written about elsewhere. I am consistently amazed and gratified by all the generosity that comes my way, belying an anachronistic and misguided notion of the critical writer as solely adversarial. Although I know my opinions will be evident throughout, they are entirely my own and not always ones with which certain readers will agree.

One goal of mine was to select writings for republication that were roughly 3000 words or under, thus some longer, but potentially equally relevant, writings were omitted. I also chose not to include some writings that worked better in my estimation in other contexts, or were revised into portions of my previous book (although there are still some evident echoes one can find here, should the reader choose to do so). I also wanted to present a collection of 50 texts written over the course of nearly two decades, a period in which I wrote such material frequently and in varied settings. You can find a list of the original sources below. I have intentionally refrained from rewriting extensively, and have only made minor edits in hope of greater clarity and readability. Thus certain of my critical opinions regarding the artists, ideas, and phenomena discussed here will have changed somewhat since the initial dates of publication.

Many thanks to the team at Intellect (Jelena Stanovnik, Jessica Lovett, May Yao, et al.) and all their editorial acumen, insight and guidance. I want to especially express my gratitude to Sophia Munyengeterwa, a terrific Production Editor who kept this project on schedule and assisted in so many ways. I am forever grateful to editors, artists, colleagues, friends and publications including the following for their significant support of my work, editorial input and overall collegiality (and please note it is an incomplete list as there are indeed so many to thank): Joe Amato, Mark Amery, Christina Barton, Barry Blinderman, Avantika Bawa, Carole Bonhomme, Chris Braddock, Ben Buchanan, Diwen Cao, Bill Conger, David Cross, Megan Dunn, Ken Friedman, Heather

Galbraith, Bryce Galloway, Jenny Gillam, Michelle Grabner, Eugene Hansen, Catherine Hoad, Matthew Jesse Jackson, Amelia Jones, Chris Kraus, Aaron Lister, Simon Mark, Greg Minissale, Anna-Maria O'Brien, Bikka Ora, Bogdan Perzyński, Bruce E. Phillips, Julieanna Preston, Rebekah Rasmussen, Dorothee Richter, Wilson Roberts, Gregory Sholette, Jill Sorensen, Shannon Te Ao, Mike Ting and Erica van Zon.

For providing assistance, access and permissions for images reproduced in this book, many thanks are due to Francis Alÿs Studio (Elizabeth Calzado Michel), Laurie Anderson Studio (Jason Stern), Scott Austin, Pat Badani, Catherine Bagnall, Wayne Barrar, Dhyana Beaumont, Gregory Crewdson, Craig Easton, Katy Grannan, Sean Grattan, Niki Hastings-McFall, Mike Heynes, Colin Hodson, Thomas Hirschhorn, Pierre Huyghe, Ilya and Emilia Kabakov, Robyn Kahukiwa, Laresa Kosloff, Kane Laing, Maddie Leach, Shona Macdonald, Richard Maloy, Simon Mark, Glen Menzies, Simon Morris, Mary Morrison, Anne Noble, Elisabeth Pointon, Bogdan Perzyński, Sally Schoon, Cindy Sherman, Leni Sinclair, Ann Shelton, Taryn Simon, Victoria Singh, Simon Starling and Yvonne Todd.

I am appreciative of the efforts of the following galleries, museums and institutions: Artists Rights Society/Copyright Agency, Berkeley Art Museum and Pacific Film Archive, Gagosian Gallery, J. Paul Getty Museum, Barbara Gladstone Gallery, Marian Goodman Gallery, the Len Lye Foundation, Lisson Gallery, Metropolitan Museum of Art, McLeavey Gallery and the Andy Warhol Foundation for the Visual Arts.

And countless thanks to the following publications, organizations and editors for their invaluable support of my art writing over the years: *Afterimage* (Karen van Meenen), *Art Asia Pacific*, *Art Monthly* (Patricia Bickers, David Barrett, Andrew Wilson), *Art New Zealand* (William Dart), *Art News New Zealand* (Virginia Were), all at *Drain* online journal, *EyeContact* (John Hurrell), *The New Zealand Listener* (Guy Somerset, Mark Broatch), Mark Williams and all at *CIRCUIT*.

This book wouldn't have been published without both university and college research funding from Massey University for which I am very grateful, and I thank Kingsley Baird, Wayne Barrar and Richard Reddaway, all of whom have been of tremendous support as research directors for Whiti o Rehua School of Art, along with Anne Noble, Tony Parker, and, more recently, Oli Wilson who have done the same for Toi Rauwhārangi College of Creative Arts. And many thanks to former Pro Vice-Chancellors Sally J. Morgan and Claire Robinson, current PVC Margaret Maile Petty and Head of School Huhana Smith. I am also hugely indebted to my dear colleagues along with students past and present in the Whiti o Rehua School of Art, where I have worked since 2008.

Many thanks to my children Zora, Nikos and Dune, from whom I always learn so much.

I would like to dedicate this book to my mother Edie Patrick, and as you are an inveterate copyeditor, please go with the flow of what exists on the page when reading its contents.

Original sources of publication

Afterimage: 'Vaguely Stealthy Creatures': Max Kozloff on the Poetics of Street Photography; William Eggleston on Film; Francis Alÿs and Photography: Snapshots from an Indefinite Vacation; Imagined Landscapes and Subterranean Simulacra; 18th Biennale of Sydney; Dan Graham: *Beyond*; Richard Long: *Heaven and Earth*; Parallel Presents: The Art of Pierre Huyghe.

Art Asia Pacific: Billy Apple: Mercurial Consistency.

Art Monthly (UK): Chris Burden, Iggy Pop, and the aesthetics of early 70s Performance Art; Laurie Anderson's Adventures in George W. Bush's America; Clement Greenberg: Late Writings; The Experimental Group: Ilya Kabakov, Moscow Conceptualism, Soviet Avant-Gardes; Performing Contagious Bodies: Ritual Participation in Contemporary Art; It's the Political Economy, Stupid: The Global Financial Crisis in Art and Theory.

Art New Zealand: Chris Heaphy's Kaleidoscopic Eye.

Art News New Zealand: Cindy Sherman: Morphing Changeling.

Broadsheet: Richard Maloy: Try and Try Again.

Christchurch Art Gallery catalogue essay: Elisabeth Pointon's Pop Problematics (or the Customer Might Just Be Wrong).

CIRCUIT: Watching Sean Grattan's *HADHAD*; On Mike Heynes: Video Art, Animation, and Activist Critique.

City Gallery Wellington catalogue essay: Vantage Points and Vanishing Spaces: Ann Shelton.

Engine Room, Massey University: Shona Macdonald: Simmer Dim; Bogdan Perzyński: Selected Photographic Documents and Video Works; *Is It the Beginning of a New Age?*.

Expressions Art Gallery catalogue essay: On the Recent Photographs of Simon Mark.

EyeContact: Taryn Simon: An American Index of the Hidden and Unfamiliar; Talking Around (and Around) Yvonne Todd; Victoria Singh: The Waiting Room.

Frieze: Teresa Hak Kyung Cha.

Ilam Art Gallery catalogue essay: Simon Morris: *Black Water Colour Painting.*

LAR Magazine: Interview with artist Catherine Bagnall.

Letting Space catalogue essay: Hope Is Not About What We Expect.

Mokapuna Island project (Mike Ting) catalogue essay: Echoes, signs, disruptions.

Nellie Castan Gallery catalogue essay: Craig Easton: Collapse.

NZ Listener: Robyn Kahukiwa; Warhol: Immortal; Niki Hastings-McFall: In Flyte; Simon Starling: In Speculum; Gregory Crewdson: In a Lonely Place; Zizz! The Life and Art of Len Lye, in His Own Words.

One Day Sculpture book essays: Encounter; On False Leads, Readymades, and Seascapes.

Play_Station Gallery (Mike Ting) catalogue essay: Reorientations.

Punctum Books, monograph: David Cross's *Confounding Hybridity.*

The Spinoff: *Split Level View Finder: Theo Schoon and New Zealand Art*; 'My Life Is One Big Experiment': A Conversation with Laurie Anderson.

Tarble Arts Center catalogue essay: Pat Badani: *[in time time].*

Te Tuhi Gallery catalogue essay: Shannon Te Ao: *A torch and a light (cover).*

University Galleries of Illinois State University: *Sad Songs.*

Preface:
The Performing Observer

When I first began writing, I certainly had imposter syndrome, having no sense of actually being a writer, historian or critic; at that time feeling simply like an art student playing a role. That role increased in its scope as my aspirations as an artist diminished. I in effect 'became' the mask I had donned. So, performing a role, I *was/am* that role. Whether our masks help us tell the truth, as Oscar Wilde famously claimed, or not; that became a key theme in my book examining art, life and our performative subjectivities. A text that took a lengthy amount of time in its gestation and writing up and was in turn informed by my semi-regular critical contributions to magazines, journals, exhibition catalogues, blogs and other rather ephemeral and fleeting settings.

The current volume is an attempt to selectively bring together what amounts to a two-decade journey of writing on deadlines, initiated both by myself and others. I learned much in the process, indulging and investigating my specific cultural interests, among them performance, photography, conceptual art, (post-)modernism and popular culture.

In titling this book *Performing Observer*, I am alluding to the fact that I am indeed performing as noted above when observing and writing about the field. I am also trained in art, having earned two studio practice qualifications. And although I did not pursue an art practice beyond some early and preliminary attempts, my time spent within studios and darkrooms, in addition to observing my surroundings with the aim of recording, documenting and interpreting them informs my writing to this day.

Critical responses to exhibitions require a certain openness from the outset. As Baudelaire noted as early as 1846, 'criticism must be partial, passionate, political [...] it should be written from a point of view that opens up the greatest number of horizons'.[1] This credo could still effectively apply today, particularly with all the cultural and social shifts, transformations and upheavals we have been confronting globally. And ever-expanding notions about the role of representations, the

definition of art and what artists might aspire to accomplish in the contemporary world.

And what lies ahead for art and artists? As well as those who provide much needed support for the same, and ways that art might continue to extend far from the museum and into varied community settings? I am far from addressing many of these huge questions in the writings in this book, but I hope to look at art with an open spirit and all the intellectual tools I may have accumulated over the years at my disposal. The great critic Lawrence Alloway described his own work as 'art criticism with footnotes'.[2] That is, historically informed but still engaging in a lively, embodied way with the present.

Questions persist regarding the relevance of art criticism, whether it is in the midst of a crisis, and indeed whether it merits existence at all. My own (perhaps self-serving) view is that we would encounter an extreme impoverishment of the arts without the manifold discourses and multiple voices critiquing the field. Whether one calls it art history, visual culture, art criticism or as is more frequently used today, 'art writing', I would argue that it assists, acknowledges and often dialogically interacts with the work of artists and that is no small accomplishment. If the work here contributes to any small part of that, I am pleased.

PART I

PERFORMANCE

This section features material on artists whose work involves performance, although one could in several instances question whether it's mediated performance, performance for video or a 'performative practice' that is being discussed. There are very well-known international performers (Chris Burden, Laurie Anderson) that I discuss, along with artists working in Aotearoa New Zealand (where I reside) that address certain readings of the embodied performer (Singh, Maloy), or the performing body in an entangled relation with the surrounding material and cultural contexts (Bagnall).

1

Chris Burden, Iggy Pop and the Aesthetics of Early 1970s Performance Art (2004)

In his performance *Through the Night Softly* (September 1973), Chris Burden enacted the following scenario: 'Holding my hands behind my back, I crawled through 50 feet of broken glass. There were very few spectators, most of them passers-by.' The artist 'saw the pieces of glass as stars' documenting the performance as a black and white film (Figure 1.1).[3]

In the Summer of the same year, Iggy Pop (born James Osterberg) was carrying out the last stage appearances of the band the Stooges, which had been branded as too avant-garde and non-commercial by most mainstream music labels. The late rock critic Lester Bangs wrote evocatively of Iggy Pop in a 1977 *Village Voice* article, calling him:

> [T]he most dangerous performer alive: he plunges into the third row, cutting himself and rolling in broken glass onstage, getting into verbal and occasionally physical brawls with his audiences. [...] This is a person who feels profoundly unalive, or, conversely, so rawly alive, and so imprisoned by it, that all feeling is perceived as pain. But feeling is still courted, in the most apocalyptic terms, which are really the only terms the performer can even understand, and the performance begins to look more and more like a seizure every time he hurls himself across the stage.[4]

Certain parallels are clear here, but questions concerning these artists' work as phenomena of their particular time viewed in retrospect today are not so easily answered. What determines whether these performative feats are considered art or showmanship? What audience seeks out these types of spectacle? How do these artists, spawned out of the Vietnam era marked by violence and alienation, protest and complacency, use the male body as a site for their actions? How do the masculine poses of preceding movements in art and music become subverted and twisted along with the bodies of these performers?

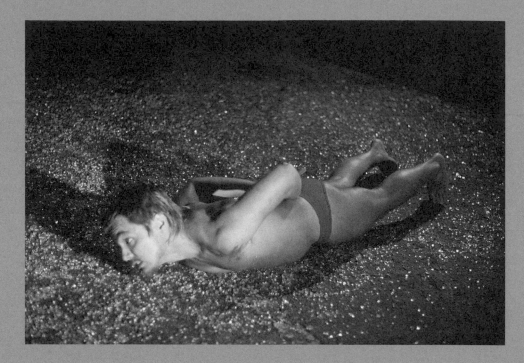

FIGURE 1.1: Chris Burden, *Through the Night Softly*, 1973, video. © 2021 Chris Burden/
licensed by The Chris Burden Estate and Artists Rights Society (ARS)/Copyright Agency.
Photograph by Charles Hill, courtesy of Gagosian.

The Stooges performed throughout July and August 1973 at Max's Kansas City in Manhattan, an artist's bar since the 1960s, which counted Andy Warhol and Robert Smithson among its famous regulars. Iggy Pop commented:

> For me there were two Max's. The first Max's was the back room, behavioural New York, gay intellectual performance-art Andy Warhol credit-card Max's. And then there was the other Max's, which was the rock and roll venue. The old Max's was for me. I was a kid from the Midwest who had some exposure, mostly through books and records, to both the outrageous and the arts. Coming into that room was kind of like a University of Dementia.[5]

In dealer Leo Castelli's words: 'Max's was the Cedar Bar of its era. The atmosphere was different because times changed so much between the abstract-expressionist period and the period of conceptual and minimal art.'[6] Max's not only summoned memories of the Cedar, frequented by artists of the New York School during the 1940s and 1950s, and characterized by its contentious debates on art and other matters, but it also helped establish the energetic connections flowing between art and music which became characteristic of the 1980s East Village art scene.

Gothic horror, violence and bloodshed have long been mainstays of American popular culture, and the comparatively recent genres of performance art and rock music have artfully manipulated this imagery. Instances of controlled and choreographed anarchy are common in pop mythmaking from the Who's Pete Townshend smashing his guitar on stage to the punk icon Sid Vicious assaulting a spectator with his bass. Likewise, within the context of performance art, acts of violence are ubiquitous. Terms like 'crawling' and 'cutting' sum up early 1970s performance art both metaphorically and actually. A matter of endurance, crawling also refers to abjection or servitude, as in Vito Acconci's landmark work *Seedbed* (1972) in which the artist lurked underneath a specially constructed floor in the gallery, silently wanking while hidden from exhibition visitors. In her *Rhythm O* (1974), Marina Abramović offered an audience in Naples the following instructions: '72 objects on the table that one can use on me as desired. I am the object. During this period I take full responsibility'.[7] Audience members proceeded to attack the artist brutally, encroaching directly on the defined limits of the artist's own physical body and calling into question the ethics of the social body in microcosm.

Documentation of Chris Burden's works may be viewed today as forming an oddly poetic record indexing procedures which pushed, pulled, prodded and punctured the artist's body: in *Velvet Water*, 1973, Burden nearly drowns himself, while in *Trans-fixed*, 1974, Burden's hands were nailed to the rear of a Volkswagen beetle and in *Kunst Kick*, 1974, Burden was kicked down the stairs. Burden has

said of *Shoot*, 1971: 'I still have some still photographs from it: they're real crude, they look kind of grainy and gory.'[8]

According to one catalogue essay,

> Chris Burden was born on 11 April 1946 in Boston, Massachusetts to Robert and Rhoda Burden. His father was an engineering professor and his mother a biologist. He spent his childhood in France and Italy and attended boarding schools in France and Switzerland. With his family, he travelled extensively in Europe and lived for six months in pre-Communist China. He became a keen photographer, and he was also interested in ceramics from an early age.[9]

However, in Burden's creative practice, he interrupts the certitude of the life he might have lived as a laboratory researcher, photojournalist, maker of clay pots, to become a series of experiments himself, albeit circulated within the context of art.

James Osterberg – on the other hand – was raised in a trailer park in Michigan, the son of a teacher and a secretary. 'Our family was definitely the only literate occupant of the entire trailer park.'[10] According to Osterberg's mother Louella, other parents would tell her 'I wish my son was as well-behaved and nice to talk to as your Jim.'[11] The future Iggy Pop read widely, earned high marks in school, and by 1965 was accepted at the University of Michigan which he attended for one term, intending to pursue an anthropology degree. He learned to play drums as a teenager and performed in two bands, the British Invasion-oriented Iguanas, and subsequently the blues-influenced Prime Movers.

Just as Burden has become almost exclusively the artist who got shot it is as though Iggy Pop had spent years solely writhing around on the broken glass. However, the primary instances in which the singer cut his body occurred in Summer 1973, when performing at Max's, and later that Autumn as he toured the Northeast and Canada (Figure 1.2).

> Like, that incident at Max's Kansas City. Everyone thought I'd fallen on some broken glass by accident. But [...] I just couldn't stand myself anymore, so I went behind the amps with this piece of broken glass, having decided to cut my jugular vein. I just didn't have the guts, though [...] I was aiming for the vein, but just couldn't make it. I cut up my chest instead.[12]

Iggy Pop began to introduce stagediving – generally associated with later punk bands – as one of his standard techniques by 1970. He became known for improvising on stage by any means necessary, whether smearing himself with peanut butter or even exposing himself and vomiting. In his autobiography *I Need More*,

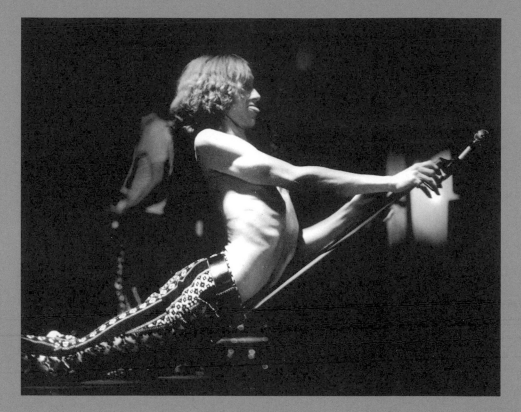

FIGURE 1.2: Leni Sinclair, *Iggy Pop at the Grande Ballroom in Detroit*, 1968, photograph. © 2021 Leni Sinclair. Courtesy of the artist.

the singer described playing in front of a collegiate audience, which he quickly began to view antagonistically:

> I began flinging myself at them! Uh, FLINGING myself on the floor, drawing blood, cutting myself, taunting [...] I started talking directly to them, staring them in the face, you figure out what it means. I guess it was just a REFUSAL TO BE IGNORED, just absolute refusal, on my part.'[13]

The Stooges did gain a 'big following [...] mostly disaffected high school kids, unemployed people, or mentally deranged people, people who came back from Vietnam always liked us.'[14]

Iggy Pop's attempts to challenge the audience recall remarks by Antonin Artaud concerning his notion of the *Theatre of Cruelty* in which he states:

> I propose a theatre in which violent physical images pound and hypnotize the sensibility of the spectator, who is caught in the theatre as if in a whirlwind of higher forces. A theatre which, abandoning psychology, recounts the extraordinary, puts on the stage natural conflicts, natural and subtle forces, and which presents itself first of all as an exceptional force of redirection. A theatre which produces trances.[15]

Chris Burden has also spoken of how his performances took little time to actually create after a long period of deliberation, later seeming almost hallucinatory or dreamlike.

Burden has consistently tried to defend himself against criticism that his early works offered only sensationalism:

> I think that our culture is totally fascinated with violence. [...] A lot of people have accused me of using danger for sensation, but I stopped doing those pieces when I got that kind of publicity. I'm not an Alice Cooper. When I did those early works, I made damn sure that NBC and all of those people weren't there because they would screw it up. It was okay to have [artist] Tom Marioni and a few of my friends there.[16]

Burden has always disliked the fact that he obtained more media coverage of his early works through popular outlets than the art press. It could be argued that Burden has offered a complex meta-commentary on media extremism, rather than simply participating within it outright.

Several of Burden's works used television explicitly, including his 1972 hijacking of a television interview, in which the artist held his interlocutor with a knife poised at her throat; the broadcast as an advertisement of a ten-second clip of *Through the Night Softly* on LA's Channel 9 each day for one month

(November–December 1973); and, in 1976, the running of several promotional spots which presented his name in a bold typeface as the seeming culmination of the following roster: Leonardo, Michelangelo, Rembrandt, Van Gogh and Picasso. In his 1964 *Understanding Media*, Marshall McLuhan drew a direct parallel between the increasing power of television and the aesthetic experimentation of modern artists: 'The aggressive lunge of artistic strategy for the remaking of Western man has, *via* TV, become a vulgar sprawl and an overwhelming splurge in American life.'[17] Burden did express a 'long-standing desire to be on television [...] on real TV – anything you could flip to on a dial.'[18]

Yet for Burden to have his work associated with entertainers like Alice Cooper was comparable to critic Douglas Davis calling him the 'Evel Knievel of art.'[19] However strongly Burden hoped to access a wider public through the television broadcast of his work (an estimated 250,000 viewers witnessed the *Through the Night* advert), he also wanted it to remain within the boundaries of 'high art' rather than the more untidy world of carnival sideshows, demolition derbies and rock concerts. By performing before small, dispersed audiences and then later disseminating the documentation of the work through photography, statements, video and miscellaneous relics, Burden kept the work an intentionally limited spectacle. Burden's decision to frame his work by continuing Modernist conceits such as the solitary artist making 'serious' work preserves his performances for posterity within a conventional art historical lineage. He developed his early works both out of the context of Minimalism and the history of twentieth-century performance: Futurist, Dadaist and Surrealist. The 1973 performance *747* – 'At about 8 am at a beach near the Los Angeles International Airport, I fired several shots with a pistol at a Boeing 747' – seems to revive the poet André Breton's definition of 'the simplest Surrealist act [...] going into the street, revolver in hand, and shooting at random into the crowd.'[20]

The decision of whether Chris Burden and Iggy Pop created 'art' is ultimately a contextual matter, as both created undeniably significant actions shaped for differing audiences, and while Burden linked his work to more traditional art to ensure being taken seriously, rock bands which are labelled arty with few exceptions often are considered less credible, thus seeming more pretentious than populist. Both performers sought to be simultaneously expressive and innovative, using previous avant-garde notions as essential background to their work: in the case of Burden, extreme statements in modern art, while in Pop's disruptive music he looked to free jazz and experimental music as forerunners. Each artist emerged to prominence during an explosive period of cultural shifts. From the perspective of 2004, I can only echo Iggy Pop's desire, in his song 'I Need More', for 'more truth / more intelligence [...] more future / more laugh / more culture / don't forget adrenaline / more freedom.'

2

Laurie Anderson's Adventures
in George W. Bush's America (2005)

Just days after the events of 11 September 2001, artist Laurie Anderson stated: 'I have never felt so acutely the lack of a counterculture.'[21] When one considers the increased amount of activism by artists and others leading up to the 2004 US Presidential election, her statement rings less true. Yet, however much the American counterculture (of sorts) which exists today has mobilized itself to form organizations advocating change, the dramatic political transformation that was hoped for by so many citizens last 2 November in the end didn't occur.

The African American philosopher and critic Cornel West has written eloquently of the 'deep democratic tradition in America', citing an eclectic genealogy of cultural dissent that extends from writers Ralph Waldo Emerson and Mark Twain to James Baldwin and Toni Morrison, and more recently the late rapper Tupac Shakur.[22] I would in addition place Anderson along such a lineage, as a visionary voice of the American cultural activity which does not fit tidily within George W. Bush's own imperialistic characterization of the postmodern world. During the reign of Bush, the elder, Anderson stated,

> I want to know what the motor is, what is driving this country further and further to the right. […] my work has become political and engaged. I'm not even sure I'm an artist anymore. More like a thinly disguised moralist.[23]

Anderson has also been fascinated with several of the iconoclastic artistic figures highlighted by West in his pantheon, including Herman Melville and Thomas Pynchon. In 1999, Anderson performed an opera based on the former's *Moby Dick*, and she has attempted to do the same with the latter's enormous novel *Gravity's Rainbow*. Anderson has recounted on several occasions her initial contact with the writer:

> I wrote to him and asked him if that would be OK (I actually found him; he's quite reclusive). And he wrote me this funny letter. He said, 'You can do it, but

you can only use banjo'. And so, I thought, 'Well, thanks. I don't know if I could do it like that'. I suppose it was his polite way of saying, 'No. No way can you do this.'[24]

All of this is prompted by my viewing of Anderson's most recent stage work *The End of the Moon* this past autumn, billed as one of an on-going series of sparser solo pieces by the artist (such as her earlier *Happiness*), this time addressing in part her period as NASA's first (and last, it turns out) artist-in-residence, a summation or final report. Much of the performance is atmospheric, gloomy, but ultimately exhilarating rather than depressing. Along with the Pynchon anecdote, she spoke of terrorism, her dog Lolabelle and the wonders of space travel (still a theoretical journey for Anderson, whom NASA had no intention of sending up despite her privileged status).

There is a drastic difference between Anderson in her more monolithic stage incarnations and in *End of the Moon*. Probably because she seems less like the floating fiery green head of the great and powerful Oz, and more like the modest operator of various switches behind the curtain. Anderson works with nearly invisible gadgetry now thanks to her laptop computer and new improvements in digital technology, so that the viewer instead becomes free to focus on the artist herself and her few props: a small image of the moon, an armchair, a miniature video camera and her violin. Anderson uses her music primarily as punctuation to emphasize and subtly frame passages of her spoken text. She seems more genuine and that summons the realization that we as viewers have come to know Anderson largely through a procession of stage and recorded personae. Much as with any famous actress, we don't know anything about an authentic Laurie Anderson, apart from what she carefully chooses to reveal. In many respects, the most recent 'Laurie' recalls the late monologist and actor Spalding Gray (a friend of Anderson's), who always rambled on – in utterly gripping fashion – about his anxieties and complaints. Perhaps this is due to the increased amount of sheer sadness infused within the work. Anderson has noted that *End of the Moon* is

> a phrase that has some of the melancholy I feel at the moment. Not just melancholy really. More like loss. Like I lost something and I can't quite put my finger on what it is. Actually I think what I lost was a country.[25]

I don't think it's that curious – perhaps only pretentious – that Anderson's most renowned work takes as both its focus and its namesake the *United States*. After all, Anderson was born nearly in the dead centre of her native country, in a suburb of Chicago, IL. Early on in her career, she became a visual artist making conceptually derived works of differing degrees of finish and articulation. As art critic Kim

Levin has written: 'She managed to make post-Conceptualist art lyrical, roman-
tic, and lovable. She took the shock out of the new and replaced it with delight.'[26]
Anderson also worked as an art historian, and tellingly, to this day, most of Ander-
son's stage works share a format common to academia: didactic lectures in the
dark before luminous images of varying origins.

But if a criticism of Anderson might be that she is arch and simplistic in certain
aspects of her monologues, she has investigated the terrain she exploits with great
vigour, to the extent of donning a McDonald's uniform to work in the belly of the
Capitalist beast itself. In the 1970s, she maintained a habit of travelling widely in
the United States and elsewhere and living a fringe existence to learn more about
the subjects she was trying to elucidate in her works. This method – and conceit –
stems from a long literary tradition such as in the work of George Orwell, Henry
Miller or Jack Kerouac (of course), and most recently in the journalism of Barbara
Ehrenreich who recorded in her bestselling book *Nickel and Dimed* her attempts
simply to get by without an economic safety net in the current climate in which
virtually no social assistance is available from government sources.

Throughout Anderson's works, the artist conveys a sense that the United States
is simultaneously a pathetic and grandiose entity. The vast country almost demate-
rializes in its scope, and thus can only be seen though anecdotes and fragmentary
depictions. In the languor and span of her large-scale performances, a Midwest-
ern stupor collides with the acceleration of Manhattan. It seems appropriate that
Anderson's collaborators have included the late William S. Burroughs, spawned
from St. Louis and one of the most idiosyncratic voices of twentieth-century Amer-
ica. His evocative statement 'Language is a virus from outer space' inspired one
of Anderson's earlier songs (Figure 2.1).

Anderson became a kind of trademark brand synonymous with Postmodern-
ism. To some degree, this was a matter of timing, but above all she became an
iconic crossover star as her engaging views of the present appeared to lead us along
with her into a fascinating future. In a remarkably encompassing move, she made
close allies of both experimental music and the visual arts, in a way not really seen
since John Cage's peak of influence in the 1950s, and although both Anderson and
Cage would be much cited by theorists of the postmodern like Frederic Jameson,
of the two, only Anderson would end in the territory of Top of the Pops, as she
did with her United Kingdom #2 hit *O Superman* in 1982.

Anderson has continued to captivate a broad audience through a vision which
has been characterized by its wide and inclusive point of view. I would use as a
counterexample George W. Bush's myopic and reactionary vision – his father
was famous for his difficulties with 'that vision thing'. Indeed, the current presi-
dent's vision involves putting countless people in harm's way and dealing with the
world as a monochromatic fantasy setting. One of the President's more outlandish

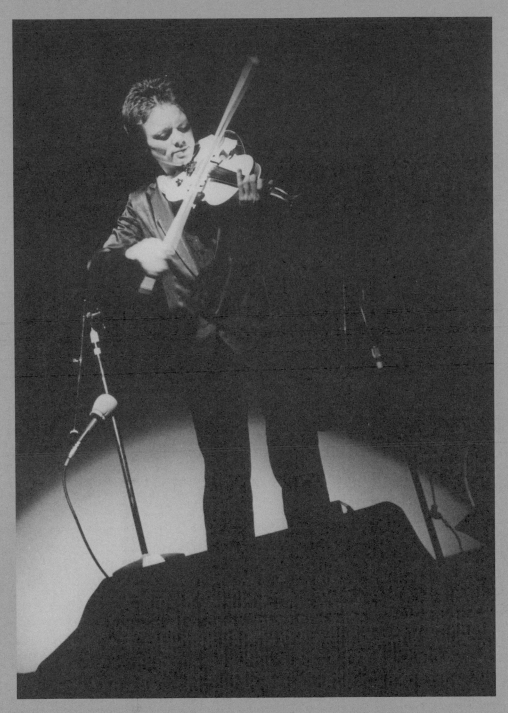

FIGURE 2.1: Laurie Anderson, *New Music America*, 1979, performance, The Kitchen, New York, NY. Photograph by Anzi. Courtesy of the artist.

statements came in January 2004, in time for his annual State of the Union address, when he announced his intentions for manned flights to the moon (and eventually Mars) by 2018, and the construction of a permanent space station. Both rational humans and late-night comedians made short work of this news, and one manufacturer of the ubiquitous American bumper sticker came up with: *Send Bush to Mars: We sure don't need him around here.*

Along with her use of technological extensions of her performing self, Anderson is well known for her exploration of the intricacies of the language, whether written, spoken or sung. One key moment in *End of the Moon* involves Anderson's story of attempting to teach several words to her dog while in a forested area of California. Suddenly vultures descended upon Anderson's diminutive pet Lolabelle in a predatory fashion. To their chagrin, the dog was not what they had been anticipating, and for the terrier there came the distinct and ugly realization that dangerous things might appear from above. In Anderson's universe, even cute animal stories ultimately bare their teeth and metamorphosize into allegories of 9/11.

Of course, President Bush is equally notorious for his own linguistic feats and tenuous grip on 'American'. In contrast to a novelty record album some years ago which advertized on its cover *The Wit and Wisdom of Ronald Reagan* – its grooves were blank – Bush has been quite garrulous, despite the fact that he rarely gives any (unscripted) press conferences, and his speeches almost never break the six-minute mark: 'Is our children learning?'... 'Too many of our imports are coming from other countries'. 'I think we agree, the past is over.'[27] There are far too many examples of these Bushisms to cite in full and they have been amply reprinted, although depending on your point of view they might be regarded as either humorous or horrifying.

In the run up to the election, Anderson participated in an event held in New York on 4 August, organized by Salman Rushdie and sponsored by the PEN American Center, in which writers and artists spoke on the topic of a 'State of Emergency'. During the Summer, Anderson was still writing *End of the Moon*, commenting,

> I wasn't going to plan to be very political in this new work. I was trying to do a dream about how we see the world and particularly how beauty influences what we look at and how we see things. And it's still largely about that but it's getting more political by the hour, I have to say.[28]

But at this point, the 2004 Presidential election is perhaps most appropriately examined by recalling its many instances of fakery, falsehood and deception: the widely circulated assumption that George Bush is regularly fed his scripted lines

through an electronic apparatus hidden within his jacket; the effective attempt by a right-wing group to smear wrongfully the war record of John Kerry, a Vietnam Veteran decorated for his heroism and a general election held with many precincts voting using electronic equipment *sans* actual, and thus verifiable, paper ballots. Even the simple act of noting the absence of weapons of mass destruction or criticizing the violent, imperialistic charade in Iraq – represented under the dubious guise of spreading freedom and democracy – couldn't develop momentum during the campaign as the notion of an anti-war President is all but oxymoronic.

Witnessing the events surrounding the inauguration of President Bush, I was feeling a terrible nostalgia for last October when Bruce Springsteen was barnstorming the country for John Kerry; when even the corporate media had to concede that Kerry won the debates with no real contest, and journalist Hunter S. Thompson vowed: 'I will do everything in my power short of roaming the streets with a meat hammer, to help [Kerry] be the next President of the United States.'[29] Such contagious excitement arose from the belief that the Presidency might actually have been within Kerry's reach, as many of the early exit polls also indicated. Now instead of the election, I'm more inclined to remember one lone artist on a stage, accompanying herself with a bit of minimalist music and the truest voice of any heard during the recent election cycle.

3

David Cross's Confounding
Hybridity (2018)

Artist David Cross's projects have an exacting, merciless feel, yet they incorporate a particular aesthetic abundance as if attempting to bring together an amalgam of art and cultural references and get them to explode into a panoply of manifold sensory phenomena. Artworks foisted upon the viewer, not strictly at their own expense, but as a generous admission of how much we enjoy confronting our funhouse fears and maddening nightmares. Much can be elicited from this act of confounding hybridity. As with any act of creative synthesis, I could, as a diligent professional art critic and historian, enact a dissection of its components (which I will likely still endeavour to do). But, whether verging on cliché or not, it's important to note that Cross's practice amounts to more than the mere sum of its constituent elements. Many factors enter into the mix that can't easily be discretely enumerated and archived: radical shifts in tone, associations between gestures, the sheer number of unpredictable variables that run through so many of the pieces. As the artist himself has stated: 'the value of performance art is that it is a medium of the moment, a mode of practice that is contingent, genuinely interactive, and often visceral.'[30]

Historically speaking, Cross's early art practice emerged from the crucible of late twentieth-century postmodernism, an era known for its wilful disunity, also characterized by the poststructuralist tangles ensuing from Anglophonic appropriation of the European relativism of Derrida et al. And in the wake of a potential downturn in the influence of 'Theory' writ large in contemporary art practice, a central problematic ensues: how to make art that's theoretically astute and informed, but not programmatic, dry as dust, so as to avoid an overly academicized pursuit more akin to the pedantic footnote than the visionary big picture. As Cross is a trained art historian, perhaps this quandary would seem even more urgent. But what's become especially significant and compelling about Cross's practice are the ways in which it both acknowledges past watershed moments of performance and body art, minimalism, and (neo-)conceptualism and sheds its direct debt, a recognition of tradition counterbalanced by a sense of contemporary

experimentation; that there are now manifold ways to attack historical problems and that perhaps they are not entirely historical, but still pressing and urgent, always already with us.

So much art is *un*funny, and perhaps this serves too often as a default guarantor of its being considered 'consequential'. Cross's work however rarely begins without an ample dose of humour, although such humour might encompass obscure in-jokes, choice verbal play (Cross is an insightful art writer also), perverse re-arrangements and re-segmenting of realities. Cross's humour could be read as rather generation-shaped if not entirely generation-specific. Douglas Coupland's once infamous 'Generation X' being the one I am citing here, or Richard Linklater's cinematic 'Slackers', redolent of certain ironic, bemused modes of viewing one's surrounding context. (A member of this same dispersed generational clan myself, I harbour tremendous affinity with this worldview, such as it is.) But also, there is in Cross's practice an inclination towards empathically investigating our intersubjective relations, however mediated and choreographed, while still keeping intellectual queries open but informed, in some ways recalling the movement of the late novelist David Foster Wallace into increasing sincerity and directness in his prose after an intense period of convoluted postmodernist mind games.

Moreover, some awfully complex, and ultimately conflicted ideas of fun (and 'funny') and games are operating herein. How pleasurable is it exactly to be precariously balanced on some intentionally unstable architectonic devices? Especially to the degree that said devices radically diminish manifest assertions of control on the part of the viewer/participant? *I have to give myself over to these works.* Cross' artworks have a tendency of creating a state of encounter that could potentially seem disempowering. The artist has spoken of his works as involving 'destabilising conditions', and this acts as a pointed pun as well, in that the actual material conditions of Cross' installations can be destabilizing as much as the affective dimensions and capacities of the work. Cross has a strong interest in evoking liminal states, in-between, ambiguous, polyvalent, disorientating. Some tricky intersections occur: nervous anxiety meeting hedonistic euphoria, dreamlike reverie juxtaposed with edgy abandon.

I have experienced these artworks in various ways, sometimes in full-on participatory mode (*Lean, Pump*), at other times vicariously through the eloquent descriptions of fellow critics, via moving or still images, or within the narratives carefully woven by the artist himself, and the accounts of participants. It is indeed something to watch the actions undertaken by visitors to Cross's work, with a unique quotient of the unexpected manifest as uncertainty, pleasure and curiosity intermingling. Cross's practice explores the intricacies of framing and negotiating transitions and contingencies, never wholly stable, always encompassing risk. If play has functioned as a consistent theme throughout Cross' work, he

17

significantly explores play as labour, work and ordeal. In his projects, participants are contracted into the schema which unfolds, which in turn usually involves contact with the sculptural installation, the site in which it is located, and with the bodies of others, at times that of the artist. This engagement is driven by examining aspects of the haptic, the contextual and with live performance mediated through video, photography and installation.

The artist in early performance and participatory installations examined the assorted modalities and impacts of the gaze, often directly engaging participants in direct acts of regard. Works such as *Tear* or *Viscous* highlighted the often-painful effects of scrutinizing the body in ways that could be seen as abject. The eyes of the artist which could only be seen through small holes atop his red domed installation *Bounce* (2006) recalled the threatening masquerade used in such movies as the *Halloween*, *Friday the 13th*, and *Texas Chainsaw Massacre* franchises. But it was Cross, lying prone inside while enacting an endurance performance who was most vulnerable to the movements of the participants scrambling onto the sculpture. More recently, this interrogation of the scopic has shifted from close consideration of the gaze towards the embodied, performative and participatory features of the work, although the provisionality of vision as a means of knowledge is still central to his practice.

Cross's inflatable installations are characterized by their bold visual identity that simultaneously camouflages the complicated scenarios of interrelation, negotiation and fear that can ensue around, on and within their confines. Ideas of play, trust and the unexpected coexist and overlap in unequal parts of a novel performative equation. This often occurs in the staging of the more overtly competitive sporting-style games that Cross has been configuring such as *Level Playing Field* (2013) and *Skyball* (2014). But there are clear and major differences to be discerned between 'real' sports and Cross's idiosyncratic artworks, as the artist has pointed out: 'While sport is, to varying degrees, focused on alignment of physical and mental coordination, it is also about beating your opponents, running faster than them, hitting more aces and cross-court winners' as he describes it in his conversation with Cameron Bishop; 'I am', he suggests,

> interested in constructing scenarios that frustrate and block pure athleticism tempering physical engagement with cognitive barriers. By limiting vision, making a surface slippery, or accentuating the potential for phobias to be brought to the fore, the works neuter the performance of a pure athleticism.[31]

Such performative contexts can be read as echoing literary theorist Mikhail Bakhtin's description of the significance of the 'carnivalesque' in the Medieval era:

18

The hierarchical background and the extreme corporative and caste divisions of the medieval social order were exceptionally strong. Therefore, such free, familiar contacts were deeply felt and formed an essential element of the carnival spirit. People were, so to speak, reborn for new, purely human relations. These truly human relations were not only a fruit of imagination or abstract thought; they were experienced. The utopian ideal and the realistic merged in this carnival experience, unique of its kind.[32]

One could argue that Cross's projects in their democratizing and diminishing of entrenched cultural and social categorizations evoke a similar notion of the carnivalesque, particularly when set against the increasing inequality and polarization of the contemporary social sphere.

Cross's variegated practice draws upon references across a wide range of the visual culture continuum: minimal, performance and pop art alongside direct and indirect references to horror films, children's amusements, sporting events and the occasional nod to sex toys. The projects involve intensely tactile, luridly spectacular means, the bright colouration of amusement park attractions coinciding with atmospheres of potential peril and unease. The works often revolve around building a taxonomic array of gestural actions and movements: to climb, to slide, to pull, to fall, to lean, to jump, to hold, to balance. Cross's own presence as an actual and 'imperfect' body functions as a sort of anchor to the more fantastical aspects of his early projects.

If we do play the art history game and put some precedents and affinities on the table, they are an eccentric and diverse lot, and among the names that occur to me are Franz Erhard Walther, Paul Thek, Bruce Nauman, Cindy Sherman, Dan Graham, Mike Parr, Paul McCarthy, Robert Morris and Yayoi Kusama. I recall Morris's concise statement in his 'Notes on Sculpture': 'Simplicity of shape does not necessarily equate with simplicity of experience.'[33] And in a different vein, McCarthy's comment on Disney: 'It's the invention of a world. A Shangri-La that is directly connected to a political agenda, a type of prison that you are seduced into visiting.'[34] Or Nauman's statement on his own approach:

> Some of the pieces have to do with setting up a situation and then not completing it; or in taking away a little of the information so that somebody can only go so far, and then can't go any farther. It attempts to set up a kind of tension situation.[35]

Cross was especially affected by seeing the 1994 Nauman retrospective at Washington, D.C.'s Hirschhorn Museum. Here he observed Nauman's ability to knit an assortment of spectacular modes with equally acute yet painful meditations on the human experience. Somewhat surprisingly, the artist also cites the late painter Ellsworth Kelly as a major influence via his engaging monochromatic

FIGURE 3.1: David Cross, *Hold*, 2010, performance space, Sydney, as part of Liveworks curated by Bec Dean. Photograph credit Alex Davies. Courtesy of the artist.

abstractions. Kelly's rich visual syntax composed of deceptively simple, adjacent forms made a huge impact on the artist, as evidenced in his inflatable structures (Figure 3.1).

In Cross's *Hold* (2007), an enormous architectural maze designed for a solo performer and an individual audience member, participants climbed one at a time into the inflatable indigo structure needing to hold – and have confidence in – the always unseen performer's hand that appeared through a slit in the wall to guide each of them across a high, narrow ledge to the exit on the other side. This, in turn, rather than being a group, athletic-style experience became paradoxically a very intimate investigation of the artist/viewer interrelationship, within a mammoth construction. While Cross's physical presence was once highly integral to – and indeed integrated within – such works, he has steadily begun to involve himself as a more choreographic, directorial presence. I would note that this might be related to his curatorial endeavours which have been significant to his creative identity in terms of thinking through and engaging with, on differing levels, projects that are site responsive and public in their orientation though he himself blames his less agile and resilient body.

Although Cross in many works has questioned the assumptions around both beauty and the grotesque in a very performative and individuated manner, redolent with his own wit, whimsy and specific approach to materiality, more recently he has cast his view more towards the social body and its corresponding codes of conduct. Cross has spent years actively interrogating and problematizing the relations between the so-called beautiful and the grotesque; and has acutely cited Baudelaire's aphorism: 'The beautiful is always strange.' Particularly framed through notions of difference and otherness, Cross's practice examines how our embodied subjectivities are nonetheless never fixed, singular or continuous. Sometimes this takes the form of a work that requires a reciprocal participation, and close contact as in *Pump* (2009), in which a smaller inflatable (easily transported in a suitcase to faraway exhibitions) allows the two performer/participants to insert their heads into openings that face one another; and control the structure via two footpumps. This exchange is non-verbal, and potentially strenuous and awkward, calling attention to each other's embodied participation and physical cues, becoming temporarily a quasi-unified being.

What Cross has in the past referred to as creating a 'Hansel and Gretel effect' with his sculptural architectural forms, a 'house of allure' is equally crucial to the understanding of a practice that recalls and reconfigures childhood fears and attractions simultaneously. The resulting effect upon the viewer often results in something far richer than one's average theme park ride, more unsettling in its implications relating to perimeters, exteriority and interiority in flux. Cross's inflatable installations and scenarios at times summon a kind of fantasyland, again

evoking childhood daydreams (or sometimes, nightmares). Notions of ambiguity, horror and the grotesque are left in eerie suspension in many of Cross's works, without any direct release of anxiety as in the resolution of standard escapist entertainment. Contrary to such formulas, Cross's practice ultimately develops its resonance through its more nuanced consideration of embodiment, experience and immersion.

In speaking from the outset of a 'confounding hybridity', I have attempted to sketchily frame but not absolutely contain Cross's practice in its capacity to challenge our normative assumptions regarding self, identity and the performance thereof. If cultural notions regarding appearances are questioned and disrupted, a key strand of Cross's creative research, new questions have an opportunity to emerge that may stretch our settled ideas, to incorporate rather than disregard difference. Similarly, this occurs in addressing notions of audience/participant, artist/author, conceptualization/visuality. By thoughtfully crafting works that intermix and entwine performance, installation and sculpture, Cross provokes us both seductively and uneasily. Our human associations are constantly pressured by sensations that ultimately are not readily identifiable, comfortable or safe.

4

Richard Maloy:
Try and Try Again (2010)

Making progress. Spending our time. Trying to get it right. Playing around. What's the difference between these phrases, and how can we determine any functional and justifiable criteria for doing so? In the works of New Zealand artist Richard Maloy, the considerable distance between a wide variety of categorizations is always strategically in play, off balance and very nearly slipping away from us as we attempt to come to terms with what we are seeing. In the current era, one might detect (just as with painting) the vestigial suspicion of a kind of formal and ideological closure within many sculptural artworks, rather than maintaining a particularly exciting or generative status. Given that, Maloy proceeds in other directions. He shifts his divided attentions towards duration, time, context, just as his concerted manipulations and stagings make cogent and legible work from literal scraps: corrugated cardboard, predominantly.

By using materials so often read as merely functional and devoid of excessively positive aesthetic associations, Maloy chooses to reroute the paths of signification and the notional emphases of his action/sculptures. The action displaces the result, or let's say becomes increasingly central to the result, as choices the artist makes to fill (and unfill) a space with cardboard also leaves the analysis of the material comparatively unproductive. By using the adamantly prosaic cardboard, the viewer is potentially led more quickly to ponder other matters addressed within Maloy's provocative installations, videos and sculptures.

Nonetheless, the use of cardboard in many of Maloy's works conjures significant referents: the maquette, the parcel, the container and furthermore the propped up amateur stage-set or flimsy children's costume. This starts an engaging spiral of references going, such that as viewers we might 'fill' up the seemingly empty spaces created by the artist with our own mental images. What happens when we scrutinize the giant cardboard room with its interior painted white (and set within the room of a gallery)? A perceptual game ensues, as the viewer is asked to walk around the perimeter of the huge bowl-like shape, peer into a window-like gap cut into its surface but be consistently relegated to the perimeter, separated from the interior constructed by the artist (Figure 4.1).

FIGURE 4.1: Richard Maloy, *Raw Attempts*, Artspace, Auckland, 2009–10. Courtesy of the artist.

Maloy has created numerous projects involving the act of residing within an exhibition space to create specific works, but often the artist himself is not on display, so to speak, but works under the cover of the evening's 'down time'. By the time the visitors are attending the exhibition each day, it might have morphed once again into another state of its aesthetic transformation. This is markedly different from the ways by which Maloy's actions and physical presence is incorporated within the context of his video works.

If an artist contends sportingly with his own weight in butter (as depicted in Maloy's video *Yellow Grotto*) is he likely to know any more about sculpture than when he began? Perhaps, or at least, there is a troubling, surreal sense that some bizarre alchemical transformation might be getting underway if the artist just pushes, pulls and slathers this enormous blob of grease just a little bit more. As it is, the artist wrestles his amorphous self-portrait, initially bringing to mind both the unbearable sculptures of de Kooning and the mounds of rather undifferentiated matter so common to postmodern installation art (or the compost pile).

But beyond this, what's most apparent here is the fact that the shape does not congeal into a finished representation. The flux's the thing. These slabs of yellowish matter are losing their identification with everyday butterness in favour of some war with their new artness, or should I say some artful transfiguration of artlessness. Maybe I won't. Scratch that. Try again. Or recall curator Natasha Conland's pointed remarks concerning *Yellow Grotto*:

> We might linger on the dominance of this commodity in our culture, the culture of dairy fat. But this isn't where the work finally resides. Rather, the extenuated experiment with handling a material we know intimately, spectacularly in his overwhelming 40-minute manipulation of this form until it softens beyond mass, is a stimulus for our senses, causing a transference between artist and audience which is somewhere between desire and revulsion.[36]

If Maloy indulges to a certain extent the procedural effects of early 1970s performance and actions or even Beuysian social sculpture, he pointedly shuns the social visions and utopian notions that such grand gestures once were identified with. His approach becomes more akin to the playfulness and ridicule characteristic of the early happenings and events of Allan Kaprow or Ben Vautier, or the contemporary revising of such historical touchstones of creative flexibility and light spiritedness by Erwin Wurm and others. *Here I am. Look at me. I am art.*

Art historian Caroline Jones writes in her book on the transformation of the studio in 1960s American art that: 'The romance of the studio had been predicated on the exclusion of others, and by extension, the critique of that romance might suggest the

potential for their inclusion and the possible origin of a practical political result.'[37] It seems to me that a major noteworthy factor in Maloy's work is its critique of the studio environment. In his practice, the garden or the living room displaces the traditional studio environment, as does the gallery and museum, or the city's streets.

Maloy doesn't seek transcendence but revels in the disconnection between mundane materials and situations, and the traditional artist's belief in something perhaps more, greater, beyond. If we can't make things anew anymore, Maloy seems to say at least make them odd, estranged, but from materials that are close to hand: DIY mainstays, anachronistic art supplies, clunky and paltry bits and pieces. Many of Maloy's actions equally evoke the gestures of the playground, whether construction or climbing. To accompany a 2005 exhibition of his photographs (*28 Compositions*), Maloy recounted the following story:

> When I was 11 years old and my brother was 3, I took it upon myself to stalk my brother with paparazzi stealth and take a series of unannounced photographs of him sitting on the toilet. Like a true professional, and even after the tears from his little face started flowing, I continued to shoot until the entire roll of film was finished.[38]

Thus, the artist appends a lively anecdote onto works that continue to extrapolate upon parallel trajectories of cruelty and creativity (Figure 4.2).

In 2004, the artist (dis-)placed a handmade wooden *Tree Hut* into the unlikely setting of his Auckland gallery. Viewers were then offered a chance to pay to spend the night in the structure. Artist Sriwhana Spong indicated the complex tangle of intersecting connotations brought forth by Maloy's project:

> In *Tree Hut*, Maloy goes some way to closing the distance between the artist and art buyer. This relationship is an important one, each needing the other to varying degrees. A fee of $150 charged by the gallery, lodges the tree hut soundly within the branches of a dealer gallery. This transaction also excludes the casual viewer, who is alienated from the intimacy created between buyer and seller. Maloy's fee is a hybrid formed from three different areas of transaction. It is the average price of hotel accommodation with similar views in the area, in relation to size per square foot. $150 divides into an hourly wage of $10 for the artists nine hours of sleep a night once the gallery cut is removed. It is also in keeping with the fee paid for a male prostitute in downtown Auckland. All three speak of some form of ownership for a set amount of time, through monetary transaction.[39]

Maloy's performatively configured prostheses are frequently both macabre and funny. A party for one, aestheticized yet off-kilter and seemingly always in the process of transforming into something else. In *Clay Nose* (1998), the artist

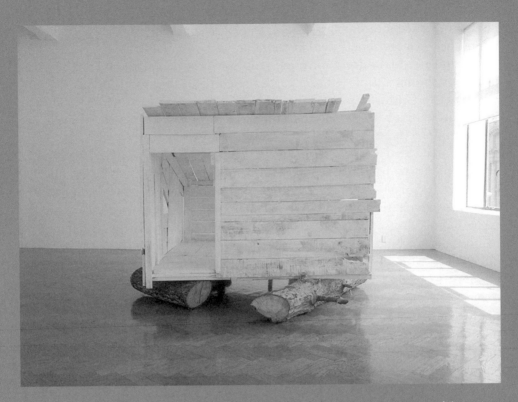

FIGURE 4.2: Richard Maloy, *Tree Hut*, Sue Crockford Gallery, 2004. Courtesy of the artist.

alternately smears and sculpts a false, elephantine proboscis. The process highlighted here is messy, contingent and utterly ridiculous: that is to say, a most interesting thing to do. In *Body Arm*, the artist applies wet clay to his torso, linking it to his right arm, as his left arm carries out all the sculptural work of shaping, moulding and ultimately concealing. This video also suggests the seminal early works of the artist Bruce Nauman, such as *Feet of Clay*, *From Hand to Mouth* and *Art Make-Up*.

In related video works, a sticky awkward plasticized wood veneer is wrapped around the artist's leg. Then the artist fabricates a cardboard covering for another man's leg. There is a distinctly eroticized quality to Maloy's practice, in both the actual use of materials and their related associations: bondage, obstacles, entrapment, hiding. Moreover, in the preponderant use of actions involving overt physicality: touching and tinkering, repeatedly playing. Maloy enacts such performative antics with relative zeal – and to the end of creating deliberately framed, elegantly lit set-up photographs – although methodically and quietly. The sound of his videos amounts to unrolled tape, the slap of clay, the wispy shudder of cardboard against denim. Maloy consistently 'unfixes' portions of the work as soon as it stabilizes, congeals. A manifest contradiction in his work is this ongoing uneasiness with finish coupled with an absolute focus on detail, clarity and realizing his chosen actions with subdued exactitude.

To my mind, the most manifestly intriguing of Maloy's videos is *28 Compositions* in which a boy wears a cardboard shell-like costume, a frontal prop, bare arms and legs protruding from the rough edges from this dark, basic shape, which resembles nothing so much as a caricatured exclamation point. The costumed figure then acts out several set pieces, poses, as a type of sculptural stutter, flickering from time to time into something recognizably iconic: the reclining, kneeling or standing figure for the most part. It almost appears as if an introduction to sculpture had been stripped down into a pantomimed series of rituals. Ways to describe sculpture to aliens, maybe? The history of sculpture transformed into a desperate burlesque. Meanwhile, this is all taking place – as recorded on a rough, amateurish video – in a suburban garden, near a fence, beneath a tree.

Maloy's works conjure aspects of the following: make-believe, dress-up, role-playing. Maloy does often occupy a theatrical role, a paper bag prince appearing to magically construct things simply as he goes along, although this is not actually the case. 'Bagism' was Yoko Ono's artistic construct derived from a communitarian politicized notion: let's get together in a bag, being friendly, being naked. Whereas with Maloy, a recent photographic edition features the clothed artist standing stiffly at attention, covered in a colourful plastic bag, eliciting not quite a statement of heroic intent, more a nonsensical

conception that continuously crashes back to earth as we can readily identify his bags as everyday consumer bags: not really masks, signs or armour, simply bags full stop.

Recently critic Lane Relyea incisively noted the ways in which contemporary sculptural practice has responded to current cultural conditions, and those of the increasingly dispersed artworld more specifically:

> Just as no TV show or pop song is as hot today as the TiVo boxes and iPods that manage their organization, so too with art it is the ease and agility of access and navigation through and across data fields, sites, and projects that takes precedence over any singular, lone *objet*. And the new sculpture [...] doesn't contradict this. It doesn't stand in defiance of network forces but rather proves their further extension by measuring how these forces have subsumed and changed the way we think about objects, have subsumed the very opposition between the single and the multiple, the enclosed and interpenetrated.[40]

Richard Maloy's self-imposed temporal and formal strictures serve to dynamically activate his sculptural projects. To a certain degree, one could say that the use of distinct boundaries helps to initiate a free space for the mind to inhabit. The marking off of hours, days, weeks and the use of rudimentary materials rather than limiting Maloy's work, engenders a climate for new possibilities. In creating a fleeting but consequential series of event-driven projects, Maloy may be enamoured with artifice and fakery, but the scope and intensity of his work belies a corresponding involvement with the specific circumstances of his actual gestures and the lived experience that cannot be readily severed from his engaging artistic practice.

5

Victoria Singh:
The Waiting Room (2014)

A stereotypical reading of performance art is that it might involve an angst-ridden, visceral public event or utterly spectacular intervention. Artist Victoria Singh's latest project, *The Waiting Room*, a rather subdued occupation of a now-emptied bookshop on Wellington's Lower Cuba Street during the month of March, acted in an entirely different manner from that model. The artist held the fort for a period of three weeks, clocking in early and leaving relatively late, in the various capacities of caretaker, minder, receptionist, front office staff, videographer, interviewer, discussant, curator and more generally (and significantly) a live, embodied presence. She might be online (as we all are these days) or out front, sweeping the entryway. Sometimes arranging the window display or temporary exterior signage. The former included some opshop-style circus ephemera to create a visual rhyme (or distorting mirror) to the glitzy consumables in the shop located almost directly across the street.

Singh's project might seem on the first approach as if it was a performance that drank from the (slightly tainted these days) well of 'relational aesthetics' as the interactions between Singh and *The Waiting Room*'s visitors served as the central locus of activity. But it's important to note Singh's previous background as both a performance artist and curator of live art (including five years at Vancouver's renowned alternative space The Western Front) and that during this particular project she was in virtual contact with one of her mentors Linda Montano, a formidable figure in the of the realm of performance, best known for her blurring of the art/life domains, role-playing in extravagant personae, extensive work with durational projects (she was once tied at the waist to the artist Tehching Hsieh for an entire year), and the integration of spiritual practices into her artworks.

The influence of Montano and other temporal performative frameworks dating back to the 1970s provides some additional cultural context for Singh's practice. And indeed, the first time I encountered Singh in person, it was when she was covered head-to-toe in green body paint, to assist her in enacting the role of an emerald Hindu goddess, offering blessings to the attendees at an art party held in Wellington. Singh's current *Waiting Room* was tidily and meticulously arranged

but in a scruffily un-gentrified space, which aided the effect of creating some type of strange, not unpleasant purgatory. A bit like a pop-up campaign office, but the candidate, Singh, is there to mess with your head and to provoke any of your preconceptions about the notion of waiting, time and various other vexing existential queries.

Ancient *Time* magazines were stacked for consultation while waiting, and a dusty-looking sofa-sized seascape hung prominently on the wall. Filled questionnaires began to be posted along the wall directly to one's left upon entering the space. Singh posed the following questions, to which participants, if willing, could write their answers (and/or) agree to be recorded onto video: *What is the longest time you have had to wait for something? Is there something you are waiting for in your life right now? What is that? How do waiting rooms make you feel? Are you patient or impatient? Do you have a few sentences you would like to share about how waiting has changed your life for better or for worse? Were you patient or impatient during this time?* (Figure 5.1)

Cuba Street, being an active public area of shops and cafés, buskers and flâneurs, became a particularly good zone to elicit curious pedestrians to wander into the space. Topics of conversation generated from the respondents (whom Singh recorded on video) included: waiting for visas, public assistance, long-haul flights, engagements and weddings, true love, old friends, family members, travels, births, world peace, birthdays, banks and hospitals, in traffic, for achievements, addressing health issues, wisdom, 'to feel comfortable in my own skin', and 'all my life'. Other visitors played musical instruments, silently read or knitted. Several small children drew pictures or scrawled on Singh's paper questionnaires.

The video documentation (portions of which played in the space and have been posted online) helped me gauge the wide-ranging effects of *The Waiting Room*. When I visited the space, it was more difficult, unless watching another visitor's encounter, to escape discussing it in a kind of meta, or art critical fashion (in my case, with the artist) when more intriguingly, I believe that many visitors engaged with Singh's project without feeling any similar pressure to designate it 'art' or provide an evaluation of its 'art' status.

This is a salient feature of its public-ness, that a 'public art performance' can both speak of and actively demonstrate the act of performance, and summon interesting discussion, outside of (or at least at an oblique angle to) characteristic institutional art framings. (Of course, the project did benefit from Creative New Zealand support, and association with the Urban Dream Brokerage initiative so institutional contexts were certainly present, but not directly foregrounded.) The act of crossing the threshold of *The Waiting Room* created a situation for a variety of potential responses, and from the evidence I've seen, very often meaningful and reflective ones.

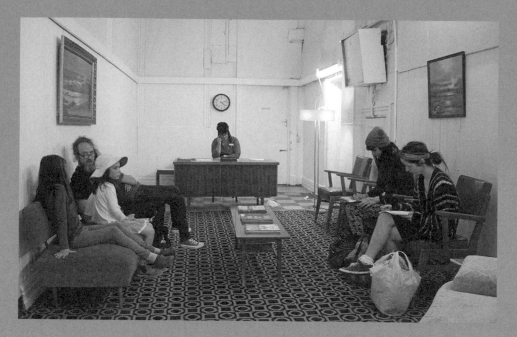

FIGURE 5.1: Victoria Singh, *The Waiting Room*, 2014, Wellington, New Zealand. Courtesy of the artist.

6

Interview with Artist
Catherine Bagnall (2015)

The artist Catherine Bagnall is a charmer. That is to say, both her work and her approach to life is filled with a disarmingly modest and endearing quality that draws one in, should you wish to travel in the circles of those who tread long distances on foot in the wilderness while wearing multi-patterned, hand-sewn animal hats and tails (for example). The fact that Catherine has both led group 'tramps' in this manner and scaled daunting precipices of Aotearoa New Zealand in cumbersome Victorian apparel is, in my estimation, mightily impressive. While Catherine maintains a relatively low profile in the local art scene, her work has been shown internationally, most recently in Mexico.

Bagnall's art practice enlivens the situations it encounters, similar to how she embraces the outdoor landscape and the actively performative gesture. Although most often represented through photographs, video and sculptural installation, Bagnall's concern is very much for the experiential and in a varied array of projects, she has attempted to communicate the very feel and the 'liveness' of her wilderness excursions. Although whimsical and childlike at times, her art practice also bears a quality of enormous seriousness and an almost mystical and neo-Romantic view of how nature influences and intersects with culture.

Catherine Bagnall's performative excursions bespeak, despite some historical allegiances, an utterly contemporary ecological worldview.

> MP: *Catherine, you once stated that you wore your own handcrafted outfits to explore 'a heightened intensity of being in the wilderness landscape'. This intrigues me as fashion (with which your artworks bear a strong relation) is often considered to emerge primarily from urban settings. Could you unpack some of the reasons behind and the origins of your 'wilderness' excursions?*

CB: I have never really worked in urban environments. I feel very happy in the bush[41] especially in the sub-alpine terrain as in the Kahurangi and Tongariro National Parks – these areas are so beautiful, and I really *like*

being far away from other people except for those I'm tramping[42] with. There are no mirrors, shopping, traffic, work, rushing when you tramp. Deciding to make work in the 'wilderness'[43] initially came from just wanting to be in it and second from reading about early mountaineering women who were often described as lesbian or odd/childless (which is me – the childless bit that is – and something I was thinking quite a bit about at that point); people that sat slightly 'outside' society. I decided the bush became a space where they could exist as they really *wanted* to be: a space where you can potentially become whatever you wish as the social rules or norms that apply to an urban setting don't necessarily apply. And using clothing (one of the most distinctively human *cultural* forms) to explore the human–animal divide I find interesting. When I dress up, I feel a full embodied-ness, a heightened intensity of being. I am exploring how clothing can enhance, rather than hinder a connection to the environment and facilitate a more physical understanding of being in the world.

How does 'tramping' play a role and what led you to organize group 'tramps', as you did last year (and have done previously)?

Growing up, I spent a lot of time in dress-up clothes in the bush behind our house. I have always dressed-up and still do. The organizing of a group 'walk' or 'tramp' arose from my own curiosity. Would other willing participants also be interested in 'becoming something else' out there? For the first group walk in 2012, I asked everyone to wear their best clothes, to dress up and I supplied fur muffs and long tails that I had sewn, along with a picnic. The walk took place in the Tongariro National Park[44] and it was a magical day – everyone was so dressed up, we walked and then picnicked, and there was some twirling in frocks. It was a very sensuous experience; everyone was happy and we all slept up on the mountain in a hut.

Did you take a very different approach when planning your second organized group tramp?

With the second tramp in 2013, I wondered how it would appear with others dressed up in hats with ears attached, and tails, and again just to find out what would happen – how people would respond to the environment and to each other – I just wanted to create an experience for the participants but not with huge expectations, just in hope that by wearing something not normally associated with walking or even usual everyday clothing, people might feel a bit different about themselves within their surroundings – to

feel very alive and possibly have a more sensual relationship to the environment. I think I am just dressing in reverence for the trees! (Figure 6.1)

How would you characterize your approach to dress and performance in relation to the specific context of Aotearoa New Zealand?

Dressing for the trees in fur muffs and tails in Aotearoa is certainly paradoxical. The fur trade is cruel and problematic, but possums are one of the pests destroying our forests. Polynesians brought the first rat (kiore) and the early whalers and European settlers brought the possum along with numerous other pests (stoats, cats, Norway rats and ship rats, mice, goats, deer and pigs), they are devastating the remaining bush and birdlife. Prior to human settlement, New Zealand had only birds and they had no natural predators. Accounts from the first European settlers, who arrived from around the mid-nineteenth-century – Māori have lived here since possibly as early as the first or second century AD – describe the incredible amount of birds and the intensity of bird song which didn't stop them burning and milling the trees to convert the bush to farmland.[45] Our national parks and wilderness areas are now all pest-controlled with trapping, weeding, hunting and even controversial droppings of the poison 1080. The management of pest control is a heavily contested area and exposes again our complex relations to 'nature'. I get the skins of possums my father traps, he was taught how to trap and skin by his mother, I then make them into the fur muffs, which form part of 'my dressing up for the trees'.[46] Also, at this time, I started painting women/girls in the forest wearing ears and tails and I think that I was also trying to become the personae in the paintings through the performances or vice versa. I am still painting those women/girls and they are becoming more maniacal: now they are dancing with arms outstretched.

You've participated in some symposia and exhibitions artist Richard Reddaway has organized on the notion of the 'baroque'[47] and how it might be read in relation to the Aotearoa New Zealand context. What are some of your thoughts on identifying with the term 'baroque'?

In terms of the Baroque project, my work fits mostly in the sense that I am calling upon the imagination to invent new ways of being in the world in a time of crisis. At the moment, humanity is wrecking the world and we need to take responsibility for that and re-think and create new possibilities both for us and other species. Maybe the sensuality and of my work alludes to the baroque. My performance/walk *Alpine Walking with Tails* was part of

FIGURE 6.1: Catherine Bagnall, *Alpine Walking with Tails and Ears*, 2013. Photograph by Scott Austin. Courtesy of the artist.

The Strange Baroque Ecology Symposium, and it operated as a rather subversive element in an otherwise traditionally academic forum (Figure 6.2).

I was wondering whether your eloquent descriptions of your acts of 'becoming' (animal) are rather paradoxical, given that you are almost attempting to abandon the sophisticated rhetoric and terminology of art/fashion/cultural studies in your works to consider how performative events can potentially develop into other, sensory modes of expression?

Yes, I am fully aware of the paradoxical nature of my work in terms of using dress to try 'becoming' another creature. Of course, I can't become a rabbit, but I think certain clothing enables me to 'become' more 'rabbity'. If I fully became a rabbit, I would possibly lose my ability to philosophize about 'becoming' rabbit, but I am interested in *feeling* more 'rabbit'.[48] Wanting to 'become' another creature comes from my interest in thinking we need to change our relationship to other non-human creatures but as philosopher Kate Soper argues we need to resist blurring the animal/human divide. She is wary of sliding into a post-humanist mode of thought, removing all distinctions between humans and non-human creatures. She argues from a position or a commitment to 'human exceptionalism',[49] to acknowledge the distinctive human demands for self-realization and self-expression. And that if we do not recognize our very humanness, we cannot take responsibility and change the environmental damage we are doing. She argues for openness, a respect for other species and a need to be aware of our limits of understanding.[50] I am interested in how one can be a voice *with* the other creatures, *with* the forest.

You write about cats and have evoked, referenced, and become a variety of creatures in your work, what are some of your beliefs on the significance of animals and of transformation (which you have spoken of in terms of becoming not only other beings of the animal kingdom but other people, characters, personae)?

'Becoming' another creature began with the idea of using a 'creature' to develop and understand aspects of myself, specifically my relationship to the environment. The dialectic between human and creature has its basis in the human psychological self and is used accordingly, this idea feels respectful to the creatures as well as allowing for the interior fictive process that goes on in the human imagination. But I don't rule out the actual transformation of humans into animals, shamanistic thinking, or at least trying the

FIGURE 6.2: Catherine Bagnall, *Alpine Walking with Tails and Ears*, 2013. Photograph by Scott Austin. Courtesy of the artist.

potential of that, and we can do it through writing, stories, and art forms. It is also about how we have placed the non-human animal in our culture, the awe about otherness. Otherness can be other characters, people, personae. I have learned a lot from sitting on the back step with my cat: about slowness and being in the moment and, most importantly, how to enjoy being idle – something I think we should be 'allowed' to spend more time doing.

What are your views on animal rights, ecology, vegetarianism?

I am an occasional wild meat eater who tries never to kill a fly or insect. I have a crazy love for animals, fish and birds and as Soper has also written about, I too still have long discussions with my dead cats. I am interested in the philosophical debates of whether how we treat animals is a moral or philosophical issue and am reading Cora Diamond's[51] writing to help work out my position. Diamond suggests that because philosophy is grounded on reason, it seals itself off from the possibility of reaching out to other forms of life and it is Elizabeth Costello who shows through the power of imagination there is no limit to thinking into the being of another animal. Elizabeth Costello, J. M. Coetzee's fictional character has been one of the most important influences on my work. Costello discusses the possibility of how a human being can feel what it is like to be a bat. She believes that to feel like a bat, one does not need to experience bat life through *actually* being a bat. Rather to feel what it is like to be a living bat is simply to be full of being, an embodiedness, based not on thought and reason but the sensations of 'being a body with limbs that have an extension in space', she describes this sensation as being 'alive to the world'.[52] I like that so much. Soper also discusses how Diamond accepts that moral sensibility, which we need to be able to respect and relate to other animals with, comes from our very humanness.[53]

The photographs that have been exhibited previously, drawing from your performative artworks often have a highly aestheticized, quiet atmosphere. What sorts of mood, atmosphere, affective qualities are you seeking in your art practice?

I don't really know exactly what sort of affective qualities I am seeking; I get more interested in conducting the walks, creating the clothes, rather than the end products. The last walk was good because it 'unfolded itself' – it was an end product and a 'performance' – there was something quite special about the whole thing and possibly because everyone bought into

it: the hats with hand-stitched silken ears in beautiful fabrics became catalysts for exchanges between strangers, as soon as people wore them. We drove past many dairy farms, just after Dr Mike Joy had explained how such farms are ruining New Zealand's fresh waterways. The international visitors were shocked that what looked so green is actually destroying wetlands and rivers, and we could see ourselves, and our problematic dairy industry.

The weather was good, we arrived at the mountain we walked for four hours then swam in a mountain stream. As everyone kept their hats and tails on, we became a tribe of wandering creatures. That night we talked over a vegetarian feast under a big full moon. I was worried the whole time about whether the 'performance' was working but it went so smoothly: people seemed to slip in and out of just walking, and/or performing, enjoying looking at each other, and talking. Of course, we didn't or couldn't do more than bump against our 'animal other'.[54] But we were surprised at what happened as the event was a kind of multiple, sensory immersion into our animal otherness and into the landscape and led to conversations between people that almost certainly would not have occurred under the conditions of a 'usual walk in the park'. My intention was to explore the role of the imagination in inventing new possible worlds, a world where we are the 'animal'.

You have used clothing with gendered and historical associations (such as fur muffs, wedding dresses). What are some of your thoughts on creating contemporary artworks that both summon and revise the historical and anachronistic? You have pointedly noted the capacity of clothing 'to disrupt linear history', and this seems to be a central and provocative notion in your practice.

Yes 'clothing as disrupting a linear line of history' is something I am interested in. When I wrote that I was trying to understand Deleuze's idea of the *'rhizome'*, and I was trying to think how clothing could be disruptive in terms of enabling an engagement with the past or a flattening out across time (and species). The act of inhabiting clothes can become hugely powerful – I would even say magical. When I wear my grandmother's clothes for example, I feel as if I am accessing her somehow. Fur *fascinates* me: I love it, and I sometimes wish I were fur-covered. I definitely have a thing about fur muffs – I mean, what a name! Fur, for me also becomes synonymous with climate change, the disappearance of winter.

Do you have specific intentions in terms of creating feminist work(s) and/ or exemplifying a feminist practice?

Yes, I think of myself as a feminist and so my work incorporates feminist ideas. But mostly I am trying to work out feminine ways of being in the world in my work, and related kinds of representations.

You once wrote: 'I am interested in the performative power of fashion to shift and question how we see ourselves – or what we can become.' One of the influences you cited in relation to this is the nineteenth-century dandy. Significantly, however, the dandy was a 'male' role, and you've shifted this gender identification. Could you elaborate?

The characteristic historical dandy strolling in urban environments – Beau Brummel – making himself a spectacle, an artwork himself, creating and constructing himself through clothing and how he wore clothing – all surface – this appeals to me. Now I am thinking about the relationship of dress, surface and negotiating the space of the animal other. Ron Broglio's[55] ideas are useful here. His argument is that if animals live on the mere surface of things where western thought has condemned them (of course he doesn't think animals exist only on the surface) he locates the surface as a site of bordering – a limit to human knowledge, then animals have something to tell us about the world of becoming. Staying on the surface with animals means a pursuing the unthought of thought. I understand this means to *feel* what is impossible to think. Clothing as a surface is a border between us and the outside world and it does collect the weather and a wet dress dragging against your legs makes for an intimate connection with the rain and the wet grass. I wanted to become something out in the 'wild' where I wouldn't *see* myself (no mirrors) but I would *feel* myself all dressed up, and would also shift the gender identification. If I were braver, possibly I wouldn't bother making anything at all except for the clothes. I would simply dress up and collect the damp and that would be enough.

What are your thoughts on connections, or rather interconnections and interconnectivity between you as an artist and cultural producer and the surrounding context you tend to seek out: the outdoor settings of NZ landscape?

I feel very spiritually connected to some of our outside spaces, but I am also aware that as a European in New Zealand, I am an introduced 'pest,' so that

in some ways I don't fit. My work attempts to address those contradictions. The work has travelled from dressing up in hyper-feminine clothes to 'feel stuff out there', to making myself animal-like clothes. I think trees are the most important, along with water, and I am working out how I can fit into that as both a human and a non-human animal.

I was also thinking about how you are 'constructing' performed events and the New Zealand landscape itself has a history of being 'constructed': for example: deforestation/reforestation, extinction/conservation, indigenous/ introduced.

I like your comments on 'constructing' performed events and the 'constructed' history and landscape. I like stories. They are important for thinking through how we fit in the world and also new modes of being. The 'wilderness' of New Zealand is gardened, managed and weeded. I have to think more about this!

You've said that you 'favour solitude' how does this manifest itself in your work and in your perceptions of the role of audience? And how does it coincide with your invitations to have others join you in performing/enacting wilderness tramps? What are your thoughts on social/relational practice and how does that influence your own approach(es)?

The 'favouring solitude' is a bit problematic. I mostly go tramping with a friend (because of safety) but I have tramped on my own as well. My first 'performance' tramps I asked my tramping partner to document me and that didn't work as I got all entangled in the gaze: who was looking and in fact who even owned the photographs. I quickly learned I needed to document myself but as I am not a photographer the images were never great but operated as a documentation of a performance. I did this for a few years. Two more recent photographic projects have been made with good friends of mine who are photographers, and these were very staged on purpose. These images were meant to function as finished works, rather than documents. The idea of involving other people on tramps is recent. I had read Nicolas Bourriaud's *Relational Aesthetics*, but I wasn't really thinking about that. It was more the thought that if the project documentation isn't really working then what happens if other people just come on them and become part of it – I was simply curious.

You use – in my view – a number of 'romantic' ways of speaking about your work, do you consider yourself drawing upon 'Romanticism' and Romantic

traditions? (I particularly think of this in terms of your engagement with certain materials and the ways you've described an 'excess of feeling' or 'heightened intensity' and 'feeling expansive.')

Yes, I am naively drawing on the Romantic tradition – especially at the start of this project (hunting for the feminine sublime and a heightened intensity of feeling).

You've spoken a bit about your affinity with 'alternative hedonism'? What does that notion consist of exactly?

Mulling over Soper's writings on 'alternative hedonism', I am thinking about how I can take on her ideas of developing new modes of satisfaction that are not based on the growth economy but modes of experience; more sensory, sensual, slower than we usually give value to. Dressing up in clothing that I have made, and walking may be a small way to do this. The gap of understanding between myself and animals with tails has not diminished but we both need clean air to breathe and the space to play.

You've written about building an archive of documentation around your performative works, but more and more documentation is getting treated for its own 'liveness' and performativity, do you have ideas in relation to this?

The *'liveness'* of the documentation is something I am beginning to understand. I have been trying to make my writing 'perform' or embody somehow 'becoming other'. I know I am not a writer; but in some ways I think some of my writing has been the most successful at performing 'becoming-other'.[56] But I think I am more interested in feeling alive than *'liveness'*. And maybe in *'liveness'* there is also fragility. On the group walk, we couldn't transcend our corporeal selves but possibly we felt a closeness to that landscape, to each other and a realisation of our own fragility because those connections were in stark view or felt.

7

'My Life Is One Big Experiment':
A Conversation with Laurie Anderson (2020)

A familiar voice is on the line. When we talk, American artist and musician Laurie Anderson is in Massachusetts preparing a forthcoming exhibition of new and existing artworks for the Smithsonian's Hirshhorn Museum and Sculpture Garden in Washington. It opens just ahead of a slew of works that she is presenting as one of three guest curators of the 2020 New Zealand Festival from late February.

> It's a really good chance for me to branch out and see who's working right around there and to see what we might have in common. And I always find people! I'm from such a small scene in a certain part of New York City, it's a way I can collaborate with people in different parts of the world, and it's not hard you know?

In Wellington, Anderson will present two string ensemble performances 'Here Comes the Ocean' and 'The Calling', a tribute to Lou Reed by using his guitars for a drone concert, and a virtual reality voyage 'To the Moon' (developed with artist Hsin-Chien Huang) at the Dowse Museum. In considering this programme, along with Anderson's wide and varied art practice, there are interesting associative links across any number of fields of inquiry: philosophically, politically, socially and aesthetically. She remains endlessly curious and open to the world. Anderson has long had a collaborative approach to her art – as ever ahead of the curve. In Wellington, she's enthusiastic about working with both her existing ensemble and artists from Aotearoa (such as taonga pūoro composer and practitioner Horomona Horo).

> I got the chance to do something last year in Hamburg for the first time, which was working with a pretty big ensemble of some of my all-time favourite musicians. We had a really wonderful time, accordion, bass, Brazilian percussion, and violin. We played a lot of festivals in Europe, and it was an absolute blast. It was such a weird sound. I love to work with people I don't often have the opportunity to work with.

That was the beginning and Greg Cohen [her bassist and music director, who has worked with Ornette Coleman, Tom Waits and John Zorn] and I have been meeting people virtually by Skype. It's been working well. I can't wait!

Laurie Anderson began her career as an avant-garde performance artist in New York's downtown scene, along with peers like sculptor Gordon Matta-Clark, dancer Trisha Brown and musician Philip Glass. Back in 1983, Anderson's ground-breaking eight-hour *United States, Pts. 1-4* featured music, stories, projections, and the song *O Superman* made her into an unlikely pop phenomenon. To sum up her country in this way was a remarkably ambitious move.

I don't think I was trying to cram the entire country into eight hours! But I think there are a lot of people who have tried to make portraits of their country, and right now I think it's so much harder. It's changing and it's so volatile what's going on. You know I can't quite keep up. It's such a whirlwind I'm at a bit of a loss. I would love to try something like that again, but I would have to do it in a different way. We're living in an absolute nightmare. It's really horrible. Everything is breaking. And it's wild to see that happen. I never could possibly have imagined something like this.

The technological devices Anderson has developed and implemented – such as self-playing (1974) and tape-bow (1977) violins, and using a vocoder to transform her voice – helped extend and make even stranger her narratives and songs.

You become tired of your own voice and if you describe the world in a different voice, you are looking at the whole thing in a different way. I found that completely fascinating. I could change my point of view just by changing my voice. You get really tired of looking at the world through the eyes of a white female artist in New York.

Anderson has always had a compelling way with words while 'always trying to use English in a vernacular way, and how it's used in the everyday'. Writer William S. Burroughs was a collaborator and an influence. She adopted his phrase, 'language is a virus from outer space'.

I think it's informed everybody now, language has literally become viral, and we've learned that a virus is a language. Things are complicated and made of many parts that are more integrated than we thought. He was really prophetic in terms of what he saw language doing and how it could move through the culture so quickly. And nobody else quite anticipated it like that.

Anderson's early albums, *Big Science* (1982) and *Mister Heartbreak* (1984) can sound stripped back and minimalist today, but during that era Anderson played to stadium crowds. And by the early 2000s, her sonic approach was pared back yet again (Figure 7.1).

> I did a lot of those big shows and frankly I got kind of burned out. They were expensive to make and to tour around. I thought I'd like to do something that's really portable and changeable. Where you're not doing the same show every night. With a big show you can't improvise. It's a trap, and my way out was to do shows where I'm the only one in it and travel by myself. Suddenly I thought: this is so much fun!

I mention that humour has played a strong, and often under-acknowledged role in her work.

> Not a lot of people have noticed that. I probably see the world in a bit of an absurdist way. I admire good jokes. It's really hard to come up with a classic good joke. And so, when I hear one, I remember it and try to pass it on, and I like to try to make things up as well. With humour, you can't fake it and you can fake so many other things in life. I trust physical things like laughter.

Anderson spent time with the late comedian Andy Kaufman, known for testing limits and antagonizing his audiences. 'He was a great friend of mine and a very smart guy, he knew exactly what he was doing. He was a strategist like no one I've ever met before.'

For many years, Anderson (along with her husband the late Lou Reed) has practiced both Buddhism and Tai-Chi.

> For me being a Buddhist and being an artist are really kind of the same. The only things you have to do are to pay attention. That's it. Otherwise, there are no rules. For artists this is the greatest; no rules, that's fantastic! And it's a way to take responsibility for yourself which of course artists have to do. Sign your name on this: what are you making and why. It's also a traditionally god-like thing to do; to create something that wasn't there, and you put it there. That's wild. And it's also good to have a reason for what you're doing. I love that there are no rules about making art. None. Zero!

Anderson is also an advocate for what the purely *visual* language of art can accomplish.

'Sometimes just seeing a gigantic blue painting can be more about freedom than any long essay about what it means to be free. We're working with the senses as well as the mind.'

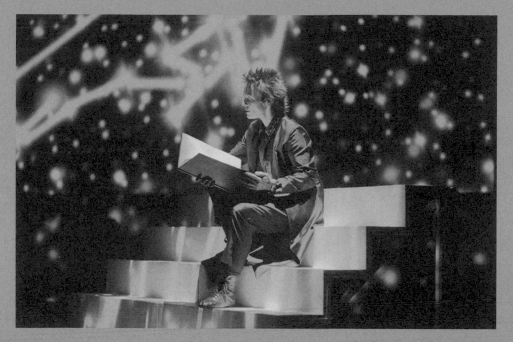

FIGURE 7.1: Laurie Anderson, *Songs and Stories from Moby Dick*, 1999, BAM, Brooklyn, NY – performing 'One White Whale'. Photo by Frank Micelota. Courtesy of the artist.

Anderson's film *Heart of a Dog* (2015) memorializes the passing of her rat terrier Lolabelle, but in the process it also talks about broader cultural loss and the loss of family members. It comes in the form of an entrancing, poetic, uncategorizable and often humorous narrative. The film will screen at the festival after a twenty-minute *Concert for Dogs*, featuring sounds beyond the range of human hearing. Anderson's comment in the film: 'If you give a command to a terrier, they say: "Is it going to be fun? Because if it's not going to be fun, I'm not interested!"' holds resonance for me, as a border terrier owner. And Anderson notes: 'I love terriers, they are just a blast – super cheerful dogs, and also like living with a cop. But once they realise a person's OK, then they are the most loving dogs in the world.'

In a sharply politicized vein, Anderson created the work *Habeas Corpus* (2015) in which she worked with Mohammed el Gharani, once the youngest detainee at the Guantanamo prison facility. In the project, el Gharani's video image is streamed and projected onto a large sculpture.

> We are rebuilding that piece to show in Washington DC. I'm really looking forward to that. I went to visit Mohammed a couple of months ago and he is still stateless and still homeless. Even though he was released he was never charged, and if you're not charged you can never be pardoned. He's in absolute limbo, in ten different countries, and sent to countries that tortured him again. It's a seriously crazy and horrible situation. He's recorded some messages for Americans, and it's been amazing to work with him. He's got an incredible sense of humour and ability to see the absurd side of things. It's astounding how he's able to do that.

The now 72-year-old artist appears to be in perpetual motion, constantly working on multiple projects across a range of media.

> My life is one big experiment. Over the past year I've been making these really bad but really big paintings, and it's the greatest fun. Other projects I'm working on have to do with spatial sound using multiple speakers, writing a couple of books. I've just recorded a quartet, and an orchestral piece, and you know they're all kind of weirdly unrelated. It's a very strange life I have. I see the relation when I'm working on a painting or an orchestral piece. I ask myself the same questions: is it big enough? Is it small enough? Is it clear enough? Is it mysterious enough? Is it vague enough? All those things, and they all have answers that change the way you're going to work on the piece. And some of them don't have any answers, and you have to work blind a little bit, to just drive in the dark.

Has she any wisdom to share about staying so curious and open?

Number one don't forget to breathe and breathe deeply. I follow that. I work with a lot of people under a lot of stress, and I often ask my artist friends their advice. For example, Philip Glass says, 'I acknowledge it.' It's important to accept your own, struggling self. You don't need to be this perfect person you think you might need to be. You're never going to be that anyway and none of us are. Accept that and see all the positive things. Once I do that, I feel 1,000 times better, much more relaxed, and my mind clears.

PART II

PHOTOGRAPHY

I began my own art studies by pursuing photography through both my BFA and MFA degrees. I was fascinated by multiple aspects of the photographic medium, particularly the fact of its incorporative capacities; ways the 'camera eye' can operate as a surrogate for the human eye, and in turn can influence and transform our (in John Berger's words) 'ways of seeing'. Considerations of the photographic image summon a range of philosophical, aesthetic and ethical issues. This section contains a selection of texts on canonical contemporary photographers (Eggleston, Sherman), critical writing on photography (Kozloff) and writings on contemporary artists who use photography in provocative ways (including Alÿs, Crewdson, Shelton and Simon).

8

Francis Alÿs and Photography: Snapshots from an Indefinite Vacation (2007)

I entered the art field by accident: a coincidence of geographical, personal, and legal matters resulted in indefinite vacations which, through a blend of boredom, curiosity, and vanity, led to my present profession.

—Francis Alÿs[57]

How might an artist who tends to wander and shift his attention to altogether different material with great regularity situate his practice; that is to say, how can the artist prevent his work from almost floating away into an eclectic and potentially inconsequential series of gestures? This question becomes especially relevant when critically examining the work of Francis Alÿs, a Belgian-born artist and resident of Mexico City for nearly twenty years. In large part, photography ends up being a consistent tool for Alÿs to 'ground' his work in documentary records that offer a concrete, unsparing verisimilitude. If his gaze occasionally wavers, the camera's relative stasis helps confirm the suspicion that there is some great internal rudder guiding this peripatetic yet often exactingly precise twenty-first century artist during his near-constant travels.

I would prefer as a point of entry into this chapter – yet another attempt to take on this prolific and perplexing artist – to discuss several of Alÿs's projects which are directly associated with the use of photography and photomedia. Manifold contradictions emerge from Alÿs's photographic works, such as his reliance on the clear recording of otherwise ephemeral incidents, but simultaneously these actions and works often consist of absurdist, almost dreamlike vignettes, such as in *The Paradox of Praxis* (1997) wherein the artist pushed a melting block of ice along the street, to exemplify the statement: 'Sometimes to make something is

really to make nothing; and paradoxically, sometimes to make nothing is to make something' (Figure 8.1).[58]

It is of course rather ironic to analyze the medium-specific attributes of an artist who is a self-professed 'hybrid'. In turn, this would be directly related to the fact that Alÿs was (again in his words) 'not trained in one medium [...] I'm not somebody who's obsessed by any specific medium'. Alÿs has noted that

> I do use the camera quite a bit whether it's to take photos or to do videos. And often the camera becomes a kind of filter with a situation I feel foreign to. Like when I'm [...] a kind of outsider the camera offers a kind of [...] protection. A mix of protection and justification [...] of my presence in that place at that moment.[59]

Alÿs is well-known for his incorporation of the 'walk' (*paseo*) and the Baudelairean *flâneur* is often cited in any extensive discussion of his practice. Alÿs is generally an urban walker, and equally relevant could be the long history of artist-walkers such as Stanley Brouwn, Richard Long and Hamish Fulton. Moreover, one could assert that Alÿs is more intent on recording details of the social landscape than the actual landscape itself in the traditional sense. The importance of the focused stroll has been integral to so many artists as it could serve to a certain degree both as 'the machine that makes the art' (to paraphrase LeWitt) and as a mechanism leading to unanticipated discoveries. As writer Rebecca Solnit has commented

> The random, the unscreened, allows you to find what you don't know you are looking for, and you don't know a place until it surprises you. Walking is one way of maintaining a bulwark against this erosion of the mind, the body, the landscape, and the city, and every walker is a guard on patrol to protect the ineffable.[60]

Alÿs originally received his professional training as an architect, and his practice even today seems to be haunted by its references, however oblique, to architecture. His works often begin from a few lines drawn onto a map, notes jotted on paper, structures conjured out of not much at all. The working methods favoured by Alÿs run almost entirely counter to certain assumptions about architecture, and this can be stated via a number of opposing terms: inside/outside, stationary/ambulatory, monumental/ephemeral. We might recall Gordon Matta-Clark here, another widely travelled artist whose antipathy toward traditional notions of architecture helped spawn his iconoclastic brand of practice, literally cutting and carving away at the façade of urbanism. In a similar fashion to Matta-Clark, Alÿs uses photo documentation to record the results of actions and site-specific projects, and such residual information 'becomes' the piece for most viewers.

FIGURE 8.1: Francis Alÿs, *Paradox of Praxis 1 (Sometimes doing something leads to nothing)*, 1997, Mexico City, photographic and video documentation of an action (five minutes). Photograph by Enrique Huerta. Courtesy of the artist.

This was made abundantly clear in the work entitled *When Faith Moves Mountains* that Alÿs organized on 11 April 2002, near Lima, Peru. A work that on one level was simply a grand choreographic feat: aligning 500 volunteers (many of them university students) along a sand dune, each with a shovel, each contributing their own physical effort to 'move' the very terrain beneath their feet. A 1600-ft long dune being shifted about four inches enacts another notion favoured by Alÿs, expending the maximal effort for minimal result.

The artist writes:

> The dune moved: this wasn't a literary fiction; it really happened. It doesn't matter how far it moved, and in truth only an infinitesimal displacement occurred – but it would have taken the wind years to move an equivalent amount of sand. So, it's a tiny miracle.

If the premise of the piece itself verges on the fantastical, as Alÿs states, the fact that it was actually carried out counts, especially as the artist considers it to be moreover a 'social allegory. [...] This story is not validated by any physical trace or addition to the landscape'. Alÿs in addition sought a kind of rebuttal to what he regarded respectively as the social insularity and aesthetic monumentality of Richard Long and Robert Smithson. As the dunes of coastal Peru are also home to impoverished shantytowns, Alÿs calls his piece 'Land Art for the Landless'.[61]

A short video offers glimpses of this project as it coalesced, and retrospective comments from several of the volunteers. The arc created across the surface of the dune by the volunteers clad in white shirts makes for a powerful still image, which graced the cover of *Artforum*. In the video, the same figures are seen through a haze of sand and wind via helicopter, and, in many shots, the lens is coated by assorted bits and pieces of gunk and detritus, so we never see an entirely clear image, devoid of imperfections. This funky, offhand quality is wholly integral to the statement being made. Little by little, small gestures count, at the very least symbolically; and sometimes the symbolic impact is the most significant when the gestures are toward some great, crazy unforeseen and perhaps ridiculous outcome. As one of the volunteer-participants recounts: 'So in fact we've got other projects like drink the Atlantic, melt the Antarctic, paint the sky, that kind of thing [...] simple stuff'.[62]

In his digital project *The Thief*, which Alÿs created for the Dia Foundation, we glimpse a silhouette of a figure emerging from a dark field, revealed to us by a bright window-like space inset into the darkness. The shadowy figure walks away from us, casts glances both left and right, raises 'his' left arm into the virtual opening, then appears to leap downward, thus out from the window, into the screen, away from our view. The portion of the project just described is a downloadable screensaver (itself now an anachronism), but the project also incorporates a text presented as a Flash animation, to be clicked through, scrolling upwards as if a film

strip. The text, co-authored with a frequent commentator on Alÿs's work Mexican critic Cuauhtémoc Medina, cites a wide range of texts, from Brunelleschi to Prince (yes, that one), discussing the format and history of the perspectival window.

Alÿs can be understood as participating within a now long-standing tradition of ephemeral artistic activities becoming transformed into evocative photographic documents. He has commented: 'The initial concept for a project often emerges during a walk. As an artist, my position is akin to that of a passer-by, [as I am] constantly trying to situate myself in a moving environment.'[63] Alÿs's approach is often characterized by this notion of perpetual movement, such that when he makes more straightforward 'classical' photographs, they become quieter, more diffuse and subtle in their impact.

In the *Sleepers* and *Ambulantes* series of photographs, the images are presented in the form of a slide show. This technique has been used to great effect in the history of contemporary art, from Marcel Broodthaers to Nan Goldin, and it also lends an atmosphere of everyday pedanticism: *this is what I saw, you should have been there, oh this was so interesting, this was the roll I shot in...* This cyclical array of frozen vignettes intimates some larger narrative sweep and carries the viewer along. *Sleepers* offers views of both human and canine inhabitants of Mexico City sleeping on the street. Here a couple sways nearly to the point of toppling off a bench, there two dogs huddle, forming an entirely relaxed and supportive duo. *Ambulantes* are relatively straightforward documents of rambling denizens of the city along with their push carts, carriages, wagons, dollies. The ramshackle vehicles are stacked, piled and wrapped with all manner of aesthetically alluring paraphernalia.

Alÿs arrived in Mexico in 1987 both to work as a public servant after the devasting earthquake and to avoid military service in his home country. Much has been made of Alÿs's living in Mexico as an 'outsider' and he himself has made light of this in a few of his works – such as labelling himself the 'turista'. But now, given the extended period of time that he has lived in the city, he as an observer has conducted a steady, prolonged investigation of the place. This has become the case with the long series of walks undertaken by the artist and then he has subsequently taken this process 'on the road' to London, Sao Paulo, Copenhagen and New York.

For the premise of *Narcoturismo/Narcotourism* (1996), Alÿs states: 'I will walk in the city [Copenhagen] over the course of seven days, under the influence of a different drug each day. My trip will be recorded through photographs, notes, and any other media that become relevant.' Thus, the experiment conducted by the artist consisted of imbibing the following substances over the course of 5–11 May: spirits, hashish, speed, heroin, cocaine, valium and ecstasy. The process of creating the work involved preserving (ostensibly) a state of intoxication for fourteen hours each day. Alÿs later displayed a page of text, including diaristic

accounts of his experiences ('Awareness of a change of state, but not followed by a visual echo. Auditory acuity enhanced. Appetite gone, smoking diminished. At night, nausea and thirst.'), and a photographic image of the artist's walking feet clad in Converse high-tops was used to represent the piece.[64]

Narcotourism appears as but one instalment in Alÿs's on-going investigation of various altered states: travel, intoxication, (potentially) violent behaviour, sleep. He has spoken of using the city as a 'laboratory' and certainly, in *Narcotourism*, he becomes a test subject himself. Alÿs walks but he also prowls as it were, and implicit violence has often served as a key theme in his works, most infamously in his *Reenactment* video, wherein he walked the streets holding a gun in plain sight until his arrest by the police. He then 'explained' the reasoning behind this piece and staged a reenactment with the complicity of the police.

In the video *Nightwatch*, the wide-angle lens of a surveillance camera records a fox – as a stand-in for the artist – roving around amidst the Tudor portraits and sculpture busts of the National Portrait Gallery in London. The intruder seems ill at ease in the galleries as he paces the perimeter. A postmodern alliance of nature and culture, yet far more quietly oblique than the bombastic neo-shamanism of Beuys and his coyote some 30 years previously. The twenty-minute piece is filled with edited 'highlights' but remains staggeringly dull, as it should be. One might recall other videos of recent vintage characterized by their 'slowness' such as Bruce Nauman's *Mapping the Studio: Fat Chance John Cage*, in which a camera records the meagre goings on in his studio at night, and the mice and insects shuttling by are the sole noteworthy events.

Nightwatch is calm yet its bookend to an extent is the far more agitated short video *El Gringo* (2004) in which the viewer follows the camera-eye as it leads into a rural Mexican locale. The camera lingers on some cacti and advances along a rough path. A few dogs approach and soon begin circling and barking loudly. Almost immediately, the dogs are out of control, baring their teeth, snarling and continuing to bark. The camera/protagonist falls to the ground, and it/we are left there, uneasily confronted by dogs still staring curiously, but beginning to direct their attention elsewhere.

A word on Alÿs and authorship: Alÿs tends to be most interested in working in a mode of collaboration, deriving an energy or friction from this approach. Even when Alÿs can be viewed as the author, his works often incorporate the use of dialogue, mediation, volunteers, research, travels such that his claim to authorship of the work is partially relinquished, an altogether appropriate stance for the current moment.

In a recent essay on Alÿs, curator Kitty Scott states that: 'Francis described his practice as "nearly writing" and referred to his sketches with fragments of text as "written drawings".'[65] Alÿs in his works brings an experiential dimension of life to

bear upon these notes and fragments. Very commonly in his gallery installations, Alÿs exhibits some of these materials which led to the completed piece, often on tabletops, loosely under glass beneath hanging metal lamps, a kind of restaging of the studio, or as Leo Steinberg famously described the methodology of Robert Rauschenberg, the 'Flatbed Picture Plane'. Steinberg writes:

> The flatbed picture plane makes its symbolic allusion to hard surfaces such as table-tops, studio floors, charts, bulletin boards – any receptor surface on which objects are scattered, on which data is entered, on which information may be received, printed, impressed – whether coherently or in confusion. The pictures of the last fifteen to twenty years insist on a radically new orientation, in which the painted surface is no longer the analogue of a visual experience of nature but of operational processes.[66]

Furthermore, Alÿs, who is less a multimedia artist than an artist who is simply antagonistic towards any idea of media specificity and imposed limits, has defended his work as a collection of mere notes and sketches and ultimately a narrative which can be related regardless of its original form of dissemination:

> The structure is similar to that of a narration or a story, something you can take with you, something you can steal and tell and tell again and again [...] One of the few criteria I apply when I am working on a script is exactly that, to simplify its structure until it becomes just a story, a joke, a fable.[67]

Alÿs has directly focused upon the amateurish, accessible and populist aspects of work conducted in the public space.

Alÿs's most recent exhibition in the United States, on view in New York at the David Zwirner Gallery, was entitled *Sometimes Doing Something Poetic can become Political and Sometimes Doing Something Political can become Poetic*, or more succinctly, *The Green Line*. The focal point of the project was a video recording of Alÿs re-enacting a work from 1995 called *The Leak*, in which the artist walked along dripping a thin trail of blue paint from a can he carried. The original work appeared to be a kind of metacommentary on the medium of painting and individual artistic identity.

By fast-forwarding almost ten years later and dripping this now-green leak in a manner incorporating historical narratives, the piece is suffused with different connotations and allowed to transform once again. The historical material in question is the drawing/carving up of Palestine in 1948 via a green line created by General Moshe Dayan's pencil. Beyond Alÿs's orchestrated spilling of 58 litres of paint over the course of a 24-kilometre walk, he later interviewed (in 2005)

a number of activists, intellectuals and officials as they were shown excerpts from the documentary footage.

Throughout the main room of the gallery were strewn rather anthropomorphic sculptures of handmade 'guns'. As they had been fabricated roughly, with film cannisters, reels and strips incorporated into their wood, wire and metal frameworks, they had an edgy, provisional quality also recalling Étienne-Jules Marey's repeating 'rifle' camera used to create chronophotographs dissecting the movement of birds in flight in 1882. On one wall of the exhibition installation hung a small, approximately five by seven-inch painting, replicating therefore the scale of a snapshot and iconography borrowed and reworked from Romantic painters such as Caspar David Friedrich: a lone (gun-)man stares off into the sea, a rifle propped upon his shoulder. The image has the murky, indistinct and somewhat amateurish quality shared by many of Alÿs's painted works.

The Green Line was not a commissioned piece, but a work entirely generated and motivated by Alÿs himself. Alÿs equally used the video as a setting for the interviews he conducted in a manner that emulated that of a working journalist. This approach in turn replaced the individual voice with a more collective expression, especially when compared to the earlier version of the piece. Alÿs has continued to pursue unusual and demanding projects that are frequently documented via photography and video, and by virtue of this on-going use of photo media, something different emerges. In this process, all his initially nebulous notes, sketches and drawings leave in their wake a newfound crystalline rendering. Without the resultant photographs, Alÿs would remain solely a spinner of tales, rather than a conjurer of images of lasting and powerful significance.

9

William Eggleston on Film (2006)

By the Ways: A Journey with William Eggleston
By Vincent Gérard and Cédric Laty
85 Minutes, 2005

William Eggleston in the Real World
By Michael Almereyda
86 Minutes, 2005

Art [...] You can love it and appreciate it, but you can't really talk about it. Doesn't make any sense.

—William Eggleston[68]

The track record of documentaries on contemporary artists has unfortunately been rather inauspicious. The nature of the problem is compounded when the artist depicted is also a documentarian of sorts. An examination of two recent films on photographer William Eggleston brings to bear many of the difficulties surrounding the cinematic depiction of a highly eccentric, mercurial and significant artist. Eggleston is as intriguing a subject as any filmmaker might hope to find. Inextricably linked to the American South, he has spent much of his life in Memphis, Tennessee, ceaselessly and ravenously photographing its surroundings.

French filmmakers Vincent Gérard and Cédric Laty are surprisingly adept (especially for first-time directors) at creating a cohesive portrait of the artist through fragments, which, while often relevant, take intriguing detours, befitting the film's title *By the Ways: A Journey with William Eggleston* (2005). However, Michael Almereyda's documentary, *William Eggleston in the Real World* (2005), suggests a parody of the documentary form. Almereyda, an accomplished director of fictional narratives, prefers the use of long, uninterrupted and often uninvolving scenes to establish the film's meandering itinerary.

Although Eggleston may be placed comfortably within the documentary tradition of post-war photography, both the matter of his influence and his own voluminous, ongoing production are far more complicated than referencing such a tidy

and direct lineage might imply. His work raises various questions: Is Eggleston more an inheritor of Walker Evans or the grandfather of Andreas Gursky? Is his cool, non-judgmental approach part of a longstanding modernist commitment to recording the everyday or an exactingly rendered postmodernism before the fact? Is Eggleston's evasion of discourse surrounding the work old-fashioned and genteel or rather timely and fashionable?

In favour of scrutinizing the taciturn man who made the inscrutable art, these questions are not directly addressed in the current films. Context is everything when banking on the artist as 'personality'. Gérard and Laty are most successful at conveying the importance of Eggleston as a product of Memphis, the home of blues, rockabilly and, later, such musical individualists as Alex Chilton and Tav Falco. One of the most charming bits of *By the Ways* features Falco, leader of the band Panther Burns, coiffed with a flowing black pompadour and sporting a pencil-thin moustache, expounding on the relative perfection of Eggleston's contact sheets and the lingering influence of Henri Cartier-Bresson.

Arguably the most indelible of Eggleston's photographic achievements is the volume *William Eggleston's Guide* (1976), 48 photos that serve to collate an idio-syncratic vision, marked by its concise and insistent clarity. *Guide* accompanied the photographer's now-benchmark and then-controversial solo exhibition of colour photographs, a rarity at the Museum of Modern Art (MoMA) in New York City and a major arbiter of taste in the narrow sliver that is/was the world of fine art photography. Photographer and critic Mark Power once succinctly remarked that it was one of the few photography books that 'reads like a novel'.[69]

John Szarkowski, then-director of the photography department at MoMA, and curator of the exhibition, wrote a penetrating and insightful analysis of Eggleston's work for the introduction:

> These pictures are fascinating partly because they contradict our expectations. We have been told so often of the bland synthetic smoothness of exemplary American life, of its comfortable, vacant insentience, its extruded, stamped, and molded sameness, in a word its irredeemable dullness, that we have come half to believe it, and thus are startled and perhaps exhilarated to see these pictures of prototypically normal types on their familiar ground [...] who seem to live surrounded by spirits, not all of them benign.[70]

Although Szarkowski is entirely correct in his alignment of that body of work with 'ordinary' subjects, Eggleston has also committed a great and eclectic variety of material to film, whether on movie sets, in Elvis Presley's home, in nightclubs, or while abroad. Eggleston, a specialist in terse replies to interviewers, has also generated many memorable dicta such as his notion of *The Democratic Forest* (the title of the long-awaited 1989 sequel to *Guide*), that no image is of estimably

greater significance than another, or his methodology of taking 'only one picture of only one thing'. He has also disdained the reading of his work as deriving from the 'snapshot' with the retort: 'They want something obvious. The blindness is apparent when someone lets slip the word "snapshot". Ignorance can always be covered by "snapshot". The word has never had any meaning. I am at war with the obvious.'[71]

In several scenes in Almereyda's documentary, Eggleston is evasive, eluding interrogations and appearing to simply go about his business. These infuriating exchanges are characteristic of the film as a whole, which initially promises much more as it circles in a deliberate, intense way around its protagonist. In an admittedly perverse fashion, a viewer could also treat this bizarrely disconnected document as a marvel to behold. The audience could then decide who is controlling the situation here. The film becomes a lugubrious situation comedy, reaching its nadir in scenes depicting the photographer doodling with coloured pencils and noodling away on musical compositions. Is this only a draft for a film, a sketch, some rough takes? The director does little to correct this impression – even with his sporadic voice-over, which, like many such meditations on the significance of photography, often reaches for the profound and settles for the banal.

With even a cursory scan of archived material, one easily discovers that Eggleston's answers to interviewers in print have often been far more inclusive and revealing than the bits shown here. In fact, critic Jim Lewis prefaced his interview in 2000 with the following comments:

> Eggleston's first answer to nearly every question was 'I don't know', or 'I never think about that', or 'I don't care about that' – an interviewer's nightmare, until I realized that he was simply being laconic in the extreme. Left in silence for some time, he'd eventually address himself to the matter at hand.[72]

In the most lucid and revealing comment made by Eggleston to Almereyda, he recalls dreaming of 'brilliant, beautiful pictures', and laments, 'I've always hated that technology is not yet here to record our dreams.'

Both film crews frequently rely on other voices in addition to Eggleston's deep and indistinct rumble (usually subtitled in *The Real World*). In *By the Ways*, a perky David Byrne recounts anecdotes from a downtown loft while photographer Rosalind Solomon describes meeting and making portraits of Eggleston in the sixties. Dennis Hopper turns up in an entirely superfluous cameo. Almereyda chats with the garrulous Rosa, Eggleston's wife of 40 years, who shares weathered photo albums dating from their teenage years.

By the Ways is constructed using a tightly organized series of twelve 'chapters' or segments. The filmmaking duo also patterns their cinematographic approach

after a gently mimetic relationship to Eggleston's vivid palette and simple framing. The film has a languorous quality without ever becoming dull. These non-natives of the South have filmed its unhurried pace with exquisite deftness. They rarely show Eggleston at work, a mistake made by Almereyda, as watching a photographer stroll along – even one of his estimable stature – is a very uninteresting proposition. It is more evocative to witness large trays mechanically rocking Eggleston's prints into existence in a custom photo lab. The film shows a darkroom technician humming along to Bob Dylan's 'Desolation Row' (1965) as the artist flips carefully through prints while wearing leather gloves.

Eggleston's sheer mysteriousness is emphasized repeatedly in *By the Ways*, which opens with the photographer discussing the impact of Alfred Hitchcock's colour films, such as the lurid *North by Northwest* (1959). This is a significant reference because the documentary concludes with the camera following Eggleston's daughter, Andra, on the street without any interaction – an apt Hitchcockian denouement. In a later section of *By the Ways*, Sherlock Holmes becomes an allegorical stand-in for Eggleston as Arthur Conan Doyle's famous detective is described in a lengthy passage by Dr Watson, who expresses astonishment at 'his ignorance of literature, philosophy, and politics' simultaneously coexisting with his attention to minute details: 'No man burdens his mind with small matters unless he has some very good reasons for doing so.'[73] This narration works wonderfully well, and after a time, I remembered that Holmes was a literary favourite of none other than Jorge Luis Borges.

Incidental music is also handled effectively by Gérard and Laty, lending an enthralling sonic texture, from blues and rockabilly to arias and fugues, to the distinctive visual character of *By the Ways*. Near the beginning of the film, we are serenaded by an Elvis impersonator in a parking lot and, by its final section, we are treated to Peggy Lee's melancholy 1969 hit 'Is That All There Is?': 'Is that all there is? / Is that all there is? / If that's all there is my friends, then let's keep dancing / Let's break out the booze and have a ball / If that's all there is'.

One of Eggleston's photographs – of a lone incandescent bulb wired into a blood-red ceiling – adorned the cover of *Radio City*, the second LP by Memphis rock band Big Star, whose singer Alex Chilton has long been an icon in the independent pop world for his clear, direct music commenting on depression, dissolution and other aspects of entropic decay. Until I watched Eggleston's video from 1974, *Stranded in Canton*, I had not realized how similar his approach was to Chilton's. Eggleston did more than cross paths with Chilton – even accompanying him once on piano, as he later recounted to critic Barry Schwabsky: 'I was, the way I put it, playing around him. His singing was the musical equivalent of abstract painting, and I was playing very clearly, not abstract music.'[74] Eggleston is a true American amalgam: mix unequal parts of William Faulkner, Jerry Lee Lewis, Hunter S. Thompson and stir.

A new edit of the *Stranded in Canton* material is a major – if uncharacteristic – addition to the more canonical work. Neither precisely cheerleader nor clinician, Eggleston dwelt amidst semi-coherent partiers capturing the gory details and repetitive phenomena of seemingly endless Saturday nights. It would be invaluable as a time capsule of the early seventies, but it has gained legendary status as a 'lost' work, particularly as, after a short stretch, Eggleston abandoned the video camera altogether. The current compilation was assembled by Robert Gordon, a filmmaker and author of the highly entertaining and informative history of the region's pop music and cultural production, *It Came From Memphis* (1995).

One might wonder what is offered in a video edited from approximately 30 hours of 35-year-old videotape material. Among the dubious highlights are fellows enacting the 'geek' trick – biting the heads off live chickens – on a Memphis street, an utterly tuneless acoustic rendition, a chant really, of John Lennon's 1971 hit, 'Power to the People' and other songs interrupted by a pistol shot repeatedly into the air. The last several scenes of *Stranded* appear as a procession of increasingly disturbing tableaux, a western of drunken scatological hedonism. This is the post-1960s, not yet the New South, its protagonists stumbling about as in a Samuel Beckett drama, three sheets to the wind.

The cast of characters is visually memorable even though we are only introduced to them in an oblique, glancing fashion. Eggleston's 'partner in crime', long-time friend Vernon Richards, seen screaming and ranting in *Stranded*, turns up in a more reassuring guise in *By the Ways* as he speaks of being 'a real dilettante [...] I dabble in just about everything'. To introduce Richards in his recent voice-over narration to *Stranded*, Eggleston states: 'sometimes he would provoke a scene just by being himself'.

Not without irony, the viewer is dropped abruptly and unceremoniously into these dark, black-and-white home movies shot by one of the world's most accomplished colour photographers. *Stranded* is visually characterized by the consistently murky, near-hallucinatory quality of early Sony PortaPak video, although Eggleston improved matters greatly by using sharper custom lenses during his low-light taping. If restraint and elegance are hallmarks of his photographs, these qualities have been jettisoned here. Eggleston is, for the most part, behind the camera rather than onscreen but is often addressed in familiar terms, both fondly ('Egg!') and not-so ('You're an imposing asshole, Eggleston. A mirror would be better.').

Eggleston also captures memorable moments that do not seem to be portending catastrophe, such as the opening shots of Eggleston's children, Winston and Andra, quietly mugging for the camera; living room performances by the legendary blues musician Furry Lewis; the artist's cohort munching Krystal hamburgers to Muzak under the glare of fluorescent light; and convoluted conversations within

domestic interiors. A relative recorded close up to the camera – as almost everyone is – speaks with maternal tenderness: 'Bill, you're a mess. I can't wait for you to eat […] I don't know how you stand yourself all the time.' However, these are but mere interludes in the predominantly all-night-party style atmosphere.

A convincing portrait of Eggleston the artist may never be made in the form of a documentary film. *By The Ways* is certainly the more successful in that it exhibits awareness that the most meaningful import of the artist's work derives from his unconventional eye and not simply his personal idiosyncrasies. What we can ascertain from the recorded residue of Eggleston's actual ventures into the real world is that his own photographs are so much more lucid and evocative than any of these other glimpses, however fascinating, can manage to convey.

10

'Vaguely Stealthy Creatures': Max Kozloff on the Poetics of Street Photography (2002)

The critic Max Kozloff frequently reminds his readers of the inherent instability of meaning within the photographic medium. In an early essay (from 1964) he considers 'the aesthetic situation in photography to be extremely fluid. Alarmingly but justifiably, anything goes'.[75] To the great benefit of Kozloff's criticism, he does not eliminate the manifold ways of discussing photographs nor overly narrow his concerns. Instead, Kozloff manages to avoid the dead end of formalist dogmas in favour of conveying his own rapt attention in front of a wide, almost startlingly diverse range of material. It is one's acute awareness of Kozloff's own deep belief in the nearly limitless potential of photography that lingers after reading his essays. Kozloff explicates this belief most convincingly in a number of his essays on 'street photographers', among them Henri Cartier-Bresson, Robert Frank and William Klein. This essay focuses on such material in particular and several of the many issues and questions it raises, as well as discussing the deft manner in which Kozloff attempts to create verbal equivalents to the near-acrobatic visual images of these artists.

Kozloff repeatedly recognizes that it is just at the moment when a photograph verges on complete incoherence that its ability to provoke thought and convey beauty is much more profound in its implications. Street photographs are simultaneously random and precise, existing both as social documents and aesthetic treasures. Kozloff, in his on-going critical project, attempts to come to terms with what he has called the 'enigmas and illuminations of photography'.[76]

The opening passage of Kozloff's essay 'The Privileged Eye' states:

consider an action photograph in which one or a bunch of figures is on the move. No matter how visually explicit, its story content is moot. Because it's unnaturally congealed, the pictorial activity becomes literally equivocal in its drive or purposes.[77]

Kozloff proceeds to try to discover what might be at stake in such images, however equivocal, as they retain the ability to snare the viewer:

> [I]f their 'truth' quotient weren't so high, they could not deceive as indiscriminately as they often do. But if they were outright fictions they wouldn't grant me the privilege of feeling that I can hold the world, sporadically, in a set of miniature durations.[78]

With the particularly evocative image by Cartier-Bresson entitled *Alicante, Spain* (1932), Kozloff speaks of being propelled into a state of

> fruitful perplexity [...] here I am saying that not knowing, a decided lack of knowledge can become a value in itself [....] if there is any such thing as a revelation that does not explain its content, this is an example.[79]

Cartier-Bresson himself in his famous statement 'The Decisive Moment' of 1952, declared that:

> In photography there is a new kind of plasticity, product of the instantaneous lines made by movements of the subject. We work in unison with movement as though it were a presentiment of the way in which life itself unfolds. But inside movement there is one moment at which the elements in motion are in balance. Photography must seize upon this moment and hold immobile the equilibrium of it.[80]

For the street photographer, it is integral to the act of making photographs to be on the lookout, the search or the prowl, to be 'vaguely stealthy creatures'[81] in Kozloff's words. When Frank was no longer on the road, he soon had to move on to other approaches to photography in an act of reinvention of his process. It seems no accident that both Frank and his contemporary Klein turned toward film – motion pictures – to escape the more restricting aspects of still photography.

Kozloff uses a Baudelairean eloquence to recount a type of photographic practice that is characterized by its energetic emphasis on blur and grain, a kind of tortured and heavy-handed romanticism eked out through incremental fragments and shards. As he remarks on Klein: 'The world he depicts which has come apart – fissures everywhere and eruptions of crud – was for him a visual discovery.'[82]

The street photographer moves. This movement is the photographer's essential task, because the street, particularly that of New York City, is rarely static, and the watchful eye must stare, yet proceed to store thousands of glimpses. Some will be held up, magnified and singled out for attention later while others will line binders, file drawers, photo boxes, portfolios and remain hidden away. (Or, in

fact, in the case of Garry Winogrand, his late work amounted to several barrels full of unprocessed 35-mm film canisters.)

Photographer Joel Meyerowitz has remarked on the act of photographing:

It's like going out into the sea and letting the waves break over you. You feel the power of the sea. On the street each successive wave brings a whole new cast of characters. You take wave after wave, you bathe in it. There is something exciting about being in the crowd, in all that chance and change – it's tough out there – but if you can keep paying attention something will reveal itself – just a split second – and there's a crazy cockeyed picture![83]

Or in the recollection of Klein concerning his 1956 book *Life is Good & Good for You in New York*, 'The sub-title was, in further tabloid-speak, TRANCE WITNESS REVELS. In three words, all I had to say about photography, at least the kind I did then. Trance + Chance, Witness = Witness, Revels + Reveals.'[84] And of course these associations with photography summon Baudelaire's description of modernity itself as a manifestation of the 'transitory, fugitive and contingent'.[85]

Kozloff also rightly calls attention to the peripatetic nature of this photographic approach as in turn reflecting the ominous alienation of contemporary America, as he comments:

[Robert] Frank was taken correctly to say that there was no spiritual coming to rest in a place that mistook affluence and acquisitiveness for culture, that brutalized its minorities, and that threatened the world with its militarism. As for the joyless Americans themselves, they were imprisoned or dissociated by meaningless drudge work, or else they were uncentered roamers, like gypsies moving over a space incomprehensibly large to a European eye. As Frank saw them, they enjoyed a pointless mobility.[86]

In a certain sense, therefore, the roaming photographer merely mimics his mindlessly pacing subjects.

Several of Kozloff's most remarkable stretches of prose occur in his 1981 article 'William Klein and the Radioactive Fifties'. In Kozloff's haunting appraisal, Klein's images

are strangely noiseless but savage, memorable but not arresting. They give the impression of a bodiless life, other than our own, of societies not exactly alien to those we know or can remember, though they differ from them, as if they existed in a netherworld that corresponds only in its surfaces, not its substance, to the one that sustains us. The poignance of these visions issues from their insubstantiality, for the

longer our acquaintance with them the more they appear to transmute everything solid into shadows – until earthiness itself dissolves into little more than flickering light and shade.[87]

Again, the strength of this passage is in Kozloff's attempt to find a literary tone to match Klein's dark and bold, but often extremely subtle, imagery. The critic often can be imagined darting about, stabbing bits of stylish prose, sprinkled with references to modern art, though considering the breadth of Kozloff's knowledge, he wears his learning lightly.

The following significant issue is raised in the act of reading (and re-reading) Kozloff's work: where does the art historian leave off and the photography critic begin? This writer is of the opinion that the two roles can be merged and synthesized effectively, yet I also believe that critics can happily live in the land of undocumented hunches, intuitive leaps and literary flourishes. However, if all of these (non-)methods are applied to the act of writing scholarly history, one – as a critical reader – must be able to differentiate murky assumptions from clear evidence.

This problematic situation emerges in light of one of Kozloff's most recent and generally most cohesive attempts to record his thoughts on street photography in the exhibition catalogue *New York: Capital of Photography*.[88] Much of this text is a series of chapters on the relation between photographers working in the context of New York City. Photographers such as Frank, Klein, Evans and others are considered at length, but a final chapter mars the serious intentions of the previous five.

In the latter instalment, Kozloff tries to link a 'Jewish Sensibility' to the bulk of New York street photography. He has lately received some harsh criticism for this approach, including such epithets as simply 'pointless' and 'a pasteboard theory'.[89] I tend to think that advancing the idea that some photographic artists are intrinsically more perceptive than others due to their ethnic background is uncharacteristically misguided given Kozloff's own general inclination toward a more democratic and inclusive 'sensibility' when writing on photography.

Throughout his criticism, Kozloff has chosen to evoke and conjure rather than merely describe and dissect the images to which he refers. The structure of Kozloff's essays often involves a slow expository progression towards an intense rush of evocations, explanations and associations that are laid out in the hope of transferring to the reader a broader understanding of the work and related issues. Kozloff knows that the photographs he comments upon represent a precarious balancing act of formal experimentation, an approach that incorporates chance effects, and thereby does not rely only on the visible subject matter at hand. Kozloff, on Klein, writes: 'To describe the actual situations in his photos is to explain nothing about their capacity to move us.'[90]

So what is the crucial point of street photography? Why does it matter? From which of its many attributes emerges its often uncanny, strange and lasting power? In speaking of Frank and Klein, Kozloff writes of

[a] form of witness in which the whole of their perception is implied or evident in the single fugitive glance [....] they breathed the air about them, and their task was to find the means to invoke the effect of that air upon social behaviour.[91]

There is much at stake here for the analysis of the underrated genre of street photography. In these images, glimpses of concrete specificity launch us as viewers into a vertiginous zone of ambiguity. Photographic details, however sharply rendered, become mysterious clues to something always just out of reach. Kozloff recognizes that to lurk near the edge of chaos without succumbing to it can be an altogether pleasant sensation.

The practitioners of street photography coming into their own a generation after Cartier-Bresson's 'equilibrium' capitalized on the '*indecisive* moment' (author's emphasis). These images incorporating 'eruptions of crud' rather than the austere and elegant classicism of their predecessors became influential as well, often harbouring a cult status. Out-of-print books passed from hand to hand and enthusiastic word of mouth kept Frank and Klein and others from disappearing from view. Klein's *Life is Good & Good for You in New York*, however, was left unpublished in the United States for decades, after its initial cool reception by editors. He remarked later: 'Yecch, this isn't photography, they would say, this is shit. This isn't New York, too black, too one-sided, this is a slum. What else did they think New York was?.'[92]

Yet perhaps today we are viewing photography itself at the end of a certain formal and technological road. The decline and very nearly total demise of street photography was noted in a 1999 essay by the Mexican photographer Pedro Meyer, who when traveling on a Guggenheim Fellowship in the United States noticed:

The disappearance almost everywhere of any downtown life. Those parts of the city had become populated mostly by parking lots and empty streets, with whatever was left of 'life' taking place inside tall buildings. What used to be a bustling environment around commerce, had now been displaced towards the 'shopping mall' located in the suburbs. 'Street life' changed from being in a public – city – space to that of a private – corporate – one, the mall.[93]

Street photography is too often relegated to a mere 'genre' status and in this unfair appraisal the breadth of the approach is diminished and underestimated. In the

increasingly diversified photographic arena of the 1980s and 1990s, the achievements of the photographers inhabiting the street were frequently considered passé. If a newer, more analytical and post-conceptual approach was now favoured, it was also often sabotaged by a bloodless, didactic tone.

Much of Kozloff's best photographic criticism was written on the eve of the desktop computer revolution, the introduction of digital cameras and the tapering off of the art photography 'boom', with in its place the focus of the artworld shifting to all matters postmodern. Kozloff's critical approach becomes more contradictory when addressing more recent technology. He seems to derive great interest from images that challenge the fixity of meaning(s); the unsteadiness of photographs in more than one sense, in terms of both technical idiosyncrasy and as a record of a physiological spasm or tremor registering the forcefulness of life.

However, Kozloff is such a humanist critic that he holds little regard for postmodern relativist positions, becoming quickly exasperated with the dehumanizing potential of new digital technology – a somewhat ironic development, as he wrote beautifully earlier in his career about the Futurist movement:

> [F]or the first time we encounter truly revolutionary artists who were perfectly prepared to attack the bourgeoisie from the right as well as the left – a cardinal reason why they are still so disturbing today. They conceived all politics as vengeance, just as they looked upon all media as interchangeable.[94]

Once the veracity of the photograph as indexical record is challenged by its new virtual malleability, the photograph simply becomes a media image/product, seemingly corroding the very essence of photography as Kozloff sees, interprets and believes in it. Potential is squandered, as the use of chance effects by an intelligent witness becomes instead a dumb series of increasingly randomized options.

Kozloff described the importance of his use of the term 'witness' in an interview from 1981, in which he stated that

> [i]n the medium of photography, just as in any other communicative utterance, a statement cannot be made without filtering it through the interests of the maker. That's why I like to use the word witness when referring to a photograph, because it describes a complex role without being tendentious. The word conveys the idea that some conscious party or agency was at a scene and can give an account of events, but it doesn't say anything about the reliability of that account. Those who did not witness an event can learn something about it from those who did.[95]

The historic street photographer is typically closemouthed, uncomfortable to hostile regarding any surrounding discourse. Many of these photographers

have made eminently quotable statements, statements that remain insightful fragments, agitated outbursts and flippant conceits. Winogrand's statement 'I photograph to find out what something will look like photographed' leads us about as far as Frank Stella's (almost contemporaneous) 'What you see is what you see'.

Both the act and the result of the street photographer's craft resist most attempts to analyze them closely, much as a jazz musician's improvisation or an abstractionist's splatter. The fact that they tend to deflect commentary has not prevented a prodigious amount of photographers, critics and historians from having their say. But this also becomes a peculiar dance. As Susan Sontag has written:

> The camera makes reality atomic, manageable, and opaque. It is a view of the world which denies interconnectedness, continuity, but which confers on each moment the character of a mystery [....] Photographs, which cannot themselves explain anything are inexhaustible invitations to deduction, speculation, and fantasy.[96]

Critics circle about these alluring specimens trying to piece together arguments and assertions that frequently refer to the oblique, confounding and mysterious nature of photographic imagery and remain necessarily inconclusive.

The general tone of the work that most often attracts Kozloff's attention is one of lament, melancholy and dread, which he, with the vibrancy of his criticism, transforms into life-affirming, positive statements. Ultimately, Kozloff is attracted to artists who care. He speaks of the 'convulsive empathy' evident in Larry Fink's startling society tableaux, and when he writes on Larry Clark, for example, Kozloff characterizes his work as exemplifying a

> brutality of vision. A recognition of the harshness and lawlessness running underneath an otherwise humdrum social surface is almost a staple of our culture. It's impossible not to be drawn to it even as it leaves you in the moral lurch. [...] it is to acknowledge the deep flaws in our psychic environment – our moral quandaries, our feckless alienation – that have hindered photographers from joining heart and mind to make a fuller art. The more they internalize the strains of our historical moment, the more convincingly they reproduce those flaws.[97]

For Kozloff, the search for meaningful ways to write about the photographic medium has been a quest in turn towards his own self-definition as a critic. Very few critics have paid as much extended attention to photography and its significance over the past quarter century. Perhaps Kozloff's circuitous, meandering path in and around photography could be summed up via a quotation from one

of the artists he has repeatedly championed, Robert Frank, who in a 1958 statement wrote the following:

> I have been frequently accused of deliberately twisting subject matter to my point of view. Above all, I know that life for a photographer cannot be a matter of indifference. Opinion often consists of a kind of criticism. But criticism can come out of love. It is important to see what is invisible to others – perhaps the look of hope or the look of sadness. Also it is always the instantaneous reaction to oneself that produces a photograph.[98]

To read Kozloff's work is to discover many things, and perhaps most significantly to be reminded that both aesthetics and politics can be engaged simultaneously within serious criticism of photography, and with great subtlety and sensitivity to language.[99]

11

Vantage Points and Vanishing Spaces:
Ann Shelton (2008)

Artist Ann Shelton's new series *Room Room* consistently uses the circular pictorial format, which can be linked by association to an aperture, convex mirror, fisheye, keyhole, peephole, porthole or vignette. Shelton thus incorporates a wilful distortion that calls attention to the image as a concerted representation. In recent years, Shelton has created images that she subsequently installed in diptych format, thereby allowing her photographs to address complex notions of doubling and reflection. In her use of this technique of display, available vantage points become manifold, and reversed images reiterate how artificial (and artful) any specific grouping of images is bound to be. Shelton does not attempt to create a portrait of naturalized vision, but instead – and more intriguingly – builds her works as strategic, layered constructions.

In the works which comprise *Room Room*, the initial image becomes a mere starting point for various procedural effects. Here Shelton has used a 4 × 5" large format view camera. A film negative of this size records even minute details with stark clarity, but after this initial stage, Shelton chose to use digital technology in order to create the convex distortion and circular shape of the final images. By using the convex form, recalling the Claude glass (or mirror), an optical tool used primarily by painters, Shelton aligns her own contextualization of this particular set of twenty images with the historical framing of vision (Figure 11.1).

Art historian Arnaud Maillet in his lively and detailed study of the 'Claude' or 'black' mirror (named after the French landscape painter Claude Lorrain) writes that:

[A] view reduced in the Claude mirror is transformed into an ideal view, that is, one with a universal character. The Claude mirror eliminates certain details and imperfections. This removal of triviality brings forth an abstraction, that of ideal beauty. The mirror allows one to select and combine different elements, which the reflection presents as a unity.[100]

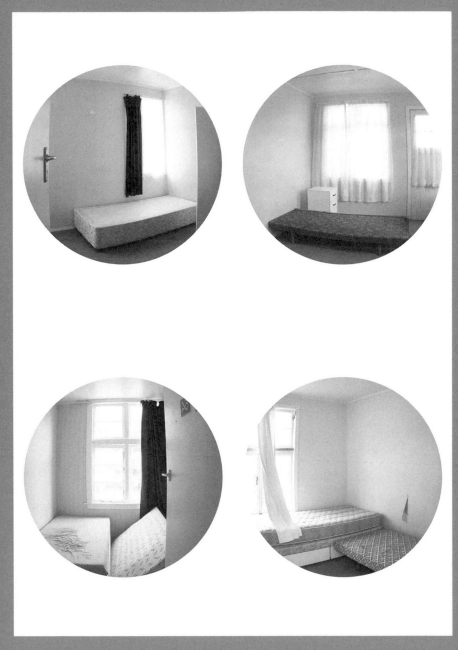

FIGURE 11.1: Ann Shelton, *Phoenix block, room # unknown [pink wallpaper]*, 2008, C type print 84 × 119 cm². *Phoenix block, room # unknown [blue bed]*, 2008, C type print 84 × 119 cm². *Phoenix block, room #54*, 2008, C type print 84 × 119 cm². *Phoenix block, room # unknown [yellow walls]*, 2008, C type print 84 × 119 cm². Titles – Top to bottom/left to right. Courtesy of the artist.

From the nineteenth-century Romantic poet Coleridge to the twenty-first century pop band Arcade Fire, the black mirror has been referenced and enthused upon for its evocative and poetic qualities.

Although Shelton's photographs are often lushly beautiful in a relatively conventional manner, they are then put to use within a conceptual apparatus that betrays her scepticism and criticality of received ideas, including photographic conventions in particular. Photography by its intrinsic qualities – which can now be stretched and reconstituted in so many respects due to digital technologies – necessarily involves a distancing from any original context. Photography indexes and records the camera/photographer's viewpoint, thus implicating the eventual spectator as a witness. The evidentiary quality of the medium presents to the viewer records which may appear to consecrate truthfulness on one or several levels. To instead confound photography's claims to veracity by emphasizing its malleability and receptivity to creative manipulations is a highly significant aspect of Shelton's practice.

Furthermore, Shelton's artistic approach has been defined in large part by its incorporation of contradictory aspects, for example: recording images of partying revellers and the subsequent debris as an intimate photo album (*Redeye*, 1994); 'retakes' of film locations as undisturbed, quietist landscapes (*A Kind of Sleep*, 2004); or recording an obsessively customized personal library in a minimalist photo installation (*a library to scale*, 2006). Interestingly, the consideration of the disinhabited exterior landscape is one of Shelton's most predominant creative devices, and in the current series, the views are all of interiors and seem to allude to interiority in its psychic sense as well.

Here Shelton has transformed what were once intimate spaces into more public documents, which nonetheless maintain a stillness and quietude that acts as a poetic lure to the spectator. They are also on their way to becoming the sole vestigial evidence of a site that has disappeared. As Roland Barthes once evocatively remarked:

> Each reading of a photo, and there are billions worldwide in a day, each perception and reading of a photo is implicitly, in a repressed manner, a contact with what has ceased to exist, a contact with death. I think that is the way to approach the photographic enigma, at least that is how I experience photography: as a fascinating and funereal enigma.[101]

Although in this instance Shelton's enigmatic pictures, one might say, are documents despite their artistry, and artworks despite their status as records.

By photographing a now-abandoned site – a residential treatment centre for drug and alcohol dependency on Rotoroa Island in the Hauraki Gulf[102] – Shelton

interweaves considerations of how the divide between nature and culture has been perceived, then and now. To isolate a group of individual citizens in the act of recovery, recuperation and convalescence with the intention of fostering their later emergence, Phoenix-like (the very name of the building photographed here refers to that mythological creature) from that process reflects a modern notion of enlisting quarantine and captivity for the greater public good. Today these assumptions are problematized, and metaphorically effaced and revised by the act of demolishing the structure itself. Perhaps this becomes even more evident with the current transformation of the island itself into a conservation area: an entirely different type of sanctuary.

Reclamation of such extant sites and subsequent transformation of their use is not uncommon today and has occurred at various locations in Aotearoa New Zealand, a nation in which both the restoration and the protection of its natural areas and addressing of Māori land claims via the Waitangi Tribunal are on-going concerns. Very often such 'reclaimed' sites were originally industrial in purpose, including gasworks, mines and landfills. Shelton's chosen site itself enacts a type of doubling, or mirroring, as it can be considered to be simply a number of points, within a small, isolated island, almost unnoticed in its location off the coast of New Zealand, itself often referred to as an isolated faraway place, differentiated and categorized by its separateness.

By using this site almost as if a theatrical set or cinematic location, Shelton makes the act of picturing plainly apparent.[103] Each photograph depicting a room in one of the buildings of the now defunct centre records in detail an inventory of such prosaic details as carpeting, panelling, light switches, door handles, moulding, windows, curtains, stripped beds, electric radiators, chests of drawers, tables, chairs and desks. Although recorded in Shelton's elegant and exacting fashion, all this clarity spawns both ambiguity and ambivalence. What exactly are we gaining the privilege to see? What might have occurred in these rooms now stripped of all but cursory reminders of their previous inhabitants?

In Shelton's portrayal, we are to a degree on a walking tour that becomes eerie and mysterious. The rooms are haunted spaces insofar as they act as quiet representations in which voices of occupants have gone missing, vanished. As viewers of these representations, we reach for associative links, both symbolically and iconographically. Is a door handle a cross? What is the use of light and its halo effect doing in most of these images? As the rooms are emptied and nearly indistinguishable, one seeks out differences: marks on walls, floors, ceilings, a picture left hanging in place, a curtain blowing in the breeze.

Shelton's images enact a type of serial repetition, although each image is markedly different. In staring at her images, we become confrontational. But one might say with whom or what? In fact, Shelton is in conversation with the realm of

a photographic (rather than actual) reality in which the light from a window seems to shine back with a disarming directness. Moreover, the rounded edge of the frame anthropomorphically seduces the viewer, with its organicism, contradicting the geometric perpendicular axes of the interior spaces.

By concerning herself with charged historical sites and their abandonment, Shelton's approach strikes an accord with other recent works dealing with temporality, memory and historical events especially via representations and actions that re-enact and reinterpret the past. These include works by Tacita Dean, Jeremy Deller, Thomas Demand, Mark Dion, Cornelia Parker, Simon Starling and Luc Tuymans. Notably most of the artists I've mentioned above use photography to some degree, even the painter Tuymans who often works from (and comments on) photographs. This is not purely accidental one might conclude, as the indexical nature of the photographic medium records and collates the imprint of history more effectively than any other competitor.

One of Shelton's undeniable strengths is to photograph with such startling acuity and directness that she bypasses melancholy, nostalgia and sentiment, in favour of a clearer – one might say cooler – point of view, leaving the spectator to draw specific conclusions of her own. Shelton's demonstrated skill in engaging with re-enactments, retracing steps and plotting new coordinates to negotiate past events is not without its significant prehistory. As a former newspaper photographer her journalistic instincts have not disappeared, but they have been transposed contextually and in addition gained in complexity and nuance.

Again, by the certain, unwavering gaze we become privy to, as spectators we inhabit a normative viewpoint, almost as authority/clinician, once removed through the gaze of the artist/documentarian/photographer. But the subjects once observed in these environments are now gone, and by reiterating the mode of entering into and creating an inventory of this place, Shelton enacts a postmodern response to this modern institution. Photography becomes not only a descriptive mechanism, but a means of analyzing and dissecting standard vantage points. By reinscribing the gaze of the 'powerful' – the camera-eye lends privilege to any human-eye – once the 'powerless' have left, Shelton interrogates how the gaze functions and operates.

If we think however of the cone of vision set out and demarcated in Euclidian geometry and later developments such as Brunelleschi's perspectival schema, and broadly speaking, the historical ordering and codification of vision in Western culture, this was concurrent with the invention of myriad tools, prostheses and mechanisms for recording imagery which in turn involved mirroring, doubling, repetition and projection. Philosophers, psychoanalysts and theorists of the twentieth-century have critiqued the gaze with intensive scrutiny.[104] Although here recalling the notion of the diegetic space – that which exists outside of the camera's

rectilinear frame – we are often intrigued in Shelton's images by what is *not* on display, *not* accessible to us and *not* immediately apparent.

The characters in this now-historical situation have left the stage, yet Shelton is front and centre to record their aftereffects and reverberations. What residual tremors are perceptible to the camera eye? How might we better understand the subtle resonance of these circular, constricted pictures of claustrophobic and peculiar cells? What can we see when the image becomes impenetrable to extracting specific meanings? Perhaps most significantly we can use Ann Shelton's compelling images as newly configured sites to assist us in generating our own conceptions and speculations.

12

Imagined Landscapes and Subterranean Simulacra (2011)

An Expanding Subterra
Wayne Barrar
Dunedin Public Art Gallery, 2010

Ice Blink
Anne Noble
Clouds, 2011

Along with its disproportionate impact in various cultural fields, from sports and cinema to music, Aotearoa New Zealand has also provided a distinctive context for fine art photography. Two recently published books by Anne Noble and Wayne Barrar strongly support this thesis. Both volumes serve as richly evocative records of longstanding photographic investigations by these increasingly renowned artists. Noble's *Ice Blink* is the first of a projected trilogy recording her research on Antarctica, both as a specific, actual geographic site, and as a historically romanticized territory of the imagination. Barrar's *An Expanding Subterra* is the lavishly illustrated catalogue of the travelling exhibition of the same name originally shown at the Dunedin Public Art Gallery.

Both artists approach their respective material with highly intriguing notions in mind. Noble has travelled to Antarctica and resided alongside other artists, writers and scientists as she sought out poetic resonances in its immense (and immensely challenging) environment. In the case of *Ice Blink*, Noble chiefly elucidates what she has termed 'the Antarctic imaginary' as represented in simulacral forms, offering up a vividly captivating procession of painted icebergs, play areas and puzzles photographed at museums and visitor centres. In this revelatory chronicle, dioramas attempting to subdue the sublime compete with fanciful tourist photo ops and aquarium penguin feedings. Despite the artificial settings in which most of Noble's images were taken, her skill as a photographer is to derive truths from at times utterly outrageous replications and re-enactments (Figure 12.1).

81

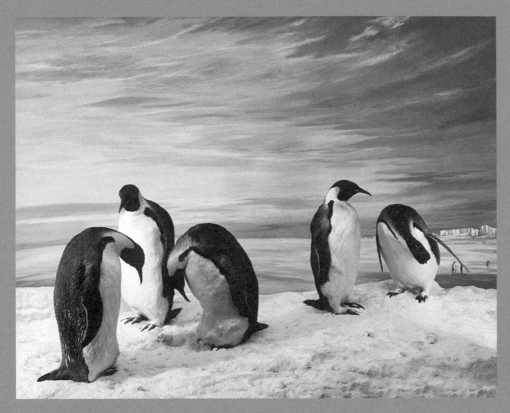

FIGURE 12.1: Anne Noble, *Emperor Penguins, Antarctic diorama*, Canterbury Museum, Christchurch, New Zealand, 2004, photograph. © 2021 Anne Noble. Courtesy of the artist.

According to Noble, '"Ice Blink" is a nautical term indicating the presence or absence of ice a long way off and refers in this exhibition also to the act of viewing photography.'[105] Writer (and current New Zealand Poet Laureate) Ian Wedde contributes an interpretative essay lucidly unpacking Noble's project and terminology:

> Noble is working with the Ice Blink's tension between seeing and not seeing, understanding and not understanding, imagining or not, and she invites us to risk ourselves there and, perhaps, discover the new language needed to describe our voyage of discovery.[106]

And to a large extent, Noble's project involves an act of *re*discovery, revising our received notional imagery of a place that to most of us is entirely imaginary in terms of first-hand experience. As she writes,

> When we look at Antarctica, from a deck of a ship, or in a make-believe tableau, and fix it in our gaze, what we see is a figment of the imagination. The sight we encounter is a sight already seen, image upon image fixed in the shadow of our dreaming by the medium of photography itself.[107]

Opening *Ice Blink*, handsomely designed by Warren Olds, throws the reader immediately into the midst of Noble's images (one must wait until the closing section of the book for revealing captions), Wedde's text, and a brief framing comment by the artist. In this way, the traditional schema of the catalogue, with textual material as a lead-in to the work, is upended. Noble's photographs elicit our close attention, constructing a narrative of sorts, with their allusive visual puns and rhymes, and subtle uses of colour.

Throughout his series *An Expanding Subterra*, Barrar takes the reader on a remarkable trip into various subterranean enclaves, from Australian mines to American office parks and a New Zealand power station. The colour images are rich in incident and telling detail, recording the lived-in (and/or worked-in) traces of these eerie spaces: a break room for miners; a teenager's bedroom in an underground house, adorned with a Limp Bizkit poster and a drum kit; '*NO SPITTING ALLOWED*' scrawled on a First World War-era tunnel dug by New Zealand soldiers while stationed in France. So much unseen activity has clearly occurred, although generally Barrar portrays its residual signs and traces rather than any inhabitants themselves. Barrar's background is as a landscape photographer and he treats the landscape, and our unnatural ongoing cultural incursions into it, with great sensitivity and near-clinical specificity. Barrar acts as a private investigator/ tour guide, remarkably 'at home' in these uncanny and disparate sites, lending them a peculiar consistency with his unwavering gaze (Figure 12.2).

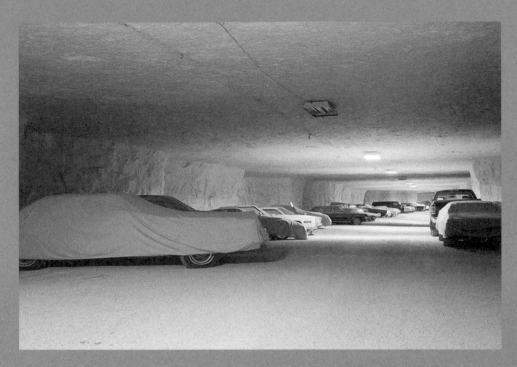

FIGURE 12.2: Wayne Barrar, *Vehicle Storage, Brady's Bend*, Pennsylvania, USA 2006, photograph. © 2021 Wayne Barrar. Courtesy of the artist.

Cultural historian and American University Professor David L Pike, who has written extensively on such underground spaces, deftly contextualizes the historical background of Barrar's imagery with wide-ranging references: 'Paradoxically, for all its imaginative tortures, Dante's hell is the first represented subterranean space in which one can actually imagine "living"'. For a – comparatively speaking – more modern photographic lineage, he summons Nadar's depictions of the Paris catacombs or Timothy O'Sullivan's images of miners. As Pike perceptively notes:

> The most commonly repeated motif in Barrar's photos – the unevenly undulating rough-hewn excavated wall or ceiling amidst the familiar accoutrements of aboveground life – is practically unique in photography of subterra. He does not present the new underground in all of its hermetically sealed fantasy, but neither does he portray it as returned to organic nature.[108]

This speaks to Barrar's strengths as photographer. The exhibition's curator, Aaron Kreisler, cites the late New Zealand environmentalist and writer Geoff Park, who wrote compellingly of Barrar's work in the 2001 catalogue *Shifting Nature*:

> [T]here is such a thing as 'a Wayne Barrar photograph', and it is commonly a landscape image. It has a sense of beauty too, if with a disturbing edge. We don't need people-in-the-landscape to discern that it's not nature that he's pointing the camera at – it's us at work on her, harnessing her power and being summarily humbled.[109]

In the cases of both Barrar and Noble, what becomes truly interesting is the care and patient attention they pay to their often extreme and seemingly strange material, never using cheap surrealism or juxtaposition, but entering situations with tremendous curiosity and attentiveness to the small moments that must be noticed – the very moments that remain crucial to creating a significant photographic image.

13

Gregory Crewdson:
In a Lonely Place (2013)

City Gallery, Wellington

The American photographer Gregory Crewdson not unlike many extraordinarily successful artists, mostly does one thing, and he does that one thing extremely well: large-scale colour photographs which offer stylized depictions of creepily gothic Americana. His neo-Noir imagery owes a huge debt to the classic Hollywood concoctions of directors Nicholas Ray (Crewdson even appropriates the title of Ray's 1950 Humphrey Bogart thriller *In a Lonely Place* for this exhibition) and Alfred Hitchcock, but also carries a strong whiff of David Lynch and Steven Spielberg-style fantasies. Crewdson, in his *Beneath the Roses* series (2003–08), which serves as the centrepiece for the current exhibition, worked in various smaller towns and cities in New England almost as a Hollywood director himself, with large crews assisting him in the production process. Towns like Rutland, Vermont and Pittsfield, Massachusetts stand in for a dreamlike and dishearteningly alienated anywhere, USA (Figure 13.1).

Crewdson fixates upon the toxicity of suburban contexts, but simultaneously monumentalizes them. He keeps them unreal, difficult to grasp, cinematic rather than close to hand. While Crewdson's photographs are painstaking constructed and often highly atmospheric, they can also seem cold, remote and lifeless. An overdose of dark postmodern irony and pastiche lingers in Crewdson's images, like some grandchild of illustrator Norman Rockwell after an especially bad acid trip. One of the more disturbing aspects of Crewdson's work is his treatment of people, who become as objectified as their surroundings. This is particularly the case in his unsympathetic representations of women: weary or waiflike, seemingly strange and totemic ciphers. It is rather ambiguous whether these images are specifically misogynistic or broadly misanthropic.

Despite these qualms, there are some unquestionably striking images here. Crewdson's stated desire to photograph at twilight occasionally lends warmth that is otherwise in short supply. A group of teenagers wander along

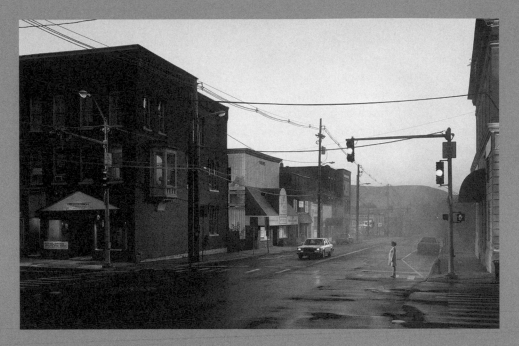

FIGURE 13.1: Gregory Crewdson, *Untitled*, 2003, Digital chromogenic print, Framed: 64 1/4 × 94 1/3 inches (163.2 × 239.4 cm²) Edition of 6 + 2 AP. © Gregory Crewdson. Courtesy Gagosian.

a railroad track, a woman gazes from a second-floor balcony of a house on a dead-end street, a red-haired girl sits on a swing, flanked by mobile homes, her appearance recalling the painter Andrew Wyeth's auburn muse Helga. I prefer Crewdson's quieter attempts like these, as when he pours on the pathos, he frequently misses the mark, veering towards a more lurid voyeurism. Although Crewdson draws much of his influence from cinema, by working with singular still images, he provides anecdotal glimpses rather than compelling insights or extended narratives. His images hinge on his lavish detailing of the old-school everyday: hotel rooms, corner diners, tattoo parlours, hair salons and porch swings.

And while Crewdson may have his issues with people, he does betray an evident fascination with the camera eye: how it sees, how it functions and how it manipulates reality. So it is that in the two additional series on view, *Fireflies* (1996) and *Sanctuary* (2009), in which people are (almost) absent, Crewdson gives himself over to his obsessive gaze in – I would argue – a much less problematic way. In the more recent *Sanctuary* works, Crewdson took as his subject the partially dilapidated film sets of the Italian film studio Cinecittà, founded by Mussolini and renowned for its close association with the director Federico Fellini. These monochromatic images are rich with silvery middle tones befitting their haunting tribute to the cinematic past. In *Fireflies*, an earlier suite of thirteen smaller black and white works, Crewdson recorded the trajectories of fireflies in fading light. Here the artist registered something that is perhaps less overtly dramatic than in his colour images but ultimately more evocative, subtler and revealing.

14

On Taryn Simon's 2007 series
An American Index of the
Hidden and Unfamiliar (2010)

Dunedin Public Art Gallery

I feel almost comfortable with the photographs of Taryn Simon. And of course, this is a rather disturbing thing to acknowledge as Simon spends much of her time acting as a kind of pictorial private detective who aims to depict extremely uncomfortable, hidden, alienating and institutional places via her meticulously researched and crafted images. But then again, I am an American and these sites however particularly and sometimes astonishingly chosen seem to be altogether emblematic and characteristic ones for my rather disunited homeland. I would like to think that these would have a much less familiar and more eerie quality to many people, particularly those not so accustomed to US Surrealism on a first-hand basis.

One could perhaps cite Sigmund Freud's term 'the uncanny' which literally translated from the original German (*Unheimlich*) means 'not homely', and I would concur ultimately that Simon's pictures are quite un-homely in many respects, although at the same time, they serve with pinpoint accuracy as evocative and telling representations of little-advertised aspects of the American cultural environment, the sort of topics that meanwhile seem to overpopulate those 'only in America' or 'there go those mad Americans again' sidebar stories so frequently found in international newspapers.

The artist Andy Warhol once said to know all there is to know about me just look at the surface, that's all there is – and so it is with Taryn Simon's chosen medium, and the medium Warhol used in historic fashion to transfer into the context of painting such archetypal American horrors as the electric chair, race riots, automobile accidents and the aftermath of the Kennedy assassination. Surfaces may be initially off-putting or reassuring, but often act to hide or veil other information difficult to directly represent. Such surfaces can help distance us from intimations of the acts of corruption, manipulation

and violence that are common undercurrents of each new wave of American culture.

Simon herself has remarked:

> Reality has always been interpreted through layers of manipulation, abstraction, and intervention. But now, it is very much on the surface. I like this honesty about its dishonesty. Every photograph has many truths and none. Photographs are ambiguous, no matter how seemingly scientific they appear to be. They are always subject to an uncontrollable context.[110]

So much is always hidden in American society, just think of all the ubiquitous and secretive acronyms such as FBI, CIA and the likely less familiar ICE, the office of US Immigration and Customs Enforcement. Thinking a few years back, there were the attempts by George W Bush's government to establish a clandestine US Bureau of misinformation, or the frequent reports of officials such as then-Vice President Dick Cheney being transported to an 'undisclosed location', for fear of terrorist attacks. More recently the publishing of the news that circumstances around the prisoners who had taken their own lives at Guantanamo Bay was suppressed under President Obama's watch. And so it goes, as another great writer on American conspiracies the late Kurt Vonnegut would say (Figure 14.1).

All this goes to show that Taryn Simon's photographs aren't necessarily just some quasi-photojournalism for the art crowd, losing their relevance with time. Instead, her images tease out the ongoing and seemingly ever-present strangeness and dissonances that aren't going away anytime soon. Simon's photographs are simultaneously historically grounded and up to the minute in their relevance.

Although many photographers come to mind when I gaze at these images, I am also cognizant of the connections Simon's work has with other contemporary artists of the last several years, including Luc Tuymans, Thomas Demand, and Jane and Louise Wilson. Notably, all of these artists are European, and don't make straightforward photographic images, but images nonetheless closely related to photojournalism and historical documentation. For example, Tuymans paints a portrait of Condoleezza Rice as if seen from a television or computer screen, Thomas Demand makes intricate sculptural constructions of rarely seen sites that could be called significant in some way, such as here a location for recounting the disputed ballots in the 2000 Bush-Gore Presidential election, or Jane and Louise Wilson, who work as a collaborative team and often scrutinize now-disused bunkers, subterranean enclaves and secret headquarters, such as that of the 'Stasi', or East German police.

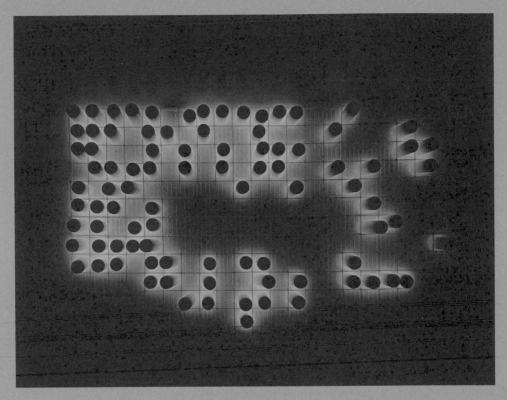

FIGURE 14.1: Taryn Simon, 'Nuclear Waste Encapsulation and Storage Facility, Cherenkov Radiation Hanford Site, U.S. Department of Energy Southeastern Washington State', from the series *An American Index of the Hidden and Unfamiliar*, 2007, chromogenic colour print. © Taryn Simon. Courtesy of Gagosian.

Taryn Simon commented in an interview with photo-historian Geoffrey Batchen:

> I prefer to have people continually re-define what [photography] is and may be. Identifying genres in photographic practice often involves a commitment to traditional thinking. Current generations are no longer working in such clear forms [in any domain]. Everything is very quickly becoming interdisciplinary. People are continually trying to place the work in a comfortable envelope and are often confounded by what envelope that may be. It bridges a number of long-established definitions: documentary, political, and conceptual. I prefer that it float between and in and out of everything.[111]

Maybe so, but I would argue that Simon's practice certainly does not float freely from a constellation of photographic antecedents and contextual referents, and some of the examples brought to mind include Robert Frank's road tripping through mid-1950s America uncovering many things considered to be off-limits in the mainstream photographic press, or the direct, unyielding gaze of Frank's most significant influence, the great Walker Evans. Evans has often been portrayed as a cold, methodical practitioner, but his approach lends a particular rigour and eloquence to his matter-of-fact, utterly direct images.

Simon's approach bears a marked resemblance to Evans as she states:

> In confronting loaded subject matter, I often choose to avoid any editorialized, spoon-fed emotion or angle. By doing so, my personal distance from the subject is built into the audience's experience of engaging with the photograph. I'm avoiding a stance of 'understanding' or of having knowledge that others don't have. It says: 'Here it is, and I don't really know.' In my own work, I avoid that which claims to have a closeness with its subject.[112]

I am also thinking about William Eggleston's many photographic bodies of work from the 1960s to now, peering closely around into the many nooks and crannies of the vernacular, camouflaging nothing. America warts and all was never so alluring and striking in its colour and atmospheric shading. When Eggleston was once asked if he could have had the opportunity to photograph Hitler's bunker, he said he'd be curious to see what was inside the rubbish bin.

The North American continent in its vast panoramic scope is impossible to contend with visually except in small doses even if one wants to somehow account for it all in a representation, such as in the genres of the road movie or the travelogue, and of course in such formidable bodies of modern and contemporary photography as Walker Evans' *American Photographs*, Robert Frank's

The Americans, or Stephen Shore's *American Surfaces*. I also think of other anecdotal examples, one being that of playwright and actor Sam Shepard, who regularly travels across the United States in a car as a way of thinking, grounding himself, taking it all in, so to speak or the British songwriter Ray Davies, famous as the singer of the Kinks, who spoke once of how the United States seemed to harbour so many possibilities as it was a place that if one was completely desperate, one could steal some money and a car, and drive across that vast expanse without stopping. Certainly, he made this comment rather ironically and romantically and in stark contrast to the geographic limitations of any similar gestures taking place in the British Isles.

In many respects, the more one wants to indulge in the scopophiliac impulse in the good old United States of A, the more one is thwarted, by one more generic fast-food franchise, strip mall or the clichés recycled yet again from film, TV, etc. Photography remains one of the last holdouts to potentially challenge the hegemony of many other kinds of imagery, as an interference and interruption. The best photographs can deliver an impact that cuts through our massive indifference if only slightly, sporadically and momentarily. As viewers, we can confront otherness with the hope of realizing that this otherness is more part of us than we previously assumed. The best photographs offer up an opportunity to challenge our complicity with and acceptance of business as usual.

15

On the Recent Photographs
of Simon Mark (2010)

*Stare. It is the way to educate your eye, and more. Stare, pry,
listen, eavesdrop. Die knowing something. You are not here long.*
—Walker Evans[113]

What is the ordinary anyway? When is it that the everyday and mundane gets
ratcheted up a few notches to become memorable and noteworthy? Very often
it's the case when a mere glance becomes a lingering stare and that process
leads to an intensified reading of a site, locale and terrain. The role the camera
can play in recording this rapt attention is crucial. Given such a prospective
trajectory, the photographer, in this specific instance, New Zealand artist Simon
Mark, is able to offer up subtle glimpses and shadings delineating the other-
wise overlooked, what the photographer Nathan Lyons once termed 'notations
in passing'.

In Mark's approach, a bold graphic awareness competes with his acute, paint-
erly use of colour to lure us in, in a thoroughly captivating stylistic manner,
although without entirely revealing his chosen subject matter. That is to say, the
photographs presented here by Mark are highly refined and for the most part,
abstractions drawn from everyday things. Gratings, railings, barriers, crossbars,
nurseries, harbours: urban non-events become something more, both fantastically
generative and poetically allusive.

To convey any sense of mystery in such a manifestly literal medium as
photography is a tall order, but Mark is up to the task, repeatedly focus-
ing in closely or taking an intentional step to the side, lending an oblique,
indirect quality to his images, in contrast with his very simple technique,
refraining from reliance upon extensive software as virtual aids to the
creative imagination. Mark instead takes his pictures to a great degree as
tourists do their snapshots, but without seeking to replicate the utterly
clichéd yet picturesque views that clog most everyone's holiday scrapbooks
(Figure 15.1).

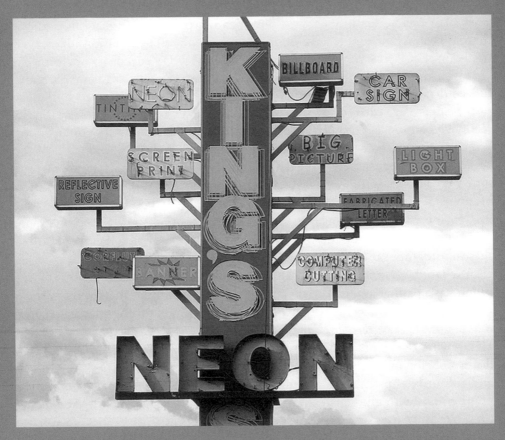

FIGURE 15.1: Simon Mark, *Kings Neon*, Fiji, 2008, digital photograph. © Simon Mark.
Courtesy of the artist.

It is of course terribly easy to pontificate at length and generalize about 'photography' full stop. (I have done so on more than one occasion.) However, the point that is missed with such statements is the very specificity and unusual character of any given image. In an era of mass production, dissemination and indeed dematerialization of imagery, an artist's eye well accustomed to the use of the camera eye can still retrieve memorable and engaging results drawn from seemingly random perambulations. This is still quite remarkable if so often underestimated.

I am struck repeatedly by the details of Mark's images but also often thrown into a vertiginous state by the reverberating patterns and colours that make my decoding of his sources go slightly awry. My detours as a (mis-)reader of the image hold their own fascination as I try to work out the context, the space, the framing.

I enjoy a revealing comment Mark has made about his work in the past: 'All of these photographs picture real objects in the real world; however, it is never quite clear what object, and which world it occupies.'[114] Mark has a substantive background as a painter and while I do not want to overdetermine that aspect of these rich images, let's just say that there is a considerable elegance and formal beauty that could easily be termed 'painterly'. This is largely in terms of Mark's shared affinity with the clarity and exactitude of Modernist abstraction. There is also a discernible joyousness and subtle lyricism, much as in the works by the gestural and colour-field painters of the mid twentieth century. Nonetheless, these *are* photographs with all their related significations as indexical records of existing sites, but Mark uses such sites solely as the points of entry for a series of carefully chosen and deftly interwoven visual images.

Mark's own experiences as a seasoned international traveller haven't dulled his curiosity and belief in strolling in new and unfamiliar environments to learn what they can reveal, quite apart from the pragmatic aspects of navigation. Mark's photographic images pay close attention to detail, incorporating an aesthete's joy in finding patterns, colour associations and formal links from one unlike place to the next. Whether in continental Europe, the Pacific Islands or in Upper Hutt, New Zealand, Mark's images have a lucid consistency and integrity, characterizing a very particular vision, both keyed into faraway places and associations, and on this occasion, bringing it all back home.

16

Talking Around (and Around)
Yvonne Todd (2012)

Some photographs scare me. Not only the ones that are blatantly, indisputably frightening, such as glimpses of horrific atrocities, crimes and disasters but those that are troubling in their implications, allusions and for what is not directly portrayed. Corporate photography has had that troubling quality for me, the depictions that glare out at you from lightboxes in airports and bus stops and other rather generic and transitory (non-)spaces. Similarly with some of the photographs of artist Yvonne Todd, I discover that they can occupy a status that seeks to be seductive and disturbing, ambiguous yet threatening and ultimately perplexing and compelling.

I would like to present a series of observations in which metonymically, we can perhaps treat the component parts and facets of Todd's work as a way towards grasping the tremendously elusive whole. And in thinking of Todd's various photographs and series I have the feeling of a kind of whirlwind tour of ancient and current pop culture, amalgamated into stranger, densely refracted patterns, as if looking at one's reflection in some crumpled up glittery wrapping paper. And the notion of artifice and surface is crucial, if Andy Warhol once stated that all one needed to know about him lay on the surface, Todd's work is a kind of skimming over synchronous yet dissimilar repositories of cultural knowledge.

Many of Todd's photographs feature models offering a seemingly affectless gaze, garbed in rather antiquated and antiseptic clothing. Wigs are ubiquitous along with many other types of prop. Much as in the photographic lexicon of wholesale catalogues, corporate reports and the traditional school portrait, the atmosphere is cool and deceptively calm. In choreographing and reconfiguring these types of images, Todd offers an alternative reading of the photographic tropes visible in most everyone's salon, wallet, bedroom, office desk.

It's difficult not to allow Todd's microcosmic universe to summon associative links with all manner of cultural artefact-oids. Perhaps this is due to the fact that despite a seemingly strict internal consistency to the manner in which her photographs are created, they take their inspiration from a wide-ranging circuit of

once-popular phenomena. The artist herself has noted her avowed interest in 'the irrelevant and obscure' as well as 'the pathetic'. When Todd reaches toward the past it is often a de-familiarized, not entirely welcoming place, characterized by uncanny intersections that remain brittle, fierce, spiky. It's perhaps also because the very constructed and spooky veneer of the photographs, so shiny and almost perfect, ultimately directs us toward the converse: entropic decline, distortion and decay.

Todd in an interview with curator Robert Leonard spoke of being more interested in Priscilla Presley than Elvis, which in turn spurred me to recall The New Pornographers once stating that they were more influenced by Wings than the Beatles. This gets at something quite telling regarding popular culture, the fact that it is always contextually dependent, and its being linked with personal associations carries it into a corresponding state of overidentification. Why did I love this and not that? When did I become invested in this cultural production that for all intents and purposes has absolutely nothing to do with me, nor my own actual experience? And sometimes, these are the products we obsess about and clutch all the more tightly for that very distancing and remove.

Exhibit A, hair and apparel: I remember a few things from my own experience growing up in the southern United States around the local broadcasts of country and western music on endless weekend afternoons, when Dolly Parton was but a whelp and the protégé of the singer Porter Wagoner. Parton's later activities have become the stuff of pop legend, but back then she was closer to a small-town girl with a fantastic beehive. Having this kind of glitz gazing back at you from a staticky television with aluminium foil on its rabbit ears was an intense experience. (Figure 16.1).

Of course, I think of other examples of hair and wigs: more country and western stars; the MTV bands of the 1980s; Warhol himself; Chloë Sevigny's star turn as a Mormon polygamist's wife on the American cable melodrama *Big Love*; and Alfred Hitchcock's so-called 'cool blonde' actresses including Grace Kelly, Tippi Hedren, Eva Marie Saint and Kim Novak. And Todd speaks nostalgically of the escapism of television in the era of *The Love Boat* and other vapid yet inviting vehicles for fantasies. And beyond Hitchcock the paradigmatic figure early on of adopting popular cinema as high art, I think of Roger Corman's drive-in style exploitation films or the British Hammer productions or Warhol/Paul Morrissey's camping up of horror films over the course of the 1960s and 1970s. I recall *Pretty Poison* in which Anthony Perkins, rather than seeming as deranged as *Psycho*'s Norman Bates, becomes a mere accomplice to a depraved young Tuesday Weld. I was also remembering my grandmother who, a voracious reader, loved the genres romance and true crime, such that one day she might be immersed in Margaret Mitchell or Barbara Cartland, the next onto narratives about serial killer Ed Gein or the Manson family.

FIGURE 16.1: Yvonne Todd, *Ethlyn*, 2005, photograph. © Yvonne Todd. Courtesy of the artist and McLeavey Gallery.

Roland Barthes's classic essay 'The Romans in Films' equally comes to mind, as when the author dissects the faulty construction of verisimilitude in Hollywood epics of the 1950s from the fringe upon Marlon Brando's forehead to

> yet another sign in this *Julius Caesar*: all the faces sweat constantly. Labourers, soldiers, conspirators, all have their austere and tense features streaming (with Vaseline). And close-ups are so frequent that evidently sweat here is an attribute with a purpose. Like the Roman fringe or the noctural plait, sweat is a sign. Of what? Of moral feeling. Everyone is sweating because everyone is debating something within himself; we are here supposed to be in the locus of a horribly tormented virtue, that is, in the very locus of tragedy, and it is sweat which has the function of conveying this.[115]

Todd has frequently rhapsodized with passion and curiosity about various aspects of dated visual culture, as in a 2008 interview with curator Natasha Conland:

> I'm inspired by professional photography trade magazines from the pre-digital era. I especially like food photography, because everything is so fake and inedible. There are fascinating props available to commercial product photographers, like acrylic and clear rubber ice cubes, extremely realistic-looking food made of resin, 'nurdles' of perfectly formed faux toothpaste, glass soap bubbles and smoke pellets.[116]

Todd also addresses the false frontality of staged realities in photography, cinema and other spectacular realms, and the fact that we might be staring at a mere scrim, a backdrop, an assortment of painstakingly created but flimsy and light-weight props. But such a constructed reality correspondingly creates the illusion of weighty significance and status. Many years ago, I worked for a commercial portrait photographer near Washington, D.C., who exhibited a true rogues' gallery on the walls of his suburban studio, images of those who walked the governmental corridors of power or tyrannically ran smallish countries – and what's the difference really? To be locked up (so to speak) in a small darkroom conjuring up smiling, soft faces out of the chemical trays – that was my job – was as claustrophobic an experience as staring into the posturing eyes of the senators and dictators hung in the entryway. Defined by a certain blankness, they still seemed to silently scream: this is an important image, pay attention!

In Todd's images, a major question becomes how to use the cliché wisely, and in so doing turn that cliché into something entirely different. Todd has commented:

> I'm not affronted by clichés, visual clichés are great. Images like roses with dewdrops still have lots of mileage, as far as I'm concerned. For me it's about creating archetypes.

I might not actually photograph a rose ever again, but at least I can entertain the idea. And I like borrowing tired, unfashionable photographic techniques, like those used in family portrait studios – the soft-focus Vaseline effect. I might use a star filter next.[117]

But beyond the clichés lies how to reinvoke and reinterpret historical references of wildly divergent forms, functions and temporalities. For example, *Wall of Seahorsel* riffs on such material as Richard Avedon's fashion photographs, the work of the French mime Marcel Marceau, and the nineteenth-century chrono-photographs by Eadweard Muybridge. Perhaps although these reference points might initially appear totally distinct from one another there is also the thread of quietude, that the sometimes over the top poses are frozen, devoid of the movement and soundtrack that might break the disorienting atmosphere, reducing it to mere slapstick. However, slapstick, mime and technological innovations in photography can all become incredibly artful means of expression.

As the artist has remarked:

Erratic behavioural mechanisms and scrambled frequencies are imbued with elements of both frivolity and blankness. The movements allude to a communal (perhaps unhinged) state of mind; the execution of obscure processes; the carrying out of unnamed and unknown tasks. To feed this sense of the indiscernible, the action takes place amid a selection of beach detritus, so there's sand, seaweed, a large seashell, a seagull, and a wet rag. Yes, it's different from my typical style; I wanted to produce something that had a more experimental quality. But it's new work and I haven't yet fully digested the implications. It still inhabits a nebulous zone in my mind.[118]

Todd's methodology still entices (or, of course, perhaps repels) due to its many uncertainties, the quality of unease that emanates simultaneously with the notion that the blunt visual fact described with precision becomes captivatingly strange. If in much fashion photography and commercial set ups the lurid and darkly erotic is meshed with high key lighting and a shimmering banality, Todd reframes these very framing devices, making her approach on one hand a conceptually sophisticated metalanguage and on the other offers a dumb and straightforward theatricality.

Writer Megan Dunn has eloquently stated that Todd

is well known for her perpetrations of anxiety and angst, her work frequently noted for its 'not quite rightness'. In *Seahorsel Subset* the artist turns her attention to signs of soul searching, that elusive state of inner calm, tranquillity. The inhabitants of this exhibition could be the members of a sect or a commune. In their white and beige outfits, the seventies chic of their billowing sleeves conjures up a whiff of Californian dreaming.[119]

101

So it is with Todd that in her artistic vision communes co-exist with cults, Romance novels with tabloid blurbs, modern dance with soft core pornography. The markedly pronounced shifts present in the artist's work between various registers of meaning, whether visual, conceptual or psychological keeps a strong momentum but does not let up on a certain confusion and disequilibrium amidst the supposed calm. When I look at imagery of Todd's *Seahorsel*, I think of Merce Cunningham and Trisha Brown in the same breaths as the stage outfits of magicians, country stars, sci-fi protagonists and glam rockers.

The artist's attitude intrigues further as once upon a time to ironically skewer kitsch was regarded as transgressive, but what's also important to remember is that so many artists who truly engage on a strong and telling level with mass culture, *LOVE IT TO DEATH*, such that the placing of the discarded, castaway bits and pieces of consumer culture into Todd's tableaux can be read as an act of affection rather than disdain. This is arguably why Warhol has remained a figure of fascination: his rapt attention and near worship, rather than critique, of his subject matter. And we see this love and attention lavished across the virtual blogosphere, in the collected, fascinated ruminations of countless amateur historians and aficionados of subcultural detritus. But in Todd's case, instead of simply *re*-presenting such artifacts she uses them as fuel to create new flames of meaning, unlikely to be extinguished anytime soon.

17

Cindy Sherman:
Morphing Changeling (2016)

American artist Cindy Sherman has been reinventing the way the art world considers photographic practice ever since the late 1970s. It's entirely difficult to imagine the last several decades without the on-going presence of her forceful images. Recipient of countless awards, citations and superlatives, she continues to also reconfigure her own practice with daunting and striking images. Her name became closely associated with notions of photographic postmodernism, along with a number of other artists including Sherrie Levine and Richard Prince. But while the others appropriated and recontextualized existing images, Sherman drew inspiration in her early works from anachronistic Hollywood cinema and in her deceptively straightforward landmark 35-mm Black and White *Untitled Film Stills* (1977–80), the artist used simple props and costumes, locations and vantage points to render anew the seemingly familiar as absolutely strange. Acting out stereotypes familiar through their often uninspired iterations in film: femme fatale, career girl, housewife, Sherman created a series of seventy images which served as an exactingly subtle, yet extremely powerful feminist treatise.

Sherman's photographs became characteristic images of the late twentieth-century's contention with earlier tactics of historical representation, and her photographs became more and more upscale in production values, and incorporated hybrid psychological undercurrents, to differing degrees satirical or grotesque, pinups or totems. And even her early photographs were historically inflected, drawing upon 1940s Film Noir to 1960s light comedies. The images 'starred' Sherman but were in no way traditional self-portraits because it seemed that any self to display had gone missing. The artist acted as a morphing changeling, onto which prostheses, wigs, makeup and extravagant dress could be applied. Then it would be up to us, the spectators, to decide what to make of this process. And of course, a raft of commentary ensued, and Sherman is undoubtedly one of the most written about and discussed artists within contemporary academia, for the very reason that her practice speaks towards

the interrogation of identities, feminisms, masquerade, cultural iconography and the social construction of same.

Sherman, born in New Jersey in 1954, is a child of American suburbia, her early years occupied by such pastimes as dress up and television watching. She began her art studies in Buffalo, New York in 1972, quickly shifting to photography rather than painting. As legend has it, she failed her first photography course due to technical inadequacy, but proceeded onwards and was particularly interested in the more conceptual and performance-related strategies for which the medium was entirely well suited. Sherman began portraying characters and subsequently experimented with performing them for the camera. In 1977, Sherman relocated to New York, began working for the alternative gallery Artists Space and commenced initial work on the *Untitled Film Stills*.

The works on view in the current exhibition at City Gallery Wellington date from 2000, offering several discrete bodies of work which fill the entirety of the gallery's many spaces. Sherman's prints are generally large, loud and brash and are sometimes difficult to look at: everything is so exquisitely right and so terribly wrong simultaneously. Images that play on and elicit your desires but aren't troubled that they are going to challenge you along the way. Sherman is a veritable queen of the cringe-inducing in the most knowing sort of way, much like filmmakers David Lynch or John Waters at their best. These later works followed on subsequent to a period of relative retrenchment by the artist in which Sherman 'left' her pictures as a visible protagonist in favour of using mannequins, still life set ups, and other strategies, such that taken together, they now appear to be a comeback with a vengeance.

If many of her early images drew upon the cinematic, the more recent work often features caricatured, exaggerated figures and a darker view of Hollywood recalling actress Gloria Swanson's forgotten silent-era star in *Sunset Boulevard*, rather than the trials of aspiring starlets. And if one might suspect a creeping sense of disdain in the images, they actually are very effective – if over the top – meditations on aging and alienation, loneliness and artificiality. Sherman acquits herself both as a formidable stylist but also as a superb comedienne, more so than ever. Were it not for a certain amount of empathy as well as self-reflexivity, how could she manage to make such haunting and horribly beautiful images? Critic Peter Schjeldahl has pointedly remarked that

> a particular cruelty pervades all her art – along with a wafting compassion that falls some degree short of reassuring. Sherman hammers ceaselessly at the delusion that personal identity is anything but a jury-rigged, rickety vessel, tossed on waves of hormones and neurotransmitters, and camouflaged with sociable habits and fashions. She does this by conveying inner states of feeling and surmise that are dramatically out of synch with outer, assumed attitudes.[120]

Sherman also summons the collective cultural imagination around phenomena such as circus clowns, ambiguous fools offered up for our enjoyment but often conjuring our fears. Sherman began those *Clown* works wondering about the characters beneath the makeup. And of course, clown makeup is both a disguise and an overused trope in crime and horror films, being both ghastly and blank, a cipher onto which we project emotions. Moreover, for those who ask if there is a 'real' Sherman, the query, although usually raised in order to negotiate the complexities of her practice, largely misses the point that Sherman as an artist attacks our assumptions around authenticity, and her work serves to shift many settled ideas around 'the real' in order to overturn binaries and reductive parameters. Sherman's work unsettles due to its very capacity to tug at and question the edges of our carefully ordered visual world. Maybe categories need undoing through a kind of travesty and burlesque in order to more clearly rethink their corresponding (un-)importance.

In the *Ominous Landscapes* series, Sherman's avatars, dressed in vintage Chanel outfits, are posed before jarringly romanticized, digitally manipulated landscapes. These again question our positioning as viewers in terms of extracting any 'truth value' from her images. As curator Robert Leonard notes:

> Evoking 'real' art, the effect is at once classy and cheesy. But it's unconvincing; it looks false. The grating disjunction between the painterly backgrounds and the not-painterly figures disables our suspension of disbelief. In one image, a figure visibly fades out below the waist, making the conceit explicit. Floating like a spectre, the woman was never really there.[121]

In *Untitled* (2010–11) Sherman, draped in luxuriant white feathers exhibits a rather birdlike visage herself and stands confronting us before a nineteenth-century sublime landscape recalling Courbet or Gericault (Figure 17.1).

In Sherman's recent works, art and fashion meet uneasily, but this would seem appropriate in an era when well-known directors make promos for perfume, and social media are overtaking the pre-eminence of the catwalk. The *Balenciaga* series features the artist clad in haute couture designs but also multiplied, as we see various Shermans within the same image with her move into digital manipulation. In *Untitled #462* (2007–08), a pair of remarkable doppelgangers are caught at an event, the graffiti behind them highlighting their temporary occupation of some fashionably fringe locale. Between their oversized glasses, army parka and patterned jumper, colours and styles clash obnoxiously. In Sherman's words, the series 'was inspired by the idea of party photos seen so often in magazines where people, desperate to show off their status and connections, excitedly pose to have their picture taken with larger-than-life-sized smiles and personalities'.[122]

FIGURE 17.1: Cindy Sherman, *Untitled*, 2010/2011, Chromogenic colour print, 79 3/4 × 136 7/8 inches. © Cindy Sherman. Courtesy of the artist and Hauser & Wirth.

For an audience in Aotearoa New Zealand, likely the most significant descendent of Sherman's very particular approach in terms of direct legible influence would be Yvonne Todd, with her embrace of the grotesque and the glamorous in her staged photographs. Especially by the way Todd has been utterly fearless in portraying herself in unflattering ways and skewering societal excesses. It would probably in fact be difficult for a viewer here *not* to retroactively read Todd's approach into a photo like *Untitled #404* (2000) in which Sherman, wearing heavily applied makeup and a toxic retro blouse clutches a teddy bear and peers sleepily at the camera. But what's also unclear when attempting to consider the trajectory of Sherman's influence is that much of it is indirect and inferred. For every emerging photographer who directly apes her approach to costumed self-portraiture, there are others who glean aspects of her sensibility or clearly have felt her impact.

Among the other artists who come to mind are Ronnie van Hout's multiple versionings of himself in his videos and sculptures, the high-key portrait paintings of Liz Maw and the intricate postcolonial photographic tableaux of Greg Semu. In an international frame, works such as the social media-influenced psychedelic mashups of video artist Ryan Trecartin are heavily indebted to Sherman's attention to masquerade and artifice. The mutability of self, the ability to render fragments of represented identity in order to question its fixity and stability, this has almost become a standard aspect of so much contemporary art practice, and it owes much to Sherman's example.

Sherman is an inveterate observer, and ironically as we are observing, noting and considering her images here in New Zealand for this significant exhibition opportunity, somewhere someway she is undoubtedly still observing *us*. That is to say, Sherman is a collector and scavenger of typologies, characteristic modes of representation that become codified and transmitted again and again, betraying a clear-eyed look at our social behavioural patterns, from opening parties to the ubiquitous selfie. We still have much to learn from Sherman's untoward gaze.

PART III

PUBLICNESS

This section contains an eclectic mix of writings on artists who have developed expanded practices often occurring outside or alongside of the gallery space, and about the economic pressures around the arts, as well as historical conceptualisms. Thus, comprising a variety of texts that in one way or another re-consider the complexity of an encounter with any given artwork, as I have noted in Chapter 18:

> *In a paradoxical way it becomes exceedingly difficult in the early twenty-first century to determine what a first-hand encounter with a work of art actually is. Quite ironically, we often 'read' a disembodied pictorial-textual surrogate as the seeming embodiment of some now-long-gone, experientially invested, and previously tangible form of practice. We are now more prone to witnessing fragmentary evidence – often in digital form – of all that we scrutinize closely. Such evidence is likely to have been further mediated by a variety of filters, interfaces, screens in advance of our encounter.*

18

Encounter (2009)

Each encounter with a contemporary artwork involves a vast and unpredictable multiplicity of factors, rather than a singular approach or set of assumptions. Moreover, the complex framing of any current 'sculptural' venture reveals itself both spatially and temporally. One could assert that the latter has taken marked precedence over the former in our recent attitudes, shaped by an era often characterized by its instant messaging and texting, communicating via Skype, as well as via blogs and Twitter.

Inasmuch as the last sentence would be incomprehensible to readers of even a decade ago, perhaps a simple step backward to get a broader view is appropriate. In unpacking the etymology of the term 'encounter', it becomes crucial to recall diverse aspects of its meaning: 'to meet as an adversary or enemy', 'to come into conflict with' and very significantly the roles of 'chance' and being 'face-to-face'.[123] Thus we are engaging with a term that involves varying degrees of hostility, immediacy and spontaneity.

So why would the notion of an *encounter* harbour potential as a privileged avenue into recent art practice? Perhaps because we are so often trying to reactivate and reconfigure the tried and true. The novelty of the initial encounter is continually reiterated as a moment of great significance (biographically, critically and historically). We could also think of the viewer as often reorienting herself to replay the very procedures of making the work. Traditionally the aestheticized view of an encounter typically involves recording a state of contemplation or absorption. But this is more relevant when standing before a classic painting, say, rather than – for example – amidst a time-based, radically situational or spatially dispersed work. As philosopher Martin Seel notes: 'One of the expectations we have when encountering artworks – at least today – is that they allow us not only to *perceive* differently but to *experience* differently – that artworks may become an *event* for our sensuous and mental disposition.'[124]

Notably, critic Nicolas Bourriaud has flatly stated 'art is a state of encounter'. 'State' actually occupies a determining role here, as Bourriaud is using that word flexibly in this phrase as a mechanism to signify at once: the current surrounding

conditions, aspects of the creative process, as well as the interrelations between the viewer and the artwork/artist. Bourriaud earlier within the same context (*Relational Aesthetics*) argued for art as a 'game' rather than an 'immutable essence', thus we might consider that encounter is a term the critic puts into play. If we then consider a state of encounter, it could be regarded as incorporating many features: a moment, a glimpse, an opportunity.

We might also even return to a seminal historical essay by critic Clement Greenberg 'The Crisis of the Easel Picture' (1948), in which he stated, in reference to abstract painting:

> This very uniformity, this dissolution of the picture into sheer texture, sheer sensation, into the accumulation of similar units of sensation, seems to answer something deep-seated in contemporary sensibility. [...] It may speak for a monist naturalism that takes all the world for granted and for which there are no longer either first or last things, the only valid distinction being that between the more and the less immediate.[125]

Exactly a decade later, Allan Kaprow in 'The Legacy of Jackson Pollock' (1958) argued for pushing the orientation of contemporary artworks further, past the fertile climate of ambiguity and indistinction evinced so boldly in Pollock's paintings towards

> entirely unheard-of happenings and events [...] An odour of crushed strawberries, a letter from a friend, or a billboard selling Drano; three taps on the front door, a scratch, a sigh, or a voice lecturing endlessly, a blinding staccato flash, a bowler hat – all will become materials for this new concrete art.[126]

Here Kaprow was moving in the direction of his subsequent happenings, in which an encounter between the spectator and work might have involved: reading an elaborate score, sitting in a certain chair, being led to a particular spot, eating a specific kind of food, or listening to a collection of unusual sounds. These actions reiterated the significance of the everyday and posited novel means by which art encounters and life encounters could influence and respond to one another, and actually merge, causing irrevocable transformations of the contemporary art context.

If happenings amounted to structures – often laid out in the form of a score and an environment – which foregrounded spontaneity, much of this derives from the indelible influence of artist Marcel Duchamp and musician John Cage, both of whom spent prodigious intellectual effort on investigation of randomized operations, the former in such works as *3 Standard Stoppages* (1913–14) in which

three dropped threads become templates for measurement, or the latter in his many compositions and writings involving chance permutations and the use of the *I Ching*, or *Book of Changes*.

What relevance do these historical excursions have for the situational and temporal artworks under discussion here? It is certainly clear that if Duchamp and Cage were the godfathers of Fluxus, conceptualism and the happenings that commenced in the 1960s, the 'discursive' and 'relational' modes of practice proliferating widely since the 1990s become closely related descendants of these earlier approaches.

One could also note that in recent years, the notion of encounter in the work of art has been influenced by widely differing methodologies, including: dialogue, direction, exchange, re-enactments, role playing and ritual. Such are the variegated textures of an encounter, and in near direct contradiction to the aforementioned definition, such encounters are often heavily mediated rather than face to face; planned meticulously rather than according to happenstance; convivial as much as confrontational.

And if we twist more than slightly in an act of misreading Greenberg's phrase: 'there are no longer either first or last things, the only valid distinction being that between the more and the less immediate', I am reminded of the call to the immediate being put forth in so much visual culture. Simply think of the mobile phone advertisements urging us to use 'global roaming' to stay constantly connected, nearly at arms' reach across multiple time zones and thousands of kilometres.

I then recall two works I might capriciously compare in light of the preceding remarks. First, the *Telephone Paintings* by the Hungarian Constructivist artist Laszlo Moholy-Nagy which he described retrospectively in the following manner:

In 1922 I ordered by telephone from a sign factory five paintings in porcelain enamel. I had the factory's colour chart before me and I sketched my paintings on graph paper. At the other end of the telephone the factory supervisor had the same kind of paper, divided into squares. He took down the dictated shapes in the correct position. (It was like playing chess by correspondence).[127]

Second, the following comments from a memoir by artist Tom Marioni:

In 1970, working under the pseudonym Allan Fish, I made an exhibition in the Oakland Museum called *The Act of Drinking Beer with Friends is the Highest Form of Art*. This was a social artwork. I am the author of this idea. In the '90s the idea of social interaction in an art context became an art movement. I invited sixteen friends to the museum on a Monday when it was normally closed. [...] Everybody showed

up, and we drank and had a good time. The debris was left on exhibit as a record of the event. Basically, the show consisted of the evidence of the act.[128]

In these instances, separated by 50 years, we have two examples of Modern artworks depicting an acute awareness of the 'more and the less immediate'. Both metonymically describe the creative process, and most specifically the distance an artist travels from conceptualisation to realisation. This is a complicated and treacherous passage, and in Moholy-Nagy's case, it traces creative acts of transmission, translation and ultimately transformation. In Marioni's work, the social event described is a one-time grouping of interpersonal encounters to which we as art historical audience have no direct access.

On a recent visit to a re-installation of the Swiss artist Thomas Hirschhorn's *Cavemanman* (2002), I found myself wandering within a constructed space that called attention to its own fabrication yet made considerable effort to defy any cohesive analysis: misshapen, brown taped corridors adorned with popular posters, spray-painted notes, foil objects, aluminium cans and theoretical texts. As I passed further along, I narrowly missed colliding with other spectators and was surprised by numerous dead ends. In speaking of this work, the artist commented:

> I wanted to make a space in which it was possible to feel outside of the real and I thought of a cave [...] I was interested in making a hidden space that awaits discovery; a space in development – indefinite, perhaps infinite – and a space in which someone has been living.[129]

My previous reading of evocative descriptions of this artwork didn't compare with the unexpected urgency I experienced when in its midst, set inside a museum that had effectively disappeared. Now there was only the cave, along with its temporary murmuring inhabitants allowed in by a guard, only a few at a time, to investigate its uncanny interior during their brief sojourns (Figure 18.1). Hirschhorn has stated:

> There's reality and my will to confront reality with my work. Art exists as the absolute opposite of the reality of its time. But art isn't anachronistic; it's diachronic. It confronts reality. As an artist, I ask myself, am I able to create an event? Am I able to make encounters?[130]

Current temporary, ephemeral and non-categorizable artworks gain their form and meaning ultimately via the encounter and intersection with their viewing public. This act of encounter is a manifold act of becoming, the viewer becoming aware and cognizant of the work's presence, as meanwhile the work becomes

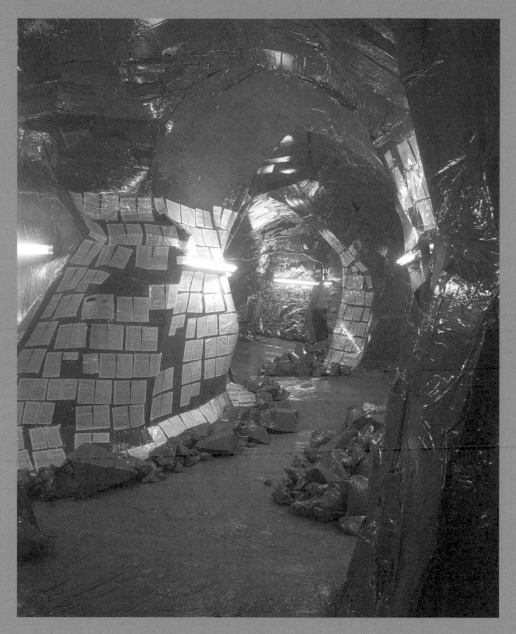

FIGURE 18.1: Thomas Hirschhorn, *Cavemanman*, 2002 exhibition view: Gladstone Gallery, New York, 2002. © Thomas Hirschhorn. Courtesy of the artist, Gladstone Gallery and D. Daskalopoulos Collection (Halandri, Greece).

itself, takes shape, materializes; to return to Duchamp's phrase: The spectator makes the picture.

In a paradoxical way, it becomes exceedingly difficult in the early twenty-first century to determine what a first-hand encounter with a work of art actually is. Quite ironically, we often 'read' a disembodied pictorial-textual surrogate as the seeming embodiment of some now-long-gone, experientially invested and previously tangible form of practice. We are now more prone to witnessing fragmentary evidence – often in digital form – of all that we scrutinize closely. Such evidence is likely to have been further mediated by a variety of filters, interfaces, screens in advance of our encounter.

Thus, it can be rather disturbing that we seem to be chasing echoes, and distorted ones at that, just as we attempt to reassure ourselves that we are on the threshold of new forms of experience. To re-encounter both very recent and historical works today presents a challenge, as we re-read and re-view their residual forms to resuscitate them from their documentary status into some direct relation to our own lived experience. Curiously also our notions of encountering artworks often remain a peculiar cocktail composed in unequal parts of mysticism, pragmatism and idealism.

But so it goes, novelty hand-in-hand with the past, as younger artists enact an ongoing dialogue with the history of temporal practices, which call into question received notions of the object/image-based work's status in favour of the artwork seen as a process, an event, an encounter. Nevertheless, what is most pressing today is the self-conscious yet generative nature of this dialogue, raising the hope that artists will thread provocative aspects of their encounters with the world into the complex fabric of their works, so as to not continually describe that which already exists, but that which we yearn to experience, as our encounters continue to unfold before us.

19

On False Leads, Readymades and Seascapes (2008)

Maddie Leach *Perigee #11*
28 August 2008, midnight to midnight
Boatshed 805, opposite 171 Breaker Bay Road,
Breaker Bay, Wellington

It was once, and now is again, a boatshed. However, for a recent 24-hour period, a picturesque seaside location in Wellington, New Zealand became alchemically transformed into an expansive site of creative possibilities. Maddie Leach's deceptively simple *Perigee #11* is a work that offers multiple challenges owing in large part to its hybrid status: not exactly sculpture, not precisely performance, not land art per se. Leach's artwork manifested an open framework, which could take on all sorts of real world 'events', whether random or intentional. By the end of its day/night run, the primary material component of *Perigee #11* had been tagged with a graffitoid blotch, its bolted main doors had been unceremoniously pushed open and liquor bottles were left behind as if votive offerings (Figure 19.1).

The immediate environs of the shed: a craggy shore akin to that depicted in some uninviting Surrealist tableau, lighthouses glimpsed across the way as if miniature children's toys and then the luscious blue sky and the less than turbulent sea. It was a blindingly gorgeous day, emerging in stark contrast to the terse phrasing printed on Leach's announcement: 'Northern declination, perigee, southerly storm, downpours, hail, wind and rain.' Thus, we were warned of an onslaught of near-Biblical – or at least typically Wellingtonian – proportions that never materialized. This prognosis was attributed to the weather predictor Ken Ring, a one-man meteorological industry, from whom Leach purchased this tip as a sort of 'readymade' to be tinkered with and used as a trigger for further research.

Indeed, Leach's updated use of Duchampian notions has been critically discussed in the past (particularly by writers Christina Barton and Marcus Moore). But rather than Duchamp directly, I am also thinking of Michael Craig-Martin's 1973 *An Oak Tree*, perhaps the apotheosis of the Duchamp heritage industry,

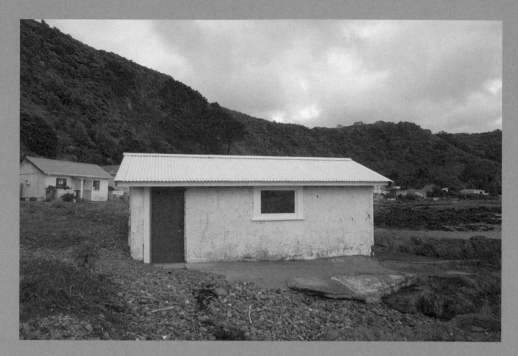

FIGURE 19.1: Maddie Leach, *Perigee #11*, 28 August 2008, Breaker Bay, Wellington, New Zealand. Photograph by Stephen Rowe. Courtesy of the artist.

in which the artist placed a glass of water on a shelf and in an act of re-naming (elucidated further in an interview-style wall text) 'transformed' the glass into the aforementioned oak tree. Inasmuch as the boatshed on Breaker Bay was simultaneously a viewing station, framing device, isolation chamber and a shelter from the (non-)storm, it also flickered ambiguously in this strange, intermediary state: both/and, either/or, within/without.

But perhaps contradictorily it must be acknowledged that after I had spent a few solitary minutes in the boatshed of *Perigee #11*, I thought: *this is a sculpture*. That is to say, sometimes one can get carried away (particularly if one is a critic) by considering overly the more abstract, philosophical and purely notional aspects of a work, such that it becomes crucial to actually contend with its concrete, material presence. Leach had carefully lined the interior of the boatshed with exterior-quality cedar, painted and replaced portions of doors and window frames, added a radio to monitor the reports on nearby nautical traffic, and a small camping-style lamp for modest illumination during the evening hours. The radio periodically offered eruptive bursts of sound: 'just passing the power station – squawk!'

The quasi-Minimalist set up lent a great amount of significance to a select number of decisions made by the artist. The cedar interior of the shed in turn had a distinct olfactory presence, and in addition wrapped around and acted to unify the space. If one looked above and below there were areas less touched by Leach's craft, notwithstanding knocking away some cobwebs and sweeping out the space. Leach sought to make a clear demarcation between the interior and the exterior of the boatshed and has emphasized her interest in classic slapstick films of Chaplin and Keaton in which the small wooden cabin is often portrayed as a refuge from arctic and desolate surroundings.

If *Perigee #11* as a work is accommodating to the notion of performance, it would be solely the performance of its visitors in response to the site, as Maddie Leach after a complex series of preparations has left the building to its own devices. Leach is de facto a feminist artist although she might shy away from telegraphing this aspect of her work overtly – after all her work gains much of its power from its subtlety and understatement. Part of this involves her generosity and the notable reciprocity between Leach as artist and viewers in the space, for whom she both makes the work but is dependent upon for the work to fully exist. Again, the Duchampian trace: viewers becoming essential to the work.

In addition, the emphasis on the gaze is intriguing and significant here, as the spectator enters a closed chamber, almost a surrogate camera to look outwards, into the unknown, to discover things only partially revealed or visible. The space subsequently becomes, as a public location, a context for social exchange and interaction between individuals. Such interactions however are much less choreographed and undramatic than, for example, the use of skating and dancing in two of Leach's earlier works

119

(*The Ice Rink & The Lilac Ship*, 2002; and *Take Me Down to Your Dance Floor*, 2004). Here instead it is quite possible that 'nothing really happens'. Nonetheless Leach leaves a trail of interesting data in her process, either wholly integral or almost immaterial to the final outcome of the piece. The accretion of facts, false leads, negotiations, pretences, alterations becomes a kind of constellation in which the work resides. Just as intriguingly enough on a radiant August morning, visitors spread outwardly from the boatshed down to the shore, walking, sitting, standing as if enacting some kind of material analogue to the many disparate and largely ephemeral components that contributed to the creation of *Perigee #11*.

Leach's mode of art practice is in the best sense 'relational' – however much this term has been of late overused and extended nearly to the point of meaninglessness. The privileging of art considered as 'games' and 'situations' which unfold within a variety of creative contexts, as highlighted in the writings of critic Nicolas Bourriaud, curator Claire Doherty and others, is relevant when considering Leach's approach. What Leach achieves in large part is a sleight-of-hand to be reckoned with. How best to pull off a risky manoeuvre like this? She has been no stranger to curious conceits: building a boat from start to finish and having it hoisted atop The Museum of New Zealand Te Papa Tongarewa high above Wellington Harbour; creating a dance floor used by troupes of all types; installing an actual ice rink with a nearby video which portrayed the passage of a cruise ship and using the auction site *Trade Me* as a context for selling timber.

What binds most of these works is Leach's concerted effort to contain, organize and merge aspects of the everyday with her own artful whimsy and loopy versatility. Leach's works betray as much affinity with the language of fables and tall tales as with documentarian social practice. This keeps the viewer guessing, off-guard and in this particular case revisiting the principles behind weather forecasting, perhaps learning new vocabulary, (perigee is not the most common word on the street) and pacing about in a tiny shed pondering its aesthetic merits.

A central character in Leach's vignette from some unknown narrative is the sea, which was visible from the shed's window, always audible, creeping its way up the floor further and further as the tide came in. As I backed up to look out the window at a beautifully rendered seascape, I thought of the painter Ad Reinhardt and his (not entirely) flippant comment that 'Sculpture is something you bump into when you back up to look at a painting'. There I was in this amazingly mad sculpture, conjuring glimpses of Caspar David Friedrich, J. M. W. Turner, Winslow Homer. But more to the point might be projects by the artists Bas Jan Ader and Marcel Broodthaers. Ader, though emerging from a conceptual scene of the early 1970s, tended towards Romanticism, incorporating movement and risk; Broodthaers, however, was purely cerebral, managing a closely controlled game of chess. Broodthaers used a banal maritime scene as readymade to satirically scrutinize as if fodder for a traditional art

history slide lecture. Ader became infamous for his untimely death somewhere in the Atlantic after setting off in his boat Ocean Wave for a performance entitled *In Search of the Miraculous*. One could also surmise that it simply seems rare for a New Zealand artist to avoid the sea, always nearby. Moreover, as a non-local observer, I couldn't realize how much the location of *Perigee #11* might be linked to one of the worst tragedies in New Zealand history, the *Wahine* ferry disaster of 10 April 1968, in which more than 50 passengers perished when, in a horrible storm, the ship struck rocks near Breaker Bay. This event understandably looms large in the local consciousness as well as throughout New Zealand broadly.

A striking aspect of *Perigee #11* was its markedly different feel between the morning and evening hours. In the former, on my first visit, it was quiet, clear and I was prone (as close as I get) to reverie and fantasizing about staying in the shed all day, both illusions broken quickly by sudden noises: the squeak of the door, a dog barking, a tyre tread upon gravel. In the late evening, a calm yet festive atmosphere had settled in and the darkness around the shed made a kind of visual barrier, drawing people (and there were more of them now) closer in. Everyone seemed to be on the verge of something, as the piece ticked its way towards culmination at midnight. Murky introductions displaced the dutiful appraisal of patterns of wood and arrangements of nails. We were the sculpture as well of course and increasingly self-conscious of the fact, getting chillier and finally chatting with the artist who had rematerialized, from her rented cottage across the road.

20

Hope Is Not About What We Expect (2011)

Colin Hodson, The Market Testament, *Wellington*

If art and politics meet at all, it's in the obligation to work concretely in the present toward an ideal that may never be fully attainable.

—Barry Schwabsky[131]

Cinematic disasters

I spent my otherwise uneventful small-town pre-adolescence squarely in the shadow of disasters. That is to say, disaster films: *Airport '77, The Towering Inferno, Jaws* (Parts One, Two and Three) and *The Poseidon Adventure.* Our collective, nightmarish fears were projected back to us incessantly, as the prosperity of the post-war era diminished. Citizens sought comfort in the soothing delirium of the still-wide-screen American movie palaces. These were becoming bifurcated into 'twin cinemas' or screened dollar movies or pornography on their way to bankruptcy, just before the advent of sprawling new multiplexes.

Cinematic disasters come in cycles, as we alternately covet or reject our (post-) apocalyptic visions. We currently see a return of this phenomenon – *The Road, Contagion* and *Rise of the Planet of the Apes.* Perhaps more to the point here is the remarkable and straightforward documentary *Inside Job,* which painstakingly delineates the financial turmoil enveloping global markets and local households since 2008 (and earlier). One could argue that 'real' devastation – whether economic, psychic or physical – bears no easy resemblance to fantastical obliteration in CGI mode. Our fears now are palpable, very real, but also conveyed in more abstracted, oblique economic channels and forms. (And of course, this is not to underestimate the long and difficult period of coping with the manifold effects of the recent earthquakes in Christchurch.)

I fully realize I'm beginning to ramble and muse overly. My intention isn't to detract from the manifest, novel singularity of Colin Hodson's remarkable artwork *The Market Testament.* Nor, by contrast the fascinating ways in which Hodson's

authorial voice was radically diffused by the techno-omniscience of the installation itself. Was the building's infrastructure itself perhaps personified in place of the author/artist? We might also remember the absolutely scarifying HAL the talking computer from Arthur C. Clarke's *2001: A Space Odyssey* more vividly than either Clarke or Kubrick as its sci-fi creators.

Regarding cycles

Reports of the Occupy movement that spread virally, globally over the past months eerily recall much earlier reports of social protest as spectacularly conjured events. Take author Norman Mailer's idiosyncratic account of the 1968 March on the Pentagon in Washington (later published as *The Armies of the Night*):

> Now the Participant recognized that this was the beginning of the exorcism of the Pentagon, yes the papers had made much of the permit requested by a hippie leader named Abbie Hoffman to encircle the Pentagon with twelve hundred men in order to form a ring of exorcism sufficiently powerful to raise the Pentagon three hundred feet. In the air the Pentagon would then, went the presumption, turn orange and vibrate until all evil emissions had fled this levitation. At that point the war in Vietnam would end.[132]

When reading journalistic reports of today's out of work artists, artisans and designers throwing their lot in to create responses to the current climate of extreme economic precariousness, I think of this proposed Yippie[133] stunt, comprising an unequal mix of goofing mockery, creative imagination and deadly earnest utopianism.

Journalists of every persuasion are digging out their arsenal of tools to try and sum up and categorize an unfinished historical period. Such as *Time* magazine's placement of 'The Protester' as their nominated 'person of the year' for 2011. In writer Kurt Anderson's words:

> 2011 was unlike any year since 1989 – but more extraordinary, more global, more democratic, since in '89 the regime disintegrations were all the result of a single disintegration at headquarters, one big switch pulled in Moscow that cut off the power throughout the system. So, 2011 was unlike any year since 1968 – but more consequential because more protesters have more skin in the game. Their protests weren't part of a countercultural pageant, as in '68, and rapidly morphed into full-fledged rebellions, bringing down regimes and immediately changing the course of history.[134]

Anderson's slightly purple prose leans more towards the so-called Arab Spring than any perceived success or failure of the Occupy (Wall Street) Movement, which some have said has succeeded mostly – and ironically – by becoming a 'brand name' itself. Anderson's mainstream user-friendly rhetoric contrasts markedly with the fervent manifesto-style approach of writers Franco Berardi and Geert Lovink in their 'A call to the Army of Love and to the Army of Software', a posted bulletin dated October 2011:

> There is only a way to awake the lover that is hidden in our paralysed, frightened and frail virtualized bodies. There is only a way to awake the human being that is hidden in the miserable daily life of the softwarist: take to the streets and fight. Burning banks is useless, as real power is not in the physical buildings, but in the abstract connection between numbers, algorithms and information. But occupying banks is good as a starting point for the long-lasting process of dismantling and rewriting the techno-linguistic automatons enslaving all of us. This is the only politics that counts.[135]

Haunted shells

Traces from all of the above have raced through my mind retrospectively after observing and reflecting upon *The Market Testament*.

A bunch of bland, boxy structures, arbitrarily generic, punctuated by little decorative flourishes: the colour of modernist glass and steel, the signage announcing their functions and/or corporate sponsors. I don't know much about these edifices of the Wellington Central Business District. I tend to avoid them assiduously. I can count on the fingers of one hand the memorable times I've spent in their midst: health exam, bank visit, solicitor consultation. Perhaps the strangest though was when graciously invited to facilitate a discussion on – or I should say *inside* – Colin Hodson's work (Figure 20.1).

At 139 The Terrace, I was ushered into the building afterhours, up a lift and into a partially emptied floor of office cubicles. The remaining contents included some dismal grey desks, formica tables, metallic filing cabinets, along with a few bits of stray, printed ephemera: Post-it notes featuring once urgent, but now discarded information. It was a haunted shell of a workplace.

The artist, curator, curatorial assistant and myself as advance party exchanged jokes, but for me, spooky unease prevailed. Then, after the typical swollen handful of attendees as at any Wellington art event had arrived, we chatted about the surrounding context, the work and the artist's intentions. But most of what I remember involved the slowly changing lights, staggering and stuttering in that typical way of antiseptic, fluorescent ceiling fixtures, being taken for a virtual

FIGURE 20.1: Colin Hodson, *The Market Testament*, 2011, installation, Wellington, New Zealand. Image: Murray Lloyd. Courtesy of the artist.

test drive, flickering according to Hodson's computerized collision course while we talked.

One collision so to speak had already been had with the local media and respondents to the *Dominion Post* website, offering uninformed and surly rants that the work didn't 'seem very artistic at all' and against 'wasting power this way', accusations that *The Market Testament* was not art, etc. In short, a typically unproductive verbal impasse.

Hodson's project took ongoing data reports from the New Zealand stock market and converted them into visual signals over the course of a fortnight. The activity of lights flickering on and off on the different floors of the building onsite was relayed via a streaming webcam video onto an accompanying website, and it was of course visible throughout certain areas of Wellington city. Thus, the project involved an actual material site, which was simultaneously mediated, dispersed and disseminated.

The readymade

Hodson's piece suggests two notions originated by the artist Marcel Duchamp: the 'readymade' and the 'infrathin' (or, inframince). In terms of *The Market Testament*, the site becomes a readymade, an existing object to which new ideas are then applied and associated.

The readymade in Duchamp's view devolved or branched off into several sub-categories, such as the altered readymade (moustache painted onto a reproduction of the Mona Lisa), or the reciprocal readymade (use a Rembrandt as an ironing board, treat an ironing table as a masterwork). And the readymade was chosen by Duchamp, ostensibly, in an 'indifferent' manner such that the readymade object itself would be unlikely to be seen as aestheticized.

Nonetheless readymades have been treated as visually elegant representations (Alfred Stieglitz's haunting photograph of the urinal Duchamp entitled *Fountain*), or as mere rubbish (the bicycle wheel readymade was once stolen from New York's Museum of Modern Art and found partly trashed nearby). But the readymade seems to maintain such force and latent energy as a conceptual apparatus by the way it serves to deflect and resist meanings. It's a shell that cannot be pried open; a sort of armoured exterior, in which the interior is left as an empty, conjectural cipher.

Moreover, the notion of infrathin (far more obscure in terms of any comparable art historical fame or ubiquity) was exemplified by a series of glancing blows at philosophical meaning, literary phrases rather than visual figures: 'the difference between a shirt when it has been ironed and after being worn'; 'the gap between two sides of a piece of paper.'

Duchamp's compelling manoeuvre was to describe that which is almost imperceptible, but actually wields a deceptively large significance. This is echoed in the ways by which *The Market Testament* addresses the seeming arbitrariness of the ascending and descending stock tallies, a steady hum underneath our daily activities. Here this is represented by flashing patterns of lights drawing from algorithmic signals pulsing through the hidden recesses of an existing office block – itself a time capsule, symbolic of the 1980s 'Greed is good' mantra.

A conjuring

Ultimately what's both fascinating and frustrating about *The Market Testament* is its very elusive quality, as if turning itself inside out from time to time, transforming the flows of unseen numerical data into the visible flickering of lights but also by asking in a sense, *where, when, how* is the piece? Even if its logistics were completely revealed to me, could I or would I comprehend them? This very opacity rejects a totalising understanding or awareness. This aspect is also quite different from a mode of activism. It instead operates as a conjuring, a sleight of hand presented only partially to the viewer, whose full comprehension is unlikely to aid the work, rather even to spoil its peculiar merits.

Its resistance to totality recalls both postmodern fragmentation but also something very of the moment – historical commentary on the spot – the splitting apart of forms, meanings, hopes that have failed to cohere. Who could have prognosticated the turbulence of the past few years of this new century?

This is not to undercut the political awareness of the artist and the cogent research done which serves as background to its quirky façade. It is significant to note that Hodson is a film director and actor as well as a visual artist, well versed in setting a scene, dealing with performance and thinking through the durational aspect of a work. Several years ago Hodson resided in New York and during that period worked closely with the renowned experimental theatre company, The Wooster Group, then comprised of members Elizabeth LeCompte, Willem Dafoe, Kate Valk, Ron Vawter, among others. The group's specialty was restaging, rewriting and utterly reconfiguring classics of the American theatre such as works by Eugene O'Neill, incorporating video, choreography, music and various postmodern style ruptures and interventions into the mix.

As in the case of many engaging temporal projects created recently, Hodson's work presents the intention of taking a snapshot that not only becomes a glimpse of one particular moment but allows for the flow of events occurring prior to and after the event to prevent that glimpse from freezing totally. In fact, I'm learning

more in retrospect from *The Market Testament* – continuing to consider its reading of mid 2011, created just as the aforementioned protest movements were on the verge of commencing. In the maelstrom of events that continue to occur in these unpredictable times, and which can take a decisive toll on one's own capacity for optimism and fortitude, I would return to the following statement by writer Rebecca Solnit:

> hope is not about what we expect. It is an embrace of the essential unknowability of the world, of the breaks with the present, the surprises. Or perhaps studying the record more carefully leads us to expect miracles – not when and where we expect them, but to expect to be astonished, to expect that we don't know. And this is grounds to act. I believe in hope as an act of defiance, or rather as the foundation for an ongoing series of acts of defiance, those acts necessary to bring about some of what we hope for while we live by principle in the meantime. There is no alternative, except surrender. And surrender not only abandons the future, it abandons the soul.[136]

I would assert that such an emphasis on 'breaks with the present, the surprises' becomes very apt when considering artworks like *The Market Testament*. Colin Hodson's welcome creative surprise simultaneously responded to the global and invigorated the local cultural context.

21

Echoes, Signs, Disruptions (2015)

The past is not dead. It's not even past.

—William Faulkner[137]

You likely see the signs every day, because they are everywhere: corporate 'restructurings', the absence of job listings, the closing of longstanding small businesses, the staggering costs of housing, food and so many basic needs of life. Of course, a lot goes on that becomes hidden in plain sight. Figures, charts, euphemisms, jargon and received notions: all of this assists in disguising some very harsh and indeed often intolerable conditions for Aotearoa New Zealand's citizens today seeking to overcome the growing, and basically insurmountable inequality gap that is now so (globally) apparent.

According to Max Rashbrooke's bracing short book on *The Inequality Debate* in this country:

> Any free society will always have some differences, but New Zealand's income gaps have now widened to such an extent that they have created something of a crisis: not in the sense of a natural disaster that strikes in an instant, but a gradual shift that builds until it reaches a tipping point. That time is now.[138]

The evidence Rashbrooke cites includes the following:

> From the mid-1980s to the mid-2000s, the gap between the rich and the rest widened faster in New Zealand than any other developed country. The average household in the top 10 per cent of New Zealand has eight times the income of one in the bottom 10 per cent. The top 1 per cent of adults own 16 per cent of the country's total wealth, while the bottom half put together have just over 5 per cent.[139]

This information acts in rather stark contrast to the detailed history laid out in David Hackett Fischer's lengthy comparative study of 'two open societies' New Zealand and the United States entitled *Fairness and Freedom*. Fischer,

an American historian who has spent much time here, argues that although both societies harbour some clear similarities, each has tended to privilege its own specific guiding ideology, in the United States, 'freedom and liberty', and in New Zealand, 'fairness and natural justice'.[140] But as Rashbrooke notes in his book:

> The word 'fairness' has many inflections, and it is telling that a key phrase in New Zealand's history has not been 'a fair society', which might imply something about equality of incomes, but 'a fair go,' which hints at being given a chance – and then being left to get on with it.[141]

Many recent cultural events have occurred in response to and in the wake of the global economic downturn, among them the 'Occupy' movement and protests (however short-lived) but it is also important to reiterate the fact that social inequities while long standing have been increasing and quality of life eroding over the course of several decades. The acknowledgement of diminishing opportunities for affordable health care, education, shelter and clean food and water has become characteristic of living in the early twenty-first century, along with politicized debates over how to manage surveillance, rationalize militarism, handle national assets. This certainly provides an appropriate backdrop context for reinvigorating 'socially engaged' artworks if there ever was one.

Throughout the increasingly globalized 'artworld', in recent years, artists have been devising works that engage with real world issues, involving exchanges, barter and time-banking, community services, memorials and re-enactments, public discussions, ecological systems and even medical clinics. These works raise their own problematic aspects and often are temporary interventions or symbolic representations of work that needs to be done on a much larger scale, beyond the scope of any specific art project, however ambitious its aims.[142] To create unusual, sometimes fractious, conversations between unlike things is a characteristic aspect of a burgeoning range of artworks often circulated under the rubric of 'social practice', and could be seen as a vital element of stirring society up, as it were.

An artist summons much from the surrounding world in all its complexities, and creates her own intriguing, hybridized mix of intersecting material. To enrich one's own art experience with philosophical considerations, and to aesthetically and performatively enact artworks are not the same things but could be viewed as mutually reinforcing. This is not to say that the art you have just experienced was created in order to 'prove' or 'test' some philosophical point, or that it might be illustrative of some kind of 'theoretical' notion. This is a facile way of equating unlike and different features of a variegated whole.

I came to New Zealand in 2008 after losing an academic job I had held for six years in the United States. A member of the institution's administration took a low opinion of me (long story); and began the process that led to my tenure denial, and although a university-wide committee upheld my appeal unanimously, I was dismissed. So, I was gratified to the extreme to obtain gainful employment here in Wellington, thousands of kilometres away.[143]

Somewhat ironically, however, not so long after my hiring, I encountered the effects of both a school workload dispute (successfully negotiated by the staff) and a university-wide 'restructuring' (the effects not so smooth, if you take into account that dozens of jobs were cut). But it was good to see that New Zealand has the vestiges of its unions, a public-health system and some remnants of its socialist history, although those appear to be slipping away.[144]

But almost everyone is 'getting hit', that is to say, very few fields are exempt from this century's transformative, precarious and unsettling conditions. Journalist Scott Timberg in his book *Culture Crash: The Killing of the Creative Class* (2015) recounts how throughout cultural work, there's been a huge disruption due to technological developments, economic downsizing and the tendentious notion that everything should be 'free'. Whether an architect, critic, designer, indie musician, journalist, book or record seller, chances are your career prospects are not what they once seemed to be.

One could argue that the continued attempts of institutions (educational, financial, governmental, medical, military and penal) to manage and dominate individuals could be read as just the most recent development from what theorist Michel Foucault called the emergence of bio-power in the Classical era, or: 'the explosion of numerous and diverse techniques for achieving the subjugation of bodies and the control of populations.'[145] This is still entirely relevant to the present given that Foucault states:

> This bio-power was without question an indispensable element in the development of capitalism; the latter would not have been possible without the controlled insertion of bodies into the machinery of production [...] it had to have methods of power capable of optimizing forces, aptitudes, and life in general without at the same time making them more difficult to govern.[146]

In a much more recent work, *The Uprising: On Poetry and Finance* (2012) the Italian Marxist theorist Franco 'Bifo' Berardi has argued that the systematic manipulation of language is impoverishing society in manifold ways: 'Debt is an act of language, a promise. The transformation of debt into an absolute necessity is an effect of the religion of neoliberalism, which is leading the contemporary world towards barbarism and social devastation'.[147] For Berardi, his hope lies in poetry.

'Poetry is language's excess: poetry is what in language cannot be reduced to information, and is not exchangeable, but gives way to a new common ground of understanding, of shared meaning: the creation of a new world.'[148]

We often shield ourselves from knowledge of the disruptive goings-on of the world, and to some degree we do this for understandable reasons, but this can also help us feel removed – geographically, temporally and by acts of 'othering'. This is not about me/us/now. Somehow, we can't help from removing ourselves from disturbing news, and often keep it at bay. But what has become profoundly strange, yet maybe a paradoxically positive thing, is that the globe is ever-shrinking, particularly in economic terms, and we are all losing grip with a potential fantasy of a 'good life', such that we might endeavour to empathize with those we once considered different, alien, not of our own communities. As Rashbrooke notes, 'Just as concentrated wealth can affect everyone, concentrations of hardship and suffering make us all worse off.'[149] I remain utterly unconvinced that we can simply accept today's climate as it is, even as solutions seem hard to configure. As always, there is much work to be done, along with the hope that cultural work, including interventions, discussions, actions might generate more responses, unanticipated changes and diversions of paths that are not yet clear to us.

22

Billy Apple:
Mercurial Consistency (2015)

Without question one of Aotearoa New Zealand's most remarkable artists, Billy Apple is nearing 80. His lengthy, and still on-going, career has encompassed direct involvement in some of the most crucial phenomena of postwar and contemporary art, from pop to conceptualism, body art to institutional critique, sometimes altogether. While the artist could be considered mercurial in terms of the sheer number of shifts in direction evidenced within his art practice, he has also exhibited a clear and specific intensity to his singular vision, and there remains a discernible, rigorous internal consistency when his oeuvre is viewed as a whole. Apple has been an early and avid investigator of the significance of mass media, as well as an exceptional problem solver, and while these qualities became evident in his advertising work, they become especially intriguing when applied to the context of his art practice.

Born Barrie Bates, in Auckland in 1935, the artist travelled to London in the late 1950s on a grant to study design at the Royal College of Art. Fellow students at that time included the emergent British pop painters Derek Boshier, David Hockney, Allen Jones and RB Kitaj. Bates became a proficient designer, working in advertising in the era now immortalized in the American television drama *Mad Men*. At the time, ideas of 'newness' and 'novelty' were salient points of intersection that artists were locating between art and design. The younger British artists in Bates' circle were intoxicated with a wider range of reference points in visual culture, drawing upon comics, cinema and science fiction. London-born artist Richard Hamilton's 1957 litany of pop art attributes evocatively reflects this new sensibility: 'Popular (designed for a mass audience), Transient (short-term solution), Expendable (easily forgotten), Low cost, Mass produced, Young (aimed at youth), Witty, Sexy, Gimmicky, Glamorous, Big Business.'[150] While scarcity still characterized many sectors of daily life in Britain the post-war prosperity of the United States attracted younger artists from afar.

It was within this environment that Bates, in 1962, presented his most provocative early gesture, the signal one that set in motion a definitive trajectory

for his practice: renaming and effectively 'rebranding' himself as Billy Apple. The images around this act were carefully choreographed, if in a fairly straightforward manner, such that the decision would be captured visually. Apple's 'rebirth' is encapsulated in the black-and-white photograph *Billy Apple Bleaching with Lady Clairol Instant Crème Whip, November 1962* (1962), which shows him with newly blonde hair looking into a small handheld mirror beneath a lamp, in a way that suggested his recent transformation. It was an act of erasure of his old identity, and an assertion of the new, a kind of unburdening. In line with the contemporaneous Canadian theorist and pop culture analyst Marshall McLuhan, Apple was very shrewd in determining and realizing how 'the medium is the message'. In a context of heightened consumerism, the product that was/is the artist Billy Apple began forming, evidenced by initial documents including 'head shot' images of Apple himself taken by the English photographer Robert Freeman – who later became renowned for his iconic depictions of the early Beatles.

While in the United Kingdom, Apple had contact with Lawrence Alloway, the visionary critic who coined the term 'Pop Art' in the mid 1950s. For an exhibition Alloway organized at the Royal College of Art, also in 1962, entitled 'Young Contemporaries', Apple designed the poster based on the submission label for participating artists – which asked for the artist's name, the title of work, price in British pounds and their school – in effect simultaneously calling attention to the process of mounting the show and annexing any surface onto which the poster was applied as his own work. In addition, Apple printed this information directly onto a canvas, creating an early conceptual gesture *as* painting, in much the way the California-based artist John Baldessari would do later in the decade with his works painted by professional sign-painters ironically offering quotes from art critics or, in one instance, *Tips for Artists Who Want to Sell*.

Greatly influenced by visiting New York City where he encountered other pop artists working in the vibrant American consumerist world, Apple relocated there himself by the mid 1960s. He later reflected in *Being Billy Apple*, a 2007 feature film directed by New Zealand filmmaker Leanne Pooley, that in the New York context: 'unlike London, anything is possible'. The seminal 1964 *American Supermarket* exhibition at Bianchini Gallery on the Upper East Side featured Apple along with many important American Pop artists of the period, including Jasper Johns, Claes Oldenburg, Andy Warhol and Robert Watts, with their works presented as if in an actual shop on shelves, in stacks. *Life* magazine highlighted – and ridiculed – the show, and foregrounded Apple's works with a photo captioned: 'Billy Apple gazes over his slice of painted bronze watermelon.' The headline noted that the sculpture in question cost 'only $500 a slice'. Apparently, the best-selling item was a Warhol paper shopping bag emblazoned with the iconic Campbell's Soup logo, which sold for $12 apiece. Much like Warhol, Apple learned from,

and perceptively used techniques drawn from his graphic arts background. This would be in contrast to artists such as Roy Lichtenstein, who came to pop after fine-arts training rather than commercial art gigs.

By 1969, Apple had formed one of the earliest alternative artist-run spaces in New York, appropriately dubbed 'Apple', at 161 West 23rd Street, in his words, 'in order to provide an independent and experimental alternative for the presentation of my own work and the work of other artists.'[151] Apple worked closely with a number of Fluxus artists during this period including Geoffrey Hendricks, Larry Miller and Nam June Paik (the latter recorded a soundtrack to accompany a 1968 film entitled *Gaseous Discharge Phenomena* featuring Apple's twisted, abstracted neon tube works of the time. Fluxus, the (non-)movement of American, European and Asian experimental artists pushing the boundaries of what 'art' can be had a significant presence in New York at that moment and (non-)leader George Maciunas had been instrumental in making Soho an important living-working district for the arts community. These artists, including Apple, were investing their efforts into far more non-commercial, ephemeral and performance-based works. The gallery/studio continued over the course of four years, incorporating a variety of exhibitions and events.

During this time, Apple performed and documented a series of works involving cleaning and sweeping surfaces, both interior and exterior, collecting detritus including broken glass, and, in *Body Activities* (1971), collecting examples of his own bodily fluids and waste in an obsessive and diaristic manner. This series of artworks makes for an interesting meditation on materiality, particularly in light of the burgeoning amount of performance works of the time, such as those of Vito Acconci (*Seedbed*, 1972) and Chris Burden (*Shoot*, 1971) and associated notions of 'dematerialization'. Critics Lucy Lippard and John Chandler had notably characterized conceptual art as increasingly 'dematerialized' by 1967, writing: 'The studio is again becoming a study. Such a trend appears to be provoking a profound dematerialization of art, especially of art as object, and if it continues to prevail, it may result in the object's becoming wholly obsolete.'[152] In his text dated 1 March 1971, however, the artist proposed contradictory aspects of such a designation in his statement: 'If you wipe a dirty spot off a wall you've removed it, but you haven't eliminated it. You're stuck with a dirty rag you didn't have before.' In the *Body Activities* works, Apple's physical residues were exhibited and archived almost as if he were a forensic investigator.

It is also notable that Apple facilitated works of so many Fluxus artists as they were, as a group, generally more interested in advancing an eccentric, playful materialism than involved in efforts to abandon the object–artwork altogether. Yet the no-frills, DIY, street-level egalitarianism of this alternative art scene, despite its temporary freedoms and capacity to fuel innovative modes of practice, ran counter

to the artist's own ambitions for greater public attention. According to American artist Jerry Vis, who exhibited at Apple's space:

> He really wanted recognition. He really wanted fame, and glory and anything that could possibly come from being a successful artist. He wanted world renown. He really did. It was very difficult for him, you know, wanting to be accepted but at the same time wanting to push the boundaries back.[153]

Although personally ambitious and stylistically restless, Apple was sincere in his desire to foster younger experimental scenes. Significantly, Apple would return to making many appearances within the context of New Zealand's alternative galleries later in his career, recalling the early 1970s period in New York. As Auckland-based critic Anthony Byrt noted in 2003:

> In the last decade or so [the 1990s], [Apple] has collaborated with younger artists and has been consistently involved with new contemporary galleries such as Teststrip, 23A, rm401, The High Street Project, and now Ramp, all of which are non-institutional project spaces that have sought to support emergent artists.[154]

Throughout his career, Apple has sought to continue as a productive artist not only working with commercial galleries and major public institutions but as a facilitator and promoter of others. Perhaps, with his media-savvy, Apple also understood that without some efforts at intergenerational recognition and cross-collaboration he would be considered solely a 'historical' artist.

Even through his period in New York, Apple maintained his international connections, and in the spring of 1974, at the invitation of British curator Norbert Lynton, Apple mounted *From Barrie Bates to Billy Apple* a midcareer retrospective at London's Serpentine Gallery, to a mixed reception. In fact, the show was shut down for three days due to complaints to the Metropolitan Police about the *Body Activities* works, which were perceived as obscene and were subsequently removed. This act became a residual documentary work itself, entitled *A Requested Subtraction 10/4/74* (1974). In the aftermath of this, Apple visited New Zealand for the first time after seventeen years abroad, holding out hope for a successful tour at galleries across the country. But instead, he was ridiculed by the popular media for his extreme approach to art in a local context that, despite the efforts of many in the art community, was still very traditional and reluctant to immediately embrace Apple's unconventional practice.

However, from 1977 to 1984, Apple found a more receptive context for certain of his installation works in the renowned Leo Castelli Gallery in New York, which was then a key supporter of pop, minimalism and later conceptualist practices. Apple had first met Castelli through Jasper Johns in 1962. In *Extension of the Given (Stairway Entrance)* (1977), a doorway leading to the gallery was fixed while open, in effect, extending the outward dimensions of the space, with the floor area of the door's arc outside the gallery demarcated by white paint. This referenced the idiom 'get one's foot in the door' and could be seen to echo Marcel Duchamp's earlier *11, Rue Larrey* studio door from 1927 that hung between and served two doorways, defying the notion that a door must be either open or shut.

It is significant to note that while Apple's works have always been attributed under his own name, he has variously enlisted collaborators, co-conspirators and contract workers, echoing to some degree his commercial training and experience. The New Zealand art critic Wystan Curnow worked with Apple as a 'copy writer' and developed in conjunction with the artist some very key notions, slogans and statements cum manifestos throughout the 1970s and 1980s. In the mid 1970s, the critic wrote a lengthy and highly appreciative piece, and later, writing of the artist, Curnow commented in retrospect:

> I decided I would myself act the part of Billy's agent, tour manager and PR man. I jacked up a lecture tour [in 1979] to fund his way around the country [New Zealand], permitting him to take up the opportunities for making in-situ works that had, by then, developed. Several venues were finalized by the time he arrived. Then we discussed his 'psychic insulation' and decided that he would be unavailable for photographs or interviews. Reporters were to be invited to lectures and referred to me in Auckland or to the gallery staff at the venues concerned. Our aim was to frustrate media attempts to fetishize the 'avant-garde' artist.[155]

Appearing on Apple's behalf, Curnow thus became a significant interlocutor and determining figure for the ways in which Apple's work was conceived and elaborated to the public. When one considers how involved and integral this process was to the work of a very driven, demanding and meticulous artist, and for an often profoundly unreceptive audience, this was indeed no small feat.

Despite his own carefully crafted public image, Apple has always sought out intermediaries. In a different sense than Curnow, the Wellington-based art historian and curator Christina Barton, with her voluminous knowledge and archivist's care, has today taken on the role of assiduously articulating the historic significance of Apple's work, most recently in the first large-scale survey of the artist's work at the Auckland Art Gallery this year: *Billy Apple®: The Artist Has to Live*

Like Everybody Else, which selectively presented examples of the artist's practice from the past 50 years. Apple is thus being increasingly recognized as one of the pathbreaking figures in terms of New Zealand's dialogue with historical developments internationally, along with artists such as Len Lye (1901–80) and later Julian Dashper (1960–2009), and gallerist Peter McLeavey (1936–2015).

'The artist has to live like everybody else' is a phrase written by Curnow (also the inspiration for the title of the recent retrospective) for Apple's *Paid* series of the late 1980s, a group of works that present an interesting comparison to Andy Warhol's practice (Figure 22.1). While Warhol was making commissioned portraits for the social elite in his later career, Apple depicted himself trading art for basic worldly needs in this series. For example, an artist-friend of mine paid the bill for the tires for Apple's car so that the vehicle would pass a road-worthy safety inspection. In return, the same artist received a 'custom' artwork from Apple memorializing the transaction. In so doing, Apple offers up a portrait of quotidian life as well as a self-portrait in which his identity remains central, rather than that of the other party in question. While Warhol was quite definitively *not* 'living like everybody else', Apple was making a critical comment particularly related to the smaller, scruffier New Zealand context rather than his longstanding adopted home of New York. In New Zealand, the chances of an artist living off the proceeds of an art practice are astronomically small, both then and now – although Apple has effectively managed to do so. At the same time, he cleverly highlights the notable differences between artists – and the economy in which their art circulates – and other members of society.

Apple built upon this concept through a number of 'Art Transactions' works in which each individual or institutional collector was able to specify certain formal characteristics of the image he produced, in a series of paintings known as *From the Collection of...* , as the title phrase itself is emblazoned on the surface of the work, becoming part of the composition's visual content. Executed in an approach that still summons aspects of institutional critique, the paintings are in effect sponsored by patrons but function within the channels of the contemporary art market. Apple continually reiterates both his status as an artist and his ability to negotiate and disperse his practice across numerous (and unlikely) settings. He has even gone as far as trading his art for dual hip replacements.

Apple's most recent projects have included offering a line of Apple-branded commodities: among them apples (of course), fragrance, wine, juice, tea and coffee, all glossily packaged and designed. In a peculiar way, this lends the impression of an artist who drew inspiration from the commercial environment, in a sense 'corporatizing' and dispersing his identity back into the land of everyday commerce. He is perhaps closing a circuit begun and alluded to more satirically in the *American Supermarket* gestures, an impulse that culminated in the artist's

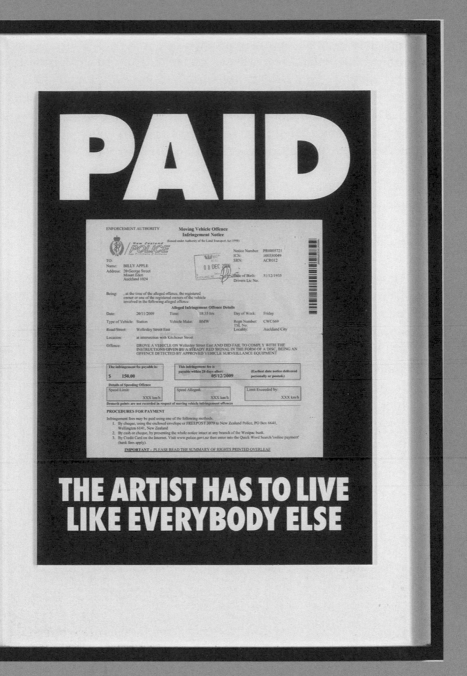

FIGURE 22.1: Billy Apple, *Paid: The Artist Has to Live like Everybody Else*, New Zealand Police Motor Vehicle Offence Infringement Notice, 2009, mounted on A3 paper printed by offset lithography, 565 × 420 × 25 mm³. Collection of Chris McCafferty. Photo courtesy of Billy Apple® Archive.

successful attempt to launch *Billy Apple* as a registered trademark (2007–08). Billy Apple had become a brand of his own.

Another project that creates a twenty-first century reverberation to that of the earlier *Body Activities* is *The Immortalization of Billy Apple* (2010–14), in which the artist, in collaboration with New Zealand biochemist Craig Hilton and biological sciences Professor Rod Dunbar, enables his blood cells to become lab cultures for use in future cellular research, as well as archiving a digital version of the artist's genome. Apple's canvas *I Consent* (2009) reads:

> I consent to the wide distribution of cell lines derived from my blood, including deposit with the American Type Culture Collection cell bank. I understand that this may enable unrestricted use of my cells in research outside my control, including the potential analysis of my DNA.[156]

Thus Apple's attempt to become an externally recognizable identity, a brand, a trademark becomes associated and conceptually merged with his own actual biochemistry and physical attributes.

Immortal or not, 'Billy Apple', a character of his own self-invention, with a little help from his friends, can almost seem like a kind of fictional concoction of multiple selves. I would have thought him a complete and total apparition if I hadn't encountered him myself from time to time, still a tireless and ubiquitous inhabitant, force and prowler of the New Zealand contemporary art scene.

23

Reorientations (2018)

Ludwig Wittgenstein once said: 'A philosophical problem has the form: "I don't know my way around."'[157] I think of this in counterpoint to the fact that today we seemingly always know where we are going, logistically speaking, due to the GPS systems embedded and enabled in so many of our technological devices. This in turn lending the false impression that we might always be able to find our way, that we are exactly situated. Perhaps we have relinquished the notion of 'being lost', via the reassurance of such technologies. But it is important to remember that while our exterior positioning may be spot on within centimetres, our interior subjectivities involve a complex array of flows, collisions, overlaps and inaccuracies. I like to think we are increasingly and fluidly *un*-bounded such that we may take on new behavioural roles, ways of thinking and patterns of living. In turn, the most intriguing works of art actively re-envision, and elicit new readings of our expansive identities in the world. Maybe the most relevant question today is: what is it to reimagine existing forms, histories and figures?

If we continue to think through the implications of slipping away from the precisely located, we might reorient ourselves around idiosyncratic coordinates, unusual patterns and different modes of perceiving our surroundings. The American essayist Rebecca Solnit, who titled one of her books *A Field Guide to Getting Lost*, writes: 'That thing the nature of which is totally unknown to you is usually what you need to find, and finding it is a matter of getting lost.' Reading Walter Benjamin, she interprets him as arguing that 'to be lost is to be fully present'.[158] Any displacement from our normative modes of thinking allows for necessary shifts intellectually, attitudinally and empathetically. To reposition ourselves further from our received notions and constructs ultimately initiates new perceptions and actions.

The late New Zealand ecologist Geoff Park's 1995 book *Ngā Uruora: The Groves of Life* was recently reissued, and his prescience is both reassuring and unsettling, given how certain things have improved since that time and others have not. Park's overall theme concerns how rapidly and unthinkingly the deforestation

owing to colonial settlement occurred here in Aotearoa. A short glimpse of his evocative prose lends a sense of his approach:

> Mention of ngā uruora today is like raising something from the dead. Go into a lowland kahikatea forest in autumn when its koroī are ripening, lie under the towering trees listening to the cacophony of birds and the constant patter of the inedible bits hitting the leaves around you, and you'll know what 'the groves of life' mean. These are the ecosystems that are now, like huia and kākāpō, vanished or down to a few survivors in need of intensive care, their wildness something to wonder at.[159]

Moreover, one might reach further back yet another century to Thoreau's statement that 'Wildness is the preservation of the world'.[160]

Today it is clear that historical eras that once claimed insight and clarity are increasingly problematic, such as the enlightenment or modernism, if read through the lens of postcolonialism or in the wake of postmodernism. Social and political violence has been a recurring symptom of ideologies of progress, and today's neoliberalism is no exception, simply a hyper acceleration of residual processes. Across the Pacific there are certainly regimes in which the mere stating of factual information is ridiculed and dismissed in an authoritarian manner. Correspondingly, being lost is not an entirely bad thing, in that one relinquishes an inaccurate and often unjust sense of control. Also, one might let other entities into the mix, rather than a consistently anthropocentric interference precluding other possibilities. To move into our uncertain future is to accept uncertainty and move in multiple directions, non-hierarchically, dialogically, without trying to navigate with false assurance, but with hopeful curiosity.

PART IV

VIDEO

This section considers a variety of approaches that artists apply to the moving image, from intentionally low-fi social critique (Heynes) to futuristic dystopian parable (Grattan) to an evocative examination of a site and its significance (Te Ao). Many artists of the late twentieth and early twenty-first century have used the video camera as a mode of intervening quickly and surreptitiously, or creating larger scaled cinematic works, but the number of time-based projects seems to have exponentially increased, and despite its ability to travel easily via digital networks, also allows the use of the immersive and often spectacular dark space, or black box, a mirror imaging of the white cube.

24

Shannon Te Ao:
A torch and a light (cover) (2015)

A 24/7 world produces an apparent equivalence between what is immediately available, accessible, or utilizable and what exists. The spectral is, in some way, the intrusion or disruption of the present by something out of time and by the ghosts of what has not been deleted by modernity, of victims who will not be forgotten, of unfulfilled emancipation.

–Jonathan Crary[161]

Life is no way to treat an animal.

–Kurt Vonnegut[162]

At the start of artist Shannon Te Ao's new video work *A torch and a light (cover)* (2015) one encounters darkness, which opens onto a narration of a poetic verse: *Sparkling brightly on high / are a hundred stars of early morn; / Would ye' together were my spouse / I would then enclasp ye all in close embrace. / I would savour unto satiety / This woman's longing within, / Rather than the fleeting caress / Of thee, O thou chilling breeze.* It is evocative even when spoken (as it is here), and summons a broad, lyric expanse; an open reach of the senses, yet rooted in the physicality of romantic love. The origin of this particular waiata remains unclear in terms of its attribution, but its poetic beauty is crystal sharp.

As is the visual information revealed by a slowly panning camera once we emerge from the initial darkness: a grey, industrial locale, almost as if a painterly conjuring of a once-busy site, now more notable for its quietude as we examine its pipes, seams, pores. This specific place happens to be a now-disused meat processing and distribution plant located in the city of Auckland. The fact that it is a former abattoir relates peripherally to the premise of the exhibition for which Te Ao's video was initially commissioned, curator Bruce E. Phillips's

145

Unstuck in Time, a grouping of contemporary artworks linked to discourses around time, labour and history, its title referring back to the late American novelist Kurt Vonnegut's book *Slaughterhouse-Five* (1969), in which the author recounted a science-fiction inflected narrative based on his very real experiences of the bombing of Dresden, Germany during the Second World War (Figure 24.1).

While Vonnegut's novel has sold millions of copies and become a classic anti-war text, what is particularly innovative and still influential about the book is the manner by which Vonnegut overcame his struggle to write a World War II novel by taking stylistic liberties, including with his protagonist Billy Pilgrim who becomes a temporal voyager, 'unstuck in time'. (Vonnegut himself was a fortunate 'non-witness' of the bombing itself, being sheltered in a slaughterhouse, ironically assisting his own survival.) That said, Te Ao in his own artworks that often speak towards unresolved dilemmas, confounding problematics and historical traumas, has done a fair bit of virtual time travelling himself.

Often this has been in the mode of performative actions responding to charged sites, such as in *Untitled (Andersons Bay)* (2012) and *Follow the Party of the Whale* (2013).[163] Bringing us also to a not unrelated notion of whether one can offer meaningful commentary on historical events one has not witnessed. (Of course one could say this is the historian's task.) But Te Ao's work is less documentary-based (although he has often collaborated with and been assisted by videographer Iain Frengley, himself a filmmaker and camera operator) than speculative and ruminative, even hallucinatory. What is the place of an artist faced with the chaotic entanglements of past and present, then and now, Pākehā and Māori, bi-cultural nation-state and indigenous traditions, belief systems and protocols? Te Ao has been making works that incorporate sites, incidents and poetry of Aotearoa New Zealand for the past several years, building an intriguing emergent practice, characterized by a precarious balance between ambiguity and specificity. This precarious balance, or even brittle quality to the work, is evidenced most captivatingly in the third segment of the video, subsequent to the introductory narration of the waiata which overlaps and folds into the slow camera-eye tour of the abattoir (Figure 24.2).

Here we see an assortment of towels, wet, slippery, bodily, a pair of hands folding them, shaping them, almost caressing them. Not sluggishly, but certainly not in an accelerated or frantic manner; deliberate but strange to call such seemingly absurd actions methodical. Although in turn, they become also highly reminiscent of more straightforward, practical actions, such as kneading bread, plaiting hair, modelling clay. And the building of an eerie landscape or a body, in the manner of optical illusions: do you see a vase or profiles? duck or rabbit? But this shaping, this activity occurs in the formal mode of Baroque chiaroscuro, as if

FIGURE 24.1: Shannon Te Ao, *A torch and a light (cover)*, 2015, installation view Te Tuhi, Auckland. Photograph by Sam Hartnett. Courtesy of the artist.

FIGURE 24.2: Shannon Te Ao, *A torch and a light (cover)*, 2015. Courtesy of the artist.

some echo of Caravaggio, absent bearded apostles stepping toward the wound, and replaced by a more homely, concrete action. In Te Ao's video I particularly note, as it progresses, its decisive shift from spoken text to muted performance, as the central activity of interest moves from narration and camera work to the protagonist/artist manipulating his unwieldy choice of materials – the soggy serviettes – which allude to the ways we wrap and comfort bodies: small children wrapped with towels on exiting the bath, perhaps at the other end of the timeline an elderly parent needing assistance with the same. Perhaps swaddling babies for comfort.

Vonnegut's novel bears the subtitle *or, The Children's Crusade*. The author recounts in the first (magnificent) chapter of the book how he is verbally confronted by his friend and war comrade Bernard V. O'Hare's wife Mary who states:

> You were just babies in the war – like the ones upstairs! [...] You'll pretend you were men instead of babies, and you'll be played in the movies by Frank Sinatra and John Wayne or some of those other glamorous, war-loving, dirty old men. And war will look just wonderful, so we'll have a lot more of them. And they'll be fought by babies like the babies upstairs.[164]

Perhaps much as Vonnegut was reprimanded, all we can do is have our children respect the darkness of dreams and possibilities but not to continue to induce and hasten calamities. Vonnegut also writes: 'I have told my sons that they are not under any circumstances to take part in massacres, and that the news of massacres of enemies is not to fill them with satisfaction or glee.'[165]

Theorist Jonathan Crary in his fervent manifesto *24/7: Late Capitalism and the Ends of Sleep* (2013) decries our current near-blind acceptance of seeming non-stop activity, which has steadily eroded cycles of 'down time' and rest since modern industrialization. For Crary, the imagination is inevitably impoverished with the disruption of our sleep/wake patterns; the relinquishing of the state of dreaming is a manifestly political matter: 'A 24/7 world is a disenchanted one in its eradication of shadows and obscurity and of alternate temporalities. It is a world identical to itself, a world with the shallowest of pasts, and thus in principle without specters.'[166] The urgency of Crary's lament has an undeniable power and a particular relevance to artists such as Te Ao and his summoning of specters. There is much that is unseen that is eminently important to reinscribe, revisit, muse over. The critic Mark Fisher has written of 'hauntology' initially in relation to contemporary music, another 'flipping' of linear time structures. As he states:

> What haunts the digital cul-de-sacs of the twenty-first century is not so much the past as all the lost futures that the twentieth-century taught us to anticipate. [...] More

broadly, and more troublingly, the disappearance of the future meant the deterio-
ration of a whole mode of social imagination: the capacity to conceive of a world
radically different from the one in which we currently live. It meant the acceptance of
a situation in which culture would continue without really changing, and where poli-
tics was reduced to the administration of an already established (capitalist) system.[167]

And in an era of near-absolute acceleration of all things, Te Ao's video work exem-
plifies an uncharacteristic slowness: how might we better linger upon things in
order to reflect upon and recognize them, see them for what they are, and could
potentially be. Piercing the darkness is the glimmer of shiny, moist surfaces, highly
ambiguous but leaving things up to the viewer. Make your own decisions Te Ao
seems to say, your own sculpture, your own song. The video has conjured and
thrown us into a residual child's play. Sometimes via memory, song, interactions,
we travel back in time or in interconnected, non-linear time to encounter evocative
glimpses of love, boundless and unpredictable, until it catches us by surprise. And
whether reciting a poetry that responds to emotional intimacy, revisiting a site
charged by intense labour or enacting a performance that remains open-ended, Te
Ao has delivered a visually rendered ode, spanning heart, earth and sky.

25

Watching Sean Grattan's *HADHAD* (2015)

I am wondering whether you might have watched Sean Grattan's *HADHAD* before reading this essay. It is rather daunting to provide an introduction in advance of viewing a time-based work of art, one reason is that while it is interesting to have some initial context, it is also very different from looking at a work 'cold', without previous assumptions, something even rarer with extremely well-known works as their reputations often precede them. Anticipation is one of the most interesting experiential phenomena when approaching any artwork for the first time, so I do not want to completely undermine that process. (I will venture that I have watched this video more than a few times now and it doesn't suffer on repeated viewings, and perhaps only seems stranger.)

One is also disinclined to 'spoil' the work, although while Sean Grattan's video piece *HADHAD* has some of the creepy, thrilling and atmospheric qualities that draw us to popular entertainment, it is not as dependent upon a narrative structural framework. The work is often unsettling, but with top-notch indie production values, and an impressive, highly imaginative scope to its timely themes and concerns. The setting of the work involves both generic California landscape: the interior of a home (seemingly a cabin) and the wooded terrain familiar from exterior shots in many US television films.

We also encounter close-up shots of everyday objects and spaces but instead of being comforting and reassuring they become alien and defamiliarized. Especially, in the case of food, which acts almost as another character in the video (gravy, mush, raw carrots and potatoes). And kitchenware, such as the rectangular plates, white coffee makers and toasters, rows of stools, bespeaking the average Briscoes or Pottery Barn chain store averageness. The actors themselves inhabit a set characterized by its clean, bland surfaces and wear non-descript khakis, pastel shirts, brown loafers: shopping mall couture. (I recall the clothing brand Gap attempting to portray khaki slacks as arty/hip, their advertisements proclaiming: 'Picasso wore khakis', 'Rauschenberg wore khakis'.) Moreover, the set design and costuming appear vaguely anachronistic without accurately conjuring a period piece; some 'good old days' that never existed, a bit like the US brand 'OLD NAVY', its products bearing no relation to either word in its name (Figure 25.1).

150

FIGURE 25.1: Sean Grattan, video still: *HADHAD*, 2012. Courtesy of Sean Grattan.

The dialogue employed in *HADHAD* is a heavily stylized, twenty-first century Orwellian text-speak, almost robotically, unemotively recited. I hasten to add that this strikes me as a very difficult thing to do, and to do well. It also resembles the stark dialogue of independent filmmakers such as Hal Hartley, Jim Jarmusch, David Lynch and Jane Campion. We encounter terse, confounding clusters of aphoristic statements, not unlike the business jargon of airplane paperbacks and corporate PR. *In the future, the past won't exist.* The future-predictive ideology of technological singularity is alluded to throughout: the notion that at some point later in this century artificial intelligence will have spectacularly outshone our own.

> *When the time comes, will humans forget what it was like to die? / The end of death is a likely result of evolution. It is clear that once the exponential acceleration of artificial intelligence begins, the next modification of humanity will follow. This will happen via the metamorphosis of people into digital technology. Elements of this change are visible today. Though nothing can prepare us for what the future will bring!*

Grattan presents us with a bracing artistic corrective to this prognosis here, with future prospects that are envisioned as mundane, ordinary, manifestly beige as our protagonists continue to recite monologues seemingly drugged, or half-asleep, tranquillized, nullified rather than emancipated by progress. There's a weird blankness in their manneristic speech incorporating strange, euphemistic language, bug-eyed earnestness and absence of irony. But the intonation of the actors' voices rises at the end of each phrase, so that each sentence, declarative or not, becomes in effect a plaintive question. And the script takes many knowingly convoluted twists and turns in and out of philosophy, logic and utopic prognostications. (And as a lecturer in art theory, I have the distinct impression that Grattan has also spent heaps of time in seminar rooms and libraries as well.)

Although Grattan has worked in the studio of the LA-based artist Ryan Trecartin, his work is quite different in its more measured pace, style and tone. Grattan has created a darkly perverse imagining that depicts more of a narrowing than awakening of unexplored human potential. If this sounds like it's no fun at all, that's absolutely not the case as it is actually very witty, well-crafted and weirdly enjoyable. Here is where the peculiar artfulness of *HADHAD* comes in, this distorted parable that allows the viewer to trace their own thoughts around its complex, unlikely and perverse surfaces. Moreover, the imagery of *HADHAD* operates along a wide spectrum between the generic and the specific, the former drawn from dystopian characterizations of the suburban wasteland and the latter a peculiarly hybridized amalgam of cultural references and New Age doubletalk. The motto of Google being 'do no harm' even though so much of their technology

derives from the military industrial complex is indirectly referenced in the following dialogue:

> *It may be a fact that violence will become a plug-in like everything else. We only have to fear the sale of that data to a business with aspirations to dominate. However, Capitalism will rejuvenate itself from the inside out, resulting in the opposite of what Hannah Arendt described as totalitarianism: absolute free movement, a purely generative social organization of people. Ultimately, this will remove the need to use violence as a means to success.*

But the loose narrative seems to build towards and hinge upon (spoiler alert!) the appearance of an 'unidentified visitor' in the midst of the five protagonists (three women, two men) we've been introduced to thus far in the video. This follows an after-dinner game entitled 'cards of meaning' and a hummed 'celebration song'. *Maybe it needs help. / Let's bring it inside.* The 'it' in question being a simian-like, furry creature with a featureless fabric head. This creature-apparition also recalls the Surrealistic films of Jean Cocteau and Luis Buñuel or René Magritte's painting *The Lovers*, which features an embracing couple with shrouded visages. Or even the parable-like prehistoric sequence of Kubrick's *2001: A Space Odyssey*. The characters' verbal reactions incorporate the a-typical sort of analyses we've encountered throughout *HADHAD*: *The introduction of a new element into a constellation of previously existing elements only causes a disruption if the formula that describes the situation cannot account for the results.* Further reactions include mimetic bodily responses to the 'creature:' crouching positions, elbows bent and jutting out, knuckles laid flat, poised on furniture. And, in the end, a precarious, Asana-style pose. *Did it just move?*

Generally speaking, which is pretty hard to do about this video, one might offer that *HADHAD* burrows into, and revels in, the enormous paradoxical contrasts that emerge between an embodied 'being in the world' and the dream/ nightmare of a dis-embodied, entirely virtual state of existence. Smiles become grimaces, food becomes repulsive and language becomes incomprehensible. The creature that makes its appearance known 'does not compute' in relation to the situation in which it arrives. This tension is made manifest both through the recited dialogue and the increasingly higher volume, Goth-ambient quotient of the soundtrack.

> *What I am doing right now does not make sense to me I believe that my actions are being controlled by a force that is outside of my body. [...] I am concerned that we do not know what to call it. And this uncertainty plants a seed of fear in me.*

But finally, *do not* be afraid, and *do* watch *HADHAD*. Even with its 'scary' parts it is not half as frightening as the world it is responding to with utterly disarming accuracy.

NOTE

All italicized sections in body of the text are quotations from *HADHAD*, which can be freely streamed at https://www.circuit.org.nz/film/hadhad. Accessed 16 December 2021.

26

On Mike Heynes:
Video Art, Animation and
Activist Critique (2016)

Video and installation artist Mike Heynes has a kind of perfect pitch for recognizing the extraordinary nuances hidden within anachronistic pop culture, spanning low budget movies, children's claymation, trash television, music videos, underground comics, punk graphics, movie titles, kit models, miniature train sets and action figures (among many other things). But alongside this, Heynes is an (ir-)reverent student of experimental film and video and its heritage, particularly such West Coast American figures as George and Mike Kuchar (video diaries), Bruce Conner (collage aesthetic) and Craig Baldwin (experimental narratives from found footage). There is a fair dose of Kenneth Anger's countercultural obsessiveness and John Waters's dark campiness influencing the mix as well. And Heynes's interest lies often in how the undercurrents of our never-ending sea of popular culture wash ashore deceptively magical detritus, such that even as cycles of cultural production become less representative of the current mainstream it never completely disappears.

In Heynes's earlier videos, scales, colour and sound are wildly variable, as miniature toys of different makes, models and origins compete as actors in a bizarro-world repertory company (toys consistently reoccur in Heynes's projects, shifting from starring to supporting roles). Heynes has also made sculptural installations featuring fantastical dioramas. In the short video *Toxic*, a monstrous toddler toy of gigantic proportions is held at bay by G.I. Joe-style soldiers, punctuated by loud graphics: *How can they stop him? Obliterate? Or medicate?* The video is the average length of an old-fashioned pop 45, 2 minutes and 25 seconds, and simultaneously resembles a trailer for a lengthier undertaking. In his *Schlock! Horror! Death of a B-Movie Empire* (2005), Heynes stitches together the composite elements of old school horror movies, mixing live action campy action with stop motion animation once again, but as a damning criticism of the increasing hegemony of the 'Wellywood' aesthetic, rather than the

low-fi NZ cinematic ventures of the past (ironically the earliest efforts of Peter Jackson exemplify this, such as *Bad Taste* (1987) or consider Jackson's childhood obsession with both *King Kong* and Ray Harryhausen's stop-motion spectaculars). More titles for imaginary (but quite enticing films) lurk within: 'Satanic Cult of the Zombie Motherfuckers' anyone?

Heynes's practice has strong affiliations to a number of underground aesthetic and fringe ventures of New Zealand, often exemplified by its avid and vibrant music subcultures, such as the legacy of Dunedin's Flying Nun records, and the on-going rock and roll mania of bands associated with the Stink Magnetic label. Heynes credits the influence of stop-motion animation in early NZ music videos including those by legendary musician and artist Chris Knox, which have a charming, low-fi aesthetic: op shop meeting bedroom clutter. Heynes' works also bear affinity to those of artists like Ronnie van Hout, whose clever and idiosyncratic perspective also emerges more from NZ's subterranean music scenes than its visual arts establishment. And as mentioned previously, figures like Craig Baldwin whose use of found footage, reconstructed and sutured together has resulted in some remarkable films and has also allied itself with the kind of appropriation-ist/mash-up/remix efforts of figures such as the band Negativland, who were the focus of Baldwin's documentary *Sonic Outlaws* (1995). Heynes calls attention in his own practice to the methods behind the madness of big and small-scale film and video making, demonstrating as a counter-critique that the attempts to make seamless, computerized entertainment fodder today betray all the seams and fissures that are being avoided. In turn, Heynes asserts the power and pleasure of the dodgy edit, the ridiculously artificial, the concertedly amateur. Of course, the very act of taking this on involves a prodigious amount of skill and clearly focused intent.

But does the so-called retro stay merely retro when creatively revitalized, or dare I say it, reanimated? What might Heynes's Dr Frankenstein-style hybrid zombie remixes of our ancient nightmares and utopian dreams of the future tell us today? I think they fit in well with an ongoing archaeology of the past yet emerge from a generational standpoint that well predates hipster hunting and gathering, in part exemplified by its very real attachment to and affiliation with a DIY ethic and its socio-political ramifications. To some degree, one could say that Heynes's process manifests the detail-orientated focus of a fan/curator/historian with the rebellious energy and contrarianism of any good artist. Heynes has in addition been an educator for many years, both teaching animation and offering skilled technical support to art students just getting the barest grasp of options that lie ahead of them. He has also the key awareness that the technical format must fit the task needed, rather than to rush blindly towards the default visual norms that become standardized all too quickly. That is to say, low tech and old tech can still

be operational in our digital, increasingly high-tech mainstream surroundings. Moreover, interrogating the ways in which media forms have intersected with specific ideologies of production and dissemination has been a primary area of interest throughout Heynes's practice.

Many of Heynes's works, despite their fascination with pop cultural excess, exhibit a lean, intensely concentrated quality that sometimes might be the inevitable by-product of the laborious process of stop motion (i.e. vastly time consuming to create a short work) but also it ties in well with an aesthetic which manifests a short and sharp wicked humour. Again, as in the best rock and roll songs, Heynes can present a killer magnum opus in fewer than three minutes flat. I am exceedingly fond of *Punk Shane* a captivating story told with dolls, vivid marker placards, a *c.*1982 video arcade, and mini BMXs. We all likely have had the sketchy, cooler older friend/acquaintance/sibling that made us envious of his/her ever-dubious exploits? Taking the form of a Thor/wrestler-like figurine emblazoned with punk logos (Dead Kennedys, Sex Pistols), Shane is a disturbing everyday anti-hero. 'Punk Shane was my hero / He left school at 14 / name like a movie star / He acted up for me and my friends / We met at the shopping mall...'[168] Robbing the cricket club and sharing the proceeds with the young 'pussies' that admire him. A bit of a dickish role model to say the least, doll Shane becomes the star of a spot-on suburban critique.

Heynes's work has moved into a quieter, more subtle area of exploration in recent years, as reconfigured train model sets become the setting of an uninhabited ghost town, the effect of which often seeming like some post-apocalyptic travels into a spare, strange environment: Could it be middle America or rural New Zealand? ... Central Europe maybe, or some preposterously conjured Fantasyland? In relation to the 'uncanny' aspects of the ghost town, the artist has noted that: 'In 1906, German psychiatrist Ernst Jentsch first described the uncanny "as something one does not know one's way about in"'.[169] This bears an intriguing resemblance to Ludwig Wittgenstein's statement in his book *Philosophical Investigations* that: 'A philosophical problem has the form: "I don't know my way around."' At any rate, this viewer's own navigation through the desolate streets of ghost town was an eerie experience. Just as with *To Be Continued...* (2015) in which soap operas are evoked via the use of dioramas featuring drunken festivities, classic cars, gaudy motels, conspiratorial behaviour, everyday deceit and drudgery, voyeurism, violence and other dastardly acts, another epic, which unfolds in only seven minutes.

A key aspect of Heynes's practice is the targeted, critical inspection of cultural genres, from sci-fi, fantasy, music video and horror to the melodramatic posturing of the episodic soap opera. Typological patterns in pop culture intrigue due to their relative rigidity and consistency, just waiting to be détourned and subverted in the

FIGURE 26.1: Mike Heynes, *News of the Uruguay Round*, 2016, installation view, Adam Art Gallery (2021) as part of 'Image Processors: Artists in the Medium 1968–2020'. Image courtesy of Adam Art Gallery.

name of art, or indeed sheer pranksterism. Some of Heynes's most recent works have involved the reconfiguration and remaking of now-superseded Hollywood studio logos of the 1990s, including Universal's globe and TriStar's Pegasus, by this very act bringing them forward into sharp focus rather than as a parenthetical, often overlooked entry point to a film, yet also bringing them back down to size, as instead of high gloss motion graphics (Figure 26.1), Heynes creates them with his characteristic hands-on animation techniques. Heynes's work in process brings to mind a key early postmodern film installation by artist Jack Goldstein, *Metro-Goldwyn-Mayer* (1975), which consisted of the incessant looping of the MGM lion's roar, with no subsequent feature to follow in its wake.

The irony now is that while Goldstein in an earlier era was arguing for the significance of a more cinematic-style approach to contemporary artworks, now such works are ubiquitous, and Heynes's practice reminds us of the political and historical trajectories that led us to the present moment. Most specifically these works emerge from Heynes's examination of the multinational trade agreements that unleashed a flood of entertainment from elsewhere onto Aotearoa NZ's screens but failed to protect the country's own film and video production base. Heynes comments that: 'The re-made logos are deliberately shonky, critiquing a persistent presence overshadowing our local identity. As a nation, we are missing the collective experience of seeing ourselves reflected on television in a meaningful way.'[170] I would add that Heynes's project seems equally critical of the eerily amnesiac and atomized viewer-spaces we now frequent: viewing streaming video files via our smartphones, tablets and laptops, drastically severed from the classic modernist modes of shared cinematic or televisual spectatorship. This critique could make for dark, drab and disconsolate results, but on the contrary, Heynes's abundance of stylistic flair and wit makes his work always remarkably watchable, and ultimately empathetic rather than alienating.

27

Pat Badani:
[in time time] (2008)

Tarble Arts Center, Eastern Illinois University, Charleston, IL, USA

Throughout her recent works, Pat Badani has enacted and exhibited an eclectic history of infiltration, a trait that goes along extremely well with the mode of operations that a mixed-genre or interdisciplinary practice necessarily entails. Badani's complex works most often explore not what already exists, but what might yet occur. This approach has resulted in a substantial group of open-ended works with indeterminate outcomes stemming from highly detailed and orchestrated 'set-ups'. By using the term infiltration, I intend to emphasize the manner in which the artist has relocated her artistic practice into various non-art settings, and equivalently aspects of the outside – non-art-world – that continually make inroads into Badani's context-specific works.

Projects initiated since the late 1990s have been characterized by the integration of digital media and environments. Moreover, whether her work is seen in a public setting, virtual site or more conventional art gallery, Badani seeks to downplay such distinctions in favour of creating, in her words, a 'communicational space'. Such a space, insofar as it fosters dialogue, then becomes far more evocative and incorporative of the problematic art-life questions of the current moment than a more traditional mode of practice.

This participatory approach has included such interdisciplinary specialists as physicians or architects along with the audience/viewers, but perhaps just as importantly the artist herself, as when Badani worked alongside bakers in one of the most prestigious of Paris bakeries to achieve her works *Tower-Tour*, *Urban Projects* (both 1997), *Cultures and Ferments* (1999), *Home Transfer* (2000) and *Where Life Is Better* (2003). She continued to work with the public-at-large in six international cities for her award-winning project *Where are you from? Stories* (2002–06), and in the case of *Me&U2* (2005), integrated physical computing. The resulting projects were manifested in multiple forms: sculptural installation, large-scale documentary plates, videos and web-oriented works. One testament

160

to Badani's thoroughly interdisciplinary approach is the fact that her work has been recorded in – and thus infiltrated – such radically disparate venues as a glossy book documenting the history of bread-making and the Poilane bakery, as well as the most competitive of international digital art and video festivals.

Badani has moved and travelled widely and makes her home, so to speak, in a rather destabilized methodological notion of artmaking. I recall Christian Boltanski's 1985 comment, 'I belong to the young tradition of Central Europe, but my real country is painting.'[171] This is not a dissimilar predicament from that of many artists who inhabit an increasingly global artworld, yet Badani has been more mobile than most. Originally from Buenos Aires, Argentina, Badani currently lives in the United States, and has also spent time as a resident of Mexico, Peru, Canada and France.

At times, Badani's practice seems dematerialized and 'rootless' while displaying a strong set of convictions regarding urban space. Having infiltrated such a variety of cosmopolitan locales, Badani seeks (and becomes) energized through her relation to these sites, characterized by their multiplicity, changeability and potential for growth, perhaps in accordance with Situationist International founder Guy Debord who theorized the effect of the city in concert with an active participant in his *Theory of the Dérive* (1958); and more recently critics such as Claire Doherty and Nicolas Bourriaud who have championed the shift of contemporary art 'from studio to situation'.[172]

However far Badani has travelled in the noise and clutter of her urban trajectories, her works in the current exhibition are noteworthy in that they again encompass the tensions of both leaving and returning home. *[in time time]* presents the viewer with two time-based pieces, *[8-bits]* an intimate, split-screen, looped documentary video; and *[ping-pong-flow]* a context-aware, interactive video installation. In the artist's words:

> The pieces are bound together by their related concerns: consciousness and reality, time and memory, and the relationship of sender and receiver in a communication channel; yet differentiated in their embodiment and in their speculative vantage points, specifically in the way that images and human experience converge.[173]

In *[8-bits]*, Badani incorporates a relative quietude into the (at times either bombastic or inconsequential) medium of video, contrasting citations from existing films and texts with close-up 'home-movie' style renderings of the artist's father depicted while questioned by the artist herself. Badani described the origin of *[8-bits]* in the following statement:

> The work began during a trip to Buenos Aires where I travelled to spend a couple of weeks with my ailing 86-year-old father. As a means of spending quality time with

him I suggested that we play a 'game' whereby we would take turns sharing personal experiences: an exercise in 'memory,' but also in 'imagination' given the fact that details pertaining to past experiences are partial and that imperfect memory invites imagination and creative embellishment through storytelling.[174]

Notably, the exploration of memory dominates the works of many of the greatest modern and contemporary writer/storytellers: Beckett, Kundera, Nabokov, Proust, Sebald, Stein and Woolf (Figure 27.1).

What is it to recycle, repeat and recount 'bits' of memories? What kind of infiltration into memory, and what kind of stitching together occurs in the resulting piece? The artist's father likened the 'interview' situation to a game of ping pong, and such a metaphor preserves a notion of tension but also a ritualism, flirtation, a somewhat awkward dance and in addition an intellectual sparring match. An act of moving back and forth, gaming, flickering. It is a curiously captivating choice, that of the artist's, to use shaky, hand-held camera work – from two parallel yet different points of view (from the separate cameras held individually by the artist and her father) – to anchor and ground a video work, made in an era that while characterized increasingly by disembodiment is often represented by forms of pristine clarity.

To subject a member of one's immediate family to interrogation is a tricky business. Interestingly there exists a rich history of artists engaging with their elderly parents: Art Spiegelman in his magisterial graphic novel *Maus*; Richard Avedon photographing his father's deteriorating health; and Bill Viola depicting his mother on her deathbed. Video as a medium itself intimates mortality, as it is ephemeral, luminescent, bespeaking a life-like quality, while being simultaneously spectral, ghostlike and secondary.

In *[8-bits]*, a split-screen world, we as viewers are offered a riveting set of short monologue/remembrances by Sr Rosato (the artist's father), interlaced with the facing reality: texts, drawings and alternate views of the 'narrator'. Sometimes left coincides almost exactly with right, as when the spoken phrase 'I see his face now' synchs up with the text 'I remember clearly his voice'. Eight bits of information correspond to the eight decades of Sr Rosato's life. Despite the inevitable anxiety that might occur with the difficulty of summoning certain memories, according to Badani's rules for the Ping Pong game, 'bad memories were not allowed'.

As he draws his childhood toys, an entrance to his school, the outline of the Americas, Sr Rosato maps his words and thoughts, offering (albeit with a slightly tremulous hand) a cartography of his consciousness. This act of both reiterating and reorienting clashes significantly with the repeated statement: 'I can't recall it very well. It's become very, very blurry.'

FIGURE 27.1: Pat Badani, *8-bits*, 2008, video stills extracted from *8-bits*, a split-screen video documentary included in the installation titled *[in time time]*, commissioned by the EIU Foundation for their Contemporary Currents series and exhibited at the eGallery, Tarble Arts Center, Eastern Illinois University, 2008. © 2008 Pat Badani. Courtesy of the artist.

Badani incorporates appropriated texts, including those of author Jorge Luis Borges, and filmmakers David Lynch and Ridley Scott, but that said, one of the most important points to make in relation to the use of borrowed words is that such textual information then becomes transformed into the artist's own words, via their recontextualization, creating a third/new quantity. And, as the viewer's attention is competed for by each side of the screen, he/she is forced to make choices akin to editing and 'recreating' the work anew each time. As artist Victor Burgin recently pointed out: 'The arrival of the domestic video cassette recorder, and the distribution of industrially produced films on videotape, put the material substrate of the narrative in the hands of the audience. The *order* of narrative could now be routinely countermanded.'[175]

Sr Rosato is also playing an unusual role, by the very fact of speaking by choice in English, his second language, somewhat ironically to detail incidents from his earliest memory and his childhood. Of course, in the twenty-first century English is the new Lingua Franca, but furthermore the venue for the premiere of this video installation is situated in the heartland of the United States. Interestingly, the last recollection of Sr Rosato involves his trip to Los Angeles in 1945: 'I always wanted to go to the United States [...] to be on the other side of the screen. Not looking at motion pictures but entering [...].' The indistinct qualities of actual memory here act in confrontation with cinematic reality. A wide variety of artists have been taken with this notion of 'entering', from Buster Keaton's portrayal of a projectionist in his film *Sherlock Jr.* (1924) to Woody Allen's fantasy *The Purple Rose of Cairo* (1984), in which actor Jeff Daniels steps 'out' of the screen to spend time with Mia Farrow, and then yearningly invites her to join him within his 'real world'.

But for all today's talk of near-complete immersion in contemporary virtual worlds, and the corresponding increase in fluidity and clarity of images, they remain fragments, nonetheless. Rather than delivering reality whole, artists must still exactingly manipulate specific portions of image, text and sound. However closely *[8-bits]* resembles and incorporates aspects of the document, archive and oral history, it escapes those inflexible categorizations via its transformation into art, rather than simply artefact. Pat Badani's accomplishment here (with the quite singular cooperation of Sr Rosato) is to broaden our awareness of elusive aspects of memory and mortality when examined in the light of the new emergent media.

In the second work, *[ping-pong-flow]*, a 3-D engine, more widely used within the context of video gaming rather than the art gallery, electronically configures direct interaction between gallery visitor and work. This process/experience/event consists of a floor projection featuring an 'avatar' depicted within a darkened, circular vignette, set and thus contained within a low barrier creating the illusion of a receding pit.

The avatar (performed by Badani herself) subsequently reacts via a number of gestures to the movements of viewers around the simulated pit. The gestures are enumerated by the artist in the following list:

[R]eaching out to touch them (touch), disapproving (no-no-no), being scared (scare), hiding (peekaboo), bending down to take a careful look at them (bend-down), laughing at them/with them (chuckle), avoiding their gaze by pretending not to see (see-not-see), falling down if the pit zone is invaded – like a hand or a foot waved within the pit area, in the projection zone (fall), etc.[176]

In direct contrast to *[8 bits]* which refers to past experience, this work continually unfolds in the present, activated by the real time experience of the participants.

One common received notion of digital art is that via its use of technological mediation, the viewer becomes more removed and distanced from direct experience, however Badani's intention is to seek the converse: 'an emotional space; felt, expressed and communicated through the body and between bodies (the virtual avatar, and the real physical bodies of those interacting with the piece).'[177] Badani's manner of using technology seems as evocative of Magical Realist fiction as computer-driven (neo-)conceptualism. Her often whimsical and persistent use of intentional discontinuities, shifting perspectives and dreamlike atmospherics owes much to an approach indissociably linked with the Latin American creative context. Particularly Badani's hybrid art, transported as it has been in her suitcase, or laptop if you will, is rooted in a postcolonial mode of critical practice, where the fantastical and the political collide.

The very fact that the avatar/personage on view is the artist herself brings to light a significant link from one piece in the exhibition to the other, that is to say, the use of both the artist and her father instead of actors from the 'outside'. However, Badani is equally interested in exploring the differences as well as the continuities between the works. In her *words*: 'If in *[8-bits]* the viewers are enlisted as perceptual editors, in *[ping-pong-flow]* they are enlisted as activators.' Thereby the movement of spectator from one installation to another by circumstance mimics the ping-pong-like motion from father to daughter created in the earlier work. A childlike 'game' of cause and effect might be said to reverberate around the totality of the exhibition space, creating a number of points of intersection between the works, and intriguingly in the reactions of the spectators.

28

Bogdan Perzyński:
Selected Photographic Documents and Video Works (2011)

Bogdan Perzyński, an artist whose own emergence paralleled the nascent postmodernism of the 1970s–80s, has consistently directed his creative process towards notions framed by language: communication and translation, borders and transformation, and the myriad social, political and interpersonal codes that define our everyday existence. Moreover, throughout the course of his works, Perzyński has carefully used aspects of technology to forcefully evoke the demands and pressures of manifold surrounding contexts. According to the artist, 'I see my work more as an organism than an object; a living system that is capable of reacting to stimulus, growth, replication and maintenance.'

Initially, Perzyński's artworks investigated the discourses of public space, cinema and philosophy, culminating in a period during the late 1980s–early 1990s characterized by a number of intricate wall-mounted and large-scale room installations. A significant turn since that time has been the shift in Perzyński's practice from his allusions to temporality often taking the form of mechanically and electronically driven constructions to – in their place – an on-going series of time-based video works which incorporate a wide-ranging amalgam of content, from spare, straightforward imagery, to complex, digitally produced scenarios.

The full-length video *Fortune Teller*, undertaken over 2004–10, is the major work of this stage of Perzyński's artistic trajectory (Figure 28.1). *Fortune Teller* derives its structure from the calendar year, as the artist describes:

> The year 2004 was a leap year. That year I collected twelve monthly horoscopes from a Vogue magazine subscription. I was not its subscriber; in a way I inherited them. It occurred to me that these short texts had the potential to become video scripts. It is noteworthy that contrary to my long-lasting interest in new physics, I did not have ongoing interest in astrology. At that time, *Fortune Teller*

FIGURE 28.1: Bogdan Perzyński, *Fortune Teller*, 2004–10, video stills. Courtesy of the artist.

was a compassionate attempt to work with astrology and new physics. I was imagining dyadic communication, with 'epistemological anarchism' in mind, to use the term of Paul Feyerabend. Uncertain about the outcome I proceeded with caution.[178]

In *Fortune Teller*, compelling yet oblique, abstract and frequently montaged images attempt to build outwardly from the traces of those horoscope pages. A compilation of brief vignettes, none lasting more than five minutes each, representing January–December, according to Perzyński, *Fortune Teller*'s component sections may be either sampled in no particular order or viewed from start to finish. There is a lush, dreamlike atmosphere to *Fortune Teller*, acting in tension with its structural rigour.

Perzyński's recent video works are also significant in that they move towards a more direct collaboration and spontaneity, less evidently beholden to technological strategies. In *A Family and Friends Event* (2010) a trio of women sing karaoke-style to the sentimental oldie 'Unchained Melody', while phrases – mostly taken from the labels of packing and shipping supplies – are simultaneously presented onscreen: *CLOCKS AND COUNTERS, BEING QUITE REAL, HANDLE WITH CARE, EXPOSED TO HEAT, HOURS OF IDLENESS, FREE AT ALL TIMES*. Lyrics, slogans and staging running counter to the evident fact that the singers in question are clearly enjoying themselves.

In *I Will Have Gold* (2011), three different women in succession face the camera (and the offscreen artist-director) while cursing. While the first two protagonists fail to muster much performative energy, the third appears to vividly deliver the goods – gold – so to speak. The video summons such settings as the audition and the screen test (whether in Hollywood or in Warhol's factory, for instance) and the notion of staged vs seemingly 'authentic' emotions (often rather disturbingly, as in some of Nauman's confrontational works) and also the difference between the trained and the untrained actor, which could work helpfully in either direction, as in Robert Bresson's use of amateur actors, or John Cassavetes's seeking of truthful emotions from highly trained actors. Perzyński highlights how vernacular language seems stiff and all too inadequate when put 'front and center' in a theatricalized environment, whether in studio isolation or a karaoke stage.

Perzyński has had a longtime interest in the interdisciplinary nature of art and has sought to incorporate creative dimensions that often remain elusive, without reaching for them with the use of new tools, hybrid forms and an openly inquisitive, multi-layered approach. One could conclude that an outcome of this methodology might involve an overestimation of technology itself as a sort of an artistic panacea, but with his contributions to expanding the frontiers of art this proves

manifestly to not be the case. In addition, the artist's work has shown an increasing interest in undertaking social criticism and analyzing the dystopian aspects of our 'high tech' world: the US-led wars in Afghanistan and Iraq, the continued use of the death penalty in 34 US states including Texas, where Perzyński currently lives and works. In his installation incorporating digital animation, *The Walls* (1999–2003) exhibited at Silpakorn University, Bangkok, Perzyński presented a view of a death chamber with the intention of 'deconstructing our feelings of comfort or indifference about death row'. The artist's *Not Good for Business* (2005) sampled and represented footage from the televised propaganda campaign leading up to the Iraq invasion.

Perzyński has frequently used cameras and sound equipment in tandem with sensors long before it became a mainstay of so much contemporary art practice. In his 1995 solo exhibition *Beware of Blindman Pictures*, the artist confined several installation works within a walled-off area, thus viewers were only able to glimpse the works via the operation of two motorized surveillance cameras, and in turn, the viewers located in what the artist termed the 'control room' were also being surveyed by an additional camera. The following year in Wrocław, Poland, a work entitled *Transfiguration of K.* featured an improvisational performance by the artist in collaboration with the classical musician Cezary Winiarski, as the movements of both participants activated sensors in the two-room installation. Perzyński has consistently shown strong interest in mirroring, doubling and splitting, via the use of partitioned settings, diptychs and dual screens. Yet this act of rupturing is often sutured together or otherwise intervened upon by an additional element, such as the spectator, another space, action or technological element, displacing and reworking the initial schema.

As far as Perzyński's actual geographic trajectory as an artist is concerned, it has also been a complicated one, as he emigrated from his native Poland in 1983, after intensive involvement in the neo-conceptual art scene of Poznań, and its unofficial artist-run galleries. Perzyński then spent some time in Hamburg, Germany before taking up lecturing positions in Santa Barbara, California, then finally to Austin in 1987. For an artist in the United States to work outside its primarily coastal metropolitan centres, such as New York and Los Angeles, can amount to consigning oneself to remaining 'off-the-radar' while still on the map. At least this was the general perception that circulated widely some years ago, prior to the era of ubiquitous internet connectivity and globalized exhibition circuits, in which Perzyński has recently become an active participant, with exhibitions, residencies and screenings occurring in Brazil, China, Greece and elsewhere.

Perzyński has also been a longtime faculty (and founding) member of the innovative 'Transmedia' program at the University of Texas, which argued for and actively supported students pursuing approaches that often lay 'beyond

traditional media'. Performance, video, installation and often-uncategorizable interdisciplinary hybrids began to work their way into a curriculum that had generally emphasized narrative painting and straightforward photography. Perzyński has evocatively described his own shift from more traditional media into electronic experimentation 'as if you would gain new vocal cords'. This also brings to mind in an inverse fashion Matisse's famous statement that 'he who wishes to become a true painter must cut out his tongue'. But moreover, it calls attention to Perzyński's own restless investigations of the mutable, changing nature of the artistic voice, particularly in an era where such voices are disseminated widely in an almost spectral fashion, but simultaneously seem to have great difficulty being heard. The rich significance of Perzyński's body of work is that in its shifting attempts to interrogate the world, a sharp, resolute voice is ever-present.

PART V

BOOKS

Contemporary visual artworlds are both heavily invested in and influenced by multiple discourses. The contexts which surround any artist, artwork and/or exhibition, can prove crucial to having a better sense of the practices at hand, along with their significance, their implications and their transitory settings. Here, I review several books on significant strands of contemporary art practice, including on performance (Braddock), social practice (Sholette and Ressler), relational aesthetics (Barikin) and avant-garde histories (Jackson, Horrocks).

29

Clement Greenberg: Late Writings, ed. Robert C. Morgan, University of Minnesota Press, 2003

One of the problems when considering Clement Greenberg (1909–94) and his critical legacy remains the fact that he was such a polarizing figure in the artworld for many years, such that frequently the responses his writings elicited conflate aesthetic and personal disagreements. In his reflective and informative introduction to *Clement Greenberg: Late Writings*, editor Robert C. Morgan – who has written extensively on Conceptual and Minimal Art – attempts to provide a more balanced portrayal of Greenberg as critic than is generally available. As he states,

> Significant criticism is not contingent on whether one agrees with a critic's lifestyle or even his judgments; rather it depends on how effectively the critical arguments are presented, how cogently the analysis is developed in relation to an artist's work, and the level of maturity at which certain insights emerge in the process.[179]

The later writings of Greenberg have very often, due to his increasingly idiosyncratic judgments – such as calling Jules Olitski the most significant painter of the late twentieth-century, when virtually no one else shared that belief – been ridiculed and considered lesser. However, the recent appearance of this carefully compiled volume illuminates the unexpected strengths of several of these texts. Certainly, by now the deficiencies of Greenberg's formalist critical approach are more than evident, largely through its exclusionary tactics such as the treatment of extra-pictorial information as superfluous. In stark contrast, the best examples of art criticism today incorporate a far more inclusive attitude towards the surrounding social and political context. Moreover, the eclectic cacophony of 1960s–90s art seemed almost destined to leave Greenberg's brand of formalism aside. Two recent exhibitions, which surveyed aspects of contemporary painting, *Painting at the Edge of the World* (Walker Art Center 2001) and *Cher Peintre* (Centre Georges

Pompidou 2002) had little to do with Greenbergian notions except to disallow their significance.

It is crucial to recall that it was during the 1940s that Greenberg worked most prolifically as a critic. In that period, he became an admirably eloquent writer of clear, crisp prose which presented considerable demands and challenges to his readers. As early as 1948, he described poetically the all-over aesthetic of Jackson Pollock (and others) as a 'hallucinated uniformity' which 'corresponds perhaps to the feeling that all hierarchical distinctions have been exhausted, that no area or order of experience is either intrinsically or relatively superior to any other'.[180]

'Modernist Painting' (1960) is however the most well-known essay in terms of outlining Greenberg's expectations for an extended modernist project:

> The essence of Modernism lies, as I see it, in the use of the characteristic methods of a discipline to criticize the discipline itself, not in order to subvert it but in order to entrench it more firmly in its area of competence.[181]

This sentence is almost excruciatingly compressed in space given the complexity of this formulation. Greenberg notoriously privileged vision made manifest through the medium of painting. Ultimately, he could not abide the conceptualist modes of artmaking in which visuality is often beside the point, or a strictly marginal concern. Thus, without being able literally to see the work in a more traditional sense, he was unable to devise an appropriate response and labelled much of this work 'novelty art'.

In Greenberg's later essays, he shifted his focus from a succinct description of current painterly practice to a specious historical trajectory, and with very few specific works of art used as support for his arguments, they tend towards a heavy-handed didacticism. Greenberg's self-criticism began to verge on self-parody. This is the point at which the *Late Writings* begins, covering material written by Greenberg for a variety of contexts throughout the 1970s and 1980s (the earlier four-volume *Collected Writings*, edited by John O'Brian, span the years 1939–69) as well as several lengthy and often fascinating interviews, which account for more than a third of the book. Many of the essays discuss and reiterate Greenberg's primary preoccupations: the role of the avant-garde, the significance of Modernism and the centrality of aesthetic experience.

One of the most striking aspects of the collection is the near ubiquity of Duchamp who was barely mentioned in the work of early Greenberg. By the 1970s, however, the critic began to discuss how Duchamp's influence in effect derailed his own vision of Modernism. In the opening essay 'Counter-Avant-Garde', 1971, Greenberg discusses how, in part owing to the example of Duchamp,

[t]he notion of art [...] proves to mean not skillful making (as the ancients defined it), but an act of mental distancing – an act that can be performed even without the help of sense perception. Any and everything can be subjected to such distancing, and thereby converted into something that takes effect as art.[182]

He calls this 'raw art' or 'art at large'. Greenberg credits Duchamp with the decision 'to show that "raw" art could be formalized, made public, simply by setting it in a formalized art situation'. Of course, in Greenberg's estimation Duchamp is assigned a 'cultural' rather than 'artistic' importance. Thought-provoking comments such as these refute the characterization of Greenberg as overly simplistic, and such material has been used to great advantage by theorist Thierry de Duve in the unusual intermingling of Duchamp and Greenberg in his book *Kant after Duchamp* (1996).

In a 1969 interview Greenberg stated: 'I say that if you have to choose between life and happiness or art, remember always to choose life and happiness. Art solves nothing, either for the artist himself or those who receive his art.'[183] This has a curious resonance to it, when compared to Fluxus artist Ben Vautier's text piece reading 'I don't want to do art. I want to be happy'. Or Duchamp's job title used to introduce him at a symposium in 1957, 'mere artist'. Or Gerhard Richter's belief that art cannot rescue the artist nor the viewer from the real horrors of the world. Or the attempts of such artists as Robert Rauschenberg, Allan Kaprow, Yoko Ono or Linda Montano to incorporate life into their art and vice versa. The gap between life and art remains but it became the choice of many of the artists Greenberg held in lesser regard to negotiate and communicate across the unexplored terrain of this dramatic fissure.

30

The Experimental Group:
Ilya Kabakov, Moscow Conceptualism, Soviet
Avant-Gardes, Matthew Jesse Jackson,
University of Chicago Press, 2010

Very few contemporary art history books are of such note that they appear to revise completely their chosen topic, as well as potentially a few others along the way, but Matthew Jesse Jackson's *The Experimental Group* does precisely that: it thoroughly reconfigures notions of Cold War visual culture in multiple ways, as well as providing insightful commentary on the legacy of that era. By examining the work of Ilya Kabakov and his surrounding circles, Jackson offers an incisive portrait of a lost world that offers both an intimate and particularized as well as panoramic view of the complexities of its cultural context.

Jackson directs the reader with impressive lucidity through a variety of intriguingly tangled settings, among them the unofficial art scenes of Russia; the corresponding academic training and 'official' options for disseminating work during the era (primarily through designs and illustrations for the state publishing houses); and the often-exceedingly curious intersections between East and West permutations of modernism. According to the author:

> Three interconnected projects drive this narrative: an investigation of the art produced by Ilya Kabakov preceding his emigration to the West in 1988, a critical account of the theory and practice of conceptual art in Moscow during the 1970s and 1980s, and a historical survey of 'the second Soviet avant-garde' covering the years 1956 to 1988.[184]

Information that could to a degree be interpreted as altogether arcane at this point becomes transformed via Jackson's passionate, engaging and at times riveting study.

Although Jackson's account contains a wealth of material involving careful readings of specific artworks, it is Jackson's interest in the changing roles of institutional frameworks that fascinates him the most, as he notes provocatively: 'I argue that the history of late-twentieth-century art, more than investigating the responses of individual artists to formal/theoretical/social challenges must attend to profound transformations in the interrelationships among artists, audiences, administrators and academics.'[185] Moreover, Jackson focuses upon the intensively discursive nature of the work under review: 'As such, Moscow conceptualism did not devise objects intended for the world's evaluation, but discourses that fostered introspection and experiment. It did not offer representations of life but rather collective work in, on and around the faktura of professional experience.'[186]

Jackson discusses and, to a great extent, helpfully decodes many of the process-oriented, temporal and obscure projects undertaken under the broad rubric of conceptualism throughout the 1970s and 1980s by Kabakov, the Collective Actions group, the 'Nest' Group, the Mukhomors (Toadstools), and critic Boris Groys, among others. Jackson writes that: 'By the early 1980s, the Conceptual Circle had established a virtual research laboratory in which artistic positions were performed, discussed and documented by a range of artists and writers' (Figure 30.1).[187]

One of the most refreshing aspects of this study is how certain received notions are held up to scrutiny only to crumble almost immediately, such as the amount of information on international art available to the unofficial artists of Moscow. Jackson makes the salient point that 'the centrality of Western art in 1960s Moscow is unavoidable, and despite appearances, even behind the Iron Curtain transnational cultural and economic processes of incorporation, disintegration and extinction were already at work.'[188] Of course, much of this information circulated in the form of magazines and other printed matter and was then shifted radically in the modes of its reception and interpretation. Furthermore, artists were viewing works from the earlier Soviet avant-garde period in short exhibitions – often only lasting days – held 1960–68 at the State Mayakovsky Museum and upon invitation to the apartment of the collectors George and Zinaida Costakis. As Jackson notes: 'The unofficial artists encountered the Soviet avant-garde's constructions not as laboratory works or productivist experiments in the gap between art and life, but as decorative adornments to domestic space.'[189]

Beyond its intellectually nuanced depictions of a particular time and place, Jackson's perceptive analysis of this territory owes much of its power as it stands in relation to the present. Jackson himself is a cultural critic and participates actively, along with several other artists and writers, in the Chicago-based collective Our Literal Speed. Clearly the lessons Jackson has learned from the researching and writing up of *The Experimental Group* are not simply academic (in the

FIGURE 30.1: Ilya Kabakov, *The Man Who Flew into Space from His Apartment*, 1988, Installation view, Ronald Feldman Fine Arts, New York. Photograph by D. James Dee, © Emilia and Ilya Kabakov. Courtesy of the artists.

worst sense of the term), cordoned off or sealed away from our contemporary realities. We can see this evidenced in Jackson's comment made early on in the volume: 'A responsible history of late Soviet art must be written from where we stand: in the midst of a transnational art world whose memory of the Soviet Union is fast fading.'[190]

When Jackson analyses artworks, it is not to fit them into some forced, pre-existing narrative, but to build a layered construction that has much to say about the relations between art and life. I remain envious of Jackson's ability to both synthesize a vast amount of research and then to subsequently convey it using very lively and distinctive prose. Lavishly – and deceptively – designed nearly in the manner of a coffee-table monograph, this format acts as bait to – one hopes – lure some unsuspecting readers towards a striking, intellectually innovative book.

31

Parallel Presents:
The Art of Pierre Huyghe,
Amelia Barikin, MIT Press, 2012

In her engaging study *Parallel Presents: The Art of Pierre Huyghe*, author Amelia Barikin details insightfully the wide-ranging interdisciplinary projects of the French artist Pierre Huyghe, arguably one of the most significant artists of his generation. While much of Barikin's text reads as a rather straightforward art historical chronicle, this effort is in fact much needed; while Huyghe's work has been shown globally and has been critically discussed in countless international catalogues, there have been no sustained attempts to contextualize his practice in this scholarly format. Existing writings on Huyghe, while copious, are both widely dispersed and often published in French, particularly when addressing his earlier work. The current volume is elegantly designed, synthesizes a wealth of critical and historical material and features a generous selection of colour images.

Huyghe's earliest artworks, discussed evocatively in the first chapter, developed out of street art and collaborative activities conducted in the mid 1980s, and while many of his projects occurred in Paris, they exhibit a keen affinity with New York's East Village Art scene of the same era. Barikin relates how Huyghe was initially more influenced by punk music and popular culture than art theory. Considering the number of fleeting, almost ephemeral endeavours with which the artist was involved, Barikin writes in retrospect: 'What Huyghe kept from this period was the instant appearance of an event in public space, and a mode of collective practice.'[191] Subsequent events that were key in shaping the emergence of Huyghe's work in the 1990s were his close associations with critic Nicolas Bourriaud, later to become by turns renowned and reviled for his writings on 'relational aesthetics' – which discussed Huyghe's work among others – and with the late Roger Pailhas, his long-time gallerist based in Marseille.

In discussing Huyghe's work in connection with several of its major aspects, including its highlighting of temporality, its emphasis on performativity and the influence of the cinematic, Barikin enlists the theories of both Henri Bergson

and Gilles Deleuze in Chapter 2, entitled 'The Open Present'. This is particularly relevant insofar as the artist has consistently negotiated the passage between framed representations of recorded time and actual, experienced time, as in his early billboard projects that replicated a nearby scene, his construction of a 'pirate' television station, and the act of 'remaking' Alfred Hitchcock's film *Rear Window* (1954) in a provisional, skeletal fashion. This treatment of represented time and space also relates to Huyghe's conception of his art practice as a 'continual construction site', inspired by houses along the Mediterranean left partially finished so that their owners could avoid property taxes indefinitely.

In Chapter 3, 'A Movie Navigated by Stops', Barikin lucidly describes Huyghe's development towards a kind of forensic dissection of cinematic tropes, from analyzing 'dubbing' – in his 1996 work of the same name – to experimenting with the deconstruction of narrative structures and devices, in order to better investigate and effectively remix received notions of both film and video production. Moreover, Barikin does a highly effective job of revisiting Bourriaud's claims for Huyghe as a 'relational' artist, unpacking the problematic factors and inconsistencies involved in this categorization, without neglecting to carefully note both the historical specificity and significance of the critic's assertions. Barikin points out that

> although there are similar issues at stake in both Huyghe's practice and Bourriaud's curatorial foci (recycling, postproduction, open temporality, collaborative practice), the overemphasis upon the 'relational' aspects of Huyghe's work in subsequent years has prevented a comprehensive investigation into what Huyghe was doing at this time and why. [...] The interactive qualities discussed by Bourriaud are symptoms of, not primary motivators for, Huyghe's interrogation of temporal formatting.[192]

Barikin also suggests that it might be more generative to consider Huyghe's work as 'seeking to demythologize the ideological functions of what Jacques Rancière has called "the perceptual regime"' (Figure 31.1).[193]

The final three chapters of Barikin's book trace the movement within Huyghe's practice into further examinations of the cinematic context in terms of intellectual property disputes and the divide between documentary and fiction, and the opening up into both larger-scale multimedia installations, and quixotic, layered performative events. Huyghe's major video works *L'Ellipse* (1998) and *The Third Memory* (2000) used two narrative films from the 1970s, Wim Wenders's *The American Friend* (1977) and Sidney Lumet's *Dog Day Afternoon* (1975), as platforms for historical excavation and artistic reinvention. The circulation and commentary on these works at the time brought greater attention to the artist, and within the next

FIGURE 31.1: Pierre Huyghe, *A Journey that wasn't*, 2005, Super 16 mm film and HD video transferred to HD video, colour, sound, 21 minutes 41 seconds. © Pierre Huyghe. Courtesy of the artist.

several years he represented France at the Venice Biennale (2001) and was awarded the Hugo Boss Prize (2002). This, to a degree, confirmed the fact that Huyghe's work spoke to an increasingly eclectic art world, captivated by the visually spectacular and the conceptually cryptic, both of which were taken up in unequal measures by the artist. In *Parallel Presents* Barikin skilfully negotiates the curious entanglements of Huyghe's positioning, rarely fixed yet frequently fascinating.

32

Performing Contagious Bodies: Ritual Participation in Contemporary Art, Christopher Braddock, Palgrave Macmillan, 2012

Auckland-based artist and scholar Christopher Braddock's *Performing Contagious Bodies* enlists a carefully chosen and wide-ranging set of theoretical references quite effectively to better contextualize a number of important emerging artists from Australia and New Zealand, including Laresa Kosloff, Alicia Frankovich, Alex Martinis Roe and Richard Maloy. By speaking of their varied approaches through both historical anthropological texts dealing with magic, ritual and animism, along with more recent writings by authors such as Jane Bennett on 'material vibrancy', Braddock lends significant breadth to his arguments engaging with current art practice. His work also might help signal to an international audience both the highly active scene of live art in the Southern Hemisphere and the on-going, energetic attempts to contend with such material discursively in the burgeoning field of performance studies. Braddock also spends time (re-)considering aspects of works by such touchstone figures as Marcel Duchamp, Ann Hamilton, Bruce Nauman, Gabriel Orozco and Hannah Wilke.

The merits of this book derive not only from its rigour and attention to detail but from Braddock's own intensive engagement with his area of study as an artist, lecturer and curator. This experiential knowledge lends more edge to his discussions of live art and its residual traces. Rather than treating such work in a purely academic manner, it is clear that Braddock is much concerned with the manifold ways in which 'liveness' can be analyzed and, although his study owes much to such key writers on performance as Amelia Jones, Peggy Phelan and Rebecca Schneider, Braddock attempts to construct his own hybrid theoretical edifice. While Braddock's book comes in at a lean 170 pages plus notes, particularly in his lengthy introduction, he works through a dense set of interwoven arguments. At times, however, one wishes for a little more breathing room as the book's

ambitious, heady mix of complex scholarly discussions places it in a territory not so far removed from its origins as a doctoral thesis. Notwithstanding this minor qualm, I heartily recommend Braddock's research for its great sensitivity, subtlety and perceptive insights.

In addressing 'magic', Braddock chose not to address any artists who explicitly use that term, in favour of the ways this notion could be applied to the connections between live actions and their resultant traces. In so doing, Braddock makes intriguing associations simultaneously across Derridean deconstruction and anthropological assertions. He focuses on magic and ritual in part to explore both infinitude and that which is difficult to contain, limit or otherwise frame. Serving almost as the centrepiece of the book is the author's chapter on Laresa Kosloff's 2011 *CAST*, a work involving the signatures that gradually accumulated on the surface of the artist's plaster cast when she appeared at the Venice Biennale, ostensibly with a broken leg, which in reality was not the case. Kosloff's piece points towards the difficulty in characterizing any 'work itself' apart from the complicated array of circumstances from which it emerged and then was circulated, disseminated and commented on (Figure 32.1).

In a characteristic passage, Braddock writes:

Magic does not merely invoke the lived body. It invokes a vital force that precedes the terms of subjects and objects. Contagious participation, as a field of tactical *affect*, is like the 'value' Derrida attributes to a field of differences as a force that we 'necessarily misconstrue, and which exceeds the alternative of presence and absence'. But, the 'trace structure' of *différence* asserts that this force is never 'present'. It can only exist as a tactical play of differences.[194]

To his credit, instead of rehearsing rather tired (and increasingly tiresome) discussions of the live/actual vs trace/document, the author leaves such categorical terminology in flux. In addition, by keeping questions of 'presence' and 'absence' open-ended and worthy of diligent, curious scrutiny throughout the book, Braddock pursues threads that are entirely relevant to a contemporary art world almost saturated with durational practices that are frequently taken solely at face value. Braddock seeks to problematize any stable notions of presence, stating in his chapter, which addresses Maloy and Nauman:

The value of magical utterance is that it highlights the possibility of 'the existence of non-Being, the presence of an absence', [...] I will argue that this points to an impossibility of absence in the symbolic order of magical ritual, which makes presence out of absence; makes visible a lack or privation.[195]

FIGURE 32.1: Laresa Kosloff, *CAST* (with Jennifer Allora, Hany Armanious, Richard Bell, Karla Black, Christian Boltanski, Mikala Dwyer, Dora Garcia, Charles Green & Lyndell Brown, Thomas Hirschhorn, Anastasia Klose, David Noonan, Michael Parekowhai, Grayson Perry, Stuart Ringholt, Renee So, Kathy Temin, Luc Tuymans, Angel Vergara and Catherine de Zegher), live performance, ACCA Pop Up Program, 54th Venice Biennale, 1–3 June 2011. Photograph by Liv Barret. Image courtesy of the Artist and Sutton Gallery, Melbourne.

In Braddock's inventive bridging of anthropological and post-structural theories, the primary arbiter is most often that of language, as in the varied acts of erasure, naming, representation, signature, utterance, metaphor/metonymy and tracing that are all integral to the author's own examination. Braddock within *Contagious Bodies* reminds the reader that his own performative investigation is a process of discovering provocative and novel ways to reflect upon the impact of performative practice, as when he states his desire to advance 'a view where all traces signify the present or "live" moment of performance'.

33

It's the Political Economy, Stupid: The Global Financial Crisis in Art and Theory, eds. Gregory Sholette and Oliver Ressler, Pluto Press, 2013

While it was inevitable that the global economic downturn, subsequent crises and related artistic responses would spawn a number of anthologies, Gregory Sholette and Oliver Ressler's is one of the most recent and, in parts, among the best. A brightly designed book that accompanies an exhibition curated by the editors, it features many colour illustrations and texts by some formidable theorists. All the same, it is sometimes difficult to figure out exactly what this volume seeks to achieve, as it offers up an awkward amalgam of art discourse, pamphleteer-style texts and a quasi-documentary dance around diverse notions of political intervention.

The title is drawn from an essay republished here by theorist Slavoj Žižek, which paraphrases a Bill Clinton motto from the 1992 US Presidential campaign: 'the economy, stupid'. Zizek analyses the strategic ways economic (mis-)information is disseminated by the engines of the status quo and returns to Francis Fukuyama's specious notion of the post-Cold War 'end of history' circulated widely via the economist's 1992 book of the same name. Using his characteristically abundant verbiage and highly theatrical rhetoric, Zizek concludes:

The new emancipatory politics will no longer be the act of a particular social agent, but an explosive combination of different agents. What unites us is that, in contrast to the classic image of proletarians who have 'nothing to lose but their chains', we are in danger of losing ALL: the threat is that we will be reduced to abstract empty Cartesian subjects deprived of all substantial content, dispossessed of our symbolic substance, with our genetic base manipulated, vegetating in an unlivable environment.[196]

Leave it to old hand Zizek to morph some fairly dry economic discussions into an apocalyptic J. G. Ballard-style landscape. But herein lies some of the difficulty presented by this ambitious volume: the attempt to synchronize truly depressing, cold hard data with various occasionally overheated artistic and textual responses. Sometimes the neo-Marxist artworks come over as being as stilted as the script of a Maoist-period Godard film. It is perhaps notable, however, that the works discussed often reflect a knowing surrender to satirical and whimsical acts that certainly cannot be expected actually to effect social change, but instead to create representations responding to the pressures of current circumstances and convey this in various provisional forms, whether discursive in tone (*Reading Lenin with Corporations*, 2008, by the collective comprising Yevgeniy Fiks, Olga Kopenkina and Alexandra Lerman; Melanie Gilligan's creepy *Crisis in the Credit System* series of videos), highly vivid (Isa Rosenberger's *Espiral – A Dance of Death in 8 Scenes*, 2010–12), or at times both (Ressler's own 2012 video *The Bull Laid Bear*).

John Roberts's essay 'The Political Economisation of Art' succeeds well in capturing the historical background of the current economic period, noting that it dates to the general stagnation of economic growth of the early 1970s. He also effectively outlines the context of the recent 'social turn' in art practice and how increasingly 'relational' approaches paralleled a decline in opportunities for artists in terms of exhibitions and teaching, and their corresponding enlistment into the workforce as 'cognitive creative/technicians' – noting that, as paradoxically, 'the artist becomes a wage labourer as an artist, rather than working as a wage labourer in order to support their work as an artist.'[197] If this is an unsettling, although familiar, phenomenon, art historian Julia Bryan-Wilson, in a rather more affirmative tone, cites Ben Kinmont's long-term project (since 1998) of being a bookseller, a work entitled *Sometimes a Nicer Sculpture Is Being Able to Provide a Living for Your Family*. Bryan-Wilson calls this 'occupational realism', stating that: 'these are performances in which artists enact the normal, obligatory tasks of work under the highly elastic rubric of "art". Here, the job becomes the art and the art becomes the job.'[198]

Brian Holmes offers a manifesto for 'Art after Capitalism' (a bit hard to contain one's scepticism even if altogether sympathetic to his stated claims). He openly acknowledges that his call for 'art into life' is indebted to earlier avant-gardism but it becomes difficult to split the divide between his advocacy of practices such as 'building a community centre, planting a garden, preparing a meal, writing a text together or just talking around a table',[199] along with his simultaneous disdain for so-called 'relational' works – is it because that term is so closely associated with artists who have become major economic properties in the art market? 'Bodies in Alliance and the Politics of the Street', a reprinted lecture by theorist Judith Butler, offers an eloquent and succinct examination of

the significance of the embodied subject in public/private space in light of recent protests, while David Graeber elucidates connections between historic anarchist principles and the Occupy movement.

Ultimately the book does make a concerted effort to link together multiple ways of making reference to and working amid the precarious conditions of today's social climate, yet it remains slightly unclear if there really is a post-crash period that is somehow wholly different in creative terms than any number of other traumatic 'post' eras that have often ushered in – at least for a time – some provocative examples of determinedly engaged yet reflective art theory and practice.

34

Zizz! The Life and Art of Len Lye in His Own Words, with Roger Horrocks, Wellington, Awa Press, 2015

One of the most interesting things about the life of artist Len Lye (1901–80) is that it never seemed uninteresting. An evidently charming and garrulous itinerant artist who led many lives and travelled in many different circles, this constant activity nearly upstages how magnificent and path-breaking his actual visual artworks are. At least this is the impression I have reading Roger Horrocks's fine compendium of Lye's scattered prose, poetry, letters and textual ephemera, selections from which the editor has ably stitched into an informal, posthumous memoir entitled *Zizz!* (In the book's epigraph, Lye states: 'I'm interested in the business of energy and getting a feeling of zizz.') Having been a careful biographer and historian of Lye's work for many years, Horrocks is exactly the right person to take on this project (Figure 34.1).

The timing of this publication coincides with the opening in July of a new centre devoted to Lye's work at the Govett-Brewster Art Gallery in New Plymouth, where the artist bequeathed his archive in 1977. Lye, a son of Christchurch who spent most of his adult years far from New Zealand, has taken some time to be properly inducted into the artistic canon of his home country. This of course is now changing, and it's remarkable to realize how much Lye was involved with cutting edge international Modernist developments. The book parcels out Lye's life according to the widely dispersed geographic locations where he worked but also in relation to the major creative developments in his practice, including direct film and kinetic sculpture.

What emerges most successfully from the publication is the fact that Lye's voice remains so utterly vibrant and rich in perceptivity. Lye was clearly very observant from an early age, as he was inspired by the landscape, most famously the shifting winds of the capital city, spurring his interest in capturing kinetic movement in his art, but also everyday phenomena: 'if I'd just heard someone clanking a nice bit of metal outside my bedroom window, it would be a sound day: I'd focus on

FIGURE 34.1: Len Lye with his painting *Land and Sea*, *c*.1979. Photographer unknown. Courtesy of Len Lye Foundation Collection, Govett-Brewster Art Gallery, New Zealand.

sounds all day.' The young iconoclast teased his mother about the hypocrisy of Christianity but was one of the first Pākehā artists to seriously engage with Māori carvings and the Samoan tapa design.

When Lye turned up in London, he presented himself to local artists and gained a surprising amount of attention, patronage and a welcome place amidst a burgeoning Modernist scene. Within a number of years, he was selling his hand-made films and short animations as commercials and called by *Time* magazine 'England's answer to Walt Disney'. He also befriended poets including Dylan Thomas: 'we'd wake up with a verbal hangover, brain reeling with thoughts and words.' Lye spoke to politicians and philosophers about his notion of 'individual happiness now'. And his experimentation also reached into other sectors: 'What I saw on mescalin wasn't that different from what I see normally and it's better when I see it normally because then I can at least remember it.' *Zizz* serves as a concise and lively vehicle to access the thoughts and ruminations of this thoroughly memorable New Zealand artist.

PART VI

EXHIBITIONS

Reviews and catalogue essays, although often considered 'peripheral' to exhibitions, are by contrast central to any working art writer's practice. Frequently invited or commissioned, and at other times self-generated responses, they can vary widely in genre and style, form and approach. In this section, however, which concludes this book I tend to address the solo shows of established artists, group exhibitions including a range of practitioners, and several artists with whom I have undertaken ongoing dialogue. They become snapshots of moments when artworks enter the public sphere, and I become an opinionated representative and performing observer.

35

Theresa Hak Kyung Cha (2003)

The Dream of the Audience, Krannert Art Museum, University of Illinois, Champaign, USA

Encountering Theresa Hak Kyung Cha's work for the first time can be a disorienting and perplexing experience. Yet perhaps this is inevitable when viewing the work of a young Korean American artist who spent her all-too-brief career producing evocative works that examined the ways in which the present is always infused with the past and how our identities are framed by language. Cha was a dedicated student of many things: conceptual and performance art, film theory and practice, linguistics and literature. Her output spanned a heady period from the early 1970s to her death in 1982, and the current travelling retrospective, curated by Constance M. Lewallen, offers an extensive selection of artworks in the form of photographs and videos, statements and paper projects.

While Cha is most famous for her posthumously published experimental novel *Dictée* (Dictation, 1982), in this particular exhibition, visitors were asked to construct an impression of the artist's visual work from a series of glimpsed fragments. Some pieces make this easier than others, but the fact that among the strongest works by Cha were performances – which now only exist as rough documentary photographs – serves to distance the viewer further from the work (Figure 35.1).

Throughout the 1970s Cha used her ritualistic performances to convey an ethereal, luminous state not unlike that of early cinema. The exhibition's title, 'The Dream of the Audience', is drawn from the artist's statement regarding *A Ble Wail* (1975): 'In this piece I want to be the dream of the audience.' Cha performed the piece behind a cloth screen that separated and obscured her from the viewers. In *Aveugle voix* (Blind Voice, 1975) the artist blindfolded herself with a headband inscribed with the word voix and covered her mouth with another headband inscribed with the word aveugle. In *Barren Cave Mute* (1974), each word from the title – transcribed in white wax on a 10 × 4-foot sheet of paper – became briefly legible with the aid of a candle, before bursting into flame and becoming a pile of ash on the floor. The quasi-mystical procedures of Cha's performances recall certain aspects of traditional Korean Shamanism,

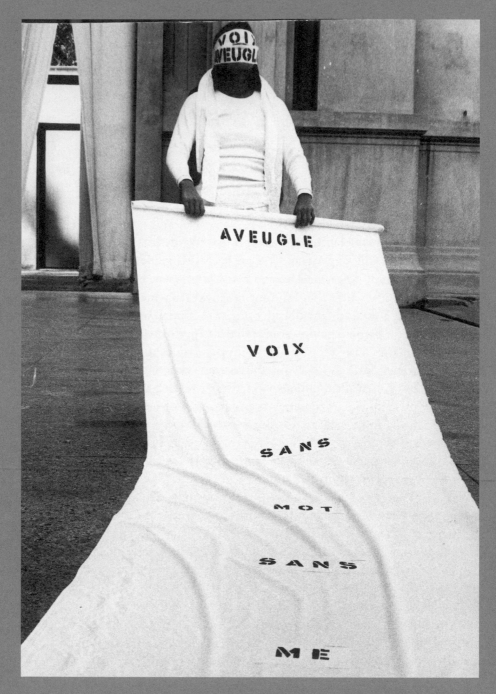

FIGURE 35.1: Theresa Hak Kyung Cha, *Aveugle Voix*, 1975; black and white photograph; 9 1/2 × 6 3/4 inches; University of California, Berkeley Art Museum and Pacific Film Archive. Gift of Theresa Hak Kyung Cha Memorial Foundation.

which features women priests (mudang) conducting rituals incorporating trance possession.

Cha's videos were without doubt the most mesmerizing and arresting pieces on view, in large part because nearly all of her work seemed to revolve around film and its structural aspects: the edit, the frame, the title, the montage and the dissolve. *Mouth to Mouth* (1975) presents a close-up view of lips mouthing Korean vowel sounds, which dissolve in turn into the white noise of television static, which is in turn followed by the reassuring sound of running water. It's a riveting piece, communicating as it does the inescapable qualities of language – we are always submerged within its watery depths. The theme of water is a recurrent one in Cha's work, as in *Re Dis Appearing* (1977), in which depictions of a bowl of tea resonate with ideas of transparency and entrapment.

In an approach similar to her videos and performances, Cha's text pieces – both visual and aural – explore the relations between dualities: subject/object, light/dark. The first page of *Presence/Absence* (1975) declares, 'water fills up the empty places'; it is followed by a family portrait, which is repeatedly photo-copied, leaving a mottled texture recalling bubbles, ripples or grains of sand. Listening to the haunting spoken component of the performance *Réveillé dans la brume* (Awakened in the Mist, 1977), one hears: 'everything is light / everything is dark [...] everything feels light / everything feels dark / everything feels light / everything weighs dark.' A chilling bicentennial piece features an American flag altered simply with the stencilled word 'amer' (bitter). In many of these visual poems, Cha attempts to resuscitate memory, to bring it forth and lend it an elegant material structure.

The exhibition and its accompanying catalogue are commendable attempts to promote awareness of Cha's work and clear a space for her in the contemporary canon. However, the essays by Whitney Museum curator Lawrence Rinder and filmmaker/theorist Trinh T. Minh-ha verge on hagiography. If only it were possible once again to view Cha as a lively young intellectual and artist rather than as the somewhat staid and beatified subject of this historical survey.

36

Robyn Kahukiwa (2012)

Maumahara: Remember, *Mahara Gallery*
Waikanae, New Zealand

In an engaging contrast, Robyn Kahukiwa, a manifestly political artist, spoke in a recent interview about the importance of 'intuition' to her creative approach. This reflects the intense, yet gentle spirit often evidenced in the artist's works. Addressing social concerns impacting Kahukiwa's whakapapa (genealogy) was not something treated at a distance, but much closer to home. The integrity and directness displayed throughout *Maumahara: Remember* the retrospective exhibition currently on view at Waikanae's Mahara Gallery bespeaks the artist's active involvement in the world, not simply the world of images.

Many of Kahukiwa's works are characterized by their illustrative qualities, acting as cohesive, richly detailed drawings as much as vibrant paintings. Moreover, Kahukiwa, throughout the course of a long and highly distinctive career, seems always ready to experiment compositionally. That is to say, her work is unified less by a singular pictorial strategy than by a variegated amalgam of methods, synthesizing aspects of traditional Māori imagery with some very contemporary stylistic turns.

While Kahukiwa has made many stirring, epic paintings, her specialty has often been the clear depiction of strong individuals on a more intimate, smaller scale, the everyday moments of mothers and children, 'whānau (family)' and as in for example the portraits *The Outcast* (1980) and *Girl in Bush Shirt* (1982) a realism true to the figures portrayed, subtle and tender rather than sentimentalized or caricatured. One of the most striking large paintings in the show is *Resistance/Te Tohenga* (2009), a vivid history painting of a history going wrong, an evocation of the current moment in which pressing issues of social justice are often either tabled or exchanged for corporate or governmental gains. Similarly, *Environmental Product* (2011) serves as a reminder that our treachery towards the environment and its fair use ultimately amounts to treachery to ourselves (Figure 36.1).

Over the span of three decades, Kahukiwa has made major inroads in revising perceptions of Māori culture and has reinterpreted with great vigour its

200

FIGURE 36.1: Robyn Kahukiwa, *Resistance, Te Tohenga*, 2009, oil, alkyd oil on canvas 2000 × 3000 mm², Auckland Art Gallery Toi o Tāmaki. Gift of the artist, 2012 (Accession no. 2012/23). Reproduced with permission of the artist.

iconography. Of particular importance is her assertion of the important roles of women, not only in canvases and prints, but in the form of empowering and widely accessible public projects: the collaborative book *Wāhine Toa* (*Strong Women*) with writer Patricia Grace, commissioned works for Tapu Te Ranga Marae in Island Bay, and even the recent dissemination of her images via Facebook for newer audiences.

Kahukiwa's imagery as it combines community commitment depicted via sensitive portraiture and graphic media is reminiscent of the African American artists Faith Ringgold and Kerry James Marshall, the former of whom has also made many children's books and the latter has appropriated the format of superhero comics as a narrative tool, just as Kahukiwa has explored the notion of reclaiming a heroism for contemporary Māori youth in action figures of Maui and Hina and boldly colourful paintings like *Whaka hokia te Whenua* (2007). Her interest in communicating to younger people through such gestures is actually a very crucial aspect of her practice, as it engages in continuing a intergenerational line of continuity. The pedagogical feel of much of the artist's work is also not entirely unusual, given that Kahukiwa first devoted herself to artmaking on a full-time basis after years working as a teacher.

Curator Hinemoa Hilliard does an admirable job of presenting and contextualizing Kahukiwa's diverse art practice, despite gallery spaces which don't allow much visual breathing room for such an inclusive show. The installation features mostly large-scale paintings and graphics in the main room, with a plethora of prints, drawings, books and smaller works in an adjacent space. Also on view is a short, informative documentary on the artist and a catalogue is in preparation. In a brief statement posted in the entryway to the gallery, Kahukiwa states: 'Greetings to all people [...] my strength is not that of the individual but that of the many.' Certainly, many styles and notions are conveyed and converge in this insightful survey of one of the most significant artists of Aotearoa New Zealand: an essential show.

37

Sad Songs (2005)

University Galleries of Illinois State University, Normal, IL, 2005

As beautification requires shadows, so clarification requires 'vagueness.' – [...] Art
makes the sight of life bearable by laying over it the veil of unclear thinking.
—Friedrich Nietzsche[200]

The case could easily be made that art – contemporary or not – often expresses a
considerable degree of sadness. If sadness is then for purposes of this argument
taken to be the primary driving force behind most of the art in the exhibition *Sad
Songs*, we could also conduct a brief bit of archaeology of the closely related term
melancholy (or, *melancholia*).

The ancient Greeks Aristotle and Hippocrates spoke of the body being
composed of four humours, or fluids, with the excess of 'black bile' (*melaina kole*)
associated with signs of depression. The notion that a melancholic temperament
could actually be linked to artistic inspiration and thereby beneficial resurfaced
and became prominent in the Renaissance, as depicted in works such as Albrecht
Dürer's engraving *Melencolia I* (1514) and continued and perhaps peaked in the
form of nineteenth-century Romanticism (Figure 37.1).

The writer Robert Burton in 1621 wrote an extensive three-volume study
entitled *The Anatomy of Melancholy* in which he stated that 'Melancholy [...] is
the character of mortality'. Sigmund Freud's influential 1917 paper 'Mourning
and Melancholia' later served to distinguish between these two terms, the former
being characterized as the therapeutic working through of grief and the latter as a
more pathological and obsessive attachment to the lost object of desire.

The discernible presence of melancholia in *Sad Songs* is largely bittersweet and
insistent rather than overwhelming and devastating in its character. Much recent
art is marked by the loss of an anchoring connection to some prevailing ethos, be it
modernism or the unmoored and more indefinable associations with the notion of
postmodernism. In the wake of the postmodern era, an ever-increasing onslaught
of eclecticism and arbitrariness enters into the fray of the social, political and
aesthetic arenas of dispute. Outward signs of political engagement are sparse to

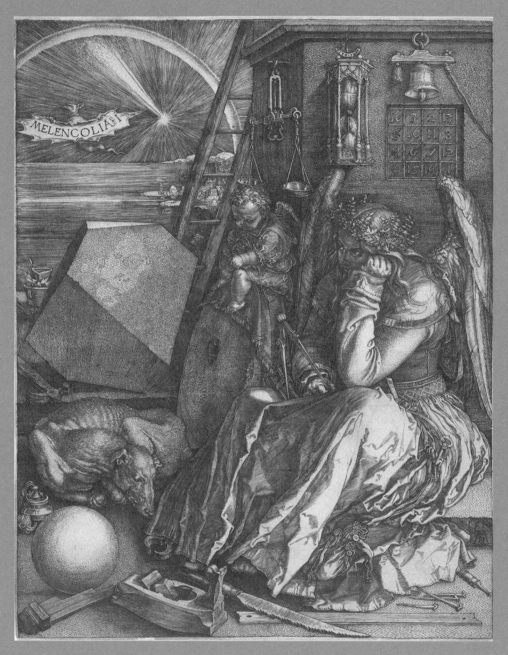

FIGURE 37.1: Albrecht Dürer, *Melencolia I*, 1514, Engraving, Plate 9 7/16 × 7 5/16 inches (24 × 18.5 cm²), Metropolitan Museum of Art. Harris Brisbane Dick Fund, 1943 (Accession no. 43.106.1).

non-existent in the works on view, displaced by those of weariness and longing. Artistic agency for most of the artists to be considered here instead consists of eliciting oblique meanings from evidentiary scraps, broken fragments and lingering traces.

It is worth noting that one of the writers most widely read (and least understood) by artists since the late twentieth-century is Walter Benjamin. An extreme melancholic personality, Benjamin's work revolved in part around both a lonely, isolated nostalgia and the vain hope for a collective, revolutionary dream. And it is in dreams that Benjamin spent most of his time, in the company of Baudelaire, Kafka and Proust. Somehow the essays of Benjamin, an obtuse thinker prone to Hashish-fueled reveries, deceased (by his own hand) well before the emergence of postmodernism, became required reading on countless art school syllabi during the formative years of the *Sad Songs* artists.

What does our sadness consist of when prompted by the remembrance of an old worn out Neil Diamond record? Or even an exceptionally memorable strain of Muzak piped into a supermarket you're running into on an especially difficult day? In twenty-first century American culture, Proust's madeleine is transformed into a Krispy Kreme donut.

Of spurned lovers and zombified paintings

Ah, painting my love is true
Painters are so horrible it's amazing they come up with you
And though the artists are all shits, I still love you.

—Rene Ricard[201]

From the text above, extracted from the earlier poetry of Rene Ricard, one might be surprised to learn that in the current exhibition Ricard, also a long-time writer of eloquent art criticism, takes on the guise of the painter himself. These recent paintings are inscribed with breathless anecdotes, as if Haikus hastily scrawled in lipstick onto a bathroom mirror. While artists today are frequently at odds with painting, Ricard offers paintings at odds with themselves, as if deciding whether to be texts, images or from a distance appealingly bright, monochromatic ciphers. *Éminence grise* of the 1980s East Village scene, Ricard is often remembered for his support of artists such as Julian Schnabel and Jean-Michel Basquiat. Here Ricard's own paintings flicker back and forth between their childlike, almost rudimentary execution and the more deliberate wordplay of an experienced but highly improvisational poet. In *But You Love Me [You Said So]* the title phrase partially obscures an overturned still smoking automobile, the aftermath

of a crash. The work summons Andy Warhol's canonical accident pictures, and one could also note that Ricard spent considerable time at the Factory. The poet has always been brutally confessional in his writings, but this approach is often leavened with an unlikely degree of tenderness. Ricard is often abrasive yet the confirmed aesthete.

While several of the artists in *Sad Songs* offer up servings of subdued gloom or otherwise sober meditations, Danielle Gustafson-Sundell's mixed-media conglomerations are charming eruptions of incandescent, neo-psychedelic abandon. Her artistic practice is decidedly clever and resourceful, featuring such favoured materials as felt, yarn, tacks and safety pins. Out of this cacophonous whirlwind of thrift shop and hardware store ephemera, the artist conjures some genuinely cohesive and rarefied moments. In *Soft, Yellow Insides*, adamantly plain cinder-block cubes act as bookends, framing a plethora of primary yellow rolls of felt, each hand rolled and pinned. The piece becomes both elegant and funky, a pleasantly wayward minimalism. *Dear Pirate, my Heart is a Bloody Tattoo* presents an actual knife blade piercing a cartoon valentine heart sewn to a round piece of stretched black felt, leaving only two exaggerated drops of 'blood'. Such gratuitously overwrought titles belie their deceptively clean and articulate materializations. Gustafson-Sundell's primary themes are love gone right, wrong and desperately awry, their visual analogues operating simultaneously as emblems of teenage angst and art school strategies. In her works, the abrupt intensity of her sentiments is matched by the hand-crafted, near-obsessive labour of her formal process, which in turn recalls both the Feminist art of the early 1970s and moreover, the neo-Surrealist and psychologically propelled works of Annette Messager and Mike Kelley.

In the late Robert Blanchon's video *I Can't Live in a World Without Love*, a dark and smoky cabaret atmosphere summoned by the vintage recording of the jazz singer Lena Horne soon gives way onscreen to a milky grey-out interrupted by a thin dark line bisecting the frame. The line – actually a hair, to be exact – twirls and wavers unsteadily. The hair remains languorously dancing before the lens, sometimes appearing a line drawn across this open field, or perhaps a crack in a wall, followed by a sleepy set of eyes. Horne dedicates her song 'to one of my friends that's slipped away', and despite the virtually abstract quality of this work, one is snapped back to the realization that this is a work by an artist now gone, who was at the time of making this work witnessing many friends and acquaintances *slipping away* due to the devastation of AIDS. It is telling that Blanchon, a gay male artist who worked prolifically on notions related to marginalization and 'otherness', chose the singer Lena Horne to 'complete' the work aurally, as Horne was one of the very first African American entertainers to cross colour lines, singing for both predominantly white and black bands, acting in Hollywood and then

in the McCarthy era she along with friends such as Paul Robeson was blacklisted for her political sympathies and civil rights activities.

Postmodern fragmentation and romantic pastoralism

Can you take me back where I came from / Can you take me back /
Can you take me back where I came from / Brother can you take me back...
 —Unfinished snippet from *The Beatles* ('the white album'), 1968

A significant theme serving as a centrepiece to *Sad Songs* is that of the constructed landscape. More specifically, I refer to artworks that may be superimposed template-like upon those visions we already carry around in our heads, whether drawn from Claude Lorrain and Caspar David Friedrich, or perhaps Hollywood and View-Master, Walt Disney and David Lynch.

In Jin Lee's *Untitled* photographs (2004–05), torn plastic bags arrive high up in a tree to create a new visual rhyme – almost as if the artist had woven the shreds and strips of detritus into the branches herself. Her works are among the quietest in the exhibition, and the most unendurably sad. Jin Lee lovingly renders a moribund, despondent landscape, the great American prairie reduced to trash caught on wintry branches. I am reminded of another photographer, Robert Frank, and his sardonic statement that fame amounted to 'old newspapers blowing down Bleecker Street'. In the manner so characteristic of photography, Lee's works record easily overlooked transitory movements and incidents for our stationary contemplation. Her hushed natural settings are continually punctuated by signs of the surrounding commercial world, such as a dangling Wal-Mart bag with a smiley face emblem, implying that: of course, good consumers, all is well in the world (especially at corporate headquarters).

Benjamin Butler's bold, subtly insinuating paintings schematize the pastoral. Stark in their drawing, effusive in their colouration, Butler's works give us abstracted traces and glimpses of the landscape rather than convincing renderings. Any attempt at verisimilitude is sabotaged by the evident width of the brushstroke in addition to the straight-from-the-tube character of the applied pigment. At times Butler evokes Dove, Avery, O'Keeffe, the grand successes of American Modernism, but by reconstituting the ghost of their gestures as small, frail and inert 'failures'. Modernist painting is thus read as a code which can be seen through, unravelled, deciphered and ultimately dismantled. Colouration comes in sour, faded greens and lemon yellows. Lakes constructed via intertwined lines are reminiscent of circuit board patterns, cluttered and claustrophobic. While 'flatness' was at one time a signifier of modernist purity, for this artist it is part of a premeditated postmodern patterning.

The wispy, diminutive look of Anya Gallacio's *Heart of Gold* is markedly different from the more bombastic sculptural approaches of such yBA ('young British Artist') colleagues as Damien Hirst or the Chapman Brothers. Here it is the viewer who might lean over the nearly five-foot high tree, cast in bronze, with its silver buds held perpetually on the verge of opening forth. The title also points toward Neil Young's now-standard 1972 song in which he seeks a 'heart of gold' but repeatedly states in downcast fashion 'and I'm getting old'.

Gallacio's sculpture feels pathetic and stunted, yet charmingly reminiscent of the Christmas tree desired by the iconic child-failure Charlie Brown. Furthermore, lending another contrast to the current piece, Gallacio's own 1996 *Intensities and Surfaces* was a 34-ton monolith composed of blocks of ice upon which a half-ton boulder of rock salt rested, slowly melting its way through the twelve-foot-high sculpture, an inexorable dematerialization by degrees.

Untitled (Tropicalia), a painting by Whitney Bedford is a scattershot mess of a picture – luridly drawn, painted and otherwise scratched. Bedford's work is like a Ouija board séance conjuring a roundtable of nineteenth-century specters: Turner, Whistler and Homer. Bedford channels such romantic atmospherics with abandon: profuse globules of paint meet vibrant streaks, smears and intentional cracks. Wispy pencilled palm trees lurk near the thick grey spill of a storm cloud. As the story goes, J. M. W. Turner asked to be lashed, Ulysses style, to the mast of a ship during a stormy crossing of the English Channel. Much as Jackson Pollock would a century later speak of being 'in his painting', Turner (according to legend) nearly became part of the sea itself when seeking inspiration for his *Snow Storm – Steam-Boat off a Harbour's Mouth* (1842). Now Bedford offers up her own future of painting: an abstracted shipwreck conveyed by way of anxious stutters and shimmers onto a tiny wooden panel.

Elements of the pathetic, grandiose and absurd

Gloom, despair, and agony on me. Deep dark depression, excessive misery.
If it weren't for bad luck, I'd have no luck at all. Gloom, despair, and agony on me.
—Song featured on the *Hee Haw* US television programme, *c.*1970s

Jack Pierson's *Passing Time #2* is a mesmerizing large-scale ink-jet print on canvas enlarged from a photographic depiction of that most clichéd and generic of scenes: frothy waves lapping across a sandy beach. The printing process is undisguised, foregrounded, evident as its primary dots, now reading as textural elements, help the grains of sand reverberate further in this example of digitized pointillism. This is Pierson at his best, as a near-stock photo becomes deceptively luminous,

seductive and beautiful – kitsch transcendent. Pierson's microcosmos is generally created from small glimpses, largely centred upon contemporary urban life and its related gay subcultures. He has commented that: 'these pictures from my real life are meant to make me believe that my real life is somehow bigger, brighter and contains more beautiful moments than it actually does.' Pierson has presented his found poetry across photography, sculptural installation and drawings. His *Christ on the Cross* is a pencilled text, a casual scrawl with an additional smear – or halo – isolating the lone title phrase. This simple drawing ends up as a weird associative conflation of Sunday School, conceptualist poetry and graffiti.

Sharing Pierson's irreverence is the photographer Justine Kurland, whose *Jesus with Girls* depicts a thin, bearded hippie speaking to two young girls dressed in white. One one level, the image is almost innocuous, but on second glance it conveys an ambiguous threat, as perhaps these teenagers are about to be preyed upon by this Charles Manson-like fellow. The image equally references the portraits – often presented in 3-D – of a distinctly Anglo-American saviour hanging in millions of households throughout the country.

Jesus seems to have just communicated something of significance to his two young foils, but this information remains mysterious. As viewers, we are left in awkwardly theatrical anticipation, watching as the water of a grey stream rushes past their ivory toes. In her nostalgically styled yet stark neo-Romanticism, Kurland echoes the staged portraits of Sally Mann, Emmet Gowin and the nineteenth-century tableaux of Julia Margaret Cameron.

The 'seventies' summoned by Keith Edmier involves a constellation of pop culture icons vaguely reanimated into some half-life for current artworld consumption. The most significant aspects of life become mere teenage obsessions: *sex* represented by the pin-up Farrah Fawcett; *mortality* by the 1980 assassination of John Lennon seen only through its chillingly mundane aftermath. In Edmier's *Morning*, sculptural replicas of the shoes worn by the doctor who officially announced Lennon's death are displayed in a translucent bag-labelled PATIENT'S BELONG-INGS, atop a large, pristine plexiglass pedestal. The formal appearance of the work also quotes a sculpture by Yoko Ono in which an apple sits atop a similarly transparent plinth; thus, Edmier (too) cleverly interweaves the grotesque popular fascination with the musician's demise with the clarity of presentation of Ono's rarefied Fluxus aesthetic. Although Edmier's work is a synthetic blend of high art sophistication applied to pop cultural references, to my mind, Edmier resembles the young boy perpetually under his blankets with a transistor radio pressed tightly to his ear (Figure 37.2).

In viewing the photographs of Katy Grannan, it is important to note that her subjects are respondents to advertisements soliciting participation. A social exchange, or perhaps more properly, a contract is thus created. Grannan in her

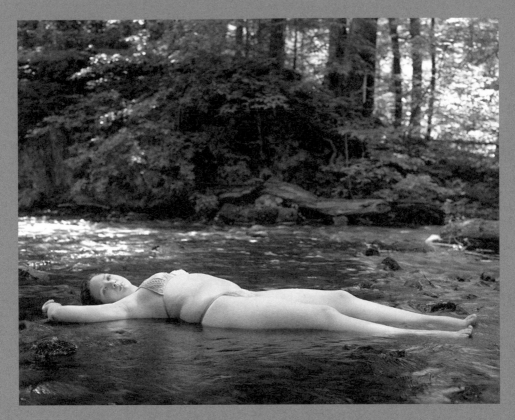

FIGURE 37.2: Katy Grannan, *Meghan, Saw Kill River, Annandale*, NY, 2002. © Katy Grannan.
Courtesy of the artist and Fraenkel Gallery, San Francisco.

images of Americans of working-class backgrounds in suburbs and small towns plays with a portraiture convention, as it is often commissioned by the wealthy to further their public image, the ruling class lionized and triumphant. Grannan's works on the other hand hark back to William Eggleston's deceptively offhand and off kilter 'documentation' shot around Memphis and northern Mississippi, or Richard Avedon's grandiose 'American West' series. Her subjects are clad in ill-fitting clothes and pose less as archetypes but awkward individuals before the camera. They are indeed monumentalized as the colour prints reach 4 × 6 foot, yet we almost hear a faint bit of country and western music drifting in the background, a white blues of slicked-back sadness and broken-down ballads.

It is difficult to arrive at some grand conclusive statement about *Sad Songs*, rather than, as I have tried thus far, to present remarks concerning the disunities and eclecticism visible in the exhibition, as well as the general context of angst and longing. The artists here with their varying approaches to addressing the fragility of human emotions equally draw our attention towards how ineffectual the visual work of art is in terms of directly accomplishing this task. But in *Sad Songs* both underlying notions and strong passions become transformed into curious conceptual wanderings: a hair traversing a screen, a few monumental portraits, a peculiar anecdote or two. Nevertheless, the art on view floats in an air-conditioned chill, ultimately an artificial surrounding for an enormous amount of actual uncertainty and anxiety.

Perhaps what much of the sadness of *Sad Songs* really amounts to is a lament for the shortcomings of the world, consistently failing to measure up to the expansive, visionary wishes of artists. As has been evidenced in the past, contemporary artists frequently explore both their thwarted desires, and a correspondingly intense yearning for that which is unattainable, unreasonable or inexplicable. If artists are alienated, they are to a degree delivered from their alienation by their hopes for the future, as The Kinks – in a soothingly banal pop song – once urged: 'Accept your life and what it brings / I hope tomorrow you'll find better things.'

38

Shona Macdonald:
Simmer Dim (2010)

The Engine Room, Massey University, Wellington

The middle term that links earth to map, and world to earth, is landscape. This is what all four items possess in common. It is their shared integument, their double-sided flesh. Like flesh, landscape is the living and lived surface of a body – the earth's body. It is how earth appears to the gaze and the touch, how it surfaces to view and grasp. It is also what is projected, complexly, into the two-dimensionality of maps and taken up, multiply, in the n-dimensional worlds of works of art. The relief that is represented in maps belongs ultimately to the fleshlike surface of landscape, just as the darkest recesses of earth that are brought forward in painting belong to the depths of the same surface. If maps for the most part represent overt landforms in detail and in all possible verisimilitude, paintings represent the land's surface in its implicit and concealed character. Both accomplish a truth that is based not on isomorphism but on bringing the reclusiveness of earth into the openness and light of world.

—Edward S. Casey[202]

Shona Macdonald's paintings and drawings offer an evocative reading of land-scape, riddled with manifold implications. Very often her works present imagery characterized by both its precisely rendered detail and confounding spatial ambiguity. Macdonald's imaginative topographies incorporate an intriguing array of pictorial tactics, as she focuses on her surroundings, observing and reworking them deftly. Drawing upon the history of the abstracted landscape, a complex range of sources become refined into renderings that lay claim to a highly layered and nuanced, sometimes haunting graphic language.

Much of Macdonald's imagery has developed out of her lived environment, most recently in the Northeastern United States, but previously in the Midwest region, where the artist resided after relocating from her native Scotland, to begin her postgraduate studies in Chicago. Macdonald has spent much time over the years moving from place to place, whether in longish commutes, her travels back

to Europe, or during the conducting of many visiting artist stints. In this process, Macdonald has taken notice of interstices, distances, downtime and has thereby made imagery stemming from such observations entirely central to her work.

The expansive American interior is often reduced in cosmopolitan short-hand to the 'flyover states'. Nonetheless, in works including *Simmer Dim Flyover*, Macdonald upsets this stereotype by zeroing in on the subtler aspects of such geographic locales, capturing the uncertainty presented by flying over a landscape shifting from darkened plains to illuminated towns, airstrips and highways. Furthermore, to flyover is to miss, omit, neglect to pay attention whereas Macdonald has heightened her awareness of such (non-)sites. And Macdonald's continual cognizance of her own displaced and dispersed identity has increasingly played a role in energizing her work, but it also leaves the artist inhabiting an ever-precarious status, somewhere between cultural settings, traditions, territories (Figure 38.1).

Earlier on, Macdonald had used such materials as vintage aerial sketches of the Scottish coast, and her own trajectory to and from work on a monotonous stretch of interstate highway as diverse research material for new drawings, paintings and mappings. Macdonald began a generative process of conflating memories and experiences with cartographic documents into her own hybridized imagery. Moreover, she was influenced by much theoretical writing on the significance of landscape, such as the more embodied, phenomenological conception as proposed in the writings of philosopher Edward S. Casey (see the epigraph above). Macdonald titled one series of work *Topamnesia*, referencing Casey's notion that: 'remembrance of place, especially that informs a painter's rendition of a place or region she has once experienced in first person; in such memory, the place or *topos* constitutes the major theme or primary concern.'[203]

The timing of Macdonald's maturation as an artist coincided with a strong resurgence of contemporary drawing, as evidenced in a variety of prominent museum exhibitions and surveys, as well as a great number of artists investigating fantastical takes on the landscape, knowingly mixing aspects of both abstraction and representation, in the wake of postmodern appropriation, irony and pastiche. But while many such artists thrive on the use of postmodernist strategies of appropriation, irony and pastiche, Macdonald's work evinces a more sombre, quieter feel, despite its very sophisticated use of palimpsest-like assemblage and layering. And unlike Julie Mehretu, a painter with whom she has been compared and has intriguing affinities, Macdonald keeps her work allied much more closely with both the handmade and the intimate in scale. In her more recent images, the everyday and prosaic from piles of snow to stacks of laundry become imbued with an unlikely resonance, simultaneously mysterious, humorous and warm, despite their dramatically stark qualities.

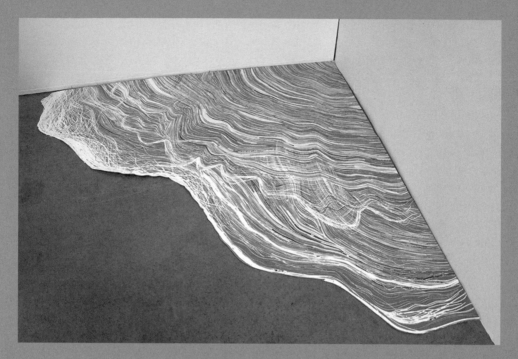

FIGURE 38.1: Shona Macdonald, *Waves, Shore*, 2009, recycled envelopes, archival PVA, cardboard and packing tape, 72 × 70 inches. Courtesy of the artist.

Macdonald often treats the earth as some massive, unwieldy, collaged entity, composed of shadowy scraps and fleetingly witnessed. Yet the rough edges of this landscape are deserving of careful scrutiny, as they are apt to deliver much more than one initially bargained for. Perhaps these are the craggy shores of a coastline, or simply the effect of a partially glimpsed memory trace, summoned through a line, a stroke, an actual tracing via the hand of the artist. As critic John Brunetti perceptively noted: 'Appearing to expand and contract, Macdonald's network of meandering estuaries, attenuated peninsulas and orphaned islands express the internal effects of an individual's external experiences.'[204] Notably Macdonald, while often clearly referencing the external world in her practice, creates new creative mappings which cannot actually direct one anywhere specifically in real space, but instead are likely to move the sympathetic viewer toward various engaging states of contemplation, reverie and wonderment.

39

Craig Easton:
Collapse (2009)

Nellie Castan Gallery, Melbourne, Australia

Collapse, implosion, possibility – Film at eleven

Painterly practice, in the most creative sense of the term—and this is something on which I would insist—is an experimentation of the theory of painting, a way of testing it against the verification of the tenability or untenability of specifically invoked conditions that are understood to make the making of paintings possible. The possible thus becomes the very reality of the work.

—Louis Marin[205]

In looking closely at the most recent paintings by Craig Easton, I am initially captivated both by their lush visual intensity and their multiple layers of contradiction. Some examples: seemingly spare, monochrome fields, yet characterized by richly evocative motifs emerging from their centres, as clusters of tangled forms swim to the surface. Or Easton's considered use of such linear elements recalling nets or webs, tendrils, maybe wires, rope, or even the actual tape that plays a decisive role in their construction. These utterly compelling pictures are highly accessible yet repel exact definition (Figure 39.1).

The artist has described these works by using the word *collapse*, which is a strikingly unambiguous term, given that these images depict a complex, shifting and often disorienting play of ambiguous forms. While painting as a general historical category remains continually elusive in almost every respect, I would argue that Easton's abstractions gain their interest in large part as individual paintings actively engaged with their dramatic and forceful particularities.

Easton's approach might, in anachronistic fashion, be regarded as symptomatic of a renewed interest in formalism. However, an artist can be deeply invested in form without succumbing altogether to formalism's excesses. Easton's works are

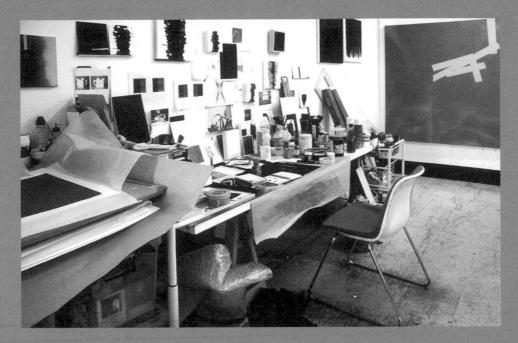
FIGURE 39.1: Craig Easton, studio view, 2009. Courtesy of the artist.

evidence of his commitment to the continued investigation of the painted surface, via both its illusionary and physical properties. These paintings can almost be read as implosions of much that is germane to the act of painting, whether modernist or of the current moment. Easton's paintings are not immune to the pressures of today's art-life surroundings but bear up to this challenge by multiple forms of visual resistance. To some degree, the artist's resistance is voiced through a perpetual 'undoing' and 'remaking' of his own practice.

Something about flatness

It could stand, that flatness, as an analogue of the 'popular' – something therefore conceived as plain, workmanlike, and emphatic. Or it could signify 'modernity', with flatness meant to conjure up the mere two dimensions of posters, labels, fashion prints, and photographs. Equally, unbrokenness of surface could be seen – by Cézanne for example – as standing for the truth of seeing, the actual form of our knowledge of things.

—T. J. Clark[206]

I do get bored, I get bored / In the flat field / I get bored, I do get bored / In the flat field
—Bauhaus[207]

Easton's works which recall the monochrome adventures of Rodchenko and Klein, Reinhardt and Stella also summon other references: the black-on-black cover of the Velvet Underground's second LP *White Light White Heat*, which if one turns it obliquely offers up a skull tattoo, the shimmering surfaces of a leather jacket or a vinyl LP itself, a darkened cinema, or the wardrobe of the late Johnny Cash. This associative game might appear unduly digressive, but painting is/was/will be a popular cultural form, with many attributes in common with other artefacts of popular culture. With all the talk of immersive and interactive environments of the twenty-first century, painting remains a spectacular and seductive setting for multiple sensory triggers.

The very flatness of Easton's paintings creates a gameboard for an utterly sophisticated, frequently shifting set of painterly moves. This is also demanding, as David Cross has noted in an insightful analysis of Easton's approach: 'Too much literal representation and that slippery border of ambiguity disappears into obviousness. Too little and we have retro hard edge painting with nostalgia stamped all over it.'[208]

Easton follows along specific edges, the multiple densities of his compositional fields, his gravitation toward forms that recall but do not represent real-world

phenomena, meanwhile transformed into sleek, abstracted painterly gestures. All of this is precisely and elegantly worried over, but also with some degree of much-needed abandon, as the artist enters a joyful and attentive dialogue with the history of the medium. Easton has, rather perversely, mentioned a 'Gothic Minimalism' and this is an evocative phase given the contradictory and productive tensions which characterize his images. I am imagining an undead Donald Judd applying his fingernail polish right now.

This utterly ludicrous image might be used to return to the notion of collapse, that is, the collapse of internal coherence when speaking of movements, ideologies, or other tendentious claims of modern and contemporary art. Yes, Easton's pictures are rooted in the rootlessness of postmodernism, the Bauhaus of Peter Murphy rather than Walter Gropius but aren't we over that too? Wasn't that just *so* twentieth-century? With what content exactly do we replace the ironic acknowledgement of the absurdity and preposterousness that was as much at the core of modernism as its high ideals and seriousness? Perhaps a very significant starting point could be a renewed interest in delving into form minus formalism, ideation without ideological overkill, the willful ambition to continue making beautiful things in an age of collapse. Certainly, there is never a shortage of parties in dark times.

In praise of the floating rectangle

The ascent to the peaks of the objectless art is arduous, painful [...]And yet it brings happiness. The familiar retreats little by little [...] the contours of the world of objects fade more with every moment; and the same thing continues in the world of figurative notions—everything that we loved and all from which we lived becomes invisible.

—Kazimir Malevich[209]

Craig Easton's paintings simultaneously reconfigure and interrupt existing lineages of abstraction. One might say that Easton seeks coordinates through a darkened and unclear space, not unlike the realm Russian Suprematist painter Kazimir Malevich termed 'the non-objective world'. Part of the intrigue in Easton's work involves his act of proceeding onward, though it remains difficult to predict some of the questions that will emerge in so doing. The act of painting in the early twenty-first century signals an intentional slowing down from our gruelingly accelerating patterns of everyday existence, allowing a breaking away and focusing of our attentions even for a brief moment. In these instants we might be said as viewers to hover, float, stopped in our tracks.

Why is it that so many abstract painters have lavished such attention upon their undifferentiated fields of colour, within which – most likely – other aspects emerge, such as the taped lines or 'zips' of Barnett Newman, the flying geometric shrapnel of Malevich, or the floating rectangular units of Rothko and Reinhardt. To isolate and concretize contingent realities as (not so) formal arrangements is a history with which Easton is well versed, and interested in overtly messing with, revising and collapsing.

Easton achieves much by articulating subtle visual differences and shadings to then be parceled out – almost as if secret information – with the viewer. We see outlines, silhouettes, tracings; the quotidian world becomes transformed into a refined painterly lexicon. Although Easton's imagery has on occasion, spilled out into 'real space' from its framing, the current works instead summon architectonic elements but keep them contained within their pictorial organization. Easton has remarked that his current work could be viewed as 'a kind of collapsing of my own orders of making. Pushing the limits of difference in the works. Working against the programmatic of much abstraction (including some of my own)'.[210]

I would say that in this sophisticated process both a collapse and conflation of historical moments ensues, such that while many have rushed (all too soon) to offer up their postmortems on the medium of painting, Easton has meanwhile been contending very productively with many of the specters still haunting his own contemporary studio. Painting has not disappeared, and Easton's works capably contend with redefining an enduring, living medium. If collapse is in order, it is collapse solely as fuel for Easton's on-going, self-critical and vibrant painterly practice.

40

18th Biennale of Sydney (2012)

27 June–16 September 2012

Each time a highly anticipated biennale arrives, whether large or small, pronouncements filter through the art world as to its relative success or failure. This is an exceedingly difficult thing to sum up adequately, particularly when, as in the case of the modest-sized 18th Biennale of Sydney, the exhibition presents a selection of works by over a hundred artists from almost half as many countries. Thus, judgments are frequently made over the relationship between the overarching curatorial premise and some portion of the works on view (after all, does anyone actually spend a lengthy time with each of them?). This biennale's title, *all our relations*, initially appears to raise questions regarding both the increasingly global 'relations' of the art context, viewed broadly and the matter of specifically 'relational' art practices.

Artistic directors Catherine de Zegher and Gerald McMaster – the first time the Sydney Biennale has been organized by a curatorial team – assert an ostensibly 'groundbreaking premise' in their press release that the Biennale 'connects absolutely local issues, the most intimate meanings of place and time, with great currents of art and thought that are linking lives as though in conversation.'[211] But doesn't almost all art today connect the global and local in de facto fashion, to use the unfortunate neologism, the 'glocal'? And what exactly are these supposed 'great currents' of art? It is perhaps this generalizing and pretentious kind of discourse that indicates one of the major shortcomings of the exhibition, which is a tendency toward lumping specific practices into amorphous, well-meaning but ill-considered generic groupings, heavily dependent on formal similarities, positive sentiments and bland philosophizing.

There are indeed many engaging works on view, yet they seem somehow submerged and muted under the flattening effect of the exhibition's loose and unchallenging frameworks and a curious stasis in the installations, which occur over several dispersed sites, including the Art Gallery of New South Wales, Museum of Contemporary Art Australia and Cockatoo Island. The curators are to be commended for their attempt to create a more geographically inclusive

biennale, with artists coming from nearly all regions of the globe, particularly from Asia, Africa and the Southern Hemisphere broadly speaking, rather than, as frequently happens, selecting artists primarily from Europe and the United States.

Many of the strongest works incorporate the engaging specificity (and relative simplicity) of straightforward documentary-style video and photography. In Susan Hefuna's project *Celebrate Life: I Love Egypt* (2011), Egyptian citizens speak about their experiences during the Arab Spring of 2011 in videos shown in tents designed and constructed by the participants in workshops coordinated by the artist, but that include their own narratives, writing and imagery. Bouchra Khalili's *Mapping Journey* (2008–11) video installation records the first-person narratives of migrants from Africa and the Near East, as they trace their complicated and clandestine routes of diaspora across the European continent. Artist duo Sarah Vanagt and Katrien Vermeire's video *The Wave* (2012) is comprised of a time-lapse montage of photographs depicting the exhumation of burial sites of victims from the Spanish Civil War, which unfolds with a harrowing intensity. Subhankar Banerjee's large prints of aerial landscapes such as *Caribou Migration I* (2002) are impressive and not solely due to their formidable technical precision but underscored by Banerjee's involvement beyond his images themselves as an active and high-profile voice on the effects of climate change. Jess MacNeil's *The Shape of Between* (2006) is a simply executed but haunting video of boats at Varanasi. Arin Rungjang worked with potters and orphaned children from Rwanda in *The Living Are Few But The Dead Are Many* (2012), recording their personal testimonies on video, which are, as one would expect, extremely poignant.

Unfortunately, too often the largest works on view – many of them situated on the sprawling setting of Cockatoo Island that allows for anachronistic, disused industrial sites to be filled with a plethora of contemporary installations – seem to operate as mere high-end store displays with an added frisson of so-called interactivity. In other words, a great many of the works are undeniable crowd-pleasers, leaving me to feel a bit like the naysayer with a notebook working my way through long lines of people with my (nearly) readymade retorts. The Biennale offered a case study in the conundrum of major contemporary art exhibitions, in that they are getting to be such well-oiled machines that my presence as a critic seems to matter less than ever, leaving me prone to make comments that could easily be interpreted as made in 'bad faith'.

Yet several projects still offered challenging and refreshing exceptions. Upon arrival by ferry onto Cockatoo Island, visitors are confronted by *Living Chasm* (2012), a massive and moist eruption of mechanically generated fog by artist Fujiko Nakaya, especially incongruous given Sydney's characteristically sunny weather. Ed Pien's *Source* (2012) is a rather ethereal construction, simultaneously resembling a maze and a magic lantern, made of mylar, rope, paper and

video projection, with the significant sonic component of Tanya Tagaq's affecting throat singing. Peter Robinson's *Gravitas Lite* (2012) involves a gigantic profusion of sculpted polystyrene, deceptively chaotic and cluttered. The sculptural reliefs of El Anatsui are majestic and evocative, albeit constructed from found metal bottle caps. I found myself transfixed by Guido van der Werve's *Nummer acht: Everything is going to be alright* (2007), a video projection that depicts the artist walking, seemingly hovering in place, in front of an imposing icebreaker ship in the Gulf of Bothnia.

The curators have created a biennale that rarely references any politically engaged, activist or interventionist creative methodologies, in favour of more indirect forms of commentary and critique, which in turn deflects the impact of the works that do involve any committed engagement with the public sphere. It seems that criticality is only valued when presented in a heavily aestheticized, mediated and rather oblique manner. The absolute disinterest in showcasing more confrontational or contentious strategies is a primary weakness of the exhibition in general. While the notion of the relational is used to signpost the Biennale, to my mind, such relations are on the order of the standard-issue art exhibition and do not feature in terms of presenting innovative ways of framing the artworks on view, nor eliciting a more concertedly dialogic relationship with the spectator (who, supposed 'interactivity' aside, in most cases remains largely a spectator rather than participant) for that matter.

The visual, in manifold forms of expression, is given the nod over concept, especially as so many of the conceptual statements espoused by the works, or at least their curatorial interlocutors, seem directed toward the flimsiest of conceits. It becomes easy to feel suffocated by the repeated use of fastidious craftsmanship in the service of obvious notions. Statements about the delicacy and fragility of life are too often reiterated with the subtlety of a sledgehammer. The curators also seem unduly fascinated by techniques of collage and assemblage, rather than also supporting more hybridized approaches that are more difficult to define or categorize. This is ultimately a Biennale that privileges craftsmanship and more traditional modes of artmaking, with very little representation of more overtly and radically experimental practices.

41

Simon Starling:
In Speculum (2014)

British artist Simon Starling is an inveterate tinkerer, a conjurer of fantastical, interwoven narratives and creator of fastidious, finely tuned contemporary installation works, often involving cinematic projections. His fascinations, whether one shares them or not, are conveyed in such a lively, engaging manner that it becomes deceptively easy to ride along. Starling was awarded the Turner Prize in 2005 and this further advanced his already strong artworld profile. It is entirely fortunate that *In Speculum*, an informative and evocative survey of the artist's work has arrived in Wellington coinciding with the commencement of the international festival. (The exhibition is an ambitious trans-Tasman curatorial venture, involving three institutions: Monash University, the Institute of Modern Art and City Gallery.)

Starling draws many of the conceptual launching points for his works from historical anachronisms, building idiosyncratic, non-linear trajectories. While taking in somewhat shadowy arcana, Starling correspondingly re-animates this material with great immediacy. Starling's practice often recalls the late novelist W. G. Sebald's approach, which merged narratives, fictional and otherwise, with photographic imagery and an intimate subjective voice. Perhaps this potential parallel arises from the melancholic tone of Starling's works, which often use black and white film, simultaneously sombre and luminous, as a seeming antidote to our disembodied digital environments.

Wilhelm Noack oHG (2006) features a marvellous film loop machine, resembling a spiral staircase or a section of DNA projecting a short, vertiginous sequence in which the camera alternately pans over documentation and roams a historically charged Berlin factory site. *Black Drop* (2012) is a wide-ranging film examining the nineteenth-century astronomer Jules Janssen and his intersection with innovations in early cinema and photography, along the way describing his attempts to record the Transit of Venus, representations of Captain Cook's death, the philosophy of Henri Bergson, and the invention of chrono-photography by Étienne Jules Marey. In *Le Jardin Suspendu* (1998), the earliest work in the show, Starling constructed a radio-controlled 1920s-style airplane to fly above the Australian Heide Museum, formerly the modernist home of arts patrons John and Sunday Reed (Figure 41.1).

FIGURE 41.1: Simon Starling, *Le Jardin Suspendu*. A 1: 6.5 scale model of a 1920s French 'Farman Mosquito', built using the wood from a balsa tree cut on the 13th of May 1998 at Rodeo Grande, Baba, Ecuador, to fly in the grounds of Heide II, Melbourne designed in 1965 by David Mc Glashan and Neil Everist, 1998. Model plane, balsa tree, bags, tools, plans, glass, steel, site-lights, transparency, clamps. Model plane 138 × 117 × 37 cm, installation dimensions variable. Installation view *Simon Starling: In Speculum*, City Gallery, Wellington, 2014. Courtesy of The Artist and The Modern Institute/ Toby Webster Ltd., Glasgow.

Starling's works are frequently site-responsive, and as becomes evident, actual, historical and gallery 'sites' are in ever-shifting dialogue with one another. *Project for a Masquerade (Hiroshima)* (2010) populates a Japanese Noh play with an extravagant cast of characters including sculptor Henry Moore, financier and art collector Joseph Hirschhorn, scientist Enrico Fermi, Sean Connery's James Bond, art historian/spy Anthony Blunt, and fast-food magnate Colonel Harland Sanders. While a voice over narrative pieces the tangled tale(s) together, we witness the carving of artisanal wooden masks of each personage mentioned above.

Justin Clemens, in an essay from the exhibition's small but lavishly illustrated catalogue, notes the 'forbidding complexity' of the artist's practice, but this should not put off potential viewers, rather it is important to set aside time so as not to run through the gallery but to slowly savour Starling's fanciful and intricately layered concoctions. The dizzying, disorienting quality of some of these projects can be overwhelming, but richly satisfying. They are unlikely to release your mind once they have shaken your senses.

42

Chris Heaphy's Kaleidoscopic Eye (2012)

One difficulty left in the wake of the postmodern approaches to painting of the late twentieth century was that while a strong critique of high modernism's pitfalls was at times truly bracing and much needed, it initially became very tough to generate new alternatives from existing strategies of appropriation, eclecticism and fragmentation. More recently we could be said to inhabit an entirely different period, dominated by the technologically charged virtual world, and its continual floating and flickering. While not entirely rudderless, we are arguably in need of a more selective and prioritized rendering of what is most meaningful and significant (if only to preserve our sanity): spirituality and healing of the self, critical explorations of ecology and reconsideration of histories and identities. In Chris Heaphy's engaging painterly practice, he has actively sought a powerful hybrid, subjectively assembled from diverse aesthetic and thematic concerns; amidst his keen awareness of the dense thicket of symbols that surrounds us, he has located his own distinctive language, a generous re-mix of lavish and busy signs conveyed in a clear graphic style.

In the almost bewilderingly complex, kaleidoscopic facets of his 2012 *Maukatere* series we are greeted by a wide array of pictorial information to decode and decipher: birds and butterflies, sunbursts and profiles commingling in clusters of fluorescent and glittering patterns.[212] The surfaces of Heaphy's paintings are covered edge-to-edge with a plethora of small, silhouetted interlacing forms and the artist skilfully negotiates his use of darker values and neon hues to make his imagery practically leap out in hallucinatory fashion into the viewer's space. Heaphy, an artist of bicultural heritage, Ngāi Tahu and Pākehā, weaves cultural associations throughout his practice. Significantly, *Maukatere* (Floating Mountain) (Figure 42.1)

also refers to the mountain of the same name, near Amberley in the South Island. The mountain holds particular resonance for Ngāi Tahu Māori as the summit is believed to be the starting point for departing souls on the journey to the afterlife.[213]

In Heaphy's paintings, shifting frequently and intentionally between macro and micro vantage points, distinctions and borders between interiority and exteriority

FIGURE 42.1: Chris Heaphy, *Maukatere*, 2012, acrylic on linen, 1900 × 2700 mm². © Chris Heaphy. Courtesy of the artist.

get a solid working over as well: when does a skull transform into a mask, or a shell, maybe a shield? Heaphy's use of skeletons and skulls, rather than being in any way macabre or morbid, on the contrary evokes aspects of joyous abandon and exuberance. In several works caricatured skeletons dance or mask-like forms are coloured so brightly one cannot help but be amused. This slapstick feel to the work is not disrespectful, but indicative of an inclination to gentle humour and witty juxtaposition.

Heaphy conjures a deceptively turbulent, yet utterly evocative neo-psychedelia that also points towards post-colonialism and the massive amount of imagery we have flowing through our systems daily via broadband, television, phones and other cacophonous technology. Heaphy's artworks reconsider that which is often termed 'white noise', rerouting it back into a pictorial structure characterized by both its precise ornamentation and lush palette. His dizzyingly repeated patterns and colourfully variegated iterations also enact a careful revision of existing modes of representation. The still-life for example, or *nature morte*, is referenced but also, regarding the fact that nearly everything in the contemporary environment seems switched on, artificially illuminated, it lends the impression of life rather than 'dead nature'. Moreover, in accordance with Māori cosmology, the sun is associated with *mana,* and the emergence into light with spirituality. Thus, the effect of the spiraling images and fractal patterning in Heaphy's work could be seen as both resonating with and focusing upon the life cycle itself. He frequently uses the koru motif, which both pushes ahead and can be re-traced to its original starting point.

The butterfly motif, often read as representing transformation and freedom, could also refer to the fractured modernism of the author Vladimir Nabokov, an avid lepidopterist, whose prose shimmered with exactitude but also cranium-twisting shifts of temporality, voice and narrative. As he writes in his autobiography *Speak, Memory*: 'I discovered in nature the nonutilitarian delights that I sought in art. Both were a form of magic, both were a form of intricate enchantment and deception.'[214] And perhaps even more relevant by association is Nabokov's synesthesia, in the author's case what is termed 'grapheme-color', meaning that words become linked to a parallel image such as 'loyalty' being 'a coloured fork in the sun'.

This is not so far away from the mix of pictographic signs and symbols that have run through Heaphy's work, often mixing stylized renderings of commercial culture alongside more richly meaningful aspects of Māori cosmology. The natural symmetry of butterfly wings also reverberates with a more cultural reference: the Rorschach ink-blot psychological texts.

Heaphy titled the works included within *Maukatere* by using the Māori names of various constellations, and this celestial interest, looking skyward from an island in the Pacific, recalls the major influence of the stars in bringing the first

residents of Aotearoa across wide, seemingly insurmountable seafaring distances. Simultaneously it could reference the way in which Heaphy constructs his images from smaller tesserae-like units, as in the way we have historically sutured patterns of stars together to configure dogs, bears, goats, rams, charioteers or bearers of water.

In a painting such as *The Inner Workings of the Mind* (2009), the emblematic silhouette of Mickey Mouse is formed from the smaller motifs of Aotearoa New Zealand that run through Heaphy's work, and it raises multiple questions concerning art, authorship and 'sampling' of iconic figures. Virginia Were has noted Heaphy's citation of the clubs and diamonds that adorned Tuhoe prophet Rua Kēnana's temple at Maungapōhatu, commenting that

> the glorious mixture of symbols from two very different worlds – early twentieth-century Māori and Pākehā – in the form of boots, hats, guns, skulls, skeletons, ruru, pipes and profiles of Māori heads, all coalescing within Mickey Mouse's outline, suggests Heaphy is taking a deeply satirical look at cultural imperialism, the loss of innocence associated with colonisation and the relations of the powerful to the weak in general – themes being played out on the world stage today.[215]

With a similar work from 2007, titled *Walk This Way*, we could even take the title as referring to the 1970s Aerosmith classic rock standby which in turn was revised a decade later by rappers Run DMC and has subsequently become a ubiquitous staple of popular culture, featured in many films, cartoons and video games, furthering the unlikely circuit from late modernity to our contemporary context.

Heaphy's earlier works sometimes intersected directly with and upon found objects such as tablecloths, and often gravitated towards atmospheric shadings and renderings, almost as if recording partially remembered or dreamlike states. In an insightful analysis of Heaphy's art in the late 1990s, David Cross commented:

> As well as dissecting the iterability of signs, Heaphy is also concerned with what makes them tick. By repeatedly using the spade or diamond playing card for example he attempts to wear down the charisma these forms have to find the point at which they collapse into ordinary images. This is not an attempt to destroy their power but to mine the vagaries of spiritually imbued forms. The artist wants to find the trigger that gives these forms such power above and beyond so-called ordinary motifs. In particular, Heaphy searches for the healing properties supposedly inherent in these signs.[216]

More recently, Heaphy's paintings are notable for their bold frontality, stark shapes and eye-catching surface density. Their visual profusion and their colorful

intricacy, along with their acknowledgment of kaupapa Māori, recall the layered and flowing imagery of John Hovell's magisterial kōwhaiwhai paintings.[217]

Heaphy's vividly depicted, nearly tactile imagery immediately gets our attention and elicits rapid movement from the 'responsive eye' (once the title of a historic 1965 Op Art exhibition).[218] Heaphy refers to infinity, using more than one mechanism, not only in his use of the infinity symbol itself but in the pictorial expansiveness that has become characteristic of his practice. A greater emphasis on the temporal aspect of painting is a feature common to many artists currently working in the realm of abstraction. Appropriately, the artist David Thomas included Heaphy's work (along with that of Lisa Benson, Craig Easton, Simon McIntyre, Simon Morris and Jeena Shin) in a 2003 exhibition held in Sydney entitled 6 *Artists From New Zealand: Abstraction and Time*, which posited the notion of 'paintings as models of time and the real'. In speaking specifically of Heaphy, Thomas notes that in his work, 'matter becomes sensation [...] images become space and energy in light [...] in time'.[219]

Several of Heaphy's works, such as *Sea of Tranquility* (2008), have referenced the Apollo moon landing of 1969. The painting itself, however, is a busy transit station of elements: infinity signs, outstretched palms, skulls, profiles, boots, leaves, eyes, pipes, all located somewhere between charm bracelet trinkets and charged poetic totems. I recently learned of the death of American astronaut Neil Armstrong from my 7-year-old daughter who stated his name and claim to fame as if mechanically reciting the achievement of some ancient figure from an unknown time – which for her, of course, he was. And I recall hearing that Armstrong stopped signing autographs many years ago, tiring of the incessant attention, his signatures conveying his considerable achievement into the territory of mere commodified spectacle. But beyond the machismo of the space age, one could also return to the significance of the moon as a feminine presence and connected to fertility and the cycle of life once again.

Heaphy commented upon his practice in a 2007 statement that:

[T]he paintings [...] work on a number of levels. They address mortality and the questioning of what it is that makes us who we are. They delve into the complexity of spirit and explore the many parts of us that make the whole. They talk about culture, experience, life, death, belief systems, the environment and attempt to embrace the idea that oneness is in many ways the sum of everything.[220]

The artist's attention to the unity that exists beneath a plethora of surface information appears simultaneously related to both holistic notions of Māori cosmology and to contemporary developments in quantum physics. Recently it has become more widely acknowledged that ostensibly major differences between the so-called

material and immaterial worlds, organic and inorganic properties, readily accessible surfaces and deep structures might actually be far less significant than we once might have thought. According to the notion of the Zero Point Field, we are all – to put it bluntly – made of the same stuff or, more specifically, the same pulsating energy field.[221] The mandala-like forms of Heaphy's work are informed by a pictorial acknowledgment that matter moves freely, intersecting and overlapping, and that in any imagery perceived as chaotic and unstable there simultaneously exists a strong, cohesive bond. Keith Stewart has aptly described Heaphy's paintings as 'the story of reductionist minimalism transformed into the holistic world of real life – little simple parts that are wonderfully clever in themselves making infinitely complex wholes'.[222]

Heaphy's imaginative realignment of the visible world with all manner of unseen atmospheric phenomena recalls for me a statement by the German director Werner Herzog in reference to his attitudes towards documentary film:

> Neither facts are that interesting nor is reality that interesting. Somehow, in all of this we are still capable of finding some illumination, some truth, some place where we step out of ourselves, where we are ecstatic, where we have an ecstatic, visionary realization.[223]

This faith that the noted European cineaste places in art, however, could also be found by recalling the visionary Māori prophets who have been referenced in Heaphy's practice such as Rua Kēnana and T. W. Rātana.

Heaphy's paintings also function in terms of an inquiry into the ways in which a diverse range of imagery drawn from visual culture is represented and displayed. At times, his work hovers between referencing album covers, advertising, packaging and other everyday signposts, but it equally makes knowing reference to manifold histories of post-war painting: op and pop, kinetic and colour field, appropriation and after. Heaphy has acknowledged in conversation the influential re-routing of twentieth-century painterly discourses by such (quite dissimilar) figures as Frank Stella and Peter Halley. One could also summon an example much closer to home, painter Gordon Walters, who became a close friend and mentor for the younger artist, who collaborated with him on several projects. And, as noted before, Heaphy's work exemplifies a strong and persistent motivation towards consciously (re-)thinking through the role of being a contemporary imagemaker of bicultural lineage living in a bicultural society with a steadily increasing global presence. Heaphy perceptively and playfully merges in his work aspects of his contemporary awareness and historical consciousness, a challenging and productive trajectory as we proceed further into this still new, ever unpredictable century.

43

Niki Hastings-McFall:
In Flyte (2013)

It becomes clear in viewing Niki Hastings-McFall's highly informative and inclusive exhibition at Pataka that while her work is engaged in subtly inflected critiques of postcolonialism and received notions about Pacific identity, she is chiefly an artist who investigates the impact of light and colour. This is not a bad thing at all, in that the immense allure of the pieces she creates in the various forms of installation, wall reliefs and smaller sculptures draws the viewer in with a striking immediacy. By appropriating, contending with and transforming everyday cultural forms she redirects our attention away from stereotypical readings, using a disarming humour and lightness of touch, rather than weighing down her often exquisitely constructed visual work with excessive commentary.

Curator Helen Kedgley balances this to a degree with an eloquent installation in which the works tend to reinforce and respond to one another with their visual reverberations and closely related themes. Hastings-McFall plays with the visual language of both public and private spaces and offers in the process significant twists in terms of our views of both, as when she, in her words, 'Polynises' the surfaces of the 'suburban furniture from my childhood' (Figure 43.1).

She draws from her personal experience as a child of European-Samoan heritage raised by English grandparents in New Zealand, and her chosen domestic objects, as in *Home from the Sea* from the *Cloud* series (2008), become enticingly tactile and luminous, covered as they are by the artificial flowers of the ubiquitous Polynesian lei. Her arrangement of nineteen floor lamps seems to turn them into an uncanny collective apparition. This image may reference the superficial view of Polynesian culture based on the bright, artificial surfaces many viewers will be familiar with, as well as eliciting a more layered chain of associations.

In an insightful essay included in the accompanying catalogue, Karl Chitham notes:

> The lei has become both a tool and an emblem for Hastings-McFall. It has come to represent all of the ideological injustices of a colonial past and of the dusky maiden

FIGURE 43.1: Niki Hastings-McFall, *Polynisation* series, 2005. Courtesy of the artist.

stereotype while also being reclaimed as an important and positive symbol of a way forward into the future.[224]

Several of her lightbox works, covered with colourful artificial flowers, are particularly engaging, sometimes fiery and vivid, or cool, entrancing, almost meditative. Here the artist makes distinctively feminist statements responding to the heritage of minimalist formalism and hard-edge geometry by means of her own vibrant and idiosyncratically tailored abstraction. The *Va-riant* series involving highly reflective surfaces of acrylic, Perspex, steel and aluminium yields wonderful illusory effects, especially when viewed from differing vantage points, as well as mirroring other sculptures on display (and the viewer's own shimmering reflection).

Similarly, the *Urban Navigator Series* (2009) invokes traditional symmetrical patterns and forms while taking on the appearance of iridescent road signs. Hastings-McFall's use of titles indicates her critical process, also evident in the formal construction strategies of the works. Nonetheless, for an artist whose other works on view speak through bold, evocative and often large-scale forms, her *Vanitas* series (2010–13) of small still-life tableaux, featuring skeletons and marble and surrealistic juxtaposition, appears a bit out of place and less memorable. However, Hastings-McFall's most arresting artworks become lush fluoro – and floral – hallucinations, skilfully wrought, often transporting.

44

Simon Morris:
Black Water Colour Painting (2015)

Black Water Colour Painting (2015) is the first of artist Simon Morris's water colour wall paintings to wrap completely around the interior of a single architectural space, as it does in the Ilam Campus Gallery. It is also Morris's sixth painting of this type. One of the inspirations behind using the pigment black, characterized by its value and tonality rather than richness of the hue, was in response to the gallery's *c.*1970s brutalist architecture, characterized in particular by its striated concrete walls. Moreover, a visual rhyme emerges when leaving Morris's work, as the modular, iterative patterns of the building itself seem to be somehow highlighted. And significantly so many abstract artists have worked effectively from a drastically reduced palette (Brice Marden, Agnes Martin, Ad Reinhardt), and Morris's general inclination is toward reduction whenever possible. Morris, who has frequently made monochromatic paintings, has stated of the colour black that, 'I don't think it's neutral or a non-colour.'[225] And in *Black Water Colour Painting*, one might find that this is especially the case (Figure 44.1).

On his systemic approach to painting, Morris has commented: 'it creates images that I wouldn't come up with myself. It's like the system partly makes the work',[226] which in turn recalls seminal conceptual artist Sol LeWitt's oft-cited dictum: 'the idea becomes a machine that makes the art.'[227] Yet unlike some artists who work using a systemic manner, the evidently handmade and executed aspects of the work are very crucial to the artist. And *Black Water Colour Painting* incorporates tremendous variety in its overlapping edges and tonal gradation. The artist used three main variables in managing the work: the amount of water added, the amount of paint removed and the amount of coverage occurring with each brushstroke. And an unyielding time structure: working with only minor interruptions from 10 a.m. to 7.30 p.m., and within fixed spatial coordinates: 153 vertical bands, their values moving from opaque black to clear water.

Upon entering the gallery for an initial view of the work, several of my preconceptions, that is, my pre-existing mental imagery of what I was likely to find, were utterly disrupted. Almost in the vein of, put bluntly: *this is a painting*

FIGURE 44.1: Simon Morris, *Black Water Colour Painting*, 2015, Ilam Art Gallery, Christchurch, New Zealand. © Simon Morris. Photograph by Mitchell Bright. Courtesy of the artist.

after all. And despite my great fascination with conceptual practices, indeed one cannot fully grasp any propositional work until it is enacted. And sometimes I find myself too distracted from the actuality of a work by the kind of mental circles one runs around art historical touchstones, the previous history of the artist in question, and certainly one's own critical biases. It is not in fact that Morris's painting was *nothing* like I imagined, but instead that its utter richness *as* a painting took me a bit by surprise. While Simon Morris's artworks avidly engage with and integrate experimental and technical processes, they escape their diagrammatic and schematic origins. I kept thinking that this is in some real sense a living surface, which has become an embodied trace of gesture, improvisation and imagination. Much has occurred in this work reaching beyond mere statistical information.

Unexpected surprises emanate from a consciously deliberate, premeditated structure and the context within which it operates. In this way, Morris bears some affinity with the avant-garde composer John Cage more than perhaps minimalist sculptor Donald Judd whom he has been closely inspired by as well. I also think of musician Philip Glass and his iterative approach to composition creating a modular and serial, almost hypnotic pattern rather than an intricately woven layering, which was closer to Morris's work as an emerging painter of note as gently shimmering textural strokes both rose out from and were submerged into the picture plane. And in marked contrast to some earlier critical readings of the artist's practice, I would argue that it would now be highly inaccurate to read Morris's works as 'cool and aloof' as his considerable skill and dedication as a painter in some sense *leaks* through the hard edges and number crunching that orients the overall structure of the work.[228] I'm taken by the spatters and drips that happen towards the floor, the diagonal lean of the painter's (left-handed) brushstroke, the amoeba-like blotches and stains, all painterly events occurring in spite of the controls put in place in advance of the work's execution.

Morris has worked with great diligence as a teacher and an artist over the course of his career to communicate the enormous significance of abstraction, which is not so widely understood in this country even now. For all the art students who might stray far from the discipline of painting, wrongly thinking it somehow anachronistic, many still have difficulty thinking through the complexities of images that are not indulgent of some romanticized mode of narrative representation. Some of the earlier historical accounts of painting in Aotearoa New Zealand were focused primarily on landscape and realism.[229] The unfortunate thing is that this need not have put undue pressure on other modes of painterly practice (although it has left a ripple effect on the reception of contemporary painting in this country). No doubt for this reason, among others, Morris found it immensely liberating when he travelled to Europe after his Bachelor of Fine Arts studies and

saw many examples of international geometric abstraction, including the works of the German Blinky Palermo or the Americans LeWitt and Judd.

And yet I don't have the impression that landscape is entirely absent from Morris's paintings, which particularly evoke the artist's close relation to water and the sea, and a correspondingly strong interest in environmental sustainability and simplicity of materials. Although Morris was born and raised in Hamilton, one of New Zealand's uncharacteristically inland towns, his studio overlooks Wellington's Lyall Bay, and he has often incorporated references to water and the aqueous in his paintings, titling one series *Folding Water* for example.[230] In Morris's most recent works, both in his discrete smaller canvasses and in his wall paintings he has used a mathematically derived system to decide on amounts of dilution from one part of the work to the next, which in turn effects the necessary rapidity of application, length and timing of brushstroke, amount of millilitres of paint held by the brush and the surface preparation of the wall or canvas. And Morris now uses acrylic paint rather than oils, a choice he made for a number of reasons, including health factors, and also the qualitative improvement in acrylic paint in recent years.

The very fact that Morris has evinced a close interest in temporality as a structuring device for his works speaks towards the surrounding world, rather than existing in a utopian sequestered setting. By measuring temporal and spatial coordinates for his works, time became a focus itself, also summoning ideas relating to memory, differing cultural notions of time and the increasingly accelerated and compartmentalized dissection of our existence. Moreover, Morris viewed the current exhibition as an opportunity to create a new painting in the very art school where he learned to paint (and he previously exhibited in the Ilam Campus gallery twice before, once as a student in the early 1980s, and again in the mid 1990s). And so *Black Water Colour Painting* (2015) represents at once an act of recall and return and a movement forward in time.

45

Dan Graham:
Beyond (2009)

Museum of Contemporary Art, Los Angeles
15 February–25 May 2009

Dan Graham is one of the artists in the United States that, until comparatively recently, has been least lionized on his home turf, instead serving as a kind of intellectual gadfly/public artist-in-exile, representing American art abroad without being either well-integrated into its canon or at ease with many of its stylistic premises. Graham's long career and variegated output are thus both paradoxical and problematic. A prolific writer of some of the most fascinating essays by any twentieth-century artist, his texts are characterized by their eclectic and hybrid sensibility, turning from punk rock to European gardens, political unrest to the phenomenology of perception. While this synthetic approach with its hyperkinetic curiosity could easily be considered utterly American, the most recent large retrospectives of Graham's work have been mounted in locations like Barcelona, Paris and Vienna, *not* in the United States.

Perhaps this is in part because Graham is unsparing in his analysis of the American social landscape. His landmark magazine piece *Homes for America* (1966–67) plotted the path between the 'little boxes' in which many of the Minimalist artists were raised in post-war suburbia and the angular geometric constructions later exhibited by Dan Flavin, Donald Judd, Sol LeWitt and company. What is it about the mesmerizing ubiquity of these spare shapes? Graham's incorporative yet sceptical views are more in line with those of his friend and colleague, the late Robert Smithson, who was also entranced with New Jersey locales as subject matter, in creating his 'non-sites', writing on 'slurbs' and documenting of 'the monuments of Passaic'.

Try to find a more brilliant appraisal of popular music and its relation to the audience than the video *Rock My Religion* (1984), today a magnificent time warp, which features a rigorous and funny narration colliding with footage of hippies, television advertising, early Patti Smith and religious fanatics, the mix becoming

in turn sensitive, scathing and scarifying. As is the hilarious documentation nearby of Minimalist composer Glenn Branca, pompadour flying and guitars hammering, and one-time D.C. punk exemplars Minor Threat – their testosterone aggression now softened in retrospect by a nostalgic sweetness. Akin to a less perverse Larry Clark, Graham seeks the reflected, abundant energies of youth via the cultural constructions thereof – skateboarding, pop music and amusement parks – rather than in their actual embodied selves.

Unfortunately, the dryness of Graham's analytic procedures can make this formidable presentation of his art at times drearier and more academic than one might hope for, given his diverse inspirations and sources. Maquettes for the public works sometimes appear as slight sketches of mild-mannered quasi-architecture. This impression is countered quickly by confronting the many full-scale installation works, shimmering funhouse pavilions that linger in their undeniably evanescent but still potent effects. It is almost as if unseen forces command one to turn, do double takes, wander about and simply revel in the demanding weirdness that accumulates along with the manifold reflections.

The early film installations lavishly repay viewers' concentrated attention. *Body Press* (1970–72), a rarely seen work, involves two protagonists 'rolling' movie cameras around their naked torsos while standing in a mirrored cylinder. For the final presentation, each of these specific vantage points was then projected directly across from one another in the space, as the twin projectors loudly rattle away. Throughout Graham's film projects, he treated the camera as a prosthetic bodily extension. The multiple views with which he was experimenting funnelled directly into the later two-way mirror pavilions.

Dan Graham was early and exacting in his dissections of temporality, surveillance and mediation. In surveying Graham's multi-layered practice, we see the clear precursor to so many 'relational' and 'neo-conceptual' works from Douglas Gordon to Dominique Gonzalez-Foerster. *Beyond* is an entirely apt title for this exhibition as the artist so often pursues notions that are difficult to grasp, measure or observe without the aid of the time-based media and architectonic structures that elucidate them, making such ideas less abstract and more accessible. By intricately weaving together the spatial and the temporal, and simultaneously evincing a great critical acuity concerning both popular culture and the public sphere, Graham has interrogated the contemporary with unerring subtlety and insight. Such a vision is altogether rare and this unusual opportunity to encounter a large selection of the artist's works gives us the possibility of contending with them, so they might yet again inform and invigorate our current artistic context.

46

Richard Long:
Heaven and Earth (2009)

Tate Britain, London
3 June–6 September 2009

In light of the recent plenitude of artworks, books and symposia devoted to the topic of walking, Tate Britain's inclusive Richard Long retrospective offered a welcome opportunity to reconsider his longstanding and influential practice. A veteran of conceptual art's heyday, Long has continued to maintain his rigorous series of creative investigations, interweaving the related phenomena of walking, mapping and travelling. In so doing, his works have convincingly served to blur unnecessary distinctions between photography, documentation and installation.

The exhibition was both spacious and elegant, allowing Long's austere and subtle images to hang effectively without the impediment of claustrophobic groupings. His works instead can be read as a slow accretion of detailed renderings and insightful commentaries. Long's typical sans serif typeface becomes an instantly recognizable signature, as is his most characteristic mode of expression: dry, selective lists featuring the dates, locations and specific details of his excursions: *A walk of 24 hours: 82 miles/A walk of 24 miles in 82 hours.*

From the earliest points in his artistic trajectory, Long's ideas were deceptively simple, but voiced in a disarming and incisive manner, like when he describes: 'making a sculpture by walking [...] which was also my own path, going 'nowhere' [...] My intention was to make a new art, which was also a new way of walking: walking as art.'[231] This breakthrough was exemplified by the seminal piece *A Line Made by Walking* (1967), depicting Long's footpath made by treading through a grassy field. Long's works were – and still are, in fact – usually presented in the form of straightforward direct photographic records, coupled with occasionally witty, often poetic, texts. Unfortunately, the artist's statements presented at the Tate also tread perilously close to the banal, as when the artist remarks that his 'work is about movement and stillness'.

A native of Bristol, England, Long has kept the southwest of the UK as his primary base of operations, despite his wide-ranging travels across Europe, Asia and the Americas. Not unlike the nineteenth-century British painter John Constable, Long seeks to examine what he has called 'my prototype landscape, plateau-like, treeless, with plenty of water – perfect walking country'. Here, he speaks of the rather wild and stark areas of Dartmoor and Exmoor. Thus, the artist situates himself in his 'own' territory, just as Constable who stated: 'I should paint my own places best.'[232]

Although Long's work raises many relevant questions relating to temporality and the sculptural, it is when he creates both sculptural and wall installations that the work fails to garner the same cohesion as in his photo/text pieces. The works are more heavy-handed, and perhaps in their dependence on overt materiality seem at odds with the evocative, yet often ephemeral, nature of Long's ambulatory wanderings. Muddy handprints applied to a wall – even if the hands belong to Richard Long – remain muddy handprints and are much less effective in conjuring notions of place and site than the photographic displacements that have become the artist's specialty.

A linguistic evocation of the natural environment has the potential to escape lurid romanticism and sentimentality, and Long has noted his interest in creating 'abstract art laid down in the real spaces of the world. It is not romantic. I use the world as I find it'.

Nonetheless, as *Heaven and Earth* proceeded, the images on display – owing in part to their increasingly large scale and use of colour – became more and more romanticized, softening and undercutting Long's previous statements. This also brings to mind the fact that conceptual works originally intended to combat a pictorial impulse can, in contradictory fashion, evince a certain remarkable beauty of their own, particularly in their direct candour. So it is with the bulging roomful of exhibition cards, artist books and catalogues that adjoined the main exhibition. Very few artists have been so assiduous and productive in the use of printed matter to forge their artistic identity as Long.

A dedicated hiking enthusiast, Long leaves only sparse lingering traces in the actual environment, in marked contrast to many of the other land artists of his generation, such as Walter De Maria, Michael Heizer and Robert Smithson. In a similar vein, however, he is highly invested in the use of archetypal symbolic forms, like the circle and the line, for example. Long's work is engaged with finding, noticing and searching. Rather than monumentality, it depends on minor adjustments of his surroundings, which he subsequently records. Examples of this include walking a line or arranging stones, as in *Dusty Boots Line The Sahara* (1988) or *A Line in Scotland Cul Mor* (1981).

Long's chosen methodology also oscillates between calling attention to sites of historical importance as well as to everyday, nondescript locales. As viewers, we are asked to share Long's perspective and vicariously travel along. For an artist

whose bodily experience is writ large in his mode of working, we so rarely gain a glimpse of the artist himself, a seemingly disembodied wanderer peripatetically tracing his journeys from the peaks of the Great Smoky Mountains to those of the Himalayas. As Long once said, 'I can make art in a very simple way but on a huge scale in terms of miles and space.'[233] We are much richer for having been privy to such path-breaking conceptual endeavours.

47

Split Level View Finder:
Theo Schoon and New Zealand Art (2019)

City Gallery Wellington, 27 July–3 November 2019

British novelist L. P. Hartley once wrote that 'the past is another country', but it is also an exceedingly fucked up place if scrutinized unflinchingly with twenty-first century eyes. In *Split Level View Finder: Theo Schoon and New Zealand Art*, I kept sensing a certain cognitive dissonance, a creative contradiction at every turn. Theo Schoon (1915–85) was born in Java to Dutch parents, and his transit back to the Netherlands and then to Aotearoa New Zealand and Australia inscribes aspects of colonial history in his own life trajectory. Irascible, cosmopolitan and gay, he was an outsider within the broader culture but a friend of such art and literary luminaries as Rita Angus, Betty and Allan Curnow and Gordon Walters.

The exhibition involves six thematic rooms across the upper floor of the gallery. Initially one encounters Schoon's painterly extrapolations from sacred Māori rock drawing sites that borrow as much aesthetically from Paul Klee or Joan Miró. A valuable catalogue contribution by artist and curator Nathan Pohio (Ngāi Tahu) lends historical context to the sites in question, noting the 1848 signing of the Kemp Deed:

> This saw 13,551,400 acres sold for £2,000. […] The Deed ended Ngāi Tahu's access to the mahinga kai routes, the noa and tapu sites and the traditional art practice of drawing and painting within the caves. It devastated Ngāi Tahu's economy and separated them from their whenua.[234]

This information places a sombre shadow over any later acts of 'preservation' such as Schoon's 1946 commission to record the sites, with no Ngāi Tahu consultation.

A reconstruction of Schoon's 1965 solo show at Auckland's New Vision gallery follows, involving abstractions that now appear dated. They are almost caricatures, distinctive mainly for the way they resemble the serviceable but dull

modernist paintings of squiggles, grids and splotches that often clog up provincial museums. More interesting is his process of automatic drawing while in a trance state. I prefer his photographs of mud pools which echo the approach of the American photographer Minor White, coincidentally another gay modernist with mystical tendencies.

A consistent presence in *Split Level View Finder*, as significant as any aesthetic influences, is the glaring amount of White male hubris. So we also glimpse a period in which Schoon and Gordon Walters both lift imagery directly and without credit from an institutionalized diagnosed schizophrenic whom Schoon met when working as an orderly at Avondale Mental Hospital. Some of the best works in this exhibition, which is nominally Schoon's, are by other artists, as in this case with the elegant pencil drawings of Rolfe Hattaway (Figure 47.1).

In the remaining large gallery is an intriguing glimpse into a bygone era of Māori Modernism. It could have been a much larger portion of the show, to its benefit. It is fascinating to see what Māori artists made of/with European abstraction, making this narrative even more entangled. As does the mural by Schoon, which has hung for three decades in Rotorua's Whakaturia Marae, and Ans Westra's photographs of Schoon documenting his presence as an invited artist at the 1963 First Festival of Māori Arts at Tūrangawaewae, Ngāruawāhia.

His gourd carving gained such attention and respect from the organizers that the festival guide stated: '[Schoon] has identified himself so thoroughly with the mauri of our culture, that his niche as an exponent and an authority is undisputed.' It is important art historically to reconsider Schoon and Walters working from the koru, and how with the latter it became a signature motif, albeit a controversial one. The fact that Walters, whose name now graces Aotearoa's preeminent art prize, was indulgent of Schoon's behaviour and frequently did the same gives one pause. A fine smaller Walters painting is included here, but the vibrant works of Selwyn Muru and Arnold Manaaki Wilson among others offer welcome breaks from Schoon's contorted cultural appropriations.

Recently a group of protesters, including several of the sharpest students I have ever had the privilege of working with, argued that Schoon's racism is enough to scrap this exhibition. While I truly respect their activism, my training as an art historian leaves me wary of such absolutism. Just as these emerging artists are in the process of defining their own artistic paths, it might seem especially infuriating to confront an artist who felt he had the right to appropriate and even *own* the traditions of others, whether Javanese dance or Māori arts, when that right was not his.

The American critic Hilton Als wrote in a recent review that

the complications of being human preclude 'straight' or uncontradictory behaviour: there is a great deal of truth in nuance and ambiguity. And yet we are living at a

FIGURE 47.1: *Split Level View Finder: Theo Schoon and New Zealand Art*, City Gallery Wellington Te Whare Toi, 2019. Courtesy of Anna-Maria Hertzer and Sally Schoon.

time when nuance and all the confused intentions, desires, and beliefs that go along with it are considered less a way of understanding human frailty than a failure of 'accountability'.[235]

I found this a highly resonant observation as I tried to wrap my head around Schoon's manifold contradictions. It is difficult for me to articulate my feeling that if an artist comes as close to another culture as Schoon managed to do in certain of his artworks, it becomes hard to reconcile that with the tidy epithet 'racist'.

Schoon made statements about his work that ranged from intriguing to patronizing, arrogant to ridiculous. In a radio interview, included in the exhibition, Schoon expounds upon his belief that Māori art was a code that could be cracked, even by a Dutchman. On one level this allows that Māori customary practices involve a sophisticated aesthetic system, but it simultaneously illustrates the mistaken belief that Māori aesthetics can be isolated from the holistic complexity of te ao Māori, comprising te reo, whakapapa and whenua. Most ignoble was Schoon's assertion that Māori art needed some kind of outside stewardship, having lost its way, and by inference that he himself could occupy that role.

To their credit, co-curators Damian Skinner and Aaron Lister are clearly not trying to make this exercise unproblematic. Some will not agree, but you can't please everyone in troubled times, in or out of the art world. The curators have framed the exhibition through in-depth research and contextual information, often taking the form of well-chosen companion artworks, as in the exquisite reciprocal portraits by Schoon and Rita Angus from 1942. The curators also note how contemporary Schoon's movement between modes of practice seems when seen through modern eyes. I also think about how charged the practices of our most interesting artists are today, and the protests that – as one example – the works of Luke Willis Thompson have elicited.

Theo Schoon was a ravenously curious aesthete, enamoured by European abstraction and Gamelan music, Buddhist temples and Māori carving. Such visual curiosity is a key element of artists's engagement with the world. But coupled with a corresponding lack of self-reflection and empathy for others, that voracious attentiveness led to an unfortunate myopia in Schoon's practice. Whether that should consign his works to museum storage areas is for others to decide, but we currently have an opportunity to consider issues of art and ethical responsibility that will continue to linger, whether we are addressing the case of Schoon or not.

48

Elisabeth Pointon's Pop Problematics (or the Customer Might Just Be Wrong) (2020)

When we see a slogan, what are we meant to do? In a Pavlovian way, jump to buy a product, support a propagandist notion or perhaps we might slow down to consider the source, and whether there are other ways to read such texts against themselves. In artist Elisabeth Pointon's practice, she takes forms of language we are overly familiar with today, often read as memes, on t-shirts, on merchandise and lends them an additional twist.

Terms of dis-engagement with our contemporary world are trailed behind airplanes, in a form of flash display which originated almost a century ago: *SPECTACULAR ... OUTSTANDING ... BIG DEAL.* The act of materializing such words in concrete, bright, large-scale actuality rather than as mere digital type upon a screen is to give them a peculiar, resonant presence. This barnstorming aeronautical flight of fancy is a logical step from earlier pieces using balloons (a reflective one emblazoned with: *'It's a big one.'*) and the inflatable, dancing figures spotted around car lots (Figure 48.1).

If Pointon selectively portrays the shiny happy surfaces of the neo-liberal capitalist machine, the undertow lying directly beneath is bleak and unsettling. By working in a corporate, establishment day job – car sales – the artist has performed multiple roles, as a self-described 'double-agent', with the real world inevitably leaking into her art practice. By repurposing motivational imperatives like 'I care about business' or 'a result we can be proud of'. Pointon enacts subversive strategies which also highlight the contextual absurdity.

Pointon's current project also involves an inflatable displaying the credo *'GET IT RIGHT'*, a provocation on manifold levels. Once again, a sample of patented business-speak, but in terms of the creative realm it addresses the huge external pressures emerging artists face along with their own self-imposed perfectionism. The scale of Pointon's projects involves a tactical method of being heard and quite literally, not getting overlooked.

I realize that I am often caught in a process of seeking out irony in Pointon's approach but am also mindful that could be a generational (X) preference of my

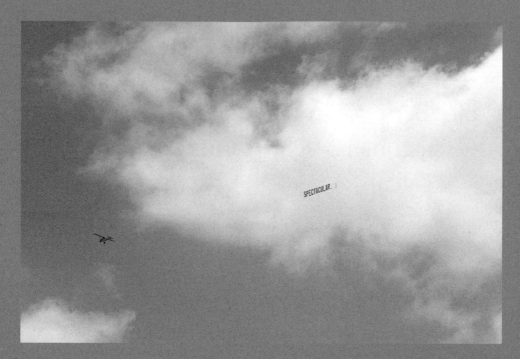

FIGURE 48.1: Elisabeth Pointon, *SPECTACULAR*, from *WOULD YOU LOOK AT THAT*, 2019. Image: Kasmira Krefft. Courtesy of the artist.

own, and that to project that onto her work is another misreading. Elisabeth has a multicultural background as an artist of Fijian-Indian and Pākehā lineage, has travelled extensively in India, and to my mind there are highly sincere, spiritually inflected aspects to her critique, which also encompass and note issues relating to race, gender and class. Who has the power to make huge, outsized, general statements globally, whether in the arts, politics, entertainment or other parts of the social sphere and why are they often so banal, so cruel? (I will not name the current, so-called 'leader of the free world' and his use of social media.)

To a certain extent, Elisabeth seeks 'goodness' an entirely untrendy notion that has been considered by other artists, notably American painter Michelle Grabner. And she echoes the phrasing of British artist Martin Creed, most well-known in Aotearoa for his large neon signs installed in Christchurch and Auckland (*EVERYTHING IS GOING TO BE ALRIGHT* and *WHATEVER*). Pointon has commented that: 'the romantic figure of the artist may still prove useful in a world that is increasingly shaped by impersonal institutions', whether academic or commercial ones. But the ongoing, ebullient and irrepressible performativity of Pointon's practice continually intrigues, a homeopathic dose of powerful language for our often seemingly disempowered times.

49

Warhol: Immortal (2013)

Museum of New Zealand Te Papa Tongarewa,
1 June–25 August 2013

I cannot pretend to be impartial in writing about Andy Warhol. For so many art-obsessed kids of the late twentieth-century like me, he was a huge influence. Many people I know sought their (mixed) fortunes in art partly because of Warhol's impact. That said, reassessments are always welcome and the opportunity to see as much carefully chosen and presented work as is on view in *Warhol: Immortal* at Te Papa is surprisingly rare, especially in Aotearoa New Zealand.

For an artist who never lost sight of making bold, visually arresting images, Warhol is a tremendously contradictory figure. Although I have read probably more about him than any other contemporary artist, he remains a challenging cipher; on the one hand, possessed by a phenomenal work ethic, amazing creative sensibility and an engaging sense of collaboration; on the other, a control freak, given to eclectic overproduction of substandard works for hire, a passive and remote figure who left others by the wayside.

Warhol: Immortal introduces us to this iconic iceman of the neo-avantgarde through his drawings, portraits of lovers and friends at once childlike and eroticized, clothed tenderly in graphite hearts and other flourishes. These early works are disarmingly accessible and humanize the artist in a way his later portraits do not. Warhol excelled in graphic simplicity even then, and his seemingly effortless lines, which he subsequently blotted, became his trademark. Nearby are family photos, schoolboy caricatures, photobooth clowning.

Born Andrew Warhola in 1928 to a working-class family in Pittsburgh, Pennsylvania, Warhol trained as a commercial artist, but after launching a successful career in New York he craved to exhibit in the mode of the most renowned artists of the 1950s, abstract painters with gravitas such as Jackson Pollock and Willem de Kooning. As the show amply demonstrates, Warhol's talents, gained working in the lost world fictionally conjured up today by *Mad Men*, became transposed into his complicated evocations of celebrity. He recorded figures that were at once

titanic and ephemeral – from a very young (and very blurred) Warren Beatty to an improbably gorgeous Sylvester Stallone – while capturing the deeper seriousness underlying his close attention to glossy surfaces in memorable aphorisms: 'I don't know where the artificial stops and the real starts.'

One of the most captivating moments in *Warhol: Immortal* is its vivid reinstallation of his psychedelic-era cow wallpaper surrounding helium-filled silver mylar pillows, which may be playfully batted around; as they appear to lurch drunkenly through the air, their silliness becomes sublime.

In the mid 1960s, the ever star-struck Warhol announced that he was giving up painting to make movies, although this proved to be an empty threat. On view are a number of the artist's *Screen Tests* from this period, in which many illustrious (and not-so illustrious) visitors to his studio, dubbed the 'Factory', posed before a camera for four minutes. Grandfather of conceptual art Marcel Duchamp stops by to offer a wry smile and Warhol's one-time protégée and the foremost 'superstar' of his cohort, the beautiful but ultimately tragic Edie Sedgwick, stares implacably into the lens.

Two of Warhol's most notorious films, *Kiss* (1963), featuring couples embracing at length, and *Sleep* (1963–64), which records poet (and Warhol's lover) John Giorno in the midst of slumber, are presented in edited versions, alternating with one another. His experiments with cinema continued sporadically, and one could argue he developed an early reality TV venture with his MTV programme *Andy Warhol's Fifteen Minutes* (1985–87), episodes of which are here along with covers from his gossip/fashion magazine *Interview*, which prefigured more recent 'lifestyle' publications (Figure 49.1).

Because of his frequent association with the fringe dwellers of New York City, Warhol might be remembered for his fixation on sex, drugs and rock and roll, whereas religion and death served as primary themes throughout his career, whether making totemic the visages of the recently deceased Marilyn Monroe – here shown in a striking 1967 work in which a spectral wash of paint casts an indistinct haze over her distinctive features – and the widowed Jacqueline Kennedy; creating his series of skull paintings; or depicting a glowing Christ alongside body-builder Joe Weider's slogan: 'Be a somebody with a body.' Other late works that still provide chills are the small Polaroid *Drag Self Portraits* (1980–81) and the larger *Camouflage Self Portraits* bookending the exhibition.

Warhol unceasingly immortalized other folk pictorially, from artists to patrons, models to pop stars, friends to film stars and in so doing staked a claim for his own status as an artist of significance, while playing the unsophisticate. What becomes clearer in reflecting upon his achievements, however much they are clouded by mythic murk, is that up until his death in 1987 he was both an exemplary artist of his own era and astoundingly prescient in terms of today's ubiquitous social networking and continuing obsession with celebrity culture. And sometimes even the most banal of his statements might be read as the most resonant: 'I think everybody should like everybody.'

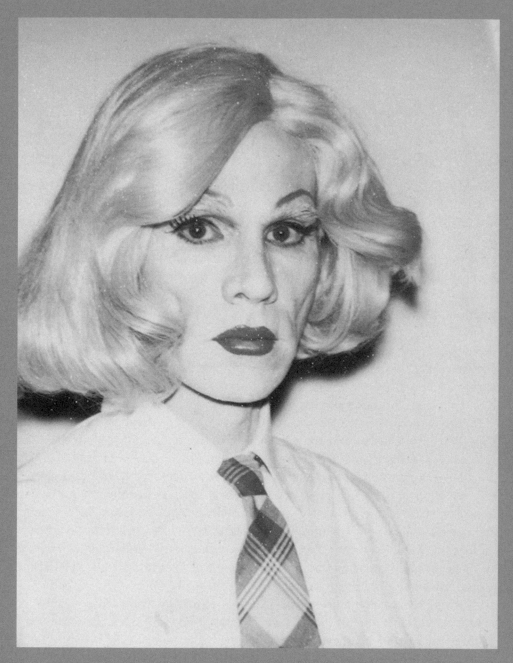

FIGURE 49.1: Andy Warhol, *Self-portrait in Drag*, 1981–82, dye diffusion print, image: 9.5 × 7.3 cm² (3 3/4 × 2 7/8 inches), sheet: 10.8 × 8.6 cm² (4 1/4 × 3 3/8 inches), The J. Paul Getty Museum, Los Angeles © The Andy Warhol Foundation for the Visual Arts, Inc.

50

Is It the Beginning of a New Age? (2016)

I was born smack in the middle of the so-called Summer of Love, in July of 1967. Perhaps this fact has uncommon staying power in that I am obsessed with this era in a variety of respects, an era that 'I missed', coming of age in a period more characterized by Ronald Reagan, post-punk, heavy metal hair bands and the King of Pop. Rather than the 'you should have been there' attitude of some of the baby boomers of my acquaintance, I possess a keen curiosity and temporally displaced fascination. In an evocative description of his experience as being a bit late for full-blown Sixties action, the late artist Mike Kelley (who was thirteen years my senior) wrote:

> I was mediated, I was part of the TV generation, I was Pop. I didn't feel part of my family, I didn't feel part of my country; I had no sense of history: the world seemed to me a media façade, a fiction and a pack of lies. This, I believe, is what has come to be known as the postmodern condition.[236]

The sort of ironic (and utterly terrifying) distance of which the artist speaks is quite similar to my own juvenile trajectory, grasping onto proto-mashup life-rafts of popular culture of different eras, genres and literature that spoke to a fragmented and bemused sensibility, literary figures early on such as Kurt Vonnegut, and later David Foster Wallace, Thomas Pynchon and Don DeLillo. Postmodernism has/ had its definite limits, however, such as in the manner that if everything potentially 'means nothing' and becomes truly image, pastiche, spectacular, we can easily become detached from first-hand experience and the cues that make lived experience that much more significant. Let alone the fact that seemingly immaterial, creative and spiritual energies of considerable importance can seem completely overridden by the energies of electronic signals and transmissions; the constant white noise and glare of the accelerated present.

The current exhibition for Massey University's Engine Room project space entitled *Is It the Beginning of a New Age?* incorporates the work of eleven artists bringing a range of aesthetics, backgrounds and experiences. All of the artists in one way or another respond to countercultures, spiritual or ethical realities, fantastic worlds, utopian possibilities and potential alternatives to any perceived

norm. Of course, this to a degree becomes relatively unified within the speculative, but often deceptively clear and distinct coordinates of current artistic practice. Paradoxically most of the works in the exhibition are devoted to the object and image, and manifestly concrete, yet speak towards that which is less evident, hard to quantify, hybridized and that becomes fuel for contesting beliefs and narratives. My hope is to make an exhibition context that is simultaneously archaeological/historical and immediate/contemporary.

This exhibition is prompted by multiple factors, not the least of which the artists that I have met over the past few years who engage with themes and histories relating to what is now often broadly termed 'mind, body, spirit' themes but once might have been called other things on a spectrum ranging from utopian sympathetic neologisms to drastically sceptical epithets. Among them of course would be the phrase 'new age'. I have always had very ambivalent relations to this notion. Of course, one could flippantly say how new, or when did this start or in comparison to what exactly?

And I can't help having a late period melodic but typically dark Velvet Underground song run through my mind, its chorus being: '*It's the beginning of a new age / It's a new age*' and that was 1969, an era in which I myself was a toddler and the Vietnam War (or depending on your perspective, The American War) was raging away, therapies such as primal scream were fads, and multiple developments of the 1960s were not exactly coming to fruition as planned. So of course, why would not young hippies, and other countercultural folk turn to what might be viewed as 'older ways', and perceived alternatives. Moreover, idealism and hope endure rough periods, and most significantly such notions might enable us to get 'beyond ourselves' via a wide range of cultural practices and belief systems, even/especially if mutated, reconfigured, and remixed in an art context. The musician Lou Reed once commented that: 'it's important not to feel alone', thus the consequential role of music.

I have included Wes Wilson's poster for a Van Morrison gig in 1967 as a kind of totemic touchstone for a mode of graphic advertisement, which although admittedly dated in some respects, is adamantly resilient in others; maybe like Syd Barrett recordings or some other timepiece, once so exactingly accurate, now so admirably 'off kilter' in the best sort of way. Wilson was a member of the formidable collective of San Francisco graphic artists known as The Family Dog. Over the course of just a few years, they created a vast array of posters for bands from the Velvet Underground to the 13th Floor Elevators. The use of anachronistic Art Nouveau references along with Day-Glo brain numbing complementary colours and imagery drawn from Eastern mysticism and American subcultures, staked a flag for the new genre that became known as Psychedelia. Such art has been prized for years, especially by those obsessed with the 'products' advertised: rock and roll, counterculture and social events, but this has only more recently translated

into more scholarly and curatorial engagement with the force and power of such innovative cultural production.

The era in which Wilson worked actively on such innovative designs has been in turn an influence on much younger artists like Theo Macdonald who in his recent comics and zines pays tribute to figures such as Lou Reed and David Bowie, describing in a moving but disarmingly unsentimental way, largely owing to his sense of humour, the impact of pop-cultural fandom, specifically the intensive and rather intimate involvement one might have with the creative production of artists one will never know. Our trainspotting attentiveness becoming ultimately deeply (and perhaps unexpectedly) affecting. With the loss of both these musicians, and even more recently, as of writing, Prince, these discussions have telling importance in the broadest sense. Macdonald's *An Original New-Waver* knowingly refers to Reed's lyrics ('The Original Wrapper'), Pop Art (Andy Warhol), as well as comics history (Archie aesthetic). In his thoughtful consideration of Reed, Macdonald ruminates upon the importance of the musician's frailty and vulnerability, although this was often in the public eye overshadowed by some tactical rudeness and bad behaviour. I can associate with this quite deeply as I spent much of my (extended) youth valorizing to a degree the 'cool shell' of artists like Reed, in order to secretly appreciate the vulnerable side much more, and in the end, with art that's what we have left.

A reading area in the exhibition features publications by a number of the artists (such as Macdonald) and a selection of texts that might harbour affinities with topics touched upon here. Those include books by Ram Dass, Alison Knowles, Alan Watts, John Cage, Marshall McLuhan and others. Of particular note in respect to this area is artist Tim Larkin's custom designed and handmade furniture to both assist in the viewing of the materials and assert a highly significant presence of their own. Larkin is an accomplished Wellington-based craft furniture maker and a Technical Demonstrator in Massey's School of Art. Larkin has exhibited his works widely, and in reference to an example from his earlier *Folk Furniture* series (2007–09), Bev Eng of the Dowse Museum commented: 'it reminds me of a dwelling in the clouds perched on knobbly-kneed sticks, or like a strange creature that could walk off on those quivery legs at any moment. I like artwork that comes alive.'[237] Larkin has often mixed a playful sense of innovation with a keen appreciation of (non-)traditional materials and diligent craft.

Catherine Bagnall's artworks operate in multiple vicinities simultaneously, as childlike reveries and staunch critical appraisals of the problematics of the here and now. In a major installation in the show, Bagnall installs an array of 'muffs', sewed, appliqued and hand worked mixtures of fabric and possum fur. Possums being the scorned pests of Aotearoa New Zealand but also prized for their warmth and in this case their pelts incorporated into the artwork refer to numerous things at once, among them eroticism, eradication and colonization, and how all these

impact on histories of dress and comportment. In the current exhibition, it veers a bit towards in one respect the so-called New Zealand Gothic, and in another to a more meditative turn towards what Kate Soper terms 'alternative hedonism', or a move towards a more ecological simplicity. And beyond a major sculptural installation, a fanciful painting on paper by Bagnall is here as well, as she makes interpretative dreamscapes that pay aesthetic homage to such visionaries as Tove Janssen, while deriving from her own performative walks in the bush throughout Aotearoa New Zealand.

Over the past several years, Bikka Ora has been exploring the manifold implications of the Town Belt, surrounding Wellington as both a highly constructed, controlled and manipulated area, and a pastoral, green and meditative space ripe for creative and discursive play. In the current installation, Ora has reconfigured some portions of a timber geodesic dome that she exhibited in two radically different settings in 2015, once in a public park and once within a gallery space. In the Engine Room, the dome is deconstructed, splayed apart and becomes simultaneously a fractal-like relief and a viewing station, an area in which Ora's videos which appear to have a dreamlike, eccentric quality of their own are, in effect, transmitted through yet another mediating structure, accenting the embodied quality of our positioning as spectators. This provides an intriguing counterpoint to the almost ethereal quality of the footage, figures walking in a reverie, costumed with numerous colourful accessories, offering up an imaginative amalgam recalling both the experimental cinema of Maya Deren and Sci-Fi otherworldliness. By interrupting such footage with inter-titles drawn from mindfulness texts, and adding a soundtrack of ambient music, Ora gives us a generous glimpse into a conjured space that is ultimately just as imaginary, constructed and seemingly elusive as the town belt itself.

Archival publications redolent of radically different geographic settings and cultural worldviews became rich source material for a series of recent works on handmade paper by Louise Menzies. In *The Spiral of History*, Menzies selected a schematic map, in style resembling more a teleological, linear representation, although opening from itself into whorls of anachronistic data, symbols, dogma and jargon. As Jon Bywater notes:

> Set within a new, broad, blank margin, though, the hubris of their particular 'universalisation' of history is laid bare. A period, Western countercultural cliché, the appropriation of Shēngxiào, the 'Chinese Zodiac', for example, only accentuates the overreach of its Eurocentric big idea (in which the term 'racial' also, in particular, jars today). The work abstracts the document from its source in this way, but at the same time re-presents it in all its physical specificity. The facsimile of the single page is not mounted onto but embedded into a new sheet – like a tile into grout, or a shell, anaerobically encased in sediment before permineralization into the fossil record.[238]

Menzies's work summons both a rather confusing temporal disjunction and displacement, and a riveting attention to the detailed, explanatory material of the source due to its careful (re-)presentation.

Dhyana Beaumont's paintings offer a plethora of coordinates from which to choose when reading the works, systems both aesthetically and spiritually derived, creating a woven pictorial structure that is as vivid as it is spatially dense and often ambiguous. Diagrammatic formal elements draw upon DNA helix spirals, sacred geometry and the Judaic tree of life. The paintings are spawned from a highly personal methodology, in which Beaumont paints and overpaints over long stretches of time, and uses spray paints, paint sticks and collaged materials, investing the surfaces with a formidable, layered intensity. As high key fluoro moments intersect with the iridescent shine of metallic paints, the works are incorporative of multiple art and life references, an abundant hybridized mix (Figure 50.1).

In his works *The Elder Dragon Wand*, *Wu-Dang Water-sword* and *Feather Sword* pendant, Daniel Kelly creates sculptural works from carved, painted and otherwise skilfully altered found materials. As Kelly states: 'In an age where Fantasy and Magic are thriving in movies and gaming, I am providing here a Taoist fuelled endeavour, of a reality more seemingly "true to self" through the journey of the collection of materials.'[239] In his recent works, Kelly has referenced an assortment of keen interests ranging from the Tao and I Ching, to tarot and martial arts, to the Wu-Tang Clan and Star Wars films. The considerable impact of Kelly's practice arrives in part from on the one hand attention paid toward the integrity of materials, and on the other a whimsical sensibility more in line with contemporary remix culture than the traditional belief systems with which he is fascinated. That said, Kelly is a passionate believer in the magical, energetic powers that can be elicited by art objects and events, and this is often communicated through his sculptures, installations, paintings and videos.

In the artworks of Georgette Brown, a colourful amalgam of symbols and representations coexist almost as if floating freely without being tethered too closely to earthly rules of gravity. Brown's aesthetic although often stylistically consistent has been mutable in terms of media and context, as she has designed posters and band costuming (Orchestra of Spheres, Womb), zines and publications, along with paintings, sculptures and drawings. Brown's works have a childlike quality that while eclectic and idiosyncratic is infectious and engaging, with its clear and forthright generosity for the viewer. Sometimes this is seen through the abundance of colour, materials and intensity, at other points via evident humour and her sensitivity towards the fantastical, utopian and open-ended. Brown's works harbour unusual juxtapositions, intersections, and encounters. Dragons, insects, tendrils, skeletons, snails, goddesses, totems, altars and sunflowers co-exist in a disarming micro-universs (see frontispiece).

FIGURE 50.1: Dhyana Beaumont, *Unified Heart Consciousness: Flower of Life*, 2016. Courtesy of the artist.

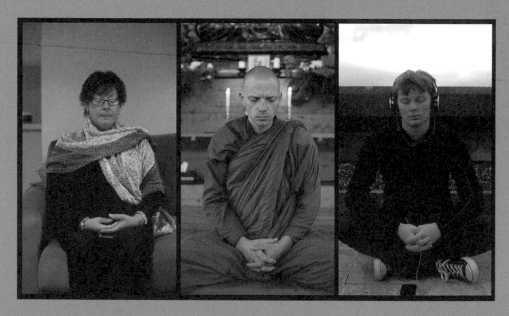

FIGURE 50.2: Kane Laing, *Meditation*, 2015. 2 hr 40 min Video loop. Courtesy of the artist.

Kane Laing is a performance and video artist along with a range of other pursuits including a serious dedication to meditation and researching the contexts surrounding it. Moreover, Laing comments that: 'in practice I am more interested in how to create an opportunity for an audience to engage with meditation in a way that goes beyond ideas and conceptual thinking.'[240] Laing considers video a helpful medium especially due to its accessibility for the viewer. His work *Meditation* is a looped video featuring portraits of people in the act of meditating. According to Laing: 'the work attempts to explore the boundaries and qualities of video in relation to photography, as well as what can be captured and stored in a video's frames and what is then, passed on to the viewer'.[241] What seems to be one of the most interesting aspects to my mind is the inability to know exactly what is going on in another person's head/body/consciousness, thus what is it that we can determine when regarding others engaging in an act of stillness, presentness and peace? Perhaps like a video signal such energies might leak through, emerging from the mediated context to play a significant role for the spectator as well (Figure 50.2).

Adrian McCleland's intention is to enact a rite of cleansing for the sealed front area of the Engine Room via the release of coloured flares. According to the artist:

> This project undertakes to investigate a combination of ideas that run up against each other in the gallery space. How an artwork emerges as a by-product/recording of a non-performative piece – a referencing around Noa and Waharoa siting an attunement and recognition of the space and utilisation, not just the function – the usage of a building as it pertains to Lebbeus Woods and 'healthy' architecture – tropes found around 'New Age.' I mention tropes as there is no holistic winner, for a majority. New Age practices sit in a somewhat grey area of brilliantly viable and tragically mystical – there is contention.[242]

As McCleland states, this 'grey area' is the territory of the current exhibition, although many of the artworks physically operate through a wide range of differing tonalities, kaleidoscopic colours and intensities of experience. To eff the ineffable, so to speak, might require multiple strategies. By ridding the space of Tapu prior to the entrance of the artworks and viewers, McCleland responds simultaneously to indigenous Māori cultural protocol and conceptual lineages in contemporary art of that which is seen/unseen, material/immaterial, present/absent.

Is it the beginning of a new age? involves an attempt to bring together some very contemporary artists, at differing points in their art/life trajectories who could be seen to have something helpful to say about the complications of mind/body/spirit in the twenty-first century. In many respects, this show is a very subjective and personal one for me as in it many of my worlds collide, both in terms of working with several artists I know well in one way or another and certain of

my extra-artistic interests in alternative healing, subcultural histories, mysticism and esoteric belief systems. At the same time, I am always holding many of these interests at a distance, perhaps keeping them at arm's length as to not become completely embraced by the force of their energy, lest it thwart my hard earned (and often hard-headed) intellectualism. That is, a real fear emerges that if somehow the 'research' becomes too entangled with the intimate and intuitive processes of my outlook that will perhaps make everything all too personal, idiosyncratic and in the worst case, unhelpful, uninteresting or untranslatable to others.

But luckily that is where the art comes in. I imagine that many of the generative, embedded and multiple contradictions of contemporary art production might end up undercutting all this textual back and forth with their aesthetic and affective presence. And my hope for this exhibition is that its abundance of intriguing content will ultimately make my indecision and fretting largely beside the point. And if I turn to the works and artists on view, it will offer an avenue to not necessarily resolve any questions raised but to establish a vibrant and important viewing, reading, meditative, and participatory platform for further discussion and reflection.

Notes

1. Charles Baudelaire, Jonathan Mayne, ed. *Art in Paris 1845–1862* (Ithaca: Cornell University Press, 1981), 44.

2. Lawrence Alloway, *Network: Art and the Complex Present* (Ann Arbor: UMI Research Press, 1984), 12.

3. Chris Burden, *Documentation of Selected Works, 1971–75* (New York: Electronic Arts Intermix, 1975), 35 min. video.

4. Lester Bangs, 'Iggy Pop: Blowtorch in Bondage', *Psychotic Reactions and Carburator Dung* (New York: Vintage Books, 1988), 205–06.

5. Yvonne Sewall Ruskin, *High on Rebellion: Inside the Underground at Max's Kansas City* (New York: Thunder's Mouth Press, 1998), 128.

6. Yvonne Sewall-Ruskin, *High on Rebellion: Inside the Underground at Max's Kansas City* (New York: Open Road Media, 2016) [E-book]. https://play.google.com/store/books/details/?id=rgi5CwAAQBAJ. Accessed 8 April 2022.

7. *Rhythm O* (1974), Marina Abramovic.

8. Jon Bewley, 'Chris Burden in Conversation with Jon Bewley', in *Talking Art I*, Adrian Searle, ed. (London: Institute of Contemporary Arts, 1993), 18.

9. Mary Horlock, 'Chris Burden: Life and Works', *Chris Burden: When Robots Rule: The Two-Minute Airplane Factory* (London: Tate Gallery, 1999), 28.

10. Iggy Pop, *I Need More* (Los Angeles: Two Thirteen Sixty-One, 1997), 50.

11. Joe Ambrose, *Gimme Danger: The Story of Iggy Pop* (London: Omnibus Press, 2002), 4.

12. Nick Kent, 'The Four Ages of a Man Named Pop: Pictures of Iggy', *The Dark Stuff: Selected Writings on Rock Music* (Cambridge: Da Capo Press, 2002), 253.

13. Iggy Pop, *I Need More* (Los Angeles: Two Thirteen Sixty-One, 1997), 81.

14. Iggy Pop, interview, *Rock and Roll*, WGBH Public Television, 1995.

15. Antonin Artaud, 'For The Theater and Its Double (1931–36)', *Antonin Artaud: Selected Writings*, Susan Sontag, ed. (Berkeley: University of California Press, 1988), 259.

16. Linda Montano, *Performance Artists Talking in the Eighties* (Berkeley: University of California Press, 2000), 344.

17. Marshall McLuhan, *Understanding Media: The Extensions of Man* (New York: Mentor, 1964), 280.

18. *Documentation of Selected Works.*

19. Robert Storr, *Dislocations* (New York: Museum of Modern Art, 1991), 26.

20. Ruth Brandon, *Surreal Lives: The Surrealists 1917–1945* (London: Macmillan, 1999), 11.

21. Neil Strauss, 'THE POP LIFE; The Times Are A-Changin', *New York Times* (27 September 2001). https://www.nytimes.com/2001/09/27/arts/the-pop-life-the-times-are-a-changin.html. Accessed 19 March 2022.

22. Cornel West, *Democracy Matters: Winning the Fight Against Imperialism* (New York: Penguin, 2004) [E-book]. https://books.google.co.uk/books?id=ZYNzIa9OyQEC. Accessed 8 April 2022.

23. RoseLee Goldberg (organizer), *High & Low: Modern Art and Popular Culture: Six Evenings of Performance*, L. Anderson, E. Bogosian, Bongwater, D. Cale and B. Eno, perfs. (New York: The Museum of Modern Art, 1990). https://assets.moma.org/documents/moma_catalogue_1764_300062992.pdf. Accessed 19 March 2022.

24. Spermatikos Logos, 'Pynchon Music: Laurie Anderson', *Shipwreck Library* (10 September 2021). http://shipwrecklibrary.comthe-modern-word/pynchon/sl-music-anderson/. Accessed 19 March 2022.

25. Kurt Anderson, 'The Protester', *TIME* (14 December 2011). http://content.time.com/time/specials/packages/article/0,28804,2101745_2102132_2102373,00.html. Accessed 19 December 2021.

26. Kim Levin, *Beyond Modernism: Essays on Art from the '70s and '80s* (New York: Harper & Row, 1988), 88.

27. No Artist, *The Wit and Wisdom of Ronald Reagan*, LP, Magic Records ans ABRA 1, 1980; and Jacob Weisberg, *George W. Bushisms: The Slate Book of Accidental Wit and Wisdom of Our 43rd President* (New York: Gallery Books, 2001).

28. Bess Hochstein, 'Laurie Anderson Touches Down at MoCA' (2006). http://www.jimdavies.org/laurie-anderson/work/interviews/berkshiresweek.txt. Accessed 19 March 2022.

29. Hunter S. Thompson, 'Ugly, Tasteless, Terrifying and Wild… Count Me In', *The Independent* (28 October 2004). https://www.independent.co.uk/news/world/americas/ugly-tasteless-terrifying-and-wild-count-me-in-5351483.html. Accessed 19 March 2022.

30. David Cross, 'Some Kind of Beautiful: The Grotesque Body in Contemporary Art' (Ph.D. thesis, Queensland University of Technology School of Visual Arts, 2006), 20.

31. Cameron Bishop, 'David Cross in Conversation with Cameron Bishop', *Drain* (Athleticism issue, 2015). http://drainmag.com/david-cross-in-conversation-with-cameron-bishop/. Accessed 12 December 2021.

32. Mikhail Bakhtin, *Rabelais and His World*, Helene Iswolsky, trans. (Bloomington: Indiana University Press, 1984), 10.

33. Gregory Battcock, ed. *Minimal Art: A Critical Anthology* (New York: E.P. Dutton, 1968), 228.

34. Benjamin Weissman, 'Paul McCarthy,' *BOMB* 84 (Summer 2003). https://bombmagazine.org/articles/paul-mccarthy/. Accessed 27 August 2022.

35. Janet Kraynak, ed. *Please Pay Attention Please: Bruce Nauman's Words* (Cambridge: MIT Press, 2003), 182.

36. Natasha Conland, *Richard Maloy's Fat Test* (Auckland: Sue Crockford Gallery, 2008). https://www.richardmaloy.net/natasha-conland-text. Accessed 14 December 2021.

37. Caroline A. Jones, *Machine in the Studio: Constructing the Postwar American Artist* (Chicago: University of Chicago), 372.

38. Richard Maloy, *28 Compositions*, Ngā Taonga Sound & Vision (2005). https://www.ngataonga.org.nz/collections/catalogue/catalogue-item?record_id=116041. Accessed 21 March 2022.

39. Sriwhana Spong, *Tree Hut* (Auckland: Sue Crockford Gallery, 2004). https://www.richardmaloy.net/sriwhana-spong. Accessed 14 December 2021.

40. Relyea, Lane, 'Studio Unbound,' in Michelle Grabner, & M J Jacobs, eds., *The Studio Reader* (Chicago: University of Chicago, 2010), 348.

41. 'Bush' is a New Zealand term for the European equivalent of a forest.

42. 'Tramping' is the New Zealand colloquial term for 'hiking'.

43. Catherine Bagnall: 'I realize that the term "wilderness" is problematic but I use the term "wilderness" because of the romantic association of "wilderness" as a place devoid of people where one can still have a sense of being overwhelmed and bewildered' (correspondence with author).

44. The Tongariro National Park is Aotearoa's oldest national park gifted by the Ngāti Tūwharetoa iwi (under duress) to the Crown and given the status of National Park in 1887.

45. The book *Ngā Uruora* by the ecologist Geoff Park (1946–2009) has hugely influenced Bagnall.

46. In 2014, Bagnall's fur muffs were exhibited in the exhibition *In-humano* at MARCO, Museo de Arte Contemporaneo de Monterrey, Mexico.

47. Artist Richard Reddaway has developed the Aotearoa Baroque Project, a series of exhibitions (New Zealand and Mexico), and through it Strange Baroque Ecologies Symposium, which investigates the intersection of baroque aesthetics and ecology. https://strangebaroqueecologies.wordpress.com/. Accessed 10 March 2022.

48. Catherine Bagnall and Katie Collier presented the paper 'The Margeila Rabbit and the Gecko Girl' at *The Shape Shifting Conference*, AUT University Auckland, 2014.

49. Kate Soper, 'The Humanism in Posthumanism', *Comparative Critical* 9, no. 3 (2012): 365–78. https://www.euppublishing.com/doi/full/10.3366/ccs.2012.0069. Accessed 27 August 2022.

50. Kate Soper, 'The Politics of Nature: Reflections on Hedonism, Progress and Ecology', *Capitalism Nature Socialism* 10, no. 2 (June 1999): 47–70. http://dx.doi.org/10.1080/10455759909358857. Accessed 12 January 2012.

51. Cora Diamond, 'The Difficulty of Reality and the Difficulty of Philosophy', *Journal of Literature and the History of Ideas* 1, no. 2 (June 2003): 1–26. http://muse.jhu.edu. ezproxy.massey.ac.nz/journals/partial_answers/v001/1.2.diamond.html. Accessed 8 December 2014.

52. John Maxwell Coetzee, *Elizabeth Costello* (New York: Penguin, 2004), 169.

53. Kate Soper, 'The Humanism in Posthumanism', *Comparative Critical Studies* 9, no. 3 (2012): 365–78, 371. https://www.euppublishing.com/doi/full/10.3366/ccs.2012.0069. Accessed 27 August 2022.

54. Ron Broglio, *Surface Encounters: Thinking with Animals and Art* (Minneapolis: University of Minnesota Press, 2011).

55. Ron Broglio, *Surface Encounters*.

56. See Catherine Bagnall, 'Archive and the Performance of Becoming "Other"', in G. Borggreen and R. Gade, eds., *Performing Archives/Archives of Performance* (Copenhagen: Museum Tusculanum Press, 2013), 349–59.

57. Gianni Romano, 'Francis Alÿs: Streets and Gallery Walls,' *Flash Art* (March–April 2000), 72.

58. Francis Alÿs and Cuauhtémoc Medina, '1000 Words: Francis Alÿs talks about When Faith Moves Mountains', *Artforum* (Summer 2002), 146.

59. 'Francis Alÿs in conversation with Hans-Ulrich Obrist', *Point of View: An Anthology of the Moving Image. V. 1* (DVD) (New York: New Museum of Contemporary Art, 2003).

60. Rebecca Solnit, *Wanderlust: A History of Walking* (New York: Penguin, 2000), 11.

61. All quotes in above paragraph from '1000 Words: Francis Alÿs talks about *When Faith Moves Mountains*', *Artforum* (Summer 2002), 147.

62. Video (DVD), included with Francis Alÿs and Cuauhtémoc Medina, *When Faith Moves Mountains* (Madrid: Turner, 2005).

63. Francis Alÿs, *Walks/Paseos* (México: Museo de Arte Moderno, 1997).

64. All quotes in above paragraph from Paul Schimmel. *Ecstasy: In and About Altered States* (Cambridge: MIT, 2005), 50–51.

65. Kitty Scott, 'Portrait: Francis Alÿs', *Parkett* 69 (2003), 24.

66. Leo Steinberg, 'Other Criteria,' in *Other Criteria* (Chicago: University of Chicago, 2007).

67. David Torres, 'Francis Alÿs, Just Walking the Dog', *Art Press* 263, 18–23.

68. William Eggleston quoted in Michael Almereyda, *William Eggleston in the Real World* (USA: Keep Your HeadHigh and Line Productions), 2005, 86 Minutes.

69. Frances Fralin, *Washington Photography: Images of the Eighties* (Washington, DC: Corcoran Gallery of Art, 1982), 10.

70. John Szarkowski, *William Eggleston's Guide* (New York: MoMA, 1976), 13.

71. William Eggleston, *The Democratic Forest* (New York: Doubleday, 1989), 173.

72. 'The Condition of Music: Jim Lewis talks to William Eggleston', *Frieze* (May 2000), 80.

73. Arthur Conan Doyle, 'A Study in Scarlet', *The Complete Sherlock Holmes* (New York: Race Point Publishing, 2013), 11.

74. Schwabsky, Barry, 'William Eggleston', *KultureFlash*, 12 January 2004.

75. Max Kozloff, *Renderings: Critical Essays on a Century of Modern Art* (London: Studio Vista, 1970), 292.

76. Max Kozloff, 'Report from the Region of Decayed Smiles…'; Max Kozloff, *The Privileged Eye* (Albuquerque: University of New Mexico Press, 1987), 233.

77. Max Kozloff, 'The Privileged Eye', *The Privileged Eye*, 3.

78. Kozloff, 'The Privileged Eye', 4–5.

79. Kozloff, 'The Privileged Eye', 3–7.

80. Vicki Goldberg, ed., *Photography in Print: Writings from 1816 to the Present* (New York: Touchstone, 1981), 385.

81. Kozloff, 'A Way of Seeing and the Act of Touching: Helen Levitt's Photographs of the Forties', in *The Privileged Eye*, 29.

82. Kozloff, 'William Klein and the Radioactive Fifties', *The Privileged Eye*, 43.

83. Colin Westerbeck and Joel Meyerowitz, *Bystander: A History of Street Photography* (Boston: Bulfinch Press, 1994), 4–5.

84. William Klein, 'Preface', in *New York* (New York: Distributed Art Publishers, 1996), 4.

85. Charles Baudelaire, *Œuvres complètes* (Paris: Robert Laffont, 1980), 797.

86. Max Kozloff, 'Koudelka's Theater of Exile', *Lone Visions, Crowded Frames: Essays on Photography* (Albuquerque: University of New Mexico Press, 1994), 149.

87. Kozloff, 'William Klein', in *The Privileged Eye*, 53.

88. Max Kozloff, *New York: Capital of Photography* (New Haven: Yale University Press, 2002).

89. Jed Perl, *The New Republic* (August 19, 2002); Frederick M. Winship, 'The Art World: Photos and the 'Jewish Eye', *UPI* (August 8, 2002).

90. Kozloff, 'William Klein', *The Privileged Eye*, 51.

91. Kozloff, 'William Klein', 48.

92. Klein, 'Preface', 4.

93. Pedro Meyer, 'Street Photography', *Zone Zero* (July 1999). http://v2.zonezero.com/index.php?option=com_content&view=article&id=561%3Astreet-photography&catid=1%3Apedro-meyers-editorial&lang=en. Accessed 19 December 2021.

94. Max Kozloff, *Cubism/Futurism* (New York: Charterhouse, 1973), 127.

95. Kozloff, 'Photography: Straight or on the Rocks?' (Conversation with David T. Hanson), *The Privileged Eye*, 237.

96. Susan Sontag, *On Photography* (New York: Farrar, and Giroux, 1978), 23.

97. Kozloff, *The Privileged Eye*, 204.

98. Goldberg, 401.

99. An earlier draft of this essay was presented on 25 October 2002, at the *Southeastern College Art Conference* in Mobile, Alabama.

100. Arnaud Maillet, *The Claude Glass: Use and Meaning of the Black Mirror in Western Art*, trans. Jeff Fort (New York: Zone Books, 2004), 143.

101. Roland Barthes, *The Grain of the Voice: Interviews 1962–1980*, trans. Linda Coverdale (Berkeley: University of California Press, 1991), 356.

102. Established in the early 1900s by The Salvation Army, the island facility was a functional, purpose-built centre for rehabilitation until its last clients left in December 2005. Currently leased by the Salvation Army to a charitable trust, Rotoroa Island is making a transition, to a conservation estate.

103. One of Shelton's diptychs graces the cover of *New Zealand Filmmakers*, Ian Conrich and Stuart Murray, eds. (Detroit: Wayne State University Press, 2007).

104. See Martin Jay, *Downcast Eyes: The Denigration of Vision in Twentieth-Century French Thought* (Berkeley: University of California Press, 1993), and Jonathan Crary, *Techniques of the Observer: On Vision and Modernity in the Nineteenth Century* (Cambridge: The MIT Press), 1990.

105. Anne Noble, *Ice Blink* (Auckland: Clouds, 2011), 95.

106. Noble, *Ice Blink*, 97.

107. Noble, *Ice Blink*, 126.

108. Wayne Barrar, *An Expanding Subterra* (Dunedin: Dunedin Public Art Gallery, 2010), 13.

109. Barrar, *An Expanding Subterra*, 114.

110. Taryn Simon, 'Interview by Geoffrey Batchen & Nell McClister' (2008). http://www.museomagazine.com/TARYN-SIMON. Accessed 15 December 2021.

111. Taryn Simon, 'Interview by Geoffrey Batchen & Nell McClister' (2008).

112. Taryn Simon, 'Interview by Geoffrey Batchen & Nell McClister' (2008).

113. *Walker Evans*, 'Many are Called' (New Haven: Yale University Press), 2004, 202.

114. Simon Mark, *13 Photographs* (Wellington, 2008), 1.

115. Roland Barthes, 'The Romans in Films,' in *Mythologies*, trans. Annette Lavers (New York: Hill and Wang, 1978), 27.

116. Natasha Conland, 'The Irrelevant and the Obscure: The Art of Yvonne Todd', *Art World*, (February/March 2008), 34–39.

117. Natasha Conland, 'The Irrelevant and the Obscure', 34–39.

118. 'Yvonne Todd Interview'. http://lightra.com/yvonne-todd-interview/. Accessed 15 December 2021.

119. Megan Dunn, 'Talking Todd-lish: Mystery and Manners in the Art of Yvonne Todd', *EyeContact* (May 15 2012). https://eyecontactmagazine.com/2012/05/talking-todd-lish-mystery-and-manners-in-the-art-o. Accessed 15 December 2021

120. Peter Schjeldahl, 'Faces: A Cindy Sherman Retrospective', *The New Yorker* (12 March 2012). http://www.newyorker.com/magazine/2012/03/05/faces-peter-schjeldahl. Accessed 19 December 2021.

121. Robert Leonard, 'Everything and Its Opposite', *Cindy Sherman* (Brisbane: Queensland Art Gallery/Gallery of Modern Art, 2016), 46.

122. 'Cindy Sherman Rocks Balenciaga' (10 Sept 2010), *Nowness*.https://www.nowness.com/story/cindy-sherman-rocks-balenciaga. Accessed 19 December 2021.

123. 'encounter.' Merriam-Webster Online Dictionary. 2009. Merriam-Webster Online. http://www.merriam-webster.com/dictionary/encounter. Accessed 19 December 2021.

124. Martin Seel, 'On the Scope of Aesthetic Experience', in *Aesthetic Experience*, Richard Schusterman and Adele Tomlin, eds. (New York: Routledge, 2008), 101.

125. *Clement Greenberg: The Collected Essays and Criticism, Vol. 2*, John O'Brian, ed. (Chicago: University of Chicago Press, 1988), 224–25.

126. Allan Kaprow, *Essays on the Blurring of Art and Life*, Jeff Kelley, ed. (Berkeley: University of California Press, 1993), 9.

127. Laszlo Moholy-Nagy, *The New Vision and Abstract of an Artist* (New York: Wittenborn, 1947), 79.

128. Tom Marioni, *Beer, Art, and Philosophy* (San Francisco: Crown Point Press, 2003), 93.

129. Michael Wilson, 'Caves of New York—Thomas Hirschhorn's Caveman', *Artforum* (February 2003). https://www.artforum.com/print/200302/thomas-hirschhorn-caves-of-new-york-4181. Accessed 6 June 2022.

130. 'Alison M. Gingeras in conversation with Thomas Hirschhorn', in *Thomas Hirschhorn* (London: Phaidon Press, 2004), 31.

131. Barry Schwabsky, 'William Eggleston', *KultureFlash* (12 January 2004).

132. Norman Mailer, *The Armies of the Night: History as a Novel/The Novel as History* (New York: New American Library, 1968), 120.

133. The 'Youth International Party', an organisation of politically active hippies in which Abbie Hoffman was a key figure.

134. Kurt Anderson, 'The Protester', *TIME*, 14 December 2011. http://content.time.com/time/specials/packages/article/0,28804,2101745_2102132_2102373,00.html. Accessed 19 December 2021.

135. Franco Berardi and Geert Lovink, 'A call to the Army of Love and to the Army of Software', 12 October 2011. https://networkcultures.org/geert/2011/10/12/franco-berardi-geert-lovink-a-ca.ll-to-the-army-of-love-and-to-the-army-of-software/. Accessed 16 December 2021.

136. Rebecca Solnit, *Hope in the Dark: The Untold History of People Power* (Melbourne: Canongate, 2005), 163.

137. William Faulkner, *Requiem for a Nun* (New York: Harper Perennial Classics, 2013) [E-book]. https://www.google.co.uk/books/edition/Requiem_for_a_Nun/1G1ArA3X-k4UC?hl=en&gbpv=0. Accessed 8 April 2022.

138. Max Rashbrooke, *The Inequality Debate: An Introduction* (Wellington: Bridget Williams Books, 2014), 1.

139. Rashbrooke, *Inequality*, 9–10.

140. David Hackett Fischer, *Fairness and Freedom: A History of Two Open Societies New Zealand and the United States* (New York: Oxford University Press, 2012).

141. Rashbrooke, *Inequality*, 66.

142. See Nato Thompson, ed. *Living as Form: Socially Engaged Art from 1991–2011* (Cambridge: MIT Press, 2012).

143. A major shift in the American academic workforce has been occurring for decades as a 2013 report states: 'Since 1975, tenure and tenure-track professors have gone from roughly 45 percent of all teaching staff to less than a quarter. Meanwhile, part-time faculty are now more than 40 percent of college instructors.' See: http://www.theatlantic. com/business/archive/2013/04/the-ever-shrinking-role-of-tenured-college-professors-in-1-chart/274849/. Accessed 19 December 2021.

144. See Nicky Hager, *Dirty Politics: How attack politics is poisoning New Zealand's political environment* (Nelson: Craig Potton Publishing, 2014).

145. Michel Foucault, *The History of Sexuality, Volume 1: An Introduction*, trans. Robert Hurley (New York: Vintage Books, 1990), 140.

146. Michel Foucault, *The History of Sexuality, Volume 1: An Introduction*, trans. Robert Hurley (New York: Vintage Books, 1990), 140–41.

147. Michel Foucault, *The History of Sexuality*, 31.

148. Michel Foucault, *The History of Sexuality*, 147.

149. Rashbrooke, *Inequality*, 11.

150. Richard Hamilton, 'Letter to Peter and Alison Smithson (1957)', in *Theories and Documents of Contemporary Art: A Sourcebook of Artists' Writings*, Kristine Stiles and Peter Selz, eds. (Berkeley: University of California Press, 2012), 344.

151. Julie Ault, *Alternative Art*, New York, 1965 1985 (Minneapolis: University of Minneapolis Press, 2002), 22–23.

152. Lucy R. Lippard and John Chandler, 'The Dematerialization of Art', in *Conceptual Art: A Critical Anthology*, Alexander Alberro and Blake Stimson eds. (Cambridge: MIT Press, 1999), 46–51.

153. Quoted in *Being Billy Apple*, directed by Leanne Pooley (Spacific Films, 2007), 1:10:27.

154. Anthony Byrt, *Two New York Works*, Ramp Gallery, Hamilton, New Zealand, September 2003. https://www.rampgallery.co.nz/exhibitions/two-new-york-works/. Accessed 26 March 2022.

155. Wystan Curnow, 'Working with Billy Apple', in *The Critic's Part: Wystan Curnow Art Writings 1971–2013*, Christina Barton, Robert Leonard and Thomasin Sleigh, eds. (Wellington: Victoria University Press, 2014), 207–08.

156. Billy Apple and Craig Hilton, 'The Analysis of Billy Apple', *Ocula* (May 2014). https://ocula. com/art-galleries/starkwhite/exhibitions/the-analysis-of-billy-apple/. Accessed 26 March 2022.

157. Ludwig Wittgenstein, *Philosophical Investigations*, trans. GEM Anscombe (New York: Macmillan, 1953), 49.

158. Rebecca Solnit, *A Field Guide to Getting Lost* (New York: Viking, 2005), 6.

159. Geoff Park, *Ngā Uruora The Groves of Life: Ecology and History in a New Zealand Landscape* (Wellington: Victoria University Press, [1995] 2018), 20.

160. Henry David Thoreau, 'Walking' (1862). https://faculty.washington.edu/timbillo/ Readings%20and%20documents/Wilderness/Thoreau%20Walking.pdf. Accessed 19 December 2021.

161. Jonathan Crary, *24/7: Late Capitalism and the Ends of Sleep* (London: Verso, 2014), 19–20.

162. Kurt Vonnegut, *A Man Without A Country* (New York: Seven Stories Press, 2005), 88.

163. See Shannon Te Ao, *I Can Press My Face up Against the Glass* (Christchurch: The Physics Room/Ilam Press, 2014).

164. Kurt Vonnegut, *Slaughterhouse-Five* (New York: Delacorte Press, 1994), 14.

165. Vonnegut, *Slaughterhouse-Five*, 18.

166. Crary, *24/7*, 19–20.

167. Mark Fisher, 'What is Hauntology?' *Film Quarterly* 66, no. 1 (Fall 2012), 16.

168. Mike Heynes, *Punk Shane* (2000). https://www.circuit.org.nz/film/punk-shane. Accessed 26 March 2022.

169. Mike Heynes, *ghost town* (2011). https://www.circuit.org.nz/film/ghost-town. Accessed 26 March 2022.

170. Heynes, conversation with author.

171. Kristine Stiles and Peter Selz, eds. *Theories and Documents of Contemporary Art: A Sourcebook of Artists' Writings* (Berkeley: University of California Press, 1996), 518.

172. See *Contemporary Art: From Studio to Situation*, Claire Doherty, ed. (London: Black Dog Publishing, 2004).

173. Statement by the artist.

174. Statement by the artist.

175. Victor Burgin, *The Remembered Film* (London: Reaktion Books, 2004), 8.

176. Statement by the artist.

177. Statement by the artist.

178. Bogdan Perzyński, Email to author, 2011.

179. Clement Greenberg, *Clement Greenberg: Late Writings*, Robert C. Morgan, ed. (Minneapolis: University of Minnesota Press, 2003) [E-book]. https://books.google.co.uk/books/about/Clement_Greenberg_Late_Writings.html?id=8wFNAAAAYAAJ&redir_esc=y. Accessed 8 April 2022.

180. Greenberg, Clement, *Clement Greenberg: The Collected Essays and Criticism*, Vol. 2, John O'Brian, ed. (Chicago: University of Chicago Press, 1988), 224.

181. Clement Greenberg, *Clement Greenberg: The Collected Essays and Criticism: Volume 4 Modernism with a Vengeance 1957–1969*, John O'Brian, ed. (Chicago: University of Chicago Press, 1993), 85.

182. Greenberg, *Late Writings*, 13.

183. Greenberg, *Collected Essays*, 314.

184. Matthew Jesse Jackson, *The Experimental Group: Ilya Kabakov, Moscow Conceptualism, Soviet Avant-Gardes* (Chicago: University of Chicago Press, 2010), 1.

185. Jackson, *The Experimental Group*, 2.

186. Jackson, *The Experimental Group*, 2.

187. Jackson, *The Experimental Group*, 179.

188. Jackson, *The Experimental Group*, 68.

189. Jackson, *The Experimental Group*, 58.

190. Jackson, *The Experimental Group*, 1.

191. Amelia Barikin, *Parallel Presents: The Art of Pierre Huyghe* (Cambridge: The MIT Press, 2012), 12.

192. Barikin, *Parallel Presents*, 80.

193. Barikin, *Parallel Presents*, 80.

194. Chris Braddock, *Performing Contagious Bodies: Ritual Participation in Contemporary Art* (London: Palgrave Macmillan, 2012), 58.

195. Braddock, *Performing Contagious Bodies*, 131–32.

196. Gregory Sholette and Oliver Ressler, eds., *It's the Political Economy, Stupid: The Global Financial Crisis in Art and Theory* (London: Pluto Press, 2013), 30.

197. Sholette and Ressler, *It's the Political Economy*, 66.

198. Sholette and Ressler, *It's the Political Economy*, 86.

199. Sholette and Ressler, *It's the Political Economy*, 166.

200. Friedrich Nietzsche, *Human, All Too Human: A Book for Free Spirits*, trans. by R. J. Hollingdale (Cambridge: Cambridge University Press, 1996), 82.

201. Rene Ricard, *God With Revolver* (New York: Hanuman Books, 1989), 47.

202. Edward S. Casey, *Representing Place: Landscape Painting & Maps* (Minneapolis: University of Minnesota Press, 2002), 354.

203. Edward S. Casey, 354.

204. John Brunetti, *Uncharted Territories: The Work of Shona Macdonald* (2003). http://s3.amazonaws.com/images.icompendium.com/artistInfo/shonamac/biblio/62.pdf?1552595912. Accessed 18 December 2021.

205. Giancarlo Politi, ed. *Art and Philosophy* (Milan: Flash Art Books, 1991), 92.

206. TJ Clark, 'Clement Greenberg's Philosophy of Art', in *Postmodern Perspectives: Issues in Contemporary Art*, ed. Howard Risatti (Upper Saddle River: Prentice Hall, 1998), 31.

207. Bauhaus, *In the Flat Field*, LP (London: 4AD Records, 1980).

208. *Questions of Minimal Importance* (Melbourne: West Space, 1998), n.pag.

209. Quoted by Jean-Claude Marcadé, 'Malevich, Painting, and Writing', in *Kazimir Malevich: Suprematism*, Matthew Drutt, ed. (New York: Guggenheim Museum, 2003), 38.

210. Easton, correspondence with author.

211. Anonymous, 'all our relations: Biennale of Sydney', Press release (28 June 2012). https://www.e-flux.com/announcements/33983/all-our-relations/. Accessed 20 March 2022.

212. Exhibited at Gow Langsford Gallery, Auckland, 16 May–9 June 2012.

213. https://www.gowlangsfordgallery.co.nz/2012/16-may-9-june-2012/maukatere/. Accessed 12 December 2021.

214. Vladimir Nabokov, *Speak Memory: An Autobiography Revisited* (New York: Vintage, 1989), 125.

215. Virginia Were, 'Exploring a New Constellation', *Art News New Zealand* (Spring 2008): 73–75.

216. David Cross, 'A Walk Along the Faultline: Recent Work by Chris Heaphy', *Art New Zealand* 89 (Summer 1998–99): 47.

217. See Damian Skinner's *The Passing World, The Passage of Life: John Hovell and the Art of Kowhaiwhai* (Auckland: Rim Books, 2010).

218. See William C. Seitz, *The Responsive Eye* (New York: Museum of Modern Art, 1965).

219. David Thomas, *Changing Times in Painting*, pamphlet (Sydney: Conny Dietzschold Gallery, 2003), n.pag.

220. Press Release for *Chris Heaphy: Daisy in My Lazy Eye* exhibition, 2–18 October 2008, Plum Blossoms Gallery, Hong Kong.

221. See Lynne McTaggart, *The Field: The Quest for the Secret Force of the Universe* (New York: Harper, 2008).

222. Keith Stewart, 'String Theory: The Heaphy Continuum', in *Chris Heaphy: Daisy in My Lazy Eye*, pamphlet (Hong Kong: Plum Blossoms International, 2008), n.pag.

223. Tom Bissell, *Magic Hours: Essays on Creators and Creation* [Ebook] (San Francisco: McSweeney's, 2012).

224. Karl Chitham, *Niki Hastings-McFall: In flyte* (Porirua: Pataka Art Museum, 2013), 6.

225. Video interview with Simon Morris, on occasion of *Collecting Contemporary* exhibition, December 2011, Te Papa Tongarewa, Wellington, NZ. http://www.tepapa.govt.nz/WhatsOn/exhibitions/CollectingContemporary/Pages/Narrative.aspx?irn=3063. Accessed 12 December 2021.

226. Video interview with Simon Morris.

227. Sol LeWitt, 'Paragraphs on Conceptual Art', *Artforum* (June 1967).

228. See David Cross, 'Abstraction after Appropriation', in *Signs of the Times: Sampling New Directions in New Zealand Art* (Wellington: City Gallery, 1997).

229. Gordon H. Brown and Hamish Keith, *An Introduction to New Zealand Painting (1839–1967)* (Auckland: Collins, 1969).

230. Simon Morris, *Folding Water*, Two Rooms Gallery, Auckland (16 October–14 November 2009). http://tworooms.co.nz/exhibitions/simon-morris09/. Accessed 19 December 2021.

231. All statements by the artist quoted here were included in the exhibition's wall texts.

232. Ronald Parkinson, *John Constable: The Man and His Art* (London: Victoria and Albert Museum, 1998), 9.

233. Richard R. Brettell, Dana Friis-Hansen, and Marti Mayo. *Richard Long: Circles, Cycles, Mud, Stones* (Houston: Contemporary Arts Museum, 1996), 16.

234. Nathan Pohio, 'Theo Schoon, a Ngāi Tahu Perspective,' in *Split Level View Finder: Theo Schoon and New Zealand Art*, Damian Skinner and Aaron Lister, eds. (Wellington: City Gallery, 2019), 97.

235. Hilton Als, 'Hannah Gadsby's Song of the Self', *The New Yorker* (22 July 2019). https://www.newyorker.com/magazine/2019/07/29/hannah-gadsbys-song-of-the-self. Accessed 18 December 2021.

236. Mike Kelley, 'Cross Gender/Cross Genre', *PAJ: A Journal of Performance and Art* 22, no. 1, 1–9 (January 2000), 1.

237. 'Collection: Our Favourites'. http://dowse.org.nz/about/collection/Larkin_Folk_Furniture/. Accessed 10 July 2016.

238. Jon Bywater, 'The Dog Who Might Be Laika', *distracted-reader #3: 'Time to Think Like a Mountain. Louise Menzies'* (2017), 63.

239. Daniel Kelly, conversation with author.

240. Kane Laing, 'About', *Exposure* 2015 Graduate Exhibition, Massey University. https://exposure.massey.ac.nz/exposure-2015-graduate-exhibition/bfa/kane-laing/. Accessed 30 April 2022.

241. Kane Laing, 'About', *Exposure* 2015 Graduate Exhibition, Massey University. https://exposure.massey.ac.nz/exposure-2015-graduate-exhibition/bfa/kane-laing/. Accessed 30 April 2022.

242. Adrian McCleland, Email to author.

Bibliography

Abramovic, Marina. *Walk Through Walls: A Memoir*. New York: Penguin Books, 2016 [E-book], https://www.penguin.co.uk/books/288046/walk-through-walls/9780241974513.html. Accessed 8 April 2022.

Als, Hilton. 'Hannah Gadsby's Song of the Self'. *The New Yorker*, 22 July 2019. https://www.newyorker.com/magazine/2019/07/29/hannah-gadsbys-song-of-the-self. Accessed 18 December 2021.

Alÿs, Francis and Cuauhtémoc, Medina. *When Faith Moves Mountains*. Madrid: Turner, 2005.

Alÿs, Francis and Cuauhtémoc, Medina. '1000 Words: Francis Alÿs talks about When Faith Moves Mountains.' *Artforum* (Summer 2002).

Alÿs, Francis and Cuauhtémoc, Medina. *Walks/Paseos*. México: Museo de Arte Moderno, 1997.

Ambrose, Joe. *Gimme Danger: The Story of Iggy Pop*. London: Omnibus Press, 2002.

Anderson, Kurt. 'The Protester'. *TIME*. 14 December 2011. http://content.time.com/time/specials/packages/article/0,28804,2101745_2102132_2102373,00.html. Accessed 19 December 2021.

Anonymous. '*all our relations*: Biennale of Sydney'. Press release. 28 June 2012. https://www.e-flux.com/announcements/33983/all-our-relations/. Accessed 20 March 2022.

Anonymous. 'Cindy Sherman Rocks Balenciaga'. Nowness. 10 September 2010. https://www.nowness.com/story/cindy-sherman-rocks-balenciaga. Accessed 19 December 2021.

Anonymous. 'Laurie Anderson on *The End of The Moon*'. New York: Brooklyn Academy of Music BAMBill, February 2005. http://academic.brooklyn.cuny.edu/music/dcohen/coremusic/site/anderson.html#EOM. Accessed 19 March 2022.

Anonymous. *The Wit and Wisdom of Ronald Reagan*. LP. London: Magic Records and ABRA 1, 1980.

Apple, Billy and Craig Hilton. 'The Analysis of Billy Apple'. Ocula. May 2014. https://ocula.com/art-galleries/starkwhite/exhibitions/the-analysis-of-billy-apple/. Accessed 26 March 2022.

Artaud, Antonin. 'For The Theater and Its Double (1931–36)'. *Antonin Artaud: Selected Writings*, Susan Sontag, ed. Berkeley: University of California Press, 1988.

Ault, Julie. *Alternative Art, New York, 1965–1985*. Minneapolis: University of Minneapolis Press, 2002.

Bagnall, Catherine. 'Archive and the Performance of Becoming "Other"'. In *Performing Archives/Archives of Performance*, G., Borggreen and R., Gade, eds. Museum Tusculanum Press, 2013, 349–59.

Bakhtin, Mikhail. *Rabelais and His World*. Translated by Helene Iswolsky. Bloomington: Indiana University Press, 1984.

Bangs, Lester. 'Iggy Pop: Blowtorch in Bondage'. In *Psychotic Reactions and Carburator Dung*. New York: Vintage Books, 1988.

Barikin, Amelia. *Parallel Presents: The Art of Pierre Huyghe*. Cambridge: The MIT Press, 2012.

Barrar, Wayne. *An Expanding Subterra*. Dunedin: Dunedin Public Art Gallery, 2010.

Barthes, Roland. *Mythologies*. Translated by Annette Lavers. New York: Hill and Wang, 1978.

Barthes, Roland. *The Grain of the Voice: Interviews 1962–1980*. Translated Linda Coverdale. Evanston: Northwestern University Press.

Batchen, Geoffrey and Nell McClister. 'Taryn Simon: Interview.' 2008. http://www.museomagazine.com/TARYN-SIMON. Accessed 15 December 2021.

Battcock, Gregory, ed. *Minimal Art: A Critical Anthology*. New York: E.P. Dutton, 1968.

Baudelaire, Charles. *Œuvres complètes*. Paris: Robert Laffont, 1980.

Bauhaus. *In the Flat Field*. London: 4AD Records, 1980.

Berardi, Franco and Geert Lovink. 'A call to the Army of Love and to the Army of Software'. 12 October 2011. https://networkcultures.org/geert/2011/10/12/franco-berardi-geert-lovink-a-call-to-the-army-of-love-and-to-the-army-of-software/. Accessed 16 December 2021.

Bewley, Jon. 'Chris Burden in Conversation with Jon Bewley.' In *Talking Art I*, Adrian Searle, ed. London: Institute of Contemporary Arts, 1993.

Bishop, Cameron. 'David Cross in Conversation with Cameron Bishop.' *Drain* (Special issue on Athleticism, 2015). http://drainmag.com/david-cross-in-conversation-with-cameron-bishop/. Accessed 12 December 2021.

Bissell, Tom. *Magic Hours: Essays on Creators and Creation*. San Francisco: McSweeney's, 2012.

Brettell, Richard R., Friis-Hansen, Dana and Mayo, Marti. *Richard Long: Circles, Cycles, Mud, Stones*. Houston: Contemporary Arts Museum, 1996.

Broglio, Ron. *Surface Encounters: Thinking with Animals and Art*. Minneapolis: University of Minnesota Press, 2011.

Brown, Gordon H. and Hamish Keith. *An Introduction to New Zealand Painting (1839–1967)*. Auckland: Collins, 1969.

Brunetti, John. 'Uncharted Territories: The Work of Shona Macdonald'. Brochure. 2003. http://s3.amazonaws.com/images.icompendium.com/artistInfo/shonamac/biblio/62.pdf?1552595912. Accessed 18 December 2021.

Burden, Chris. *Chris Burden: Documentation of Selected Works, 1971–75*. New York: Electronic Arts Intermix, 1975. 35 min. video.

Burgin, Victor. *The Remembered Film*. London: Reaktion Books, 2004.

Byrt, Anthony. *Two New York Works*. Ramp Gallery, Hamilton, New Zealand. September 2003. https://www.rampgallery.co.nz/exhibitions/two-new-york-works/. Accessed 26 March 2022.

Bywater, Jon. 'The Dog Who Might Be Laika'. *distracted-reader #3: 'Time to Think Like a Mountain. Louise Menzies'* (2017), 63–64.

Casey, Edward S. *Representing Place: Landscape Painting & Maps*. Minneapolis: University of Minnesota Press, 2002.

Chitham, Karl. *Niki Hastings-McFall: In flyte*. Porirua: Pataka Art Museum, 2013.

Clark, T. J. 'Clement Greenberg's Philosophy of Art'. In *Postmodern Perspectives: Issues in Contemporary Art*, Howard Risatti, ed. Upper Saddle River: Prentice Hall, 1998.

Coetzee, J. M. *Elizabeth Costello*. New York: Penguin Books, 2004.

Conland, Natasha. *Richard Maloy's Fat Test*. Sue Crockford Gallery, July 2008. https://www.richardmaloy.net/natasha-conland-text. Accessed 14 December 2021.

Conland, Natasha. 'The Irrelevant and the Obscure: The Art of Yvonne Todd'. *Art World*, February/March 2008: 34–39.

Conrich, Ian and Stuart Murray, eds. *New Zealand Filmmakers*. Detroit: Wayne State University Press, 2007.

Crary, Jonathan. *24/7: Late Capitalism and the Ends of Sleep*. London: Verso, 2014.

Crary, Jonathan. *Techniques of the Observer: On Vision and Modernity in the Nineteenth Century*. Cambridge: MIT Press, 1990.

Cross, David. 'A Walk Along the Faultline: Recent Work by Chris Heaphy'. *Art New Zealand*, Summer 1998–99.

Cross, David. 'Some Kind of Beautiful: The Grotesque Body in Contemporary Art'. Ph.D. thesis, Queensland University of Technology School of Visual Arts, 2006.

Cross, David. 'Abstraction after Appropriation'. In *Signs of the Times: Sampling New Directions in New Zealand Art*. Wellington: City Gallery, 1997.

Curnow, Wystan. 'Working with Billy Apple'. In *The Critic's Part: Wystan Curnow Art Writings 1971–2013*, C. Barton, R. Leonard and T. Sleigh, eds. Wellington: Victoria University Press, 2014, 207–08.

Diamond, Cora. 'The Difficulty of Reality and the Difficulty of Philosophy'. *Journal of Literature and the History of Ideas* 1, no. 2 (June 2003), 1–26. http://muse.jhu.edu.ezproxy.massey.ac.nz/journals/partial_answers/v001/1.2.diamond.html. Accessed 19 December 2021.

Doherty, Claire, ed. *Contemporary Art: From Studio to Situation*. London: Black Dog Publishing, 2004.

Doyle, Arthur Conan. 'A Study in Scarlet'. In *The Complete Sherlock Holmes*. New York: Race Point Publishing, 2013.

Dunn, Megan. 'Talking Todd-lish: Mystery and Manners in the Art of Yvonne Todd'. *EyeContact*. 15 May 2012. https://eyecontactmagazine.com/2012/05/talking-todd-lish-mystery-and-manners-in-the-art-o. Accessed 15 December 2021.

Easton, Craig. Correspondence with the author, August 2009.

Eggleston, William. *The Democratic Forest*. New York: Doubleday, 1989.

Faulkner, William. *Requiem for a Nun*. New York: Harper Perennial Classics, 2013 [E-book]. https://www.google.co.uk/books/edition/Requiem_for_a_Nun/1G1ArA3Xk4UC?hl=en&g-bpv=0. Accessed 8 April 2022.

Fisher, Mark. 'What Is Hauntology?' *Film Quarterly* 66, no. 1 (Fall 2012), 16–24.

Foucault, Michel. *The History of Sexuality, Volume 1: An Introduction*. Translated by Robert Hurley. New York: Vintage Books, 1990.

Fralin, Frances. *Washington Photography: Images of the Eighties*. Washington, DC: Corcoran Gallery of Art, 1982.

Gingeras, Alison M. 'Alison M. Gingeras in Conversation with Thomas Hirschhorn'. In *Thomas Hirschhorn*. London: Phaidon Press, 2004.

Goldberg, RoseLee (organizer). *High & Low: Modern Art and Popular Culture: Six Evenings of Performance*, L. Anderson, E. Bogosian, Bongwater, D. Cale and B. Eno, perfs. New York: The Museum of Modern Art, 1990. https://assets.moma.org/documents/moma_cata-logue_1764_300062992.pdf. Accessed 19 March 2022.

Goldberg, Vicki, ed. *Photography in Print: Writings from 1816 to the Present*. New York: Touchstone, 1981.

Greenberg, Clement. *Clement Greenberg: Late Writings*, Robert C. Morgan, ed. Minneapolis: University of Minnesota Press, 2003 [E-book]. https://books.google.co.uk/books/about/Clement_Greenberg_Late_Writings.html?id=8wFNAAAAYAAJ&redir_esc=y. Accessed 8 April 2022.

Greenberg, Clement. *Clement Greenberg: The Collected Essays and Criticism, Vol. 2*, J. O'Brian, ed. Chicago: University of Chicago Press, 1988.

Greenberg, Clement. *Clement Greenberg: The Collected Essays and Criticism: Volume 4 Modernism with a Vengeance 1957–1969*, John O'Brian, ed. Chicago: University of Chicago Press, 1993.

Hackett Fischer, David. *Fairness and Freedom: A History of Two Open Societies New Zealand and the United States*. New York: Oxford University Press, 2012.

Hager, Nicky. *Dirty Politics: How Attack Politics Is Poisoning New Zealand's Political Environment*. Nelson: Craig Potton Publishing, 2014.

Hamilton, Richard. 'Letter to Peter and Alison Smithson (1957)'. In *Theories and Documents of Contemporary Art: A Sourcebook of Artists' Writings*, Kristine Stiles and Peter Selz, eds. Berkeley: University of California Press, 2012, pp. 343–47.

Heynes, Mike. *ghost town*. 2011. https://www.circuit.org.nz/film/ghost-town. Accessed 26 March 2022.

Heynes, Mike. *Punk Shane*. 2000. https://www.circuit.org.nz/film/punk-shane. Accessed 26 March 2022.

Hochstein, Bess. 'Laurie Anderson touches down at MoCA'. 2006. http://www.jimdavies.org/laurie-anderson/work/interviews/berkshiresweek.txt. Accessed 19 March 2022.

Horlock, Mary. 'Chris Burden: Life and Works'. In *Chris Burden: When Robots Rule: The Two-Minute Airplane Factory*. London: Tate Gallery, 1999.

Jackson, Matthew Jesse. *The Experimental Group: Ilya Kabakov, Moscow Conceptualism, Soviet Avant-Gardes*. Chicago: University of Chicago Press, 2010.

Jay, Martin. *Downcast Eyes: The Denigration of Vision in Twentieth-Century French Thought*. Berkeley: University of California Press, 1993.

Jones, Caroline A. *Machine in the Studio: Constructing the Postwar American Artist*. Chicago: University of Chicago Press, 1996.

Kaprow, Allan. *Essays on the Blurring of Art and Life*, Jeff Kelley, ed. (Berkeley: University of California Press, 1993.

Kazimir Malevich: Suprematism. New York: Guggenheim Museum, 2003.

Kelley, Mike. 'Cross Gender/Cross Genre'. *PAJ: A Journal of Performance and Art* 22, no. 1 (January 2000): 1–9.

Kent, Nick. 'The Four Ages of a Man Named Pop: Pictures of Iggy'. In *The Dark Stuff: Selected Writings on Rock Music*. Cambridge: Da Capo Press, 2002.

Klein, William. *New York*. New York: Distributed Art Publishers, 1996.

Kozloff, Max. *Cubism/Futurism*. New York: Charterhouse, 1973.

Kozloff, Max. *Lone Visions, Crowded Frames: Essays on Photography*. Albuquerque: University of New Mexico Press, 1994.

Kozloff, Max. *New York: Capital of Photography*. New Haven: Yale University Press, 2002.

Kozloff, Max. *The Privileged Eye*. Albuquerque: University of New Mexico Press, 1987.

Kozloff, Max. *Renderings: Critical Essays on a Century of Modern Art*. London: Studio Vista, 1970.

Kraynak, Janet, ed. *Please Pay Attention Please: Bruce Nauman's Words*. Cambridge: MIT Press, 2003.

Laing, Kane, 'About'. *Exposure* Graduate Exhibition, Massey University. https://exposure.massey.ac.nz/exposure-2015-graduate-exhibition/bfa/kane-laing/. Accessed 30 April 2022.

Lee, Peggy. 'Is That All There Is?' *Is That All There Is*, Lyrics by Mike Stoller and Jerry Lieber. 1969. https://genius.com/Peggy-lee-is-that-all-there-is-lyrics. Accessed 12 March 2022.

Leonard, Robert. 'Everything and Its Opposite'. In *Cindy Sherman*. Brisbane: Queensland Art Gallery/Gallery of Modern Art, 2016.

Levin, Kim. *Beyond Modernism: Essays on Art from the '70s and '80s*. New York: Harper & Row, 1988.

Lewis, Jim. 'The Condition of Music: Jim Lewis talks to William Eggleston'. *Frieze*. May 2000.

Lippard, Lucy R. and Chandler John. 'The Dematerialization of Art'. In *Conceptual Art: A Critical Anthology*, A. Alberro and B. Stimson eds. Cambridge: MIT Press, 1999, 46–51.

Mailer, Norman. *The Armies of the Night: History as a Novel/The Novel as History*. New York: New American Library, 1968.

Maillet, Arnaud. *The Claude Glass: Use and Meaning of the Black Mirror in Western Art*. Translated by Jeff Fort. New York: Zone Books, 2004.

Maloy, Richard. *28 Compositions*. Ngā Taonga Sound & Vision, 2005. https://www.ngataonga.org.nz/collections/catalogue/catalogue-item?record_id=116041 Accessed 21 March 2022.

Marcadé, Jean-Claude. 'Malevich, Painting, and Writing: On the Development of a Suprematist Philosophy'. In Matthew Drutt. *Kazimir Malevich: Suprematism*. New York: Guggenheim Museum, 2003. 32–43.

Marioni, Tom. *Beer, Art, and Philosophy*. San Francisco: Crown Point Press, 2003.

Mark, Simon. *13 Photographs* (catalogue). Wellington, 2008.

McCleland, Adrian. Email to the author, Wellington, 2016.

McLuhan, Marshall. *Understanding Media: The Extensions of Man*. New York: Mentor, 1964.

McTaggart, Lynne. *The Field: The Quest for the Secret Force of the Universe*. New York: Harper, 2008.

Meyer, Pedro. 'Street Photography'. *Zone Zero*, July 1999. http://v2.zonezero.com/index.php?option=com_content&view=article&id=561%3Astreet-photography&catid=1%3Apedro-meyers-editorial&lang=en. Accessed 19 December 2021.

Moholy-Nagy, Laszlo. *The New Vision and Abstract of an Artist*. New York: Wittenborn, 1947.

Montano, Linda. *Performance Artists Talking in the Eighties*. Berkeley: University of California Press, 2000.

Morris, Simon. *Folding Water*. Two Rooms Gallery, Auckland, 16 October–14 November 2009. http://tworooms.co.nz/exhibitions/simon-morris09/. Accessed 19 December 2021.

Morris, Simon. Video interview. *Collecting Contemporary* exhibition, December 2011. Te Papa Tongarewa, Wellington, NZ.

Nabokov, Vladimir. *Speak Memory: An Autobiography Revisited*. New York: Vintage, 1989.

Nietzsche, Friedrich. *Human, All Too Human: A Book for Free Spirits*, Translated. by R. J. Hollingdale. Cambridge: Cambridge University Press, 1996.

Noble, Anne. *Ice Blink*. Auckland: Clouds, 2011.

Obrist, Hans-Ulrich. 'Francis Alÿs in Conversation with Hans-Ulrich Obrist'. In *Point of View: An Anthology of the Moving Image. V. 1 (DVD)*. New York: New Museum of Contemporary Art, 2003.

Park, Geoff. *Ngā Uruora The Groves of Life: Ecology and History in a New Zealand Landscape*. Wellington: Victoria University Press, [1995] 2018.

Parkinson, Ronald. *John Constable: The Man and His Art*. London: Victoria and Albert Museum, 1998.

Perzyński, Bogdan. Email to author. 2011.

Pohio, Nathan. 'Theo Schoon, a Ngāi Tahu Perspective'. In *Split Level View Finder: Theo Schoon and New Zealand Art*, D. Skinner and A. Lister, eds. Wellington: City Gallery, 2019, 95–99. https://www.teuru.org.nz/teuru/assets/File/schoon-final-complete-web.pdf. Accessed 12 April 2022.

Politi, Giancarlo, ed. *Art and Philosophy*. Milan: Flash Art Books, 1991.

Pooley, Leanne, dir. *Being Billy Apple*. New Zealand: Spacific Films, 1 hr 10 min.

Pop, Iggy. 'I Need More'. *Soldier*. Los Angeles: Two Thirteen Sixty-One, [1980] 1997.

Pop, Iggy. Interview. *Rock and Roll*. WGBH public television, 1995.

Questions of Minimal Importance. Melbourne: West Space, 1998.

Rashbrooke, Max. *The Inequality Debate: An Introduction*. Wellington: Bridget Williams Books, 2014.

Relyea, Lane. 'Studio Unbound'. In *The Studio Reader*, M. Grabner and M. J. Jacobs, eds. Chicago: University of Chicago Press, 2010.

Ricard, Rene. *God With Revolver*. New York: Hanuman Books, 1989.

Romano, Gianni. 'Francis Alÿs: Streets and Gallery Walls'. *Flash Art*, March–April 2000.

Ruskin, Yvonne Sewall. *High on Rebellion: Inside the Underground at Max's Kansas City*. New York: Thunder's Mouth Press, 1998.

Schimmel, Paul. *Ecstasy: In and About Altered States*. Cambridge: MIT Press, 2005.

Schjeldahl, Peter. 'Faces: A Cindy Sherman Retrospective'. *The New Yorker*, 5 March 2012. http://www.newyorker.com/magazine/2012/03/05/faces-peter-schjeldahl. Accessed 19 December 2021.

Schwabsky, Barry. 'Signs of Protest: Occupy's Guerilla Semiotics'. *The Nation*. 14 December 2011. https://www.thenation.com/article/archive/signs-protest-occupys-guerilla-semiotics/. Accessed 8 April 2022.

Schwabsky, Barry. 'William Eggleston'. *KultureFlash*, 12 January 2004.

Scott, Kitty. 'Portrait: Francis Alÿs'. *Parkett* 69 (Zurich) 2003.

Seel, Martin. 'On the Scope of Aesthetic Experience'. In *Aesthetic Experience*, R. Schusterman and A. Tomlin, eds. New York: Routledge, 2008.

Seitz, William C. *The Responsive Eye*. New York: Museum of Modern Art, 1965.

Sewall-Ruskin, Yvonne. *High on Rebellion: Inside the Underground at Max's Kansas City*. New York: Open Road Media, 2016 [E-book]. https://play.google.com/store/books/details/?id=rgi5CwAAQBAJ. Accessed 8 April 2022.

Sholette, Gregory and Oliver, R, eds. *It's the Political Economy, Stupid: The Global Financial Crisis in Art and Theory*. London: Pluto Press, 2013.

Skinner, Damian. *The Passing World, The Passage of Life: John Hovell and the Art of Kowhaiwhai*. Auckland: Rim Books, 2010.

Sol LeWitt. 'Paragraphs on Conceptual Art'. *Artforum*, June 1967.

Solnit, Rebecca. *A Field Guide to Getting Lost*. New York: Viking, 2005.

Solnit, Rebecca. *Hope in the Dark: The Untold History of People Power*. Melbourne: Canongate, 2005.

Solnit, Rebecca. *Wanderlust: A History of Walking*. New York: Penguin, 2000.

Sontag, Susan. *On Photography*. New York: Farrar and Giroux, 1978.

Soper, Kate. 'The Humanism in Posthumanism'. *Comparative Critical Studies* 9, no. 3 (2012): 365–78. https://www.euppublishing.com/doi/full/10.3366/ccs.2012.0069. Accessed 27 August 2022.

Soper, Kate. 'The Politics of Nature: Reflections on Hedonism, Progress and Ecology'. *Capitalism Nature Socialism* 10, no. 2 (June 1999), 47–70. http://dx.doi.org/10.1080/10455759909358857. Accessed 12 January 2012.

Spermatikos Logos. 'Pynchon Music: Laurie Anderson'. Shipwreck Library, 10 September 2021. http://shipwrecklibrary.com/the-modern-word/pynchon/sl-music-anderson/. Accessed 19 March 2022.

Spong, Sriwhana. *Tree Hut*. Sue Crockford Gallery, October 2004. https://www.richardmaloy. net/sriwhana-spong. Accessed 14 December 2021.

Steinberg, Leo. *Other Criteria*. Chicago: University of Chicago, 2007.

Stewart, Keith. 'String Theory: The Heaphy Continuum'. In *Chris Heaphy: Daisy in My Lazy Eye*. Hong Kong: Plum Blossoms International, 2008, n.p.

Stiles, Kristine and Peter Selz, eds. *Theories and Documents of Contemporary Art: A Sourcebook of Artists' Writings*. Berkeley: University of California Press, 1996.

Storr, Robert. *Dislocations*. New York: Museum of Modern Art, 1991.

Strauss, Neil. 'THE POP LIFE; The Times Are A-Changin'. *New York Times*. 27 September 2001. https://www.nytimes.com/2001/09/27/arts/the-pop-life-the-times-are-a-changin.html. Accessed 19 March 2022.

Szarkowski, John. *William Eggleston's Guide*. New York: MoMA, 1976.

Te Ao, Shannon. *I Can Press My Face up Against the Glass*. Christchurch: The Physics Room/ Ilam Press, 2014.

The Beatles. 'Can You Take Me Back'. Hidden track on *The Beatles*, London: Capitol Records, 1968. https://genius.com/The-beatles-can-you-take-me-back-lyrics. Accessed 19 March 2022.

Thomas, David. *Changing Times in Painting*. Sydney: Conny Dietzschold Gallery, 2003.

Thompson, Hunter S. 'Ugly, tasteless, terrifying and wild... count me in'. *The Independent*. 28 October 2004. https://www.independent.co.uk/news/world/americas/ ugly-tasteless-terrifying-and-wild-count-me-in-5351483.html. Accessed 19 March 2022.

Thompson, Nato, ed. *Living as Form: Socially Engaged Art from 1991–2011*. Cambridge: MIT Press, 2012.

Todd, Yvonne. 'Yvonne Todd Interview'. http://lightra.com/yvonne-todd-interview/. Accessed 15 December 2021.

Torres, David. 'Francis Alÿs, Just Walking the Dog'. *Art Press* 263 (2001): 18–23.

Vonnegut, Kurt. *A Man Without A Country*. New York: Seven Stories Press, 2005.

Vonnegut, Kurt. *Slaughterhouse-Five, or The Children's Crusade*. New York: Delacorte Press, 1994.

Walker Evans. *Walker Evans: Many Are Called*. New Haven: Yale University Press, 2004.

Weissman, Benjamin. 'Paul McCarthy'. *BOMB* 84 (Summer 2003). https://bombmagazine.org/ articles/paul-mccarthy/. Accessed 27 August 2022.

Were, Virginia. 'Exploring a New Constellation'. *Art News New Zealand* (Spring 2008): 73–75.

West, Cornel. *Democracy Matters: Winning the Fight Against Imperialism*. New York: Penguin, 2004 [E-book]. https://books.google.co.uk/books?id=ZYNzIa9OyQEC. Accessed 8 April 2022.

Westerbeck, Colin and Joel Meyerowitz. *Bystander: A History of Street Photography*. Boston: Bulfinch Press, 1994.

Wilson, Michael. 'Caves of New York – Thomas Hirschhorn's Caveman'. *Artforum*. February 2003.

Wittgenstein, Ludwig. *Philosophical Investigations*. Translated by G. E. M. Anscombe, Joachim Schulte and P. M. S. Hacker. Germany: Wiley, 2010 [E-book], https://www.google.co.uk/books/edition/Tractatus_Logico_Philosophicus/thgsEAAAQBAJ?hl=en&gbpv=0. Accessed 8 April 2022.

Index

3 Standard Stoppages (Duchamp) 112–13
6 Artists from New Zealand: Abstraction and Time exhibition 231
[8-bits] (Badani) 161–62, *163*, 164, 165
11, Rue Larrey (Duchamp) 137
11 September 2001 10
13th Floor Elevators 256
24/7: Late Capitalism and the Ends of Sleep (Crary) 148
28 Compositions (Maloy) 26, 28
747 (Burden) 9
2001: A Space Odyssey (Kubrick) 122, 153

A

A Ble Wail (Cha) 197
abbatoir 145–49
Abramović, Marina 5
abstraction 112, 220, 238
Acconci, Vito 5, 135
The Act of Drinking Beer with Friends is the Highest Form of Art (Marioni) 113–14
Ader, Bas Jan 120–21
advertising 133
Aerosmith 230
AIDS 206–07
Alicante, Spain (Cartier-Bresson) 68
all our relations, 18th Biennale of Sydney 221–23
Allen, Woody 164
Alloway, Lawrence xx, 134
Almereyda, Michael 61–66

Alpine Walking with Tails and Ears (Bagnall) 35, *36*, 37, 38
Als, Hilton 246, 248
altered states 57–58
alternative hedonism 43
Alÿs, Francis 53–60, *55*
Ambulantes (Alÿs) 57
The American Friend (Wenders) 181
An American Index of the Hidden and Unfamiliar (Simon) 89–93
American Photographs (Evans) 92
The Americans (Frank) 92–93
American Supermarket (Apple) 134, 138, 140
American Surfaces (Shore) 93
The Anatomy of Melancholy (Burton) 203
Anatsui, El 223
Anderson, Kurt 123–24
Anderson, Laurie 10–15, *13*, 43–49, *47*
Andy Warhol's Fifteen Minutes (Warhol) 253
Anger, Kenneth 155
Angus, Rita 245, 248
animal/human 37, 39–41
Antarctica *see Ice Blink*
Aotearoa New Zealand *see* New Zealand
Apollo moon landing 231
Apple, Billy 133–40, *139*
Apple, 161 West 23rd Street, New York 135
appropriation 246, 248, 258
Arab Spring 222
Arcade Fire 77

architecture 54

Aristotle 203

The Armies of the Night (Mailer) 123

Armstrong, Neil 231

art

 and economics 129–32, 188–90

 and happiness 175

Art After Capitalism (Holmes) 189

Art Make-Up (Nauman) 28

Art Transactions (Apple) 138

Artaud, Antonin 8

artificial intelligence 152

Artists Space, New York, USA 104

astrology 166, 168

authorship 58, 230

Avedon, Richard 101, 162, 211

Aveugle Voix (Blind Voice) (Cha) 197, 198

Awakened in the Mist (Réveillé dans la brume)
 (Cha) 199

B

Bad Taste (Jackson) 156

Badani, Pat 160–65, *163*

'Bagism' (Ono) 28

Bagnall, Catherine, 33–43, *36, 38,* 257–58

Bakhtin, Mikhail 18–19

Baldessari, John 134

Baldwin, Craig 155, 156

Baldwin, James 10

Balenciaga (Sherman) 105

Banerjee, Subhankar 222

Bangkok, Thailand, Silpakorn University 169

Bangs, Lester 3

Barikin, Amelia 180–83

Baroque project (Bagnall) 35, 37

Barrar, Wayne 81–85, *84*

Barren Cave Mute (Cha) 197

Barrett, Syd 256

Barthes, Roland 77, 100

Barton, Christina 117, 137

Basquiat, Jean-Michel 205

Batchen, Geoffrey 92

Bates, Barrie *see* Apple, Billy

Baudelaire, Charles xix, 21, 54, 68–69, 205

Bauhaus 218, 219

The Beatles 98, 207

Beatty, Warren 253

Beau Brummel 41

Beaumont, Dhyana 259, *260*

beautiful, and grotesque 21–22

Beckett, Samuel 65, 162

becoming 37, 39, 41

Bedford, Whitney 208

Being Billy Apple (Apple) 134

Beneath the Roses (Crewdson) 86

Benjamin, Walter 141, 205

Bennett, Jane 184

Benson, Lisa 231

Berardi, Franco ('Bifo') 124, 131–32

Bergson, Henri 180–81, 224

Beuys, Joseph 25, 58

Beware of Blindman Pictures (Perzyński) 169

Beyond (Graham) 240–41

Big Love, TV melodrama 98

Big Science (Anderson) 46

Big Star 64

*Billy Apple®: The Artist Has to Live Like
 Everybody Else* (Apple) 137–38, *139*

*Billy Apple Bleaching with Lady Clairol
 Instant Crème Whip* (Apple) 134

Billy Apple trademark 140

bio-power 131

birdlife, New Zealand 35

Bishop, Cameron 18

Black Drop (Starling) 224

black mirror 75, 77

Black Water Colour Painting (Morris)
 236–39, *237*

Blanchon, Robert 206–07

Blind Voice (Aveugle Voix) (Cha) 197, *198*

Blunt, Anthony 226

boatshed 117–21, *118*

'Bodies in Alliance and the Politics of the Street' (Butler) 189–90

Body Activities (Apple) 135, 136

Body Arm (Maloy) 28

Body Press (Graham) 241

Boltanski, Christian 161

Bond, James 226

books

 Barikin 180–83

 Barrar 81–85

 Braddock 184–87

 Horrocks 191–93

 Jackson 176–79

 Morgan 173–75

 Noble 81–85

 Sad Songs exhibition 257

 Sholette and Ressler 188–90

Borges, Jorge Luis 64, 164

Boshier, Derek 133

Bounce (Cross) 18

Bourriaud, Nicolas 42, 111–12, 120, 161, 180, 181

Bowie, David 257

Braddock, Christopher 184–87

Branca, Glenn 241

Brando, Marlon 100

Breaker Bay, Wellington, New Zealand 117, *118*, 121

Bresson, Robert 168

Breton, André 9

Brisbane, Institute of Modern Art 224

Broglio, Ron 41

Broodthaers, Marcel 57, 120–21

Brouwn, Stanley 54

Brown, Charlie 208

Brown, Georgette 259

Brown, Trisha 44, 102

Brunetti, John 215

Bryan-Wilson, Julia 189

Buddhism 46, 248

The Bull Laid Bear (Ressler) 189

Bulleen, Australia, Heide Museum of Modern Art 224

Buñuel, Luis 153

Burden, Chris 3–8, *4*, *9*

Burgin, Victor 164

Burroughs, William S. 12, 44

Burton, Robert 203

Bush, George W. 12, 14–15, 90

Bush-Gore Presidential Election 2000 90

But You Love Me/You Said So (Ricard) 205

Butler, Benjamin 207

Butler, Judith 189–90

By the Ways: A Journey with William Eggleston (Gérard and Laty) 61–66

Byrne, David 63

Byrt, Anthony 136

Bywater, Jon 258

C

Cage, John 12, 112–13, 238, 257

'A call to the Army of Love and to the Army of Software' (Berardi and Lovink) 124

The Calling (Anderson) 43

Cameron, Julia Margaret 209

Camouflage Self Portraits (Warhol) 253

Campion, Jane 152

Caribou Migration I (Banerjee) 222

carnivalesque 18–19

Cartier-Bresson, Henri 62, 67, 68, 71

Cartland, Barbara 98

Casey, Edward S. 212, 213

Cash, Johnny 218

Cassavetes, John 168

CAST (Kosloff) 185, *186*

Castelli, Leo 5, 137

Cavemanman (Hirschhorn) 114, *115*

Cedar Bar, New York, USA 5

Celebrate Life: I Love Egypt (Hefuna) 222
Cha, Theresa Hak Kyung 197–99, *198*
Champaign, Illinois, USA, Krannert Art Museum 197
Chandler, John 135
Chaplin, Charlie 119
Chapman brothers 208
Charleston, Illinois, USA, Tarble Arts Center 160
Cheney, Dick 90
Cher Peintre exhibition 173–74
Chilton, Alex 62, 64
Chitham, Karl 233, 234
Christ on the Cross (Pierson) 209
Christchurch, New Zealand, Ilam Campus Gallery 236
Cinecittà Studios, Rome, Italy 88
Clark, Larry 73, 241
Clark, T.J. 218
Claude glass 75
Clay Nose (Maloy) 26, 28
Clemens, Justin 226
Clement Greenberg: The Collected Essays and Criticism (O'Brian) 174
Clement Greenberg: Late Writings (ed. Morgan) 173–75
Clinton, Bill 188
clothing 34–35, 40–41, 257–58
Cloud series (Hastings-McFall) 233
Clown (Sherman) 105
Cockatoo Island, Sydney, Australia, 18th Biennale 222–23
Cocteau, Jean 153
Coetzee, J.M. 39
Cohen, Greg 44
Coleman, Ornette 44
Coleridge, Samuel Taylor 77
Collapse (Easton) 216–20
Collective Actions group 177
comics 133, 155, 202, 257

Conan Doyle, Arthur 64
Conceptualism 113, 165, 176–79
Concert for Dogs (Anderson) 48
Conland, Natasha 25, 100
Conner, Bruce 155
Connery, Sean 226
Constable, John 243
Cooper, Alice 8
Copenhagen, Denmark *57*
Corman, Roger 98
Costakis, George and Zinaida 177
Costello, Elizabeth 39
'Counter-Avant-Garde' (Greenberg) 174–75
counterculture 10, 155, 255–57 *see also* happenings
Coupland, Douglas 17
Craig-Martin, Michael 117, 119
Crary, Jonathan 145, 148
crawling 5
Creative New Zealand 31
Creed, Martin 251
Crewdson, Gregory 86–88, *87*
Crisis in the Credit System (Gilligan) 189
The Crisis of the Easel Picture (Greenberg) 112
criticism
 Frank 74
 Greenberg 173
 Kozloff 70, 73–74
 of major exhibitions 222
Cross, David 16–22, *20*, 218, 230
Culture Crash: The Killing of the Creative Class (Timberg) 131
Cultures and Ferments (Badani) 160
Cunningham, Merce 102
Curnow, Betty and Allan 245
Curnow, Wystan 137–38

D
Dafoe, Willem 127
dairy farming 40

dandies 41
Dashper, Julian 138
Dass, Ram 257
David Zwirner Gallery, New York, USA 59
Davies, Ray 93
Davis, Douglas 9
Dayan, Moshe 59
de Duve, Thierry 175
de Kooning, Willem 25, 252
De Maria, Walter 243
de Zegher, Catherine 221
Dean, Tacita 79
Dear Pirate, my Heart is a Bloody Tattoo (Gustafson-Sundell) 206
death 152, 169, 253
Debord, Guy 161
The Decisive Moment (Cartier-Bresson) 68
deforestation 141–42
Deleuze, Gilles 40, 181
DeLillo, Don 255
Deller, Jeremy 79
Demand, Thomas 79, 90
The Democratic Forest (Eggleston) 62–63
Deren, Maya 258
Dia Foundation 56
Diamond, Cora 39
Dictée (Cha) 197
difference *see* otherness
digital cameras 72
Dion, Mark 79
disasters 121, 122–23
Disney 19, 207
documentation 5, 9, 42–43, 54, 242
Dog Day Afternoon (Lumet) 181
dogs 11, 14, 48, 58
Doherty, Claire 120, 161
Dowse Art Museum, Lower Hutt, New Zealand 43
Drag Self Portraits (Warhol) 253

drawings
 Macdonald 212–15
 Māori 245
 Pierson 209
 Schoon 246
 Warhol 252
The Dream of the Audience (Cha) 197–99
dreaming 148
drugs 57–58
dualities 199
Duchamp, Marcel 112–13, 174–75, 184
 11, Rue Larrey 137
 and Hodson 126–27
 and Leach 117, 119
 readymade 126–27
 and Warhol 253
Dunbar, Rod 140
Dunedin Public Art Gallery, New Zealand 81, 89
Dunn, Megan 101
Dürer, Albrecht 203, *204*
Dusty Boots Line The Sahara (Long) 243
Dylan, Bob 64

E
East Village, New York, USA 5
Easton, Craig 216–20, *217*, 231
economics, and art 129–32, 188–90
Edmier, Keith 209
Eggleston, Andra 64, 65
Eggleston, Rosa 63
Eggleston, William 61–66, 92, 211
Eggleston, Winston 65
Egypt 222
Ehrenreich, Barbara 12
The Elder Dragon Wand (Kelly) 259
el Gharani, Mohammed 48
El Gringo (Alÿs) 58
Emerson, Ralph Waldo 10
emotion 165, 168, 211
Emperor Penguins, Antarctic diorama (Noble) 82

encounters 111–16

The End of History and the Last Man (Fukuyama) 188

The End of the Moon (Anderson) 11, 14

Eng, Bev 257

Engine Room, Massey University, Wellington, New Zealand 212, 255, 258, 261

Environmental Project (Kahukiwa) 200

epistemological anarchism 168

Espiral - A Dance with Death in 8 Scenes (Rosenberger) 189

Ethlyn (Todd) 99

Evans, Walker 70, 62, 92, 94

Evel Knievel of art 9 *see also* Burden

exhibitions xix, 189

 6 Artists from New Zealand: Abstraction and Time 231

 Cher Peintre 173–74

 Is It the Beginning of a New Age? 255–62

 Painting at the Edge of the World 173–74

 Sad Songs 203–11

 Sydney Biennale 2012 221–23

 Young Contemporaries 134

 see also name of artist

An Expanding Subterra (Barrar) 81–85

The Experimental Group: Ilya Kabakov, Moscow Conceptualism, Soviet Avant-Gardes (Jackson) 176–79

Extension of the Given (Stairway Entrance) (Apple) 137

F

The Factory 253 *see also* Warhol, Andy

fairness 129–30

Fairness and Freedom (Hackett Fischer) 129–30

Falco, Tav 62

A Family and Friends Event (Perzyński) 168

The Family Dog collective 256

Faulkner, William 64, 129

Fawcett, Farrah 209

Feather Sword (Kelly) 259

Feet of Clay (Nauman) 28

Fellini, Federico 88

feminism 41, 103–04, 119, 206, 235

Fermi, Enrico 226

Feyerabend, Paul 168

A Field Guide to Getting Lost (Solnit) 141

Fiks, Yevgeniy 189

film 68, 100, 122

 Almereyda 61–66

 Anderson 48

 Apple 134, 135

 Badani 161, 164

 Baldwin 156

 Burden 3

 Crewdson 88

 Cross 19

 Gérard and Laty 61–66

 Graham 241

 Grattan 152, 153

 Heynes 155–56, 159

 Hodson 127

 Huyghe 181

 Leach 119

 Lye 191, 193

 Shelton 75

 Sherman 103–04

 Starling 224

 Warhol 98, 253

 Winogrand 69

 see also horror films; video

film and video production, New Zealand 159

Fink, Larry 73

Fireflies (Crewdson) 88

Fish, Allan *see* Marioni, Tom

Fisher, Mark 148–49

flâneurs 54 *see also* walking

Flatbed Picture Plane 59

flatness 218–19

Flavin, Dan 240

Fluxus 113, 135, 175
Flying Nun records 156
Folding Water (Morris) 239
Folk Furniture (Larkin) 257
Follow the Party of the Whale (Te Ao) 146
formalism 216, 218, 235
Fortune Teller (Perzyński) 166, *167*, 168
Foucault, Michel 131
Fountain (Duchamp) 126
Frank, Robert 67, 69, 70, 71, 74, 92, 207
Frankovich, Alicia 184
Freeman, Robert 134
Freud, Sigmund 203
Friedrich, Caspar David 60, 120, 207
From Barrie Bates to Billy Apple retrospective 136
From Hand to Mouth (Nauman) 28
From the Collection of ... (Apple) 138
Fukuyama, Francis 188
Fulton, Hamish 54
furniture 233, 257
Futurist movement 72

G
Gallacio, Anya 208
Gaseous Discharge Phenomena (film) 135
the gaze 18, 42, 79–80, 88, 119–20
Gein, Ed 98
Generation X 17
Gérard, Vincent 61–66
GET IT RIGHT (Pointon) 249
Gilligan, Melanie 189
Giorno, John 253
Girl in Bush Shirt (Kahukiwa) 200
Glass, Philip 44, 49, 238
Goldin, Nan 57
Goldstein, Jack 159
Gonzalez-Foerster, Dominique 241
goodness 251
Google 152–53

Gordon, Douglas 241
Gordon, Robert 65
Gothic Minimalism 219
gourd carving 246
Govett-Brewster Art Gallery, New Plymouth, New Zealand 191
Gowin, Emmet 209
Grabner, Michelle 251
Grace, Patricia 202
Graeber, David 190
Graham, Dan 19, 240–41
Grannan, Katy 209, *210*, 211
Grattan, Sean 150–54, *151*
Gravitas Lite (Robinson) 223
Gravity's Rainbow (Pynchon/Anderson) 10–11
Gray, Spalding 11
Greenberg, Clement 112, 113
The Green Line (Alÿs) 59–60
Gropius, Walter 219
grotesque, and beautiful 21–22
Groys, Boris 177
Guantanamo 48, 90
Gursky, Andreas 62
Gustafson-Sundell, Danielle 206

H
Habeas Corpus (Anderson) 48
Hackett Fischer, David 129–30
HADHAD (Grattan) 150–54, *151*
Halley, Peter 232
Hamilton, Ann 184
Hamilton, Richard 133
Hansel and Gretel effect 21
happenings 25, 112, 113
see also counterculture
Happiness (Anderson) 11
Harryhausen, Ray 156
Hartley, Hal 152
Hartley, L.P. 245
Hastings-McFall, Niki 233–35, *234*

Hattaway, Rolfe 246

hauntology 148–49

Heaphy, Chris 227–32, *228*

Heart of a Dog (Anderson) 48

Heart of Gold (Gallacio) 208

Heaven and Earth (Long) 242–44

Hedren, Tippi 98

Hee Haw TV programme 208

Hefuna, Susan 222

Heide Museum of Modern Art, Bulleen, Australia 224

Heizer, Michael 243

Hendricks, Geoff 135

Here Comes the Ocean (Anderson) 43

Herzog, Werner 232

Heynes, Mike 155–59, *158*

Hilliard, Hinemoa 202

Hilton, Craig 140

Hippocrates 203

Hirschhorn, Thomas 114, *115*

Hirshhorn, Joseph 226

Hirshhorn Museum and Sculpture Garden, Washington D.C., USA 19, 44

Hirst, Damien 208

Hitchcock, Alfred 64, 86, 98, 181

Hockney, David 133

Hodson, Colin 122–27, *125*

Hoffman, Abbie 123

Hold (Cross) 20, 21

Hollywood 100, 103, 104, 159, 207

Holmes, Brian 189

Holmes, Sherlock 64

Home from the Sea (Hastings-McFall) 233

Home Transfer (Badani) 160

Homer, Winslow 120, 208

Homes for America (Graham) 240

hope 122–28, 131–32

Hopper, Dennis 63

Horne, Lena 206

Horo, Horomona 43

horror films 19, 98, 155

see also film

house of allure 21

Hovell, John 231

Hsieh, Tehching 30

Huang, Hsin-Chien 43

humour

 Anderson 46, 48

 Brown 259

 Cross 17

 Hastings-McFall 233

 Heaphy 229

 Heynes 157

 Macdonald 257

Huyghe, Pierre 180–83, *182*

I

I Can't Live in a World Without Love (Blanchon) 206–07

I Consent (Apple) 140

I Need More (Pop) 6–7, 9

I Will Have Gold (Perzyński) 168

Ice Blink (Noble) 81–85

The Ice Rink & The Lilac Ship (Leach) 120

identity

 Alÿs 59

 Apple 134, 138, 140

 Cross 21, 22

 Hastings-McFall 233

 Long 243

 Macdonald 213

 Sherman 104, 107

Iguanas 6

Ilam Campus Gallery, Christchurch, New Zealand 236

Illinois, USA

 Krannert Art Museum, University of Illinois, Champaign, 197

 Tarble Arts Center, Eastern University, Charleston 160

University Galleries, Illinois State University, Normal 203
The Immortalization of Billy Apple (Apple) 140
In a Lonely Place (Crewdson) 86–88
inequality 19, 129–30
The Inequality Debate (Rashbrooke) 129
inflatables 18, 21, 249–51
In Flyte (Hastings-McFall) 233–35
The Inner Workings of the Mind (Heaphy) 230
In Search of the Miraculous (Ader) 121
Inside Job (Ferguson) 122
In Speculum (Starling) 224–26
installations
 Alÿs 59, 60
 Apple 137
 Badani 160, 161, *163*, 164, 165
 Bagnall 33, 257–58
 Cross 17–18, 21–22
 Graham 241
 Hastings-McFall 233
 Heynes 155, *158*, 159
 Hirschhorn 114
 Hodson 123, *125*
 Huyghe 181
 Kabakov *178*
 Kahukiwa 202
 Kelly 259
 Khalili 222
 Long 242, 243
 Maloy 23, 25
 Ora 258
 Perzyński 166, 169–70
 Pierson 209
 Shelton 77
 Starling 224, *225*
 Te Ao *147*
Intensities and Surfaces (Gallacio) 208
interdisciplinarity 92, 160–61, 168–69, 170, 180
Interview magazine (Warhol) 253
[in time time] (Badani) 160–65, *163*

Is It the Beginning of a New Age? exhibition 255–62
Is That All There Is? (Lee) 64
It Came From Memphis (Gordon) 65
It's the Political Economy, Stupid: The Global Financial Crisis in Art and Theory (eds. Sholette and Ressler) 188–90

J
Jackson, Matthew Jesse 176–79
Jackson, Peter 156
Jameson, Frederic 12
Janssen, Jules 224
Janssen, Tove 258
Le Jardin Suspendu (Starling) 224, *225*
Jarmusch, Jim 152
Jentsch, Ernst 157
Jesus with Girls (Kurland) 209
Johns, Jasper 134, 137
Jones, Allen 133
Jones, Amelia 184
Jones, Caroline 25–26
The Journey that Wasn't (Huyghe) *182*
Joy, Dr Mike 40
Judd, Donald 219, 238, 239, 240

K
Kabakov, Ilya 176–79, *178*
Kahukiwa, Robyn 200–02, *201*
Kant after Duchamp (de Duve) 175
Kaprow, Allan 25, 112, 175
Kaufman, Andy 46
Keaton, Buster 119, 164
Kedgley, Helen 233
Kelley, Mike 206, 255
Kelly, Daniel 259
Kelly, Ellsworth 19, 21
Kelly, Grace 98
Kemp Deed 245

Kennedy, Jacqueline 253

Kerouac, Jack 12

Kerry, John 15

Khalili, Bouchra 222

A Kind of Sleep (Shelton) 77

Kings Neon (Mark) *95*

The Kinks 93, 211

Kinmont, Ben 189

Kiss (Warhol) 253

Kitaj, RB 133

Klee, Paul 245

Klein, William 67, 68, 69–71, 218

Knowles, Alison 257

Knox, Chris 156

Kopenkina, Olga 189

Korea 197, 199

Kosloff, Laresa 184, 185, 186

Kozloff, Max 67–74

Krannert Art Museum, University of Illinois, Champaign, USA 197

Kreisler, Aaron 85

Kubrick, Stanley 153

Kuchar, George and Mike 155

Kundera, Milan 162

Kunst Kick (Burden) 5

Kurland, Justine 209

Kusama, Yayoi 19

L

Laing, Kane 260, 261

Land and Sea (Lye) *192*

'Land Art for the Landless' (Alÿs) 56

land management and use, New Zealand 35, 42, 78, 258

landscapes 238

 Alÿs 54, 56

 Bagnall 33–43

 Banerjee 222

 Barrar 81–85

 Butler 207

 Graham 240

 Grattan 150

 Lee 207

 Long 243

 Lye 191

 Macdonald 212–15

 Morris 238–39

 Noble 81–85

 Shelton 77

 Sherman 105

language 131–32

 Anderson 12, 14, 45, 46

 Badani 164

 Berardi 131–32

 Braddock 187

 Bush 14

 Cha 197, 199

 Grattan 152, 153

 Kozloff 74

 Leach 120

 Perzyński 166, 168

 Pointon 249–51

Larkin, Tim 257

Laty, Cédric 61–66

Leach, Maddie 117–21, *118*

The Leak (Alÿs) 59

Lean (Cross) 17

LeCompte, Elizabeth 127

Lee, Jin 207

Lee, Peggy 64

The Legacy of Jackson Pollock (Kaprow) 112

lei 233, 234

L'Ellipse (Huyghe) 181

Lennon, John 65, 209

Leo Castelli Gallery, New York, USA 137

Leonard, Robert 98, 105

Lerman, Alexandra 189

Level Playing Field (Cross) 18

Levin, Kim 11–12

Levine, Sherrie 103

Lewallen, Constance M. 197
Lewis, Furry 65
Lewis, Jerry Lee 64
Lewis, Jim 63
LeWitt, Sol 54, 236, 239, 240
a library to scale (Shelton) 77
Lichtenstein, Roy 135
Life is Good & Good for You in New York (Klein) 69, 71
lights 124, 126, 127
Lima, Peru 56
A Line in Scotland Cul Mor (Long) 243
A Line Made by Walking (Long) 242
Linklater, Richard 17
Lippard, Lucy 135
Lister, Aaron 248
The Living Are Few But The Dead Are Many (Rungjang) 222
Living Chasm (Nakaya) 222
Lolabelle 14, 48
London, England
 National Portrait Gallery 58
 Serpentine Gallery 136
 Tate Britain 242
Long, Richard 54, 56, 242–44
Lorrain, Claude 75, 207
Los Angeles, USA, Museum of Contemporary Art 240
lost 11, 141–42
love 102, 145, 149, 205–06
The Love Boat, TV series 98
The Lovers (Magritte) 153
Lovink, Geert 124
Lower Hutt, New Zealand, Dowse Art Museum 43
Lumet, Sidney 181
Lye, Len 138, 191–93, *192*
Lynch, David 86, 104, 152, 164, 207
Lynton, Norbert 136
Lyons, Nathan 94

M
Macdonald, Shona 212–15, *214*
Macdonald, Theo 257
Maciunas, George 135
MacNeil, Jess 222
magic 34, 40, 165, 184–85, 259
Magritte, René 153
Mahara Gallery, Waikanae, New Zealand 200
Mailer, Norman 123
Maillet, Arnaud 75, 77
Malevich, Kazimir 219, 220
Maloy, Richard 23–29, *24, 27,* 184, 185
The Man Who Flew Into Space From His Apartment (Kabakov) *178*
Mann, Sally 209
Manson family 98
Māori carvings 193, 248
Māori cosmology 229–30, 231–32
Māori culture 35, 78, 146, 200, 202, 248, 261
Māori imagery
 Heaphy 227, 229, 230–32
 Kahukiwa 200, 202
 Schoon 245–46, 248
Māori Modernism 246 *see also* Modernism
Mapping Journey (Khalili) 222
Mapping the Studio: Fat Chance John Cage (Nauman) 58
Marceau, Marcel 101
March on the Pentagon 1968 123
Marden, Brice 236
Marey, Étienne-Jules 60, 224
Marin, Louis 216
Marioni, Tom (Allan Fish) 8, 113–14
Mark, Simon 94–96, *95*
The Market Testament (Hodson) 122–27, *125*
Marshall, Kerry James 202
Martin, Agnes 236
Martinis Roe, Alex 184
Massey University, Wellington, New Zealand 212, 255, 257, 258, 261

materials
Alÿs 59
Apple 135
Beaumont 259
Gustafson-Sundell 206
Kelly 259
Larkin 257
Macdonald 213
Maloy 23–29
Te Ao 148
Matisse, Henri 170
Matta-Clark, Gordon 44, 54
Maukatere (Heaphy) 227, *228*
Maumahara: Remember (Kahukiwa) 200–02
Maungapōhatu, New Zealand, Rua Kēnana
temple 230
Maus (Spiegelman) 162
Maw, Liz 107
Max's Kansas City, New York, USA 5, 6
Mayakovsky Museum, Moscow, Russia 177
McCarthy, Paul 19
McCleland, Adrian 261
McDonald's 12
McIntyre, Simon 231
McLeavey, Peter 138
McLuhan, Marshall 9, 134, 257
McMaster, Gerald 221
Me&U2 (Badani) 160
Medina, Cuauhtémoc 57
Meditation (Laing) 260, 261
Meghan, Saw Kill River, Annandale, NY
(Grannan) *210*
Mehretu, Julia 213
melancholy 73, 203, 205, 224 *see also*
sadness
Melbourne, Australia
Monash University 224
Nellie Castan Gallery 216
Melencolia (Dürer) 203, *204*
Melville, Herman 10

Menzies, Louise 258–59
Messager, Annette 206
Metro-Goldwyn-Mayer (Goldstein) 159
Mexico City 57
Meyer, Pedro 71
Meyerowitz, Joel 69
Mickey Mouse 230
Miller, Henry 12
Miller, Larry 135
Minh-ha, Trinh T. 199
Minor Threat 241
Miró, Joan 245
Mister Heartbreak (Anderson) 46
Mitchell, Margaret 98
mixed media, Gustafson-Sundell 206
Moby Dick, Songs and Stories From (Melville/
Anderson) 10, *47*
Modernism 142, 203, 207, 219, 227
Greenberg 174–75
Kabakov 176
Lye 193
Māori 246
'Modernist Painting' (Greenberg) 174
Moholy-Nagy, Laszlo 113–14
Monash University, Melbourne, Australia, 224
Monroe, Marilyn 253
Montano, Linda 30, 175
Moore, Henry 226
Moore, Marcus 117
Morgan, Robert C. 173–75
Morning (Edmier) 209
Morris, Robert 19
Morris, Simon 231, 236–39, *237*
Morrissey, Paul 98
Morrison, Toni 10
Moscow, Russia, Mayakovsky Museum 177
Moscow Conceptualism 176–79
see also Conceptualism
Mourning and Melancholia (Freud) 203
Mouth to Mouth (Cha) 199

MTV 98, 253
Mukhomors (Toadstools) 177
Murphy, Peter 219
Muru, Selwyn 246
Muybridge, Eadweard 101

N
Nabokov, Vladimir 162, 229
Nakaya, Fujiko 222
Narcoturismo/Narcotourism (Alÿs) 57–58
NASA artist in residence 11
National Portrait Gallery, London, England 58
Nauman, Bruce 19, 28, 58, 168, 184, 185
Negativland 156
Nellie Castan Gallery, Melbourne, Australia 216
Nest Group 177
New Age 152, 255–62
New Music America (Anderson) 13
New Plymouth, New Zealand, Govett-Brewster Art Gallery 191
The New Pornographers 98
New York, USA
 Apple 135
 Artists Space 104
 Cedar Bar 5
 David Zwirner Gallery 59
 East Village 5
 The Factory 253
 Leo Castelli Gallery 137
 Max's Kansas City 5, 6
 Museum of Modern Art 62
New York: Capital of Photography (Kozloff) 70
New Zealand
 and artists 138
 birdlife 35
 Dowse Art Museum, Lower Hutt 43
 Dunedin Public Art Gallery 81, 89
 film and video production 159
 Govett-Brewster Art Gallery, New Plymouth 191
 Ilam Campus Gallery, Christchurch 236
 land management and use 35, 42, 78, 258
 Mahara Gallery, Waikanae 200
 pests 35, 41–42, 257
 Rotoroa Island 77–78
 Rua Kēnana temple, Maungapōhatu 230
 Tapu Te Ranga Marae 202
 Tongariro National Park 34
 Whakaturia Marae, Rotorua 246
 see also Wellington
New Zealand Festival 2020 43
New Zealand Gothic 258
News of the Uruguay Round (Heynes) 158
Newman, Barnett 220
Ngā Uruora: The Groves of Life (Park) 141–42
Nickel and Dimed (Ehrenreich) 12
Nietzsche, Friedrich 203
Nightwatch (Alÿs) 58
Noble, Anne 81–85, *82*
North by Northwest (Hitchcock) 64
Not Good For Business (Perzyński) 169
'Notes on Sculpture' (Morris) 19
Novak, Kim 98
Nuclear Waste Encapsulation and Storage Facility (Simon) 91
Nummer acht: Everything is going to be alright (van der Werve) 223

O
An Oak Tree (Craig-Martin) 117, 119
Obama, Barack 90
O'Brian, John 174
Occupy movement 123, 124, 130, 190 *see also* protest
Oldenburg, Claes 134
Olds, Warren 83
Olitski, Jules 173
Ominous Landscapes (Sherman) 105
O'Neill, Eugene 127
Ono, Yoko 28, 175, 209

Ora, Bikka 258

Orchestra of Spheres 259

An Original New-Waver (Macdonald) 257

Orozco, Gabriel 184

Orwell, George 12

Osterberg, James *see* Pop, Iggy

O'Sullivan, Timothy 85

O Superman (Anderson) 12, 44

otherness 21, 39, 43, 93, 132, 206–07

Our Literal Speed 177

The Outcast (Kahukiwa) 200

P

Paid series (Apple) 138, *139*

Paik, Nam June 135

Pailhas, Roger 180

painting 111

 abstract 112, 220, 238

 and postmodernism 227

 systemic approach 236

 in twenty-first century 218, 219

Painting at the Edge of the World exhibition
 173–74

paintings

 Alÿs 59, 60

 Anderson 48

 Apple 134, 138

 Badani 161

 Bagnall 35, 258

 Beaumont 259

 Bedford 208

 Butler 207

 Easton 216–20

 Greenberg 173–74

 Heaphy 227–32

 Kahukiwa 200–02

 Lye *192*

 Macdonald 212–15

 Moholy-Nagy 113

 Morris 236–39, *237*

 Ricard 205–06

 Schoon 245–46

 Turner 208

 Warhol 89, 253

Palermo, Blinky 239

Palestine 59–60

Panther Burns 62

paper projects 197–99, 258

paradox 37, 53–54, 55, 153, 240

The Paradox of Praxis (Alÿs) 53–54, *55*

Parallel Presents: The Art of Pierre Huyghe
 (Barikin) 180–83

Park, Geoff 85, 141

Parker, Cornelia 79

Parr, Mike 19

Parton, Dolly 98

Passing Time #2 (Pierson) 208–09

PEN American Center 14

performance art 5, 30, 135

 Ader 121

 Anderson 10–15, *13*, 43–49, *47*

 Bagnall 33–43, *36*, *38*

 Braddock on 184–87

 Burden 3–8, *4*, *9*, 135

 Cha 197–99

 Cross 16–22, *20*

 Laing 261

 Leach 117, 119

 Maloy 23–29, *24*

 Perzyński 169–70

 Pop 3–8, *7*

 Sherman 104

 Singh 30–31, *32*

Performing Contagious Bodies: Ritual Participa-
 tion in Contemporary Art (Braddock) 184–87

Perigee #11 (Leach) 117–21, *118*

Perkins, Anthony 98

Perzyński, Bogdan 166–70, *167*

pests, New Zealand 35, 41–42, 257

Phelan, Peggy 184

Phillips, Bruce E. 145–46
Philosophical Investigations (Wittgenstein)
 157
Phoenix block series (Shelton) 76
photographs
 Alÿs 53–60
 Apple 134
 Bagnall 39, 42
 Banerjee 222
 Barrar 81–85, *84*
 Burden 6
 Cartier-Bresson 68
 Cha 197
 Clark 73
 Crewdson 86–88, *87*
 Eggleston 61–66
 Frank 68, 74
 Grannan 209, *210*, 211
 Klein 68, 69–71
 Kozloff 67–74
 Kurland 209
 Laing 261
 Lee 207
 Long 242, 243
 Maloy 26, 28
 Mark 94–96, *95*
 Noble 81–85, *82*
 Perzyński 166–70
 Pierson 208–09
 Schoon 246
 Shelton 75–80
 Sherman 103–107, *106*
 Simon 89–93, *91*
 Starling 224
 Todd 97–102, *99*
 Vanagt and Vermeire 222
 Westra 246
photography 67–74, 77, 79, 92–93
 corporate 97, 100
Pien, Ed 222–23

Pierson, Jack 208–09
Pike, David L. 85
[ping-pong-flow] (Badani) 161, 164–65
play 17–18, 25–26, 28
poetry 131–32, 146, 149, 191, 205, 209
Pohio, Nathan 245
Pointon, Elisabeth 249–51, *250*
The Political Economisation of Art (Roberts)
 189
politics 188–90, 203, 205, 223
 and Anderson 10, 14, 48
 and Heynes 159
 and Kahukiwa 200–02
 and Te Ao 148–49
Pollock, Jackson 112, 174, 208, 252
Polynisation (Hastings-McFall) *234*
Pooley, Leanne 134
Pop Art 133, 134, 257
Pop, Iggy 3–8, *7*
popular (pop) culture 5, 98, 155–59, 209,
 218, 238, 255
 Graham 241
 Heynes 155
 Huyghe 180
portraits 100, 211
 Angus 248
 Apple 138
 Cha 199
 Eggleston 63, 66
 Grannan 209, *210*, 211
 Kahukiwa 200, 202
 Kurland 209
 Laing *260*, 261
 Maloy *25*
 Maw 107
 Schoon 248
 Sherman 103, 107
 Tuymans 90
 van Hout 107
 Warhol 138, 252–53, *254*

possums 35, 257
posters 83, 114, 134, 256–57, 259
Postmodernism 142, 203, 227, 255
 and Anderson 12
 and Cross 16
 and Easton 219
 and Macdonald 213
 and Perzyński 166
 and Sherman 103
Power to the People (Lennon) 65
Power, Mark 62
Presence/Absence (Cha) 199
Presley, Elvis 62, 98
Presley, Priscilla 98
Pretty Poison (Black) 98
Prime Movers 6
Prince 257
Prince, Richard 103
The Privileged Eye (Kozloff) 67–68
Project for a Masquerade (Hiroshima) (Starling) 226
prostheses 26, 28, 103
protest 123–24, 128, 130, 246, 248 *see also* Occupy movement
Proust, Marcel 162
psychedelia 107, 206, 229, 253, 256–57
Psycho (film) 98
publicness 31, 109–42
 Apple 133–40
 Badani 160–61
 Graham 241
 Hastings-McFall 233
 Hodson 124–28, *125*
 Leach 117–21
 Singh 30–31
Pump (Cross) 17, 21
Punk Shane (Heynes) 157
The Purple Rose of Cairo (Allen) 164
Pynchon, Thomas 10–11, 255

R
Radio City (Big Star) 64
Rancière, Jacques 181
Rashbrooke, Max 129, 132
Rātana, T.W. 232
Rauschenberg, Robert 59, 175
Raw Attempts (Maloy) *24*
Ray, Nicholas 86
Re Dis Appearing (Cha) 199
Reading Lenin with Corporations (collective) 189
readymade and infrathin 126–27
reality 73, 100
 and Badani 161, 164
 and Crewdson 88
 and Herzog 232
 and Hirschhorn 114
 and Kelly 259
 and Shelton 79
 and Simon 90
Rear Window (Hitchcock) 181
Reddaway, Richard 35
Redeye (Shelton) 77
Reed, John and Sunday 224
Reed, Lou 43, 46, 256, 257
Reenactment (Alÿs) 58
Reinhardt, Ad 120, 218, 220, 236
Relational Aesthetics (Bourriaud) 42, 112, 180
Relyea, Lane 29
remembering 162, 200–02
reorientations 141–42
A Requested Subtraction 10/4/74 (Apple) 136
Resistance/Te Tohenga (Kahukiwa) 200, *201*
responsive eye 231
Ressler, Oliver 188–90
Réveillé dans la brume (Awakened in the Mist) (Cha) 199
Rhythm O (Abramović) 5
Ricard, René 205–06
Rice, Condoleezza 90
Richards, Vernon 65

Richter, Gerhard 175
rifle camera 60
Rinder, Lawrence 199
Ring, Ken 117
Ringgold, Faith 202
Roberts, John 189
Robeson, Paul 207
Robinson, Peter 223
Rock My Religion (Graham) 240–41
Rodchenko, Alexander 218
The Romans in Films (Barthes) 100
Romantic tradition/Romanticism 203, 207–08
 Ader 120
 Alÿs 60
 Bagnall 42–43
 Kozloff 68
 Kurland 209
 Long 243
 Sherman 105
Rome, Italy, Cinecittà 88
Room Room (Shelton) 75–80
Rosato, Sr 162, 164
Rosenberger, Isa 189
Rothko, Mark 220
Rotoroa Island, New Zealand 77–78
Rotorua, New Zealand, Whakaturia Marae 246
Rua Kēnana 232
Rua Kēnana temple, Maungapōhatu, New Zealand 230
Run DMC 230
Rungjang, Arin 222
Rushdie, Salman 14
Rwanda 222

S
Sad Songs 203–11
sadness 11, 203–11
Saint, Eva Marie 98
Samoa, tapa design, Lye 193

Sanctuary (Crewdson) 88
Sanders, Colonel Harland 226
Schjeldahl, Peter 104
Schlock! Horror! Death of a B-Movie Empire (Heynes) 155–56
Schnabel, Julian 205
Schneider, Rebecca 184
Schoon, Theo 245–48, *247*
Schwabsky, Barry 64, 122
Scott, Kitty 58
Scott, Ridley 164
Screen Tests (Warhol) 253
sculpture 111
 Alÿs 60
 Anatsui 223
 Anderson 48
 Apple 134
 Badani 160
 Brown 259
 Cross 18, 21, 22
 Demand 90
 Edmier 209
 Gallacio 208
 Hastings-McFall 233, 235
 Heynes 155
 Kelly 259
 Kinmont 189
 Leach 119, 120, 121
 Long 242, 243
 Lye 191
 Maloy 23, 25, 28–29
 Morris 19
 Ono 209
 Pierson 209
 Robinson 223
 van Hout 107
Sea of Tranquility (Heaphy) 231
Seahorsel Subset (Todd) 101
Sebald, W. G. 162, 224
Sedgwick, Edie 253

Seedbed (Acconci) 5, 135

Seel, Martin 111

Semu, Greg 107

Serpentine Gallery, London, England 136

Sevigny, Chloë 98

Shakur, Tupac 10

shamanism 37, 197, 199

The Shape of Between (MacNeil) 222

Shelton, Ann 75–80, *76*

Shepard, Sam 93

Sherlock Jr. (Keaton) 164

Sherman, Cindy 19, 103–107, *106*

Shifting Nature (Barrar) 85

Shin, Jeena 231

Sholette, Gregory 188–90

Shoot (Burden) 135

Shore, Stephen 93

Silpakorn University, Bangkok, Thailand 169

Simmer Dim (Macdonald) 212–15

Simmer Dim Flyover (Macdonald) 213

Simon, Taryn 89–93, *91*

Singh, Victoria 30–31, *32*

Situationist International 161

Skinner, Damian 248

Skyball (Cross) 18

Slackers (Linklater) 17

Slaughterhouse-Five (Vonnegut) 146, 148

Sleep (Warhol) 253

Sleepers (Alÿs) 57

Smith, Patti 240

Smithson, Robert 56, 240, 243

Snow Storm - Steam-boat off a Harbour's Mouth (Turner) 208

Soft, Yellow Insides (Gustafson-Sundell) 206

Solnit, Rebecca 54, 128, 141

Solomon, Rosalind 63

Sometimes a Nicer Sculpture Is Being Able to Provide a Living for Your Family (Kinmont) 189

Sometimes Doing Something Poetic can become Political and Sometimes Doing

Something Political can become Poetic (Alÿs) 59–60

Sonic Outlaws (Baldwin) 156

Sontag, Susan 73

Soper, Kate 37, 39, 43

Source (Pien) 222–23

Spanish Civil War 222

Speak, Memory (Nabokov) 229

SPECTACULAR (Pointon) 249, *250*

Spielberg, Steven 86

Spiegelman, Art 162

The Spiral of History (Menzies) 258–59

Split Level View Finder: Theo Schoon and New Zealand Art exhibition 245–48, *247*

Spong, Sriwhana 26

sport 18

Springsteen, Bruce 15

stagediving 6

Stallone, Sylvester 253

Starling, Simon 79, 224–26, *225*

Stieglitz, Alfred 126

Stein, Gertrude 162

Steinberg, Leo 59

Stella, Frank 73, 218, 232

Stewart, Keith 232

still life 104, 229, 235

Stink Magnetic music label 156

Stooges 3, 4, 8

see also Pop, Iggy

Stranded in Canton (Eggleston) 64–65

The Strange Baroque Ecology Symposium (Bagnall) 37

street photography 67–74

see also photography

studios 100

 Alÿs 59

 American 1960s 25–26, 135

 Apple 135

 Cinecittà 88

 Easton 217

Hollywood 159
Maloy 26
Morris 239
Nauman 58
New York 135
Warhol 253
Sunset Boulevard (film) 104
surfaces
 Apple 135
 Bagnall 41
 Hastings-McFall 233, *234*, 235
 Heaphy 227, *230*, 231–32
 Simon 89–90
 Todd 97
 Warhol 89, 97
Surrealism 9, 117, 153
Swanson, Gloria 104
sweat 100
Sydney, Australia, 18th Biennale (2012) 221–23
Szarkowski, John 62

T
Tagaq, Tanya 223
Take Me Down to Your Dance Floor (Leach) 120
tapa design, Lye 193
Tapu Te Ranga Marae, New Zealand 202
Tarble Arts Center, Eastern University, Charleston, USA 160
Tate Britain, London, England 242
Te Ao, Shannon 145–49, *147*
Tear (Cross) 18
Telephone Paintings (Moholy-Nagy) 113–14
television 8–9, 98, 159, 181
Texas, University of, USA, Transmedia program 169
texts 249
 Alÿs 56–58
 Anderson 11
 Badani 162, 164

Cha 199
Long 242, 243
Ora 258
Perzyński 166
Pierson 209
Pointon 249–51
Vautier 175
The Thief (Alÿs) 56–57
The Third Memory (Huyghe) 181
Theatre of Cruelty (Artaud) 8
Thek, Paul 19
Theory of the Dérive (Debord) 161
Thomas, David 231
Thomas, Dylan 193
Thompson, Hunter S. 15, 64
Thompson, Luke Willis 248
Through the Night Softly (Burden) 3, *4*, 8–9
Timberg, Scott 131
time 148–49, 221, 231
 Badani 160, 161–62
 Crary 148
 Graham 241
 Huyghe 181
 Maloy 23
 Morris 236, 238, 239
 Perzyński 166
 Phillips 145–46
 Pierson 208–09
 Singh 31
 Te Ao 149
Time magazine 31, 123, 193
Tips for Artists Who Want to Sell (Baldessari) 134
Toadstools (Mukhomors) 177
To Be Continued.... (Heynes) 157
To the Moon (Anderson) 44
Todd, Yvonne 97–102, *99*, 107
Tongariro National Park, New Zealand 34
Topamnesia (Macdonald) 213
A torch and a light (cover) (Te Ao) 145–49, *147*

Tower-Tour (Badani) 160

Townshend, Pete 5

Toxic (Heynes) 155

toys 155–59

tramping 34–35, 42

see also walking

Transfiguration of K. (Perzyński) 169

Trans-fixed (Burden) 5

Transmedia program, University of Texas 169–70

Trecartin, Ryan 107, 152

Tree Hut (Maloy) 26, 27

Turner, J.M.W. 120, 208

Tuymans, Luc 79, 90

Twain, Mark 10

U

uncanny (Unheimlich) 89

Understanding Media (McLuhan) 9

Unified Heart Consciousness: Flower of Life (Beaumont) 260

United States (Anderson) 11

United States, Pts. 1-4 (Anderson) 44

Unstuck in Time (Phillips) 145–46

Untitled (Crewdson) 87

Untitled (Sherman) 105, 106

Untitled #404 (Sherman) 107

Untitled #462 (Sherman) 105

Untitled (Andersons Bay) (Te Ao) 146

Untitled (Tropicalia) (Bedford) 208

Untitled Film Stills (Sherman) 103, 104

The Uprising: On Poetry and Finance (Berardi) 131–32

Urban Dream Brokerage 31

Urban Navigator series (Hastings-McFall) 234

Urban Projects (Badani) 160

V

Valk, Kate 127

van der Werve, Guido 223

van Hout, Ronnie 107, 156

Vanagt, Sarah 222

Vancouver, Canada, The Western Front 30

Vanitas series (Hastings-McFall) 234

Varanasi, India 222

Va-riant series (Hastings-McFall) 234

Vautier, Ben 25, 175

Vawter, Ron 127

Vehicle Storage, Brady's Bend (Barrar) 84

Velvet Underground 218, 256

Velvet Water (Burden) 5

Vermeire, Katrien 222

Vicious, Sid 5

video

Alÿs 54, 55, 56, 58–59, 60

Anderson 18, 48

Badani 160–65, 163

Blanchon 206–07

Burden 3, 4, 9

Cha 197, 198, 199

Eggleston 64–65

Gilligan 189

Graham 240–41

Grattan 150–54, 152

Heynes 155–59, 158

Hodson 126

Huyghe 181–83, 182

Kelly 259

Khalili 222

Laing 260, 261

Leach 120

MacNeil 222

Maloy 25, 28–29

Ora 258

Perzyński 166–70, 167

Pien 222–23

Ressler 189

Rungjang 222

Singh 31

Te Ao 145–49, 147

Trecartin 107
Vanagt and Vermeire 222
van der Werve 223
van Hout 107
see also film
View-Master 207
Village Voice 3
Viola, Bill 162
violence 5–9, 58, 142, 153
Vis, Jerry 136
Viscous (Cross) 18
vision 18, 73, 79–80, 174
see also the gaze
Vonnegut, Kurt 90, 145, 146, 148, 255

W
Wagoner, Porter 98
Wahine ferry disaster 121
Wahine Toa (Strong Women) (Kahukiwa) 202
Waikanae, New Zealand, Mahara Gallery 200
Waitangi Tribunal 78
The Waiting Room (Singh) 30–31, 32
The Wooster Group 127
Waits, Tom 44
A walk of 24 hours: 82 miles/A walk of 24 miles in 82 hours (Long) 242
Walk this Way (Heaphy) 230
walking
 Alÿs 54, 57–58, 59–60
 Bagnall 34, 35, 36, 38, 39–40, 43, 258
 Long 242–44
 Ora 258
 van der Werve 223
Wallace, David Foster 17, 255
Wall of Seahorsel (Todd) 101
The Walls (Perzyński) 169
Walters, Gordon 232, 245, 246
Walther, Franz Erhard 19
Warhol, Andy 5, 89, 97, 98, 102, 252–53, 257
 and Apple 134–35, 138

The Factory 168, 206
 films 98, 253
 portraits 138, *254*
Warhol: Immortal exhibition 252–53
Washington D.C., USA, Hirshhorn Museum and Sculpture Garden 19, 44
water 199, 236, 239
Waters, John 104, 155
Watson, Dr 64
Watts, Alan 257
Watts, Robert 134
The Wave (Vanagt and Vermeire) 222
Waves, Shore (Macdonald) *214*
Wedde, Ian 83
Weider, Joe 253
Weld, Tuesday 98
Wellington, New Zealand
 Breaker Bay 117, *118*, 121
 City Gallery 86, 104, 224, *225*, 245
 Cuba Street 30–31
 Central Business District 124, *125*
 The Engine Room 212, 255, 258, 261
 Lyall Bay 239
 Massey University 212, 255, 257, 258, 261
 Museum of New Zealand Te Papa Tongarewa 120, 252
 Town Belt 258
Wenders, Wim 181
Were, Virginia 230
West, Cornel 10
Westra, Ans 246
Whaka hokia te Whenua (Kahukiwa) 202
Whakaturia Marae, Rotorua, New Zealand 246
When Faith Moves Mountains (Alÿs) 56
Where are you from? Stories (Badani) 160
Where Life is Better (Badani) 160
White Light White Heat (Velvet Underground) 218

White, Minor 246
The Who 5
wilderness 33–43
see also landscape
Wilhelm Noack oHG (Starling) 224
Wilke, Hannah 184
William Eggleston in the Real World
(Almereyda) 61–66
William Klein and the Radioactive Fifties
(Kozloff) 69–70
Wilson, Arnold Manaaki 246
Wilson, Jane and Louise 90
Wilson, Wes 256
Wings 98
Winiarski, Cezary 169
Winogrand, Garry 69, 73
The Wit and Wisdom of Ronald Reagan
(album) 14
witness 69, 72
Wittgenstein, Ludwig 141, 157

Womb 259
Woolf, Virginia 162
WOULD YOU LOOK AT THAT (Pointon)
250
Wu-Dang Water-sword (Kelly) 259
Wurm, Erwin 25
Wyeth, Andrew 88

Y
Yellow Grotto (Maloy) 25
Yippies 123
Young Contemporaries exhibition 134
Young, Neil 208

Z
Zero Point Field 232
Žižek, Slavoj 188–89
Zizz! The Life and Art of Len Lye in His Own
Words (Horrocks) 191–93
Zorn, John 44